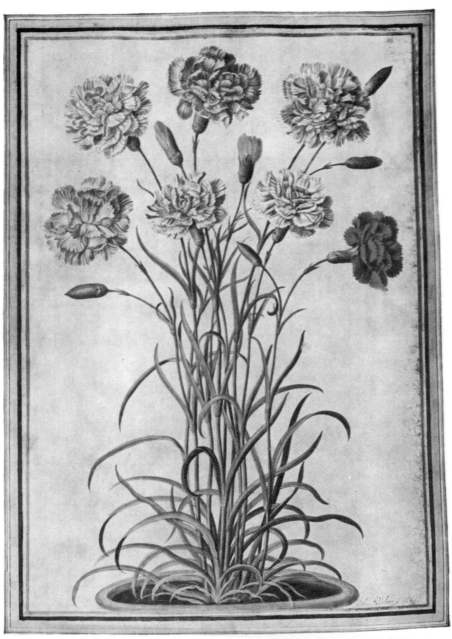

CARNATIONS. Water-colour drawing by Johann Walther, 1654
Victoria and Albert Museum, London

THE ART OF
BOTANICAL ILLUSTRATION
An Illustrated History

WILFRID BLUNT

with the assistance of William T. Stearn

DOVER PUBLICATIONS, INC.
New York

TO GRIZEL

Bibliographical Note

This Dover edition, first published in 1994, is an unabridged republication of the fourth edition of the work originally published by Collins, London, in 1950 as No. 14 of The New Naturalist Series.
Fifty-five illustrations formerly reproduced on 24 color plates are here reproduced in black and white.
A new selection of 16 color plates has been added.

Library of Congress Cataloging-in-Publication Data

Blunt, Wilfrid, 1901–
 The art of botanical illustration : an illustrated history / Wilfrid Blunt, with the assistance of William T. Stearn.
 p. cm.
 Originally published: 4th ed. London : Collins, 1950. With new col. insert.
 Includes bibliographical references and index.
 ISBN 0-486-27265-6
 1. Botanical illustration—History. I. Stearn, William T. (William Thomas), 1911– . II. Title.
QK98.15.B58 1994
581′.022′1—dc20 93-45550
 CIP

Manufactured in the United States of America
Dover Publications, Inc., 31 East 2nd Street, Mineola, N.Y. 11501

CONTENTS

CONTENTS

"If you can paint *one* leaf
you can paint the world"

RUSKIN

COLOUR PLATES

(following page 76)

K 'Amaryllis Brasiliensis' (*Hippeastrum* sp.)
Stipple engraving by Bessin after a painting by P. J. Redouté; from P. J. Redouté, Les Liliacées, *1816*

L Rosa centifolia Bullata
Stipple engraving by Langlois after a painting by P. J. Redouté; from P. J. Redouté, Les Roses, *1817–24*

M Tulips
Aquatint and stipple engraving by J. Hopwood and F. C. Lewis after a painting by T. Baxter; from S. Curtis, The Beauties of Flora, *1806–20*

N Chinese Tree Peony
Hand-coloured aquatint by Miss Smith [of Adwick Hall]; from Studies of Flowers from Nature, *1820*

O *Epidendrum vitellinum*
Hand-coloured lithograph by M. Gauci after a painting by Miss Drake; from J. Bateman, Orchidaceae of Mexico and Guatemala, *1837–41*

P Thistles
Hand-tinted lithograph after a painting by Mrs. Jane Webb Loudon; from The Ladies' Flower-Garden of Ornamental Perennials, *1843–44*

PLATES IN BLACK AND WHITE
(*Formerly in Colour*)

vii

The illustration on the front cover is *Rosa sulfurea* from
Les Roses by Pierre-Joseph Redouté.

PLATES IN BLACK AND WHITE

PLATES IN BLACK AND WHITE

xiii

PLATES IN BLACK AND WHITE

It should be noted that throughout this book roman numerals refer to Black-and-White Plates; arabic figures refer to Black-and-White Plates formerly in colour; and letters refer to Colour Plates.

ILLUSTRATIONS IN THE TEXT

xvii

FIGURES IN APPENDIX A

EDITORS' PREFACE

Plant illustration ranges from the purely botanical to the purely artistic, from a drawing of a magnified root-section to a water-colour of a vase of roses. Between these two extremes lies a vast body of drawings and paintings with a combined scientific and æsthetic appeal —botanical records which are at the same time works of art. It is the history and development of this type of plant illustration that Mr. Blunt has, for the first time, explored and recorded in the present volume.

Clearly, with such a subject, he has found it necessary to range beyond native British artists and native British plants, since the history of science and the history of art, which form the background of his story, are international in their ramifications. Indeed, as Mr. Blunt shows, the influence of one country on another, for example of the continental herbals of the sixteenth century on later British herbals, is one of the outstanding features of the history of plant illustration.

The selection of plates for this volume, from the wealth of material available, has not been an easy task, and much care has been taken by the author to choose not just a set of " pretty pictures," but a series which fully illustrates artistic, botanical and technical developments from the early paintings and sculpture of the Egyptians and Cretans down to the work of living artists. His aim has been to select illustrations that enrich, and do not merely embellish, the text.

Mr. Blunt is an artist, with a craftsman's appreciation of the quality of the illustrations he is describing, but he is also an historian who has spared no pains to investigate, from original sources, the lives and labours of the men who made the illustrations. We feel that he has succeeded in writing a really valuable book which not only does full justice to the individual artists and their work, but also brings out, in

a fascinating way, how developments in botany, for example the discovery and introduction of new species, and also advances in the techniques of reproduction, have influenced plant illustration throughout its history. Of the assistance that he has received from Mr. Stearn, he himself will speak. This volume will, we hope, enable the many lovers of flower-paintings and drawings to study and appreciate them in the future with a fuller realisation of their botanical and artistic significance.

THE EDITORS

AUTHOR'S PREFACE

WHEN I had completed my manuscript in the rough, I submitted it to Mr. William T. Stearn, the erudite librarian of the Royal Horticultural Society, who has made a special study of my subject. He most generously provided me with some thirty foolscap pages of comments, almost all of which have been incorporated, often indeed verbatim, in my text. In breaking so much new ground, it was inevitable that certain artists of merit should be treated with less than justice or even wholly overlooked ; Mr. Stearn drew my attention to many such omissions, and pointed out where my artistic bias had caused me to underrate works of botanical, though not of æsthetic, importance. He also gave my bibliography and index a more professional appearance, checked the identity of many plants, and compiled the list of illustrated books dealing with the British flora. For this and other valuable assistance my readers, no less than myself, have deep cause for gratitude.

This book, so far as I am aware, is the first attempt to present a general survey of the development of botanical illustration from the crude scratchings of paleolithic man down to the highly scientific work of the present day ; though it inevitably falls far short of what I would wish it to be, it was high time for such an attempt to be made.

Twenty or thirty years ago, both in this country and on the Continent, there was on the part of the general public almost complete apathy with regard to flower-painting. Fine Dutch flower-pieces sold for ridiculously small prices ; splendid flower books illustrated with sumptuous colour plates could be had for a song ; for more strictly scientific botanical books and drawings there was virtually no market at all. Only the incunabula herbals, valued as examples of early printing, aroused the cupidity of collectors. All this is now changed.

With the vogue for colour-plate books in general came the craze for illustrated flower books in particular. Early volumes of the *Botanical Magazine* and the like were eagerly competed for in the saleroom, and then as eagerly torn in pieces to make table-mats and lamp-shades. Finer works fared little better : their dismembered pages, flashily framed in looking-glass and chromium plate, passed swiftly and profitably from the windows of expensive shops to the walls of smart dining-rooms. For better or for worse, flower-paintings have become the rage.

Among engravings, the taste in this country is still in the main for decorative work of the first half of the nineteenth century ; the pages of Thornton's *Temple of Flora* have become the ultimate prize, the single plate of Roses fetching as much, I believe, as fifty pounds. In France, the craze for the work of Redouté has given birth to a spate of meretricious reproductions, of forgeries so blatantly produced, on paper so improbable, that they would hardly deceive the blind. Dutch and French flower paintings in oils are everywhere eagerly sought after, and command fantastic figures.

Yet there still remains a wealth of splendid botanical illustration with which the general public is largely or wholly unacquainted. The work of artists such as Rabel, Nicolas Robert and Aubriet in France, of Ehret and the brothers Bauer in England, remains unknown because it lies for the most part hidden, often uncatalogued even, upon the shelves of museums and herbaria. Dürer alone among early flower painters in water-colour has received, thanks to the admirable facsimiles published by the Albertina, a due measure of recognition. If, by drawing attention to the great corpus of magnificent water-colour flower paintings in this country, I prove instrumental in providing the public with more opportunity of seeing the originals and of acquiring adequate facsimiles of them, I shall not have written in vain. This book and the exhibition which I have been invited to organise for the National Book League will, I hope, at least serve to whet the appetite.

It was not easy to find a title which exactly defined the field that I have attempted to cover in this book. *Botanical Illustration* seemed too narrow in that it implied a purely scientific approach ; yet it was at the same time too broad a label for a work which refers only incidentally to trees, grasses, mosses, fungi and fruit. *Flower Painting* was too comprehensive for a book which does not cover the flower-

piece. The title finally agreed upon, *The Art of Botanical Illustration*, puts a certain accent on art as well as on science. It is an attempt at a compromise, and like all compromises it is not wholly satisfactory ; an explanation of the scope of this volume is therefore desirable. I propose to deal for the most part with studies of individual flowers naturalistically rather than decoratively treated. The progress of botanical illustration, in its fuller sense, steers a parallel course ; to follow it in detail would be to make this book at once too bulky and too technical for the general reader.

Both the text and the illustrations of a volume in the *New Naturalist* series ought, strictly speaking, to deal only with our native flora. If this limitation had been rigidly imposed it would have been impossible for me to have attempted a balanced account of my subject. Though many foreign artists have made studies of flowers that happen also to be natives of this country, many other artists, both here and on the Continent, have been almost wholly concerned with exotics. The great seventeenth-century florilegia, for instance, deal almost exclusively with introduced plants ; and it would have been a mockery to have represented painters such as Ehret or Redouté merely by a humble wild flower, when their whole genius was primarily directed to the portrayal of foreign introductions. I have therefore tried to choose for my illustrations at any rate one characteristic specimen of each artist's work—for Ehret, for example, a very sophisticated auricula ; for Sowerby a common marsh marigold and a sprig of cross-leaved heath.

It was said of Ruskin—and he admitted the truth of the accusation —that when he wanted to get to know about a subject he began to write a book upon it. I must plead guilty to the same offence. Certain tracts of the vast field of botanical illustration had already been explored—some fully, some in part ; yet others I found wholly uncharted. My debt to Professor Charles Singer's valuable research on the manuscript herbal, and to Dr. Agnes Arber's no less able study of the printed herbal, is only too apparent. Mr. Gordon Dunthorne's *Catalogue Raisonné* of illustrated flower and fruit books of the eighteenth and early nineteenth centuries has been a useful pointer, drawing my attention to certain things that I might otherwise have overlooked. For the seventeenth century, and for the difficult period of the last hundred years, I have been obliged to depend in the main upon my own resources.

But throughout my work I have been helped and encouraged by countless friends both here and abroad. Of my debt to Mr. Stearn I have already spoken. Dr. Charles Raven, Dr. Julian Huxley, Mr. John Gilmour, Mr. James Fisher, Mr. W. A. R. Collins, Mrs. Arthur Harrison, Mrs. Otto Kurz, Mr. F. T. Smith and Mr. Tom Lyon were also kind enough to read my typescript and to make helpful suggestions. To my brother Anthony I turned as usual for assistance on all matters of art, though I found his botany rather shaky ! Miss Stella Ross-Craig was good enough to write a valuable description of her method of work which will, I believe, be of great use to botanical artists ; and the Editor of *The Gardeners' Chronicle* kindly allowed me to reproduce Fitch's excellent articles on botanical drawing.

The staffs of the Royal Botanic Gardens, Kew, and the British Museum (Natural History), South Kensington,[1] accorded me free access to their treasures and their knowledge, and bore with my frequent questions and interruptions with exemplary kindness and patience. Those of the Warburg Institute, the London Library, the British Museum (Bloomsbury), the Courtauld Institute, the Victoria and Albert Museum, the Linnean Society, the Royal Society, the Bodleian Library, the Lindley Library (Royal Horticultural Society, London) and the Oxford Botanic Garden were no less generous with their help and in allowing works in their possession to be photographed. In particular, I must record the assistance that I have received from Dr. Otto Kurz, Mr. Spencer Savage, Mr. Gerald Atkinson and Mr. Henry Marshall.

By gracious permission of His Majesty the King I have been enabled to reproduce drawings and engravings in the Royal Library, Windsor Castle. Of the many private owners who have allowed work in their collections to be examined and photographed, I must particularly mention Major the Hon. Henry Broughton who gave me access to his magnificent library of botanical books and manuscripts.

The Directors of many public collections in Holland, France, Belgium and Italy made me welcome and assisted me in many ways ; I must especially place on record the extreme kindness with which I was everywhere received in Holland during a visit which I shall not easily forget.

On the production side, I have nothing but praise and gratitude

[1] Known popularly as the Natural History Museum, by which title I shall in future refer to it.

to extend to Charles Fenton and F. Pickering, who often photographed work again and again because the results—which seemed to me to be faultless—did not in some minute particular achieve the high standard which they had set themselves. Miss Joan Ivimy, who prepared the book for the press, has also worked indefatigably behind the scenes ; to her, and to all those connected with the publication, I am deeply grateful.

In a short bibliography are listed some of my sources of information. At one time, I had hoped to be able to add, in a second bibliography, details of the more important illustrated flower books. When I had noted some eight hundred of them, and found my list still growing daily, I realised the impossibility of publishing a comprehensive bibliography in the space at my disposal and have therefore included in its place a more concise guide to illustrated works on British plants.

In many instances I have given several illustrations of the same flower ; this has been done deliberately, so that the reader may see how artists of different periods have tackled the same problem. I have not thought it necessary to state the exact dimensions of the drawings and engravings reproduced ; but often—and especially where very considerable reduction is involved—I have given in the text some indication of the original size.

To avoid any misunderstanding I must emphasise the limited aim of this book which is to present a general survey of the history of botanical illustration ; it accordingly makes no attempt to deal in an encyclopaedic manner with every draughtsman who has made meritorious illustrations of plants, and there are necessarily various artists omitted, e.g. Joseph Seboth (d. 1877) and William Henry Harvey (1811-66) whose claims equal those of many who have been included.

W. J. W. B.

BALDWIN'S SHORE,
ETON

July, 1949

AUTHOR'S PREFACE TO SECOND EDITION

I TAKE this opportunity to correct some errors in the text, and to append some additional information which has been brought to my notice through the kindness of readers.

Rinio (p. 26). Dr. Claus Nissen has pointed out to me that 1415 is the year of Rinio's arrival in Venice, and that the composition of the Herbal must therefore be dated a little later. (*See* Appendix C, Addenda, under Teza and Toni.) The copies of the drawings which were made for Ruskin are now in the library of Whitelands College, Putney.

Venetian MS. Herbals (p. 26). To the three herbals here mentioned must be added another. Some leaves of this are in the Städelsche Institut, Frankfurt-am-Main, and Dr. Rosy Schilling and I each possess one leaf. Dr. Schilling has also drawn my attention to the floral borders of a Book of Hours which she attributes to Michelino da Besozzo, a Lombardic artist working in the opening years of the fifteenth century; the Martin Bodmer Library at Zürich possesses the fragment which survives. (*See* Otto Pächt's essay, " Early Italian Nature Studies," in *J. Warburg and Courtauld Inst.*, vol. 13; 1950.)

Dutch Botanical Studies (ch. 10). Dr. J. G. van Gelder has brought to my notice a large and important collection of drawings which in 1731 was in the possession of Valerius Röver at Delft. Röver's MS. list of the collection is in the University Library, Amsterdam, but the drawings themselves are now at Cassel. They were made for Agnete Blok, from flowers at her country seat at Vijverhoff. The artists represented include: H. Saftleven (about 200 drawings); W. de Heer; R. van Veen; A. and P. Withoos; J. Withorst; N. Juweel and M. S. Merian.

Hand-painted Florilegia (Ch. 10). Dr. Nissen (*Die naturwissenschaftliche Illustration*; Bad Münster, 1950; p. 41) mentions the following: 1, *Hortus Honselaerdigensis*, by Jean Henri Brandon (d. 1714), a French artist who probably settled in Holland in 1680, after the revocation

of the Edict of Nantes. 2, *Hortus Cellensis*, by the brothers Prévost. (Paris; Bib. Nat., 12 vols., folio.) I hope that more information about these florilegia will be contained in Dr. Nissen's important book on Botanical Illustration, the first instalment of which was published in December, 1950. (See Appendix C, Addenda.)

Van der Vinne the Younger (p. 121). See also W. Martin, "Een wetenschappelijk bloemstuk voor Leiden's hortus," in *Historische opstellen*, pp. 210-17. (Haarlem, 1948.)

H. Wise (Ch. 10). A collection of water-colour drawings of flowers made for Henry Wise, gardener to William III and Queen Anne, is in the possession of Col. Disborow Wise. (*See Country Life Annual* 1949; pp. 34, 36.)

Flora Danica (p. 166). A second Flora Danica service was made in the nineteenth century as a wedding present for Queen Alexandra. See *The Flora Danica Service* by Bredo L. Grandjean (Copenhagen, 1950.)

M. M. Daffinger (Ch. 17). Mention should have been made of this talented Austrian artist. (*See* Appendix C, Addenda, under Lietgeb.)

H. C. Andrews (p. 210). Mr. G. E. L. Carter, of Budleigh Salterton, possesses a volume of original drawings made by Andrews for his *Coloured Engravings of Heaths*.

Mrs. Bury (p. 213). A volume of original drawings by Mrs. Bury is in the collection of Mr. Percy Muir.

THIRD EDITION: ADDITIONAL NOTES

Dioscorides (p. 9). An eighteenth century copy of a fine MS of Dioscorides' *De Materia Medica*, made in Persia in the twelfth century, is in the possession of the Society of Herbalists. The original MS is preserved in the Mashad Shrine, Persia. See *J. Roy. Hort. Soc.* 77. 369-71.

Nature Printing (p. 138). A nature print of a leaf is shown on folio 72 *v.a.* of Leonardo da Vinci's *Codice Atlantico*.

Audubon (p. 178). The flower-drawings of about the first one hundred plates of the *Birds of America* were made by a boy of 13 named Joseph Mason—a remarkable achievement.

Turpin (p. 180). The original drawings for F. P. Chaumeton's *Flore Médicale*, by P. J. F. Turpin and Mme E. Panckoucke, are in the possession of Nada Kramar, Booksellers, of Washington, D.C.

Sowerby (p. 190). Two further volumes of Sowerby's *Hortus Sylva Montis* are in the Natural History Museum, London.

FOURTH EDITION: ADDITIONAL NOTES

Redout (p. 178). During the reign of King Louis-Philippe, the collection of watercolour drawings on vellum for *Les Roses* was separated into at least two lots. The main group appears to have remained in France even after the sale of the library at Rosny following upon the death of the duchesse de Berry It is probable that these were destroyed at the time of the burning of the Tuileries Palace.

The other group, some 45 or 50 drawings preserved in the armorial morocco portfolios made for the duchesse de Berry, reached Brazil and were brought from there to Portugal by members of the Orléans-Braganza family. It was one of these portfolios that was sold at Sotheby's in 1948 to Lord Hesketh; two more are in the Morgan Library, and a fourth is at Harvard. Two further drawings were acquired by Mr. Lucien Goldschmidt of New York, who kindly supplied me with the above information.

The splendid Hunt Botanical Library in Pittsburgh contains further original drawings by Redouté, and by other botanical artists.

For Redouté see also, René Delcourt and André Lavalrée: Pierre-Joseph Redouté, botaniste illustrateur; *Lejeunia*, 13, pp. 5-20, (1949).

Le Moyne de Morgues (p. 81). In 1962 the British Museum acquired a magnificent folio album of 25 paintings of flowers, fruit and insects by Jacques le Moyne de Morgues. The drawings, which are in gouache, were made in England about 1585.

Di Nobili (p. 87). A rare Italian herbal, engraved and published in Rome by Pietro Nobile, bears no date but was probably produced about 1580. If so it must be the earliest botanical work illustrated from metal plates. (Copies at Kew and in the Hunt Botanical Library).

T. Robins (p. 151). Mr. Albert Lownes informs me that the botanical artist Thomas Robins died in Bath in 1806. He may therefore perhaps be the same T. Robins who made topographical drawings of that city.

Johann Walther (p. 124). A florilegium by Walther in the Bibliothêque Nationale, Paris, is perhaps even finer than that in London.

W.J.W.B.

THE BOTANICAL ARTIST

WHAT DOES the flower painter set out to do ? To answer this question is to give in brief the whole history of the development of botanical illustration and flower portraiture.

The earliest flower drawings were for the most part made to assist the searcher after herbs and simples. Realism was desired and soon to a surprising degree achieved, for there can be little doubt, as we shall see, that the illustrations provided for herbals nearly two thousand years ago were highly naturalistic. Gradually, however, unintelligent copying led to a debased and stylised type of figure which was nothing more than a decorative embellishment to the text. With the Renaissance came a revival of naturalism, but the function of the botanical illustrator remained at first unchanged. In the seventeenth century, however, the merely useful plant yielded place to the merely beautiful, and artists were required to record the rare flowers grown in the gardens of wealthy amateurs. This was the heyday of the flower painter ; for with the development of scientific botany, his services were also required for the portrayal of plants with little to recommend them beyond their novelty, and for the drawing of dissections which gave small scope for artistic expression. But the demand for bright picture-books of flowers long persisted, and throughout the eighteenth and early nineteenth centuries the artist, as well as the more scientific illustrator, was rarely short of work. The vulgarisation of taste and the multiplication of cheaply produced periodicals resulted in much shoddy work during the second half of the nineteenth century, but the age can also show some carefully illustrated botanical books. In the present century, the photographer has largely usurped the place of the botanical

artist, though happily there is still a certain amount of work in which the camera is no adequate substitute for the pencil.

England, France, Germany and Austria, and Holland are the countries which have produced the finest flower paintings. Italy, with her great artistic traditions, can show one or two botanical draughtsmen of distinction, but at no time did she produce a school of flower painters. The lovely herbal painted by the Venetian Benedetto Rinio in 1415 is probably the first corpus of flower paintings which can stand comparison with classical work made a millennium earlier, nor must we forget the little group of plant studies made by Leonardo da Vinci ; but it is to Burgundy and Flanders, rather than to Italy or Germany, that we must turn to discover the earliest schools of flower painting. The crude woodcut illustrations to German and Swiss incunabula and early sixteenth century herbals, which are coeval with the wonderful floral borders of French and Flemish manuscripts, testify that the best artists of that day were not employed to illustrate strictly botanical works. But in 1530 the German herbalist Brunfels published a herbal containing splendid naturalistic woodcuts of plants by Hans Weiditz, an artist who was closely associated with Dürer. This great book was followed by the herbal of Fuchs (1542), and by the publications of the famous house of Plantin at Antwerp, which during the latter half of the century produced a large number of notable botanical works illustrated by woodcuts. In the seventeenth century France and Holland were pre-eminent : both countries explored fully the potentialities of etching and engraving for plant illustration, and many splendid hand-painted florilegia were also produced ; in France, the genius of Daniel Rabel and Nicolas Robert showed to special advantage in the latter type of work. During the eighteenth century, England first began to play an important part, though her greatest botanical artist of the period—Ehret—was German by birth and upbringing. Much fine work was also produced at this time in France, Germany and Austria. The opening years of the nineteenth century are ever memorable for the paintings of the brothers Bauer in England and of Redouté and his school in France ; but by 1840 the great age of flower painting was drawing rapidly to its close, and during the Victorian era, though much important scientific illustration was being made both in England and in France, Walter Fitch was the only figure whose stature could stand comparison with that of his great predecessors.

We are singularly fortunate in the wealth of original flower drawings that have found a permanent home in Britain ; if we make exception of Dürer and Ligozzi, and of certain French artists who painted mainly for the Royal Collection, there are few flower painters of importance whose work cannot be adequately studied in our public collections. We have, for instance, more and better Dutch florilegia than can be found in all Holland. But alas, only the determined student can hope to see the finest work, most of which is stored away in the cupboards of natural history and other museums, and rarely exhibited or made readily accessible. Few people even know of the existence of these treasures ; but if public interest is aroused, more opportunity will perhaps be given for their display.

For the representation of flowers, many media have at one time or another been employed. Of these, water-colour upon vellum was one of the earliest to be used, and has remained one of the most excellent for recording delicate detail. Hand-made hot-pressed paper, vellum's modern equivalent, is capable of yielding even finer work. Oil painting, except for flower-pieces of the Dutch type, has not on the whole proved so satisfactory. Almost all the processes of reproduction have at one time or another been harnessed to botanical illustration : first woodcutting ; then etching and metal-engraving ; next every conceivable combination of aquatint, mezzotint and stipple, with or without colour ; finally lithography and, of course, photography. Pencil is invaluable for quick notes, and pen and ink is now considerably used for reproduction by line block.

The landscape artist may be tempted to feel that the flower painter has an easy task. Shifting skies and changing light do not indeed disturb the tranquil labours of the latter. But only those who have attempted to draw flowers can appreciate what restless models these can sometimes be—how quickly petals open and stems curve. Further, the colour of many flowers is so dazzling that at the best it can only be approximated in paint. Moreover, the botanical artist finds himself at once and always in a dilemma : is he the servant of Science, or of Art ? There can, I think, be no doubt that he must learn to serve both masters. The greatest flower painters have been those who have found beauty in truth ; who have understood plants scientifically, but who have yet seen and described them with the eye and the hand of the artist. The purely decorative treatment of plants, though it has produced much beautiful work, lies outside the scope of this book.

A great botanical artist must have a passion for flowers. You can set a good architectural draughtsman to draw a flower, and he will give you—if he thinks the subject worthy of real effort—a careful and precise study of the plant before him. But unless he *loves* what he is drawing, unless he *knows* the flower in all its moods, in all the stages of its development, there will be something lacking in his work. Look at Rabel's little studies (Pl. XVI, p. 97). Here, assuredly, we see the hand of a man who cultivated his own garden and saw with joy the first snowdrop breaking through the frozen soil. Then turn to Mrs. Pope's *Peonies* (Pl. 37, p. 212). They are spectacular, dazzling ; but they show no true sympathy or understanding : they lack soul. The artists, poets and philosophers of the Far East have shown how little in reality is the gulf which separates man from the rest of Nature ; we in the West have still much to learn from them.

To those, therefore, who would study flower painting I would say : First study flowers. It is not enough to enjoy the bright tapestry of the herbaceous border, to walk with pleasure through primrose woods in spring ; to get a deeper understanding and a fuller joy you must observe the individual plant. If you will also try to draw it—however badly—so much the better. You must notice the texture of the petal, the veining of the leaf, the structure of the seed-pod ; you must watch the bud unfold, the flower mature to full beauty, the petals wither and fall. And do not scorn even the commonest and most vulgar flowers provided that they have some element of beauty in rhythm, proportion, texture or colour. If dandelions happened to cost a guinea a root and had to be cosseted the winter through, they would find a place in every rich man's greenhouse.

A little knowledge of botany—by which I mean some elementary understanding of the structure of a plant and the functions of its various parts—is obviously of value ; any one, indeed, who studies a flower will soon feel the desire to know why it thrives, how it keeps its enemies at bay, how it is fertilised, and by what means it propagates itself. There are dozens of popular text-books which will give such information in simple language. A small magnifying glass (x 8) is of great assistance in the appreciation of plant structure, and will reveal undreamed-of beauties in the humblest flowers.

Thus equipped, we may turn with confidence to the study of the work of the great botanical painters.

THE LEGACY OF ANTIQUITY

IT MAY at first sight seem surprising that the delineation of plants, in every early civilisation, followed tardily upon the more obviously difficult art of representing animals. Paleolithic man, who covered the roofs and walls of his caves with realistic paintings of wild beasts, apparently made scarcely any attempt to draw the leaves and berries with which he eked out his meagre fare (see Fig. 1) ; but the magical character of his art, the purpose of which was to cast a spell upon the game he hunted, affords in his case an adequate explanation. Less readily understandable is the relative rarity of recognisable plant forms in early Egyptian art which, by the fourth dynasty, had already reached a high standard of excellence in rendering the human figure. The same time-lag is found in Mesopotamia and Crete, and in the highly anthropocentric art of Greece. Even in the Far East, figure painting seems to have preceded flower painting. In short, not until plants had become domesticated do we find any representation of them ; and not until medicine, harnessed to science, had prepared the way for the herbal, do we encounter more than the occasional, and usually decorative, use of them in art.

FIG. 1—Plant Form. Scratched on bone ; paleolithic

One remarkable exception must be mentioned. On the walls of a small, roofless hall at the eastern end of the Great Temple of Thutmose III at Karnak, the tourist, urged perpetually forward by his pitiless guide, may be fortunate enough to catch a hurried glimpse of a series of limestone bas-reliefs of unique botanical interest (Pl. IIa, p. 17). They constitute the earliest florilegium known to us, and, if we exclude a tattered fragment of a herbal known as the Johnson Papyrus (*c.* A.D. 400), are perhaps the only surviving scientific drawings of plants until we come to the famous codex of Dioscorides of the beginning of the sixth century A.D. The Karnak reliefs date from the fifteenth century B.C., and record a part of the spoils which the victorious Thutmose III brought back from his campaigns in Syria. An inscription states that they show " all the plants that grow, all the

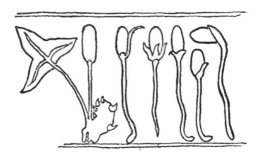

FIG. 2—*Dracunculus vulgaris* seedlings. Egyptian stone relief in the Great Temple of Thutmose III at Karnak, *c.* 1450 B.C.

goodly flowers that are in the Divine Land [i.e. the country north-east of Egypt] His Majesty saith, ' As I live, all these plants exist in very truth ; there is not a line of falsehood among them. My Majesty hath wrought this in order to cause them to be before my father Ammon, in this great hall for ever and ever.' "

Some of the plants—such as the pomegranate, *Arum italicum* and *Dracunculus vulgaris* (see Fig. 2)—are easily recognisable ; the identification of others, it must be admitted, taxed to the full the ingenuity of that great scholar and authority on the Egyptian flora, Georg Schwein-furth, and some appear to be largely or wholly imaginary. But considered as a whole, the two hundred and seventy-five plants portrayed upon the walls form a collection which compares favourably with those in the first printed herbals of nearly three thousand years

later. There is, at all events, nothing at Karnak to match the absurdity of the goose-hatching barnacle tree which persisted in European herbals until the end of the eighteenth century.

In Egyptian, Cretan, Assyrian, Greek and Roman art, we find trees and plants represented with a greater or lesser degree of realism ; but since these are in the main conceived as decorations, or as the accessories of figure compositions, they do not strictly come within the scope of the present book. The palm-tree jar from Knossos (Fig. 3) dates from the second Middle Minoan period (*c.* 1800 B.C.) ; the lilies (Pl. IIIa, p. 32) from a mural painting at Amnisos, a port of

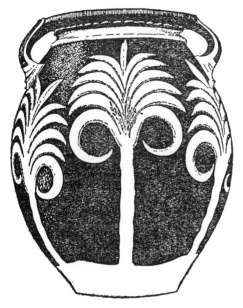

FIG. 3—Earthenware Jar decorated with palm trees ;
from Knossos, *c.* 1800 B.C.

Knossos, belong to the first Late Minoan (*c.* 1550 B.C.),[1] and the Cycladic jar decorated with crocuses (Fig. 4) must be of about the same period. In Egypt, the ' lotus', the papyrus and the palm are the plants most frequently represented. The " natural, graceful, and

[1] These lilies (*Lilium candidum*) were often portrayed as early as the third Middle Minoan period (*c.* 1750-1600 B.C.). (See Möbius, 1933.)

spirited " lilies shown in Fig. 5 are from the Northern Palace at
Kuyundjik, near Nineveh, and date from the beginning of the
seventh century B.C. The Greek coin from Metapontum, shown in
Fig. 6, is decorated with an ear of barley, and many of those from
Rhodes bear a rose. For examples from Roman art we may cite the
silver plane-leaf cup from Boscoreale (Louvre), and the flowered
garlands upon the walls of the House of Livia on the Palatine, which

FIG. 4—Earthenware Jar decorated with crocuses ; Cretan, c. 1550 B.C.

are botanically accurate and give an indication of what the artists of
the Augustan Age might have achieved in this field if they had
considered it better worth their attention.

Curiosity regarding the medicinal properties of plants was the
humble origin of scientific botany. No illustrated herbal of classical
times has survived, but it seems improbable that copies of the *Enquiry*

into Plants, by Aristotle's pupil, Theophrastus (370—*c.* 285 B.C.), were not supported by drawings. Moreover, we have the evidence of Pliny the Elder that herbals of the first century B.C. were often provided with coloured illustrations :

> *Cratevas* [Krateuas] likewise, *Dionysius* also, and *Metrodorus* . . . painted every hearbe in their colours, and under the pourtraicts they couched and subscribed their severall natures and effects. But what certeintie could there be therein ? pictures (you know) are deceitfull ; also, in representing such a number of colours, and especially expressing the lively hew of hearbs according to their nature as they grow, no marveile if they that limned and drew them out, did faile and degenerat from the first pattern and originall. Besides, they came far short of the marke, setting out hearbs as they did at one onely season (to wit, either in their floure, or in seed time) for they chaunge and alter their forme and shape everie quarter of the yeere . . .[1]

Krateuas, whom Pliny mentions, was physician in ordinary to Mithridates VI Eupator. Though his paintings have perished, it is probable, as we shall see, that their designs, slowly but steadily degenerating through constant copying, have been in part preserved to us in countless manuscript and printed herbals from the sixth century onwards.

The first century A.D. is memorable for the appearance of two important botanical works — the *Natural History* of the Elder Pliny, and Dioscorides' *De Materia Medica*. The former is a vast compilation in Latin from the writings of Greek authors, and contains a large section devoted to plants of every kind.

FIG. 5—Lilies. Stone relief from Kuyundjik, near Nineveh ; early seventh century B.C.

[1] *Natural History* ; quoted from Philemon Holland's translation, 1601.

" The main thought that goes through Pliny's book", says Singer, " is that Nature serves man." The latter work deals only with healing herbs ; though it is much slighter, its influence was paramount until as late as the seventeenth century.

It is probable that the earliest copies of *De Materia Medica* were not

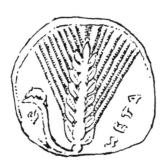

illustrated ; but we possess a splendid monument of botanical art in the great Juliana Anicia Codex of Dioscorides (*Codex Vindobonensis*), one of the treasures of the Vienna Library. This magnificent manuscript, which dates from about the year 512, displays a standard of excellence in plant drawing that was not to be surpassed for almost a thousand years ; with it must begin our investigation of the fluctuating fortunes of botanical illustration over a period of nearly a millennium and a half.

FIG. 6—Greek Coin. Harvest-mouse on an ear of Barley ; Metapontum, *c.* 350 B.C.

Juliana Anicia, for whom the manuscript was made, was the daughter of Flavius Anicius Olybrius, Emperor of the West in the year 472. The work was presumably written in Constantinople ; at all events it was seen there about 1423, in the monastery of St. John the Baptist, by a Sicilian traveller named Aurispa, and in 1562 by Ogier Ghiselin de Busbecq (1522-92), ambassador from the Emperor Ferdinand I to the court of Suleiman the Magnificent. Busbecq describes in his letters his unsuccessful attempt to add it to the " whole waggonfuls, whole shiploads " of Greek manuscripts which he sent back to Vienna :

> One manuscript I left behind at Constantinople, one much worn with age, containing the whole text of Dioscorides written in capital letters, with painted representations of plants, among which are a few by Cratevas, unless I am mistaken, as well as a small treatise on birds. This is in the hands of a Jew, the son of Hamon, who while he lived was the doctor of Suleiman. I wished to buy it but the price discouraged me ; for it was valued at a hundred ducats, a sum for the Emperor's purse, not for mine. I shall not cease while I have influence with the Emperor to urge him to ransom this noble author from such humiliation. On account of its age the

FIG. 7—Millet (*Panicum miliaceum*). Outline drawing from a water-colour in Dioscorides, *Codex Vindobonensis*, A.D. 512. National Library, Vienna

manuscript is in a bad state, the outside being so gnawed by worms, that hardly anyone finding it in the street would trouble to pick it up. (Stearn, 1949 b.)

But seven years later the precious manuscript found its way into

the Imperial Library in Vienna, though whether the purchaser was
Busbecq himself, or the Emperor, is not known. After the first World
War the codex was seized, on the flimsiest of pretexts, by the Italians
and removed to Venice ; it has now been returned to the Vienna
State Library.

The book,[1] which is of the greatest importance for the interpretation
of plant names used by Dioscorides, contains nearly four hundred
full-page paintings of plants and a number of smaller ones of birds.

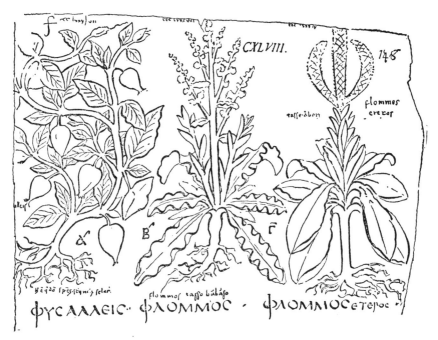

FIG. 8—(a) *Physalis alkekengi* and *Verbascum* spp.
Outline drawing from an original water-colour in Dioscorides, *Codex Neapolitanus,*
seventh century. Biblioteca Nazionale, Naples

These are preceded by several pages of miniatures, one of which shows
Dioscorides at work upon his book while Epinoia (Intelligence) holds
up a mandrake for Krateuas to draw. The plant drawings strike us at
once by their boldness and naturalism—a naturalism alien to Byzantine

[1]Reproduced in facsimile (monochrome) by Karabacek (1908) ; and with line
illustrations and English text, by Gunther (1934).

art of that period. It is obvious, therefore, that they are derived from originals of a much earlier date—as early, at least, as the second century A.D. Among the best are those which illustrate a part of the text which had been incorporated from the writings of Krateuas ; and there is no reason to doubt that these, and probably many others as well, closely resemble the actual designs of Krateuas himself. But already there are traces of the evils which result from copying and recopying—a process which was to continue with increasingly disastrous results throughout the Dark Ages and Middle Ages. The first millen-

FIG. 8—(*b*) *Physalis alkekengi*. Outline drawing from a water-colour in Dioscorides, *Codex Vindobonensis*, A.D. 512. National Library, Vienna

nium of the history of plant illustration shows, in fact, no steady advance from primitive work to naturalistic, but a gradual decline which was not fully arrested until early in the sixteenth century, when Weiditz, turning once more to nature for his model, produced his triumphant illustrations to Brunfels's *Herbarum Vivae Eicones*. The spirited drawing of a bramble (*Rubus fruticosus*) from this wonderful sixth century manuscript (Pl. I, p. 16) may be compared with a twelfth-century figure of the same plant (Pl. 1a, p. 20), and with Leonardo da Vinci's

still more famous drawing at Windsor (Pl. IXa, p. 48) made just a thousand years later than the study in the *Codex Vindobonensis*.

Many other illustrated Greek manuscripts of Dioscorides have survived, among the most important being the seventh-century *Codex Neapolitanus* in the Biblioteca Nazionale, Naples. Its drawings, at first sight, appear scarcely inferior to those in the Anician Codex ; but a

closer scrutiny reveals them to be nothing but " simplified, coarsened and sometimes misunderstood versions " of the latter. They acquire, however, a certain decorative quality through the plants being grouped two or three together on a single page (compare Fig. 8 a and b). This manuscript appears to have remained in Naples until 1717 (where Ferrante Imperato, the Naples pharmacist, would probably have been able to consult it).[1] It seems then to have been given by the monks to the Emperor and taken to Vienna. After the first World War the Italians reclaimed it. The ninth-century Paris Dioscorides is of interest in that it contains a number of drawings derived from a different, and perhaps even earlier, source than those of the Anician Codex. But the majority of these later Byzantine codices merely betray the

FIG. 9—*Dracunculus vulgaris* Manuscript Herbal of Apuleius, seventh century. University Library, Leiden

deadening effect of repeated copying " not even exact enough to be called slavish."[2]

Through the Nestorian Christians, the works of Dioscorides and

[1]See Stearn (1949 *b*.).
[2]Charles Singer (1927).

other Greek authors passed into Syriac and Arabic, finally reaching that outpost of Islam—Spain. New figures were provided for some of the plants, founding a tradition of illustration which still survives in the Orient. But it is to the West, rather than to the East, that we must now direct our search.

The most influential early Latin herbal was that of a certain

FIG. 10—Meadow Saxifrage (*Saxifraga granulata*)
Manuscript Herbal of Apuleius, *c.* 1050. British Museum

Apuleius—known as Apuleius Barbarus, Apuleius Platonicus or Pseudo-Apuleius to distinguish him from the author of the *Golden Ass*. It is an unimportant compilation of medical recipes, put together from Greek material about the year 400. The earliest known copy, which is now at Leiden, dates from the seventh century and was probably written in the south of France. It contains figures (see Fig. 9) that must have already degenerated from their Roman prototypes but which, like those of the *Codex Vindobonensis* in the East, were in their turn to provide Western illustrators from Italy to the Rhine with material for many generations to come. Dioscorides's *De Materia Medica* was translated into Latin during the first half of the sixth century ; and these two works, together with a pseudo-Dioscoridean treatise named *De Herbis Feminis*, formed the chief corpus of botanical knowledge and provided the main theme for plant illustration during the Dark Ages in the West.

During this period there arose, in the Duchy of Benevento, a "Lombardic" type of plant illustration based upon byzantinised Greek models and thus perpetuating the tradition of Krateuas. The first herbals to reach England, though probably produced in Northern France, introduced this tradition, and formed the basis of a characteristically English school of botanical illustration which grew up between the tenth and twelfth centuries.

The Herbal of Apuleius was probably translated into Anglo-Saxon about the year 1000, and the finely illustrated codex in the British Museum—*Cotton Vitellius* C. III—dates from the middle of the eleventh century. Its southern ancestry is proclaimed by the realistic scorpion in one of the figures, and by the fact that, all Greek notions of plant distribution having been forgotten, a number of the species represented are of Mediterranean origin. The manuscript had already suffered from the use of a virulent green pigment, probably sulphate of copper, which had eaten away the vellum, when the disastrous fire at Ashburnham House in 1731 reduced it to "a shrivelled blackened lump of leaves." But the pages have been skilfully washed, flattened and mounted, so that some, at any rate, of its former beauty has been revived. Plate 1b (p. 20) shows the figure of "Wolf's Comb" (*Dipsacus fullonum*), used in the treatment of dropsy, poison, and liver complaints.

Cockayne, in his *Leechdoms, Wortcunning and Starcraft*, has drawn attention to the curious figure in this manuscript which he identifies as *Saxifraga granulata*. "This plant", he says, "throws out, adhering to its roots, many small bulbs of the form and colour of onions, but not bigger than the heads of large pins. . . . You will see that the outline represented these characteristics of the plant ; an oval piece of turf suggested that the part under earth's surface was delineated, and then the roots and granules were seen below it. The artist knowing nothing about this, amended, as clever fellows are always doing, his original ; heightened the colour of the underside of the bit of surface, and seeing no leaves, rounded and made green the granules, so as to do the duty of leaves".[1] The ultimate fate of this figure will be discussed in a later chapter (see p. 32 and Fig. 14, p. 35).

Even more interesting is the fine Oxford manuscript, *Bodley 130*, which was written and illustrated at Bury St. Edmunds towards the year 1120. The naturalism of some of the figures in it can only be

[1] The resemblance may at first appear slight, but Bewick's wood engraving (Fig. 53, p. 242) will help the reader to understand what has happened.

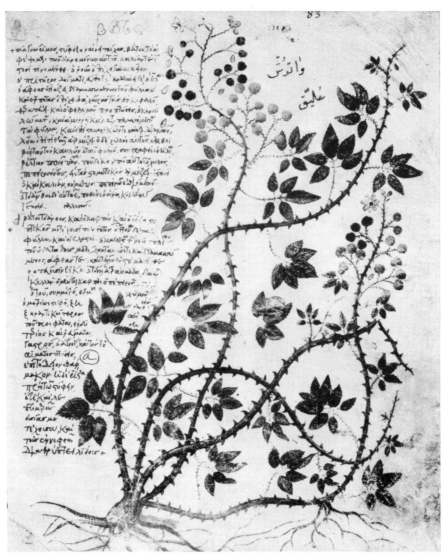

Plate I

BRAMBLE (*Rubus fruticosus*)
Water-colour drawing from Dioscorides, *Codex Vindobonensis*, A.D. 512
National Library, Vienna

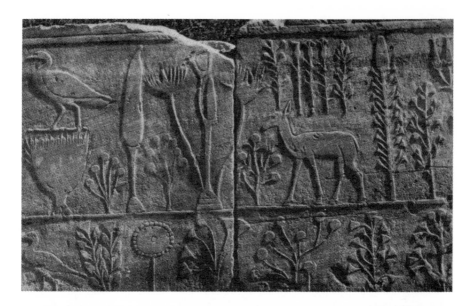

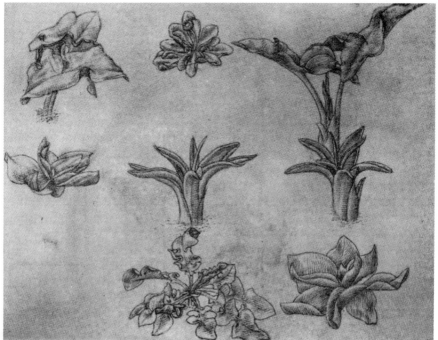

Plate II *a* SYRIAN PLANTS
Egyptian stone relief in the Great Temple of Thutmose III at Karnak, *c.* 1450 B.C.
b STUDIES OF PLANTS. Drawing by Pisanello (1397?—1455). Louvre, Paris

explained by the assumption that the artist for the moment abandoned the age-old habit of copying and turned to the plants themselves for his models. This remarkable work, which had no successor, has been reproduced in facsimile for the Roxburghe Club by R. T. Gunther. The figure of the bramble (Pl. 1a, p. 20), though not free from stylisation and far inferior to that in the Anician Codex, must almost certainly have been made with reference to a living specimen.

During the twelfth century this English school was gradually ousted by a new element imported from Normandy. Founded upon debased Roman models modified during their passage through northern Italy, this Norman, or " Romanesque ", style of painting had been evolved in the north of France towards the close of the tenth century. Its characteristics were a symmetry and formalism which carried botanical illustration so far in the direction of abstraction that most of the plants became totally unrecognisable. Though it must be conceded that the artist, by diagrammatising his plants and setting them against plain backgrounds of rich blue or glowing red framed in burnished gold, achieved a considerable measure of artistic success (as may be seen in the Oxford manuscript *Ashmole 1462*, and in two other fine examples, *Sloane 1975* and *Harley 1585*, in the British Museum), it is safe to assert that at the beginning of the thirteenth century scientific botanical illustration reached its nadir in the west.[1]

[1] It is interesting to note that at this very moment the Muslim botanist Ibn al-Sūrī (1177-1242) was searching for plants in the Lebanon in the company of an artist who made drawings of them in colour, as they were found, in various stages of growth. These drawings have not survived (see Sarton, G., *Introduction to the History of Science*, 2 : 54, 649 ; Baltimore, 1927—).

THE REBIRTH OF NATURALISM

T HIS LONG winter drew slowly to its close ; though snow still lay upon the ground, there was promise of spring in the air. The love-songs of the Troubadours, with their joy in birds and flowers, were echoed in Germany by the Minnesänger ; in Assisi, St. Francis praised God " for our Sister, Mother Earth, who . . . bringeth forth divers fruit and bright flowers and herbs "; and the decade which saw the birth of Dante and the writings of Albertus Magnus also witnessed the exquisite chiselled foliage upon the capitals of Rheims and Naumburg cathedrals.[1] Gradually the dread of Nature was banished from men's minds ; once again the world took pleasure in her meadows, her flowers, and the song of birds.[2]

In the fourteenth century—the age of Petrarch, Boccaccio and Chaucer—we find the same genuine love of Nature in the great Tuscan painters ; but, strangely enough, we rarely discover in their work a flower whose genus is recognisable. Almost alone, the " compulsory " white lily (*Lilium candidum*) is portrayed with some degree of naturalism. Cennini's advice to the artists of the late trecento—" Scatter a few flowers and birds upon the green grass "—was the formula which his contemporaries employed for the representation of spring—a formula which was perpetuated in the " florettes " of generations of tapestry designers.

[1] In England, similar work may be seen at Southwell. (See Pevsner, 1945.)

[2] The subject is admirably dealt with by Joan Evans (1933). See also Kenneth Clark, *Landscape into Art* (John Murray, 1949). In the *Tickhill Psalter* (*c.* 1310), " though there are a number of carefully drawn plant-forms, they play an unimportant part in the whole design. Dr. Egbert has identified columbine, ground ivy, herb robert, marsh mallow, germander, veronica, hazel, vetch, sweet woodruff, box, forget-me-not and quince." (Joan Evans; *English Art, 1307-1461*; Oxford, 1949.)

As the fourteenth century drew to its end, we find naturalism breaking out almost simultaneously in the art of Italy, Germany, Flanders and France. It seems certain that, in landscape at any rate, the Franco-Flemish miniaturists were first in the field ; and that their discoveries, travelling swiftly along age-old trade routes, spread through France, Flanders, Germany, and, by way of Trent and Verona, to all northern Italy. We shall find it convenient to discuss the various schools separately, and to trace, during the hundred years which follow, the development of each in turn.

FIG. 11—Madonna Lilies (*Lilium candidum*)
Detail from a thirteenth century mosaic in the Baptistery, Florence

In Burgundy the so-called " International Gothic," with its new-found and fearless joy in Nature, came into being towards the year 1390, and reached its highest fulfilment in the fresh, sparkling landscapes of the Flemish miniaturists, the Limbourgs.[1] Among the pages of their chef d'œuvre, the *Très riches Heures* made between 1410 and 1416 for their illustrious patron Jean, Duc de Berry, may be found one border with flowers treated naturalistically. Such work, at that date, is rare. But soon, in Flanders, the brothers van Eyck were setting lilies (Pl. IIIb,

[1]It must not be forgotten that, where figures and animals are concerned, the Limbourgs owed a considerable debt to Italy, and in particular to the works of Simone Martini (1283-1344) and Giovannino de' Grassi (*d.* 1398).

p. 32) and irises upon the green meadows of their great Ghent altarpiece (*c.* 1430);[1] The work of Hans Memling (*d.* 1494.) and Gerard David (1464?-1523) contains charming wild flowers ; and in the Berlin altarpiece of van der Goes (*c.* 1476) there is a clump of *Iris germanica* executed in glowing, jewelled colours with all the understanding of a true botanist. A flower detail from a painting by van der Goes is shown in Plate IV (p. 33). Londoners can study, in the National Gallery, a beautiful example of such work in the *Legend of St. Hubert*, by that perplexing artist the Master of St. Hubert. We may also mention here some clumps of *Iris germanica* in a remarkable French tapestry known as the *Cerfs-volants* (Fig. 12), which was designed between 1450 and 1469 and certainly shows Flemish influence.[2]

Occasionally in French manuscripts of the early and mid-fifteenth century we find borders of flowers which, though arranged decoratively, have some pretence to botanical accuracy ;[3] but such treatment is exceptional, for the taste of the day favoured a conventional scrollwork of ivy leaves and stylised flowers. Gradually, however, the close observation of nature introduced by the Limbourgs began to affect the manuscripts of Flanders, and through them those of the rest of

[1]Rosen (1903) has written at length about the flowers and trees shown in early Flemish and Italian paintings. Upon the meadow of the *Adoration of the Lamb*, the centre panel of the Ghent altarpiece, he has identified the following : dandelion (*Taraxacum officinale*), lily of the valley (*Convallaria majalis*), lesser celandine (*Ranunculus ficaria*), lady's smock (*Cardamine pratensis*), violet (*Viola odorata*), water cress (*Nasturtium officinale*), peony (*Pæonia officinalis*), bearded iris (*Iris germanica*), rose campion (*Lychnis coronaria*), greater celandine (*Chelidonium majus*), woodruff (*Galium odoratum*), solomon's seal (*Polygonatum multiflorum*), Madonna lily (*Lilium candidum*) and *Achillea nobilis* ; and a red rose, vine, pomegranate, fig, palm and orange. The inclusion of south European plants was the result of Jan van Eyck's visit to Portugal in 1428.

[2]Such work prepared the way for the so-called " verdure " tapestries, of which a fine set, made at Brussels by Willem Pannemaker between 1525 and 1550, is in the Kunsthistorisches Museum, Vienna.

[3]See, for example, the *Book of Hours* of the use of Châlons-sur-Marne (*c.* 1420) in the Dyson Perrins collection, a page from which is reproduced by Evans (1933).

PLATE 1*a*
BRAMBLE (*Rubus fruticosus*). Herbal of Apuleius ; MS. written at Bury St. Edmunds, *c.* 1120. Bodleian Library, Oxford

PLATE 1*b*
'WOLF'S COMB' (*Dipsacus fullonum*). Anglo-Saxon MS., *c.* 1050. British Museum

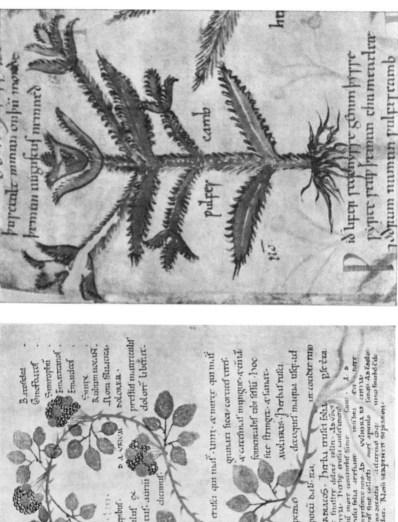

Plate 1a

b

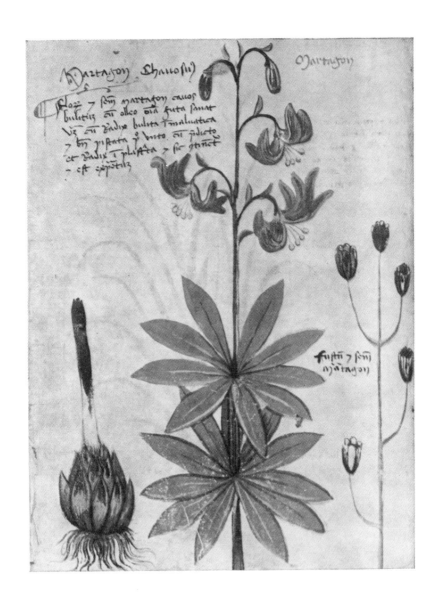

Plate 2 MARTAGON LILY (*Lilium martagon*)
Venetian MS. Herbal, early 15th century. British Museum

Europe. Upon stiffly-framed borders of flat colour or of gold were painted flowers, insects and birds drawn with much realism and thrown into relief by strong shadows. This style of decoration, which we probably owe to the genius of the Master of Mary of Burgundy, was invented towards the close of the fifteenth century and culminated in the magnificent *Grimani Breviary* and the manuscripts of Jean Bourdichon.

The *Book of Hours of Mary of Burgundy* (Berlin Printroom), made about 1480, and the *Liure des Proprietez des Choses* (B.M. Reg. 15 E 111), written at Bruges in 1482, are among the earliest surviving manuscripts of this type. The artist of the former work, whom it is tempting to identify with Alexander Bening, also made for Engelbert of Nassau the lovely little *Book of Hours* which is now in the Bodleian Library (*Douce 219, 220*). Plate 3a (p. 28) shows one of its pages, and reproductions of others may be seen in Pächt's *The Master of Mary of Burgundy* (1948).

The borders of Jean Bourdichon's works are deliberately botanical in conception, and must therefore be discussed in more detail. Bourdichon, who was born at Tours in 1457, was trained in the atelier of Jean Fouquet, and became court painter in turn to Charles VIII, Louis XII and François I. He had more than a touch of renaissance versatility : we know that, besides his manuscripts, he painted portraits and religious pictures, designed coins and standards, made a plan of the town of Caudebec, and was chosen to take the death mask of St. Francis of Paola.

About ten manuscripts, all with floral borders, are ascribed to Bourdichon. One of these is in the British Museum (*Add M.S. 18855*) ; but the finest is the celebrated *Book of Hours* made for Anne of Brittany between 1500 and 1508, and now in the Bibliothèque Nationale, Paris. We must pass over its attractive subject miniatures and turn to the borders. Upon gilded rectangles, and forced into high relief by strong shading, are portrayed in gouache more than three hundred and forty plants, named in French and Latin, chosen from the local flora and familiar garden flowers of Touraine. It has been rather frivolously said of them that they constitute " a seedsman's illustrated catalogue "; besides being objects of considerable beauty, they certainly do form a valuable early florilegium. We must not, however, forget that Bourdichon, for all his love of flowers, was an artist first and a botanist after : he does not hesitate to distort a stem or a leaf in order to fill

FIG. 12—Iris (*Iris germanica*)
Detail from a French tapestry known as *Cerfs-volants*, c. 1460. Musée des
Antiquités, Rouen

his picture space more happily ;[1] worse still, he does not even shrink
from painting the snowdrop and the carnation his favourite shade of
blue. Nevertheless, the manuscript has always excited the curiosity
and admiration of botanists. In 1722, Antoine de Jussieu obtained
permission from Louis XV to take it for closer study to his house,
where he prepared a paper which was subsequently read to the
Académie des Sciences. Among the figures of special botanical

[1]In its imitation of a sculptural relief, and in the compromise which it makes
between naturalism and formalism, Bourdichon's work recalls the decorations upon
the lintels and jambs of Ghiberti's doors and the garlands of the plaques of the
della Robbia. In the *Adoration of the Magi* (1423) of Gentile da Fabriano, and in
some of the works of the Sienese painter Giovanni di Paolo (1403 ?-1482), may be
seen narrow rectangles containing flowers—a device which also seems to anticipate
the method of Bourdichon.

interest may be mentioned that of the black currant—suggesting, as Camus points out, that it was cultivated in France at a much earlier date than was formerly supposed. Plate V (p. 36) shows the wild guelder rose and bean flower. Bourdichon died at Lyons, probably about the year 1521.

The *Grimani Breviary*, a work by artists of the Bruges-Ghent school, was probably made about 1510. This lovely but bulky volume —it contains 831 leaves, and is seven inches thick—was acquired by Cardinal Domenico Grimani in 1520 and bequeathed by him to the Venetian Republic. It remains one of the most precious possessions of the St. Mark's Library, Venice. The decorations reveal an unbounded fantasy : countless flowers—some standing in pots or glass jars, others scattered in sprigs or separate blossoms, yet others combined with arabesques or threaded like daisy-chains—are strewn upon the broad margins. Butterflies, bees and other insects ; animals of all kinds ; jewels, scrolls, and the miscellaneous stock-in-trade of the renaissance illuminator ; are distributed among the flowers. Many of the plants are drawn with a less definitely botanical intention than Bourdichon's ; but what, for instance, could be more charming—or, for that matter, more naturalistic—than the red and white roses, affixed to the blue background with gold pins, which surround the miniature representing the release of St. Peter from prison (Pl. 3b, p. 28) ? The whole work has been magnificently reproduced in facsimile by Giulio Coggiola (1903-08), who also discusses in an appendix the fifty-nine different varieties of flowers which are shown upon its pages.

The Hortus Conclusus, which, like the poetry of Hafiz, combined the sensuous and the mystical, and may, indeed, have been derived from the Persian miniature, was a charming and characteristic theme in late medieval art. In the *Little Paradise Garden*, painted about the year 1420 by an anonymous Rhenish master and now in the Frankfurt Gallery, we find a green sward diapered with flowers—lilies of the valley, Madonna lilies, peonies and irises—depicted with loving care. In the work of Pleydenwurff (*c.* 1470), and more especially in the wonderful Stuppach altarpiece of Grünewald (1519). there are flower details equal to the best Italian work of the day ; and in the botanical studies of Dürer (1471-1528) we have the German counterpart of Leonardo's vigorous flower drawings.

Exquisitely delicate and sensitive, yet retaining something of the Gothic crispness of medieval illumination, Dürer's water-colours of flowers have long been favourites with the general public. Nuremberg, in Dürer's day, was famous for its gardens, and we cannot doubt that he himself was a keen gardener. " About the windows of its houses, where reigns undying spring ", wrote one of its citizens in 1495, " innumerable flowers and foreign plants fill the air with their sweet scents, which the lightest breeze carries into the bedrooms and innermost chambers . . .". The artist's simple delight in the flowers he paints is everywhere apparent. He grasps instinctively the peculiarities of a plant's habit. Some of the drawings have been made as studies for particular pictures : that of the iris (now at Bremen), for instance, has been used in the *Madonna with the Iris* (1508) recently acquired for the National Gallery from the Cook Collection (see Pl. VIIb, p. 44).[1] Other flowers, we may assume, were chosen for their medicinal properties.

Perhaps the most remarkable study of all is that known as *Das grosse Rasenstück*, painted in 1503 (Pl. 4, p. 29), which shows the worm's-eye view of a foot or so of meadow turf, each blade of grass, each leaf, each dandelion flower drawn with masterly precision and wonderful tenderness. It is a microcosm such as that which Goethe's young Werther describes with rapture but dismisses as unpaintable : " When I lie in the tall grass and, closer thus to the earth, become conscious of the thousand varieties of little plants ; when I feel the swarming of all that diminutive world amongst the blades—the countless inexplicable forms of little worms or of tiny winged creatures ; when I feel these closer to my heart, and feel the presence of the Almighty who created us in His image, and feel too, the breath of the all-loving Father who sustains and keeps us in eternal bliss ; then how often, longingly, do I say to myself : ' Ah ! if you could but express, if you could but bring to life again on paper, the feeling that pulses so richly,

[1]K. R. Towndrow, in an article in *The Burlington Magazine* (April, 1947) was the first to point out that the iris in the National Gallery picture appears to be *I. trojana*, a plant which was not established in western gardens until 1887. It is possible that Gentile Bellini brought back a rhizome of it from Constantinople, and that Dürer made a drawing of the flower when he visited the Italian painter in Venice in 1506. (On the occasion of his first visit he was not in Venice at the right time of year.) Mr. Towndrow now agrees with me that the iris in the sketch is the same species as that in the painting. It should be mentioned that the attribution to Dürer of the National Gallery picture is not universally accepted.

so warmly within you, so that it might become the mirror of your soul, just as your soul is the mirror of the infinite Godhead . . .' ".[1]

The picture has a particular interest as being the first ecological study ever made. Moreover, it is the only flower painting of Dürer's whose authenticity is virtually unchallenged, and the only one which bears an authentic date.

Eleven other flower paintings, and several less known studies of trees, are considered by Winkler to be genuine. Of these, the most important are the studies at Bremen of peony, martagon lily and anchusa, all on paper ; and the vellum paintings of columbine, greater celandine and violets in the Albertina at Vienna. A second iris drawing, from the collection of Philip II of Spain, now hangs in the Escorial. The tree studies were made between 1494 and 1497 ; those of flowers probably belong to the opening years of the sixteenth century. For the benefit of those who have not seen the originals, it may be worth while mentioning that all the flowers are represented about life-size ; thus the Bremen iris study is more than two feet six inches in height.

The delightful work of Dürer's contemporary, Weiditz, was made for the illustration of a printed herbal, and will be discussed when we come to deal with the woodcut.

A remarkable Italian manuscript in the British Museum—*De septem vitiis* (*c.* 1390)—shows trees, birds, insects and other animals drawn with exquisite feeling and oriental tenderness. Its origin remains unexplained, though there is undoubted evidence of the direct influence of contemporary Persian miniatures. We cannot but regret that its author—perhaps the monk Cybo—included no individual studies of flowers among his delightful details. Cybo, a Genoese who became librarian to the monastery of St. Honoratus near Antibes, was said to " draw and imitate to perfection plants, flowers and other objects of natural history". The little that is known of this interesting artist may be found in Bradley's *Dictionary of Miniaturists*. Giovannino de' Grassi, a Milanese who anticipates Pisanello in the naturalistic treatment of animals, is another artist who may well have made flower studies, though we have no actual evidence that he did so.

[1]Compare also Ruskin (*Præterita* II. x. 199) : " on fine days when the grass was dry, I used to lie down on it and draw the blades as they grew, with the ground herbage of buttercup or hawkweed mixed among them, until every square foot of meadow, or mossy bank, became an infinite picture and possession to me."

Closely related to Giovannino's work, however, are the *Theatrum Sanitatis* (Rome ; Bibl. Casanatense, *Cod. 4182*) and the two similar manuscripts entitled *Tacuinum Sanitatis* in Paris and Vienna. All these three north Italian codices may be dated about the year 1400. The *Theatrum Sanitatis*, which has been published in facsimile by Luigi Serra, contains beautiful paintings of fruit trees, and of vegetables and medicinal plants growing in allotments.[1]

Three important Venetian herbals, the first of which was probably made during the last decade of the fourteenth century and the other two about the year 1415, are proof that, contrary to what is often affirmed, there was a real attempt to revive the naturalistic type of botanical illustration long before the advent of Brunfels's great *Herbarum Vivae Eicones* in 1530. These herbals, though it is convenient to refer to them at this point, cannot be considered as immediately connected with the International Gothic which radiated from the Burgundian court.

First in date of these herbals is an Italian translation of a treatise on medical botany by the Arab physician Serapion the Younger (*c.* A.D. 800). This manuscript (British Museum ; Eg. 2020) was written by a Paduan monk named Jacopo Filippo, probably for Francesco Carrara, Lord of Padua (d. 1406), and was later in the possession of Ulisse Aldrovandi (1522-1605), the celebrated Bolognese naturalist. Space was left in the manuscript for a considerable number of figures, only about fifty of which were executed. Most of these are highly naturalistic, and beautifully painted in gouache upon vellum. Particularly successful are those of privet, red clover, dodder, asparagus, white convolvulus and camomile, and there are excellent figures of grapes and other kinds of fruit. So naturalistic, indeed, is the treatment that one is tempted to wonder whether the figures may not be a generation or so later in date than the writing (see Pl. VIa, p. 37).

By far the finer of the other two manuscripts is that of Benedetto Rinio, now preserved in the St. Mark's Library, Venice (*Cod. Lat. VI 59*), which contains nearly five hundred full-page paintings of plants by an otherwise unknown artist named Andrea Amadio. The purpose of the book was to assist herbalists in gathering the correct plants—no easy

[1]An earlier, and apparently isolated example of the same kind will be found in an address in Latin verse sent about 1340 from the town of Prato to Robert of Anjou, King of Naples. (British Museum ; Royal MS. 6E ix f. 15 v.)

matter at a time when botanical nomenclature was in chaos. Ruskin wrote enthusiastically about this " wonderful MS " which contained " the earliest botanical drawings . . . of approximate accuracy " that he knew—presumably he was not acquainted with Filippo's herbal— and employed an artist to make copies of all the figures. " They are however," he adds, " like all previous work, merely suggestive of the general character of the plant, and are very imaginative in details. . . . Every plant, whatever its own complexity of growth, is reduced in this book to some balanced and ornamental symmetry of arrangement ; not, as in our base mechanical schools, by making one side of every leaf or cluster like its opposite, but by making them different, yet lovely in relation."

He continues : " There is a beautiful piece of fancy in the page representing the common blue chicory. Its current Latin name in the fifteenth century, from its rayed form, was 'Sponsa Solis'. But its blue colour caused it to be thought of as the favourite, not of the sun only, but of the sky. And the sun is drawn above it with a face, very beautiful, in the orb, surrounded by vermilion and golden rays, which descend to the flower, through undulating lines of blue, representing the air. I have never seen the united power of Apollo and Athena more prettily symbolised."

The plants are painted upon paper in opaque colour, and are shown with their roots. Where trees and shrubs are portrayed, this inevitably leads to some stylisation and incorrect proportion ; but as a general rule the treatment is remarkably naturalistic. For its date, the work is truly astonishing : the colour is admirable ; and the painter has not shirked the difficult task of representing a twisted leaf or a half-turned flower. With the exception of a few drawings which seem to be by an inferior hand, the level of the work is uniformly high. Amadio's skill as a colourist is well revealed in his treatment of the glaucous green of the *Eryngium* ; his delicacy of touch in the veinings upon the *Crocus sativus* ; and his grasp of form and of rhythm in the drawing of millet (see Pl. VIb, p. 37). If we compare the latter with the corresponding figure in the Anician *Codex Vindobonensis* (Fig. 7) we see, for the first time in nine hundred years, definite evidence of progress. The upper leaves of the mallow (Pl. VIc, p. 37) show the most subtle observation, though the calices are somewhat under-developed.

Rinio bequeathed his herbal to his son who, dying without issue,

left it to the monks of SS. Giovanni e Paolo on condition that they treated it with care and agreed to show it, in the presence of two monks, to any who wished to study it.

The third Venetian herbal, which is undated but whose script is clearly of the early fifteenth century, was acquired by the British Museum about twenty years ago (*Add. M.S. 41623*). Though a book of much less beauty and skill, it adds further proof that Rinio's Herbal was not an isolated phenomenon. From internal evidence, it is known that it was made at Belluno, in the Venetian Alps ; it therefore contains paintings of many interesting alpines, including the earliest known representation of an edelweiss. The text is largely based on Dioscorides. The names of the author and artist are not known. Plate 2 (p. 21) shows a martagon lily vigorously painted in gouache ; but the artist has been baffled by the petals which approach and recede from the spectator, and has been obliged to employ an unsatisfactory convention.

Early in the fifteenth century, northern influences crossed the Alps to Verona, where Stefano da Zevio became the first Italian exponent of International Gothic. Soon Pisanello developed the style, and with Gentile da Fabriano disseminated it through northern Italy. Sculptors such as Ghiberti (1378-1455) and the della Robbias began to make use of naturalistically treated flowers and fruit to fill formal spaces ; and it was not long before a host of Florentine painters were setting exquisite flowers in their landscapes[1] or in pots at the feet of their Madonnas. These artists must undoubtedly have made many separate studies of plants ; it may therefore seem surprising that, with the exception of a few hasty drawings by Pisanello (1397 ?-1455) and the well-known sketch of an iris by Jacopo Bellini (*c.* 1450), no drawings of individual flowers appear to have come down to us from the hands of the great Italian painters who preceded Leonardo da Vinci, and very few from those of his contemporaries. Probably sketches were not

[1]No less than thirty species of plants have been identified by Mattirolo in Botticelli's *Spring* (Primavera), leaving ten more as unidentifiable (Mattirolo, 1911).

PLATE 3*a*
POPPY (*Papaver rhoeas*), etc. Illuminated page from a *Book of Hours* by the Master of Mary of Burgundy, *c.* 1480. Bodleian Library, Oxford

PLATE 3*b*
ROSES. Illuminated border from the Grimani Breviary, Bruges-Ghent School, *c.* 1510. St. Mark's Library, Venice

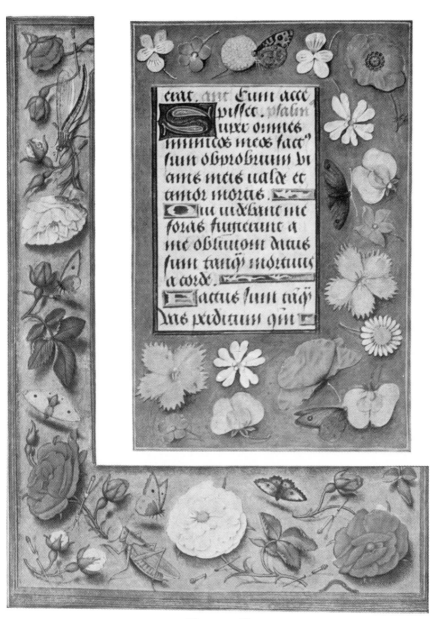

Plate 3a and b

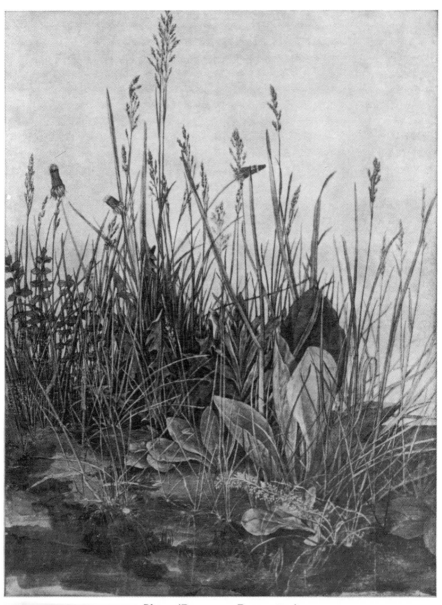

Plate 4 'Das grosse Rasenstück'
Water-colour drawing by Dürer, 1503. Albertina, Vienna

thought worth preserving ; and no doubt even the figure studies which chance has spared represent only a small fraction of those actually made. Nor, alas, does any trace remain of the studies of Angiolo da Siena, who was paid eight hundred lire to furnish Borso d'Este (1413-71) with " a painted flower " every Easter.

Jacopo Bellini's Iris (Pl. VIIa, p. 44) is a fine drawing, more angular and less suave than Dürer's study but no less personal in its treatment. It is no mere generalisation, but the true portrait of a particular flower. Pisanello's sketch (Pl. IIb, p. 17) is by comparison more formal, his line rather mechanical ; but his approach is definitely scientific. In his painting of the Este Princess (Louvre), however, he had decorated the boughs of a tree with little flowers of columbines and pinks among which puzzled butterflies flutter—a device successful enough from a decorative point of view if botanically rather surprising.

Leonardo's botanical studies, though they are few in number and illustrate but one facet of his restlessly inquiring mind, must be counted among his most interesting and original work. The earliest—of a Madonna lily (Pl. VIII, p. 45), made about the year 1479—is a full-scale working drawing, the pricked outlines showing that it was actually used, but upon some picture no longer extant. It is strong and accurate, but lacks the peculiar quality of his later work ; any competent late quattrocento artist, we feel, could have made (and doubtless did make) many such studies. This is, perhaps, the only surviving example of the " many flowers drawn from life " which Leonardo mentions having made in his early years, and which are, in any case, implied by his paintings of that period. Two or three more plant drawings may be placed between 1480 and 1490. But the most lively and personal studies belong to the years between 1505 and 1508, and are connected by Sir Kenneth Clark with the two Leda cartoons ; of these, the splendid spray of bramble (*Rubus fruticosus*), in red chalk upon paper prepared with a pink wash, is a typical example (see Pl. IXa, p. 48). They show considerable understanding of plant structure and habit, and must rank among the first truly modern botanical drawings ever made. Leonardo's flower drawings were appreciated in his own day, and the Spanish historian Oviedo, who probably knew the artist personally, laments that he was not with him in Mexico to portray the plants of the New World.

In view of the close observation and honesty of purpose revealed in Leonardo's botanical drawings, it is surprising to find that the plants

included in his paintings are relatively feeble and ill-constructed. The iris[1] in the foreground of the Louvre version of his *Madonna of the Rocks* (1483-90), for instance, is no doubt intended to represent *I. pseudacorus* ; but its habit, the structure of its leaves, its irresolute stem, seem to be the result of apathy rather than of calculated stylisation. The irises of Dürer and Bellini show far more of the essentials of the genus ; and even those in the *German Herbarius* (see Fig. 17), for all their crudity, are more honestly conceived.

In general, the borders and decoration of Italian manuscripts show no trace of botanical naturalism until they were directly influenced, in the sixteenth century, by Flemish models. But the Earl of Leicester's copy of Pliny's *Natural History*, printed in Venice in 1476 and illuminated by hand, shows, at the head of the chapter devoted to plants, a versal beautifully decorated with a rose-bush, Madonna lily and violets.

We have seen in the present chapter how the love and appreciation of natural beauty had once again brought into being a naturalistic type of plant drawing ; we must now turn to the printed herbal, which remained fettered to the traditional type of stylized illustration until the genius of Weiditz set it free.

[1]See *Leonardo da Vinci* (Phaidon ; 1943), Plate 85.

THE FIRST PRINTED HERBALS

HE ART of the woodcut, practised at a relatively early date in the Far East, was either introduced into Europe or independently rediscovered there shortly after the year 1400. In the early block books, text and figures were cut upon the same piece of wood. But with the invention of movable type, wood-cutting still remained the ideal method of book illustration, for, being a process involving surface printing, figures and text could be set up side by side and passed simultaneously through the press.

The woodcut is usually conceived as a black-line drawing, the unwanted background being cut away so that it may not come into contact with the ink roller. The use of the plank (as opposed to the end grain) made this a simple operation. The term *wood-engraving* is usually reserved for work on the end grain of hard woods such as box or yew, the cutting being done with a gouge instead of with a knife. Thomas Bewick (1753-1828), though not the inventor of this process, was the first to give it popularity. Wood-engraving is often, but by no means always, to be distinguished from wood-cutting by the predominance of the white line. It has been suggested that some of the earliest "woodcuts"—those in the *Herbarium* of Apuleius Platonicus, for instance—may in fact have been printed from rudely cut metal blocks. The method of printing wood blocks, being the same as that of type, is too familiar to require explanation.

It might well be imagined that these new discoveries would have effected an immediate revolution in botanical illustration, but this was far from being so. During the closing years of the fifteenth century,

when naturalism had already taken a firm hold of painting and illumination from Italy to Flanders, the illustrators of the first printed herbals were for the most part still perpetuating the degraded plant figures derived from classical models. These incunabula, with one important exception, must therefore be considered as belated expressions of an outworn tradition, just as the Venetian herbals of the beginning of the fifteenth century were the advance guards of a new age.

The *Půch der Natur* of Konrad (Cůnrat) von Megenberg, printed at Augsburg in 1475, contains a short section on plants and two botanical woodcuts, one of which portrays a lily of the valley, buttercup, violet and other flowers growing in a meadow. Fig. 13 shows this woodcut as it appears in the 1482 edition of the same work ; here the original design is reversed and use made of white lines on a black ground. Arber illustrates the same figure in its original form. Though the plants are far from convincing, they are considerably more naturalistic than those in the first printed herbal—the *Herbarium* of Apuleius Platonicus (Rome, 1481 ?).

We have already mentioned some of the manuscripts of that famous work. We learn from the preface to the printed edition that a manuscript from Monte Cassino provided the version used. Until recently, it was assumed that this was no longer in existence ; but Hunger believes that a ninth century codex, preserved until the last war at Monte Cassino, was the source of the Roman edition. His fine facsimile of the two works, so arranged that they can be compared page by page, shows many striking similarities ; though there are also marked differences, there exists unquestionably a very close relationship between the two. A curious feature of the figures, no doubt intended to assist those unable to read, is that herbs used in the treatment of bites or stings of animals are portrayed with the appropriate animal beside the plant.

The figure of *Saxifraga granulata* in the Monte Cassino codex (Fig. 14) has been derived from the same source as that in the eleventh century

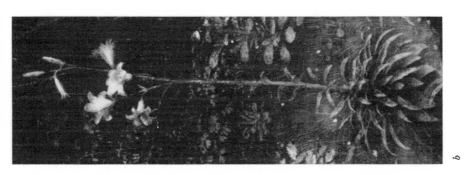

Plate III a

b

c

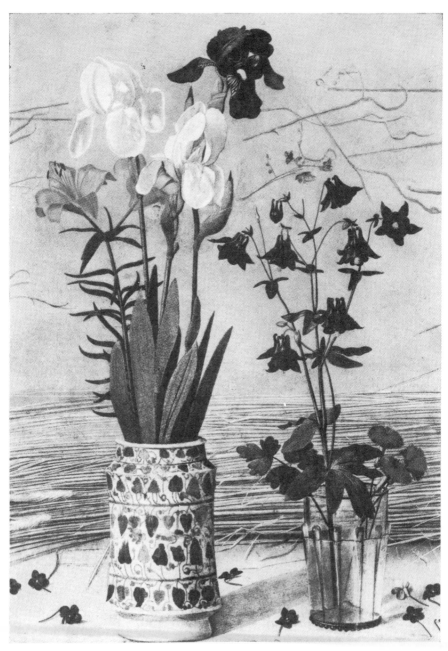

Plate IV Jars of Iris, Lily and Columbine
Detail from the Portinari Altarpiece, by Hugo van der Goes (1435?—1482?). Uffizi, Florence

Cottonian manuscript (Fig. 10, p. 15). Some ignorant copyist of the original drawing, noticing that the plant appeared to be standing upon its head, reversed it and converted the granules into fruit. The engraver of the cut in the printed edition has shown himself no less ingenious by turning the berries into flowers.

All the three illustrated incunabula herbals which remain to be discussed were first printed at Mainz, though they were soon translated or republished, and in one case even given new figures, elsewhere. The *Latin Herbarius*,[1] produced by Peter Schöffer in 1484, was a compilation —very possibly made a century or so earlier, though no manuscript of that date has so far been discovered. It is a small volume containing German native and garden plants, and was intended to serve as a book of simple remedies for simple people. Its figures, though not without boldness and decorative charm, are largely symmetrical and sometimes little better than diagrams ; correct proportion is rarely attempted, the flowers usually being of an exaggerated size ; and the roots, when they are included, are purely conventional. The drawings, like the text, are not connected with the *Herbarium* of Apuleius ; but it is obvious that they have not been made from Nature. Their source is unknown.

The figure of the iris (Fig. 15) shows how little the structure of the inflorescence has been understood ; that of the fullers' teasel (*Dipsacus fullonum*) (Fig. 16) though still crude, is perhaps better. The treatment of plants such as the hop and bryony shows a strong affinity with the borders of medieval missals.

The *German Herbarius*,[2] a fine folio volume published by Schöffer a year later than the *Latin Herbarius*, is an independent work and not, as has sometimes been asserted, a German translation of the latter. It is the only botanical incunabulum of real importance, and the supremacy of its illustrations remained unchallenged for nearly half a century.

The preface opens with a noble pæan to the Creator for His benevolence in providing mankind with natural remedies for diseases. We learn from what follows that the book was put together by a wealthy amateur who employed the services of a physician, probably Dr.

[1] Also known as *Herbarius in Latino* ; *Aggregator de Simplicibus* ; *Herbarius Moguntinus;* *Herbarius Patavinus* ; etc.

[2] Also known as the *German Ortus Sanitatis* ; the *Smaller Ortus* ; the *Herbarius zu Teutsch* ; the *Gart der Gesundheit* ; and *Cube's Herbal.*

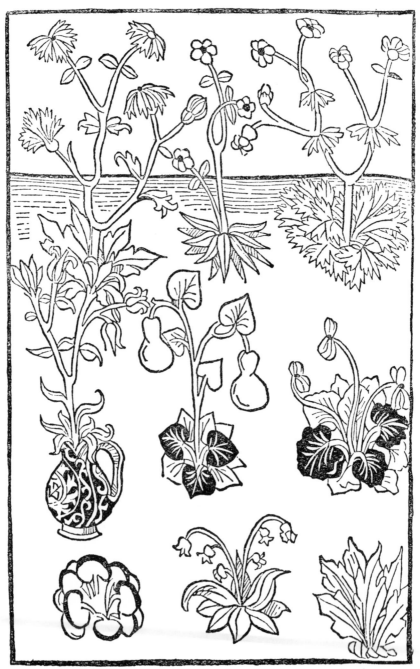

FIG. 13—Various Plants. Woodcut from *Púch der Natur*, 1482 ed

Johann von Cube of Frankfurt-am-Main, to prepare the medical section. While the work was in progress, the compiler, discovering that many of the herbs mentioned by the Ancients did not grow in Germany, set out for the Holy Land upon a pilgrimage whose object was partly spiritual, partly botanical. He continues : " In order that the noble work I had begun and left unfinished should not come to nothing, and also that my journey should not benefit my soul only, but the whole world, I took with me a painter of good sense, skilful and

FIG. 14—Meadow Saxifrage (*Saxifraga granulata*)
(*a*) Illumination from the Herbal of Apuleius, ninth-century manuscript. Formerly at Monte Cassino. (*b*) Woodcut (or metal-cut) from the Herbal of Apuleius, first printed edition ; Rome, 1481 ?

cunning." Passing through Italy and the Balkans, the travellers sailed by way of Crete, Rhodes and Cyprus to Palestine. After visiting Jerusalem, they made the customary detour to include Mount Sinai, returning through Cairo to Alexandria where they embarked for home.

" In wandering through these kingdoms and countries," the author explains, " I diligently sought after the herbs there, and had them drawn and depicted in their true forms and colours." On his return, he completed the book, which showed three hundred and fifty plants " in their true forms and colours."

It is tempting to identify the anonymous author and his painter with von Breydenbach and the artist Rewich who accompanied him on a similar voyage at the same date, but this has been shown to be impossible. Such journeys, in spite of the almost incredible hardships and dangers involved, were not uncommonly made at the time.

The finest of the woodcuts in the *German Herbarius* are unquestionably made from drawings of the living plant. Though they have none of the subtlety of Dürer's plant studies and none of the craftsmanship of his woodcuts, they show an honest attempt to represent the structure and habit of the flowers portrayed. That of " Acorus " (*Iris pseudacorus*), for instance, shown in Fig. 17, is excellent in its way, though there are signs that the engraver did not fully understand the artist's intentions, especially where the flowers are concerned. The teasel

FIG. 15—Iris (probably *Iris pseudacorus*)
Woodcut from the *Latin Herbarius*, 1484

(Fig. 18), if crude, is nevertheless lively. But side by side with these naturalistic drawings are many others which are scarcely better than those in the *Latin Herbarius*; and the inevitable mandrake (*Mandragora officinalis*), whose forked root gave it a resemblance to the human body, appears in its usual anthropomorphic guise. A single figure is made to serve for both " gladiolus " and " affodilus," and is, in fact, a bearded iris. Moreover, the figures of plants from Egypt, Syria and the Levant are disappointingly few in number and poor in

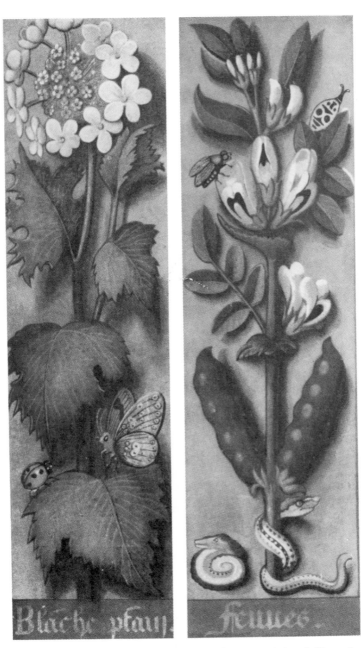

Plate V 'BLANCHE PUTAIN' (Guelder Rose, *Viburnum opulus*) and 'FEUVES'
(Broad Bean, *Vicia faba*). Border decorations from the *Book of Hours of Anne
of Brittany*, by Jean Bourdichon, *c.* 1508. Bibliothèque Nationale, Paris

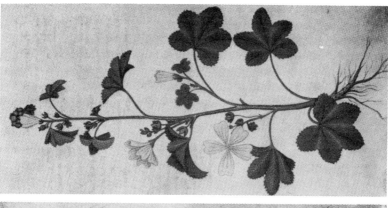

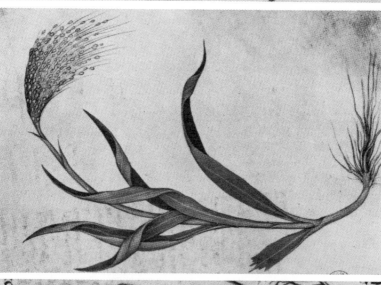

Plate VI *a* 'MATRICARIA' (probably *Matricaria* sp.), Venetian manuscript herbal, *c.* 1390. British Museum, London
b MILLET (*Panicum miliaceum*) and *c* COMMON MALLOW (*Malva sylvestris*). Water-colour drawings by Andrea Amadio, *c.* 1415
Herbal of Bendetto Rinio. St. Mark's Library, Venice

quality ; with the possible exception of those of senna and ginger, they show no sign of having been made from nature. There is, in short, so little evidence of " skill and cunning " that the very existence of the adventurous painter becomes suspect.

It is clear from what is stated in the preface that the woodcuts in the *German Herbarius*, and doubtless those in most other herbals of the fifteenth and sixteenth centuries, were intended to be coloured. Probably the artist would himself paint one or two copies, from which assistants, often mere children, could colour others ; in further copies, sold no doubt at a lower price, it would be left for the purchaser to paint them himself if he had the inclination and leisure.

The *Ortus Sanitatis*, published by Johann Meydenbach in 1491, was a book of much wider scope than its predecessors, for besides dealing with plants it included sections upon fishes, birds and other animals, minerals and medical matters. But again it was largely a compilation, supported by the same wealthy patron who has been mentioned in connection with the *German Herbarius*.

About two-thirds of the illustrations in the *Ortus Sanitatis* were taken from the German herbal, reduced, recut, and usually misunderstood. The actual cutting, however, was skilfully done, and showed a technical advance in the occasional use of white lines upon black, or of small patches of pure black, a device already employed in the 1482 edition of the *Pûch der Natur*. Of the new figures, those of native plants were tolerably naturalistic, the remainder largely or wholly fanciful. An example of the latter class is the "narcissus" (Fig. 19a), which shows a strange survival

FIG. 16—Fullers' Teasel (*Dipsacus fullonum*). Woodcut from the *Latin Herbarius*, 1484

of the classical legend and would be more at home among the nonsense botany of Edward Lear (Fig. 19b). "Ligusticum" (see

FIG. 17—Yellow Flag (*Iris pseudacorus*)
Woodcut from the *German Herbarius*, 1485

Fig. 20) is amusingly placed in a landscape setting, with water in the foreground and a church in the middle distance.

It is easy enough for a sophisticated age to mock at the credulity of the early herbalists ; let us rather choose to enjoy the happy

FIG. 18—Fullers' Teasel (*Dipsacus fullonum*)
Woodcut from the *German Herbarius*, 1485

invention of the artist who illustrated these pretty fables for us. Some of the figures, says Arber, display a "liveliness of imagination which one misses in modern botanical books. A tree called 'Bausor', for instance, which was believed, like the fabulous upas tree, to ex-

FIG. 19—(*a*) ' Narcissus'
Woodcut from *Ortus Sanitatis*, 1491

hale a narcotic poison, has two men lying beneath its branches, apparently in the sleep of death. . . . The tree-of-knowledge, with Adam and Eve and the apple, or with a woman-headed serpent, and the tree-of-life, are considered among other botanical objects. We are promised, enchantingly, that he who should eat of the fruit of the tree-of-life 'should be clothed with blessed immortality, and should not be fatigued with infirmity, or anxiety, or lassitude, or weariness of trouble.'"

It is not possible to deal in detail with the various reissues of the

incunabula herbals, but mention must be made of an interesting edition of the *Latin Herbarius*, published in Venice in 1499 and sometimes known as *Herbarius Arnoldi de nova villa Avicenna*. This was provided

FIG. 19—(*b*) 'Manypeeplia Upsidownia'
Drawing by Edward Lear from his *Nonsense Botany*, 1871

with a new set of plates, derived, it is believed, from a German source. They are slightly less stylised than the diagrammatic cuts in the *editio princeps*, but still very formal and symmetrical. Though only

fifteen years separate the two editions, the change of type from Gothic to Roman gives the volume a modern appearance which makes the figures seem doubly archaic. Arber has drawn attention to the Japanese quality of that of the *Iris pseudacorus* (Fig. 21), which serves for both " Acorus " and " Ireos vel Iris." The bird certainly has a

Fig. 20—' Ligusticum '
Woodcut from *Ortus Sanitatis,* 1491

superficially Japanese appearance ; but the symmetry of the plant is wholly alien to the art of the Far East. The figure of the plantain (Fig. 22) is far better, and the artist has successfully suggested the turn of the leaves.

The first thirty years of the sixteenth century produced no botanical illustrations of interest ; indeed few botanical books were published

during that period, the only important work being the *Grete Herball* (1526), with woodcuts derived from the *German Herbarius* and other incunabula. Hieronymus Braunschweig's treatise on Distillation, published at Strasbourg in 1500 and translated into English in 1527, depended for its illustrations upon similar sources ; its author showed that he was aware of their inadequacy, for, while emphasising the

FIG. 21—Iris (probably *Iris pseudacorus*)
Woodcut from the *Latin Herbarius*, 1499

importance of the text, he admitted that the figures were " nothing more than a feast for the eyes, and for the information of those who cannot read or write."

But the dawn of a new age was at hand : within three years of the publication of Hieronymus's book, the printed herbal was to break

free from the tyranny of the past and establish a truly naturalistic type of botanical illustration.

FIG. 22—Plantain (*Plantago major*)
Woodcut from the *Latin Herbarius*, 1499

PLATE VIIa
IRIS (*Iris germanica*). Detail from a water-colour drawing by Jacopo Bellini, *c.* 1450. Louvre

PLATE VIIb
IRIS (probably *Iris trojana*). Detail from a water-colour drawing by Dürer, *c.* 1506. Kunsthalle, Bremen

Plate VII a

b

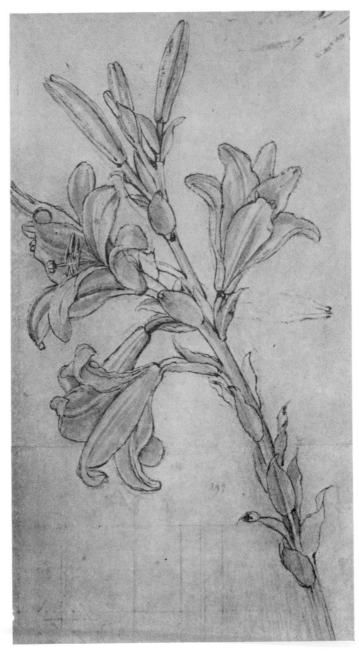

Plate VIII MADONNA LILY (*Lilium candidum*)
Study by Leonardo da Vinci, *c.* 1479. Windsor Castle

THE HERBALS OF BRUNFELS AND FUCHS

I T IS usually accepted that the publication by Schott of Strasbourg in 1530 of the first volume of Otto Brunfels's *Herbarum Vivae Eicones* inaugurated a new era in botanical illustration ; but, as we have already seen, the way had been prepared by the Venetian herbalists and by the artist of the *German Herbarius.*

As frequently happens with botanical books, the fame of the author has eclipsed that of the maker of the drawings. Yet Otto Brunfels (Otho Brunfelsius), though claimed by Sachs and his countrymen as one of the great pioneers of modern botany, was in reality little more than a compiler, who sought the substance of his inspiration in the well-worn pages of classical and medieval writers, discreetly seasoned with livelier passages from the works of his immediate predecessors in Italy. The draughtsman, Hans Weiditz (Johannes Guidictius), on the other hand, was a brilliant and original artist who set new standards of truth and beauty for the printed herbal ; and his designs were interpreted upon the wood by highly accomplished engravers.

Of Brunfels, little more need be said. Born at Mainz, he may possibly have acquired an interest in botany through contact with the various herbals published in that city towards the close of the fifteenth century. After some years spent in a Carthusian monastery, he became in 1521 a convert to Lutheranism. Settling finally as a schoolmaster in Strasbourg, he wrote various theological works before turning his attention seriously to medicine. Shortly before his death, which occurred in 1534, he was appointed town physician at Berne. His *Herbarum Vivae Eicones*—the third and last part of which was published in 1536—must therefore be considered as the product of his leisure hours.

45

Helleborus Niger.

Chriſtwurtz.

FIG. 23—Green Hellebore (*Helleborus viridis*)
Woodcut from Brunfels, *Herbarum Vivae Eicones,* 1530

At the beginning of the first volume of the work a generous tribute is paid to the artist who illustrated it :

Nunc & Johannes pictor Guidictius ille
Clarus Apellæo non minus ingenio,
Reddedit ad fabras æri sic arte figuras
Ut non nemo Herbas dixerit esse meras !

Such was the draughtsman's skill, then, that no one could say " these plants are not real." The very title of the work—" Living portraits of plants "—gives us a clue to the character of Weiditz's innovation : the artist, unlike the author, had not been content to adapt once again the oft-repeated formulae of his predecessors ; he had used his own eyes ; he had relied entirely upon Nature for his inspiration.

Two of the most oustanding woodcuts are those showing the green hellebore (*Helleborus viridis*) (Fig. 23) and the pasque-flower (*Anemone pulsatilla*) (Fig. 24). A whole world separates these vigorous, well-observed drawings from even the best figures in the *German Herbarius* of 1485. We are reminded at once of Dürer ; and much of Weiditz's work has in fact been falsely attributed at one time or another to that great master, or to Burgkmair. How vigorously the hellebore thrusts its leaf diagonally across the page ; how exquisitely the hairy quality of the pasque-flower has been realised ! The outline is never dull or mechanical, the design never banal. Though there is still present a certain Gothic angularity in the conception, there is tenderness too ; we sense that strange admixture of severity and sweetness which gives to the Madonnas of medieval German art their peculiar charm.

Though the woodcuts do not all show the same excellence, there is uniform honesty of purpose throughout. Weiditz accepted Nature as he found her. Was a leaf torn or drooping, a flower withered ?— he observed the fact with the cold eye of the realist and recorded it with the precision of a true craftsman. Yet beauty was never wantonly sacrificed to mere scientific accuracy ; the poet in him always triumphed, the artist in him always prevailed. His work must ever remain the high-water mark of woodcutting employed in the service of botanical illustration.

Perhaps the greatest defect of the book as a whole is that no consideration seems to have been given to the general appearance of the printed page. The woodcuts vary in size from splendid full-page

plates, such as those of water-lilies, to little figures only an inch or two in height ; and the latter are scattered through the pages of the book in what, artistically speaking, appears to be the most haphazard manner.

Less than twenty years ago, a number of original water-colours made by Weiditz for the *Herbarum Vivae Eicones* were discovered at Berne. They had been incorporated in the herbarium of Felix Platter, and though many had been damaged by cutting, enough remains to give a just impression of their beauty. They recall the more famous flower studies of Dürer, though differing from them technically in that the former are first outlined with bistre ink whereas the latter are in pure wash. A comparison between Weiditz's paintings and the wood-cuts made from them shows that certain liberties were taken with the originals ; this was the inevitable result of imperfect collaboration between artist and engraver—a fact which Brunfels himself admits. In particular, tall plants are compressed, with some loss of elegance, to make them fit more conveniently upon the printed page. Plate X (p. 49) shows Weiditz's painting of common comfrey (*Symphytum officinale*), and other examples of his work may be seen in Rytz's fine portfolio of facsimiles.

Rösslin's *Kreutterbůch* (1533), most of whose illustrations are taken, reduced and reversed, from Brunfels, need not detain us long. Egenolph, Rösslin's publisher, sued successfully by Schott for piracy, appears to have been obliged to surrender his blocks, for they were used the following year in a German edition of the *Herbarum Vivae Eicones*. As Arber has pointed out, since the third part of Brunfels's work was not issued until 1536, Rösslin was at a loss to find " copy " for a number of his plates. For the asparagus, for instance, he was reduced to adapting the curiously stylized cut which had appeared archaic even in the pages of the *German Herbarius* and the *Ortus Sanitatis* (see Fig. 25). Rösslin also used the Greek form of his name —Rhodion.

Immeasurably more important were the splendid folio volumes of Fuchs's *De Historia Stirpium* (1542) and its German translation *New Kreüterbůch* (1543). Here again, as with Brunfels, the value of the illustrations outweighs that of the text which, scholarly though it is, is based in the main upon Dioscorides. Yet Fuchs is immortalised in the Fuchsia, an American genus that he never saw, while the names of his artists, though gratefully recorded, are unremembered.

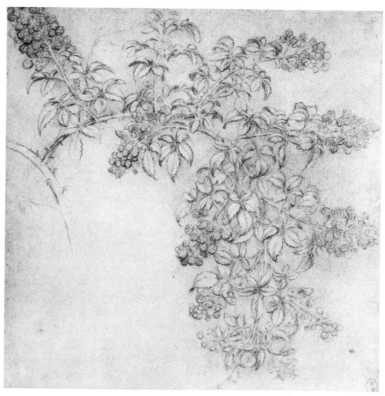

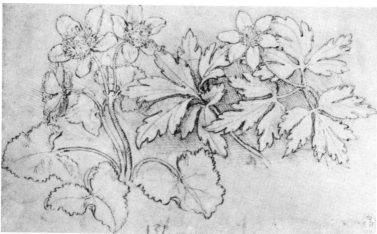

Plate IX a Bramble (*Rubus fruticosus*). Study by Leonardo da Vinci, *c.* 1503
Red chalk on pink prepared paper. Windsor Castle
b Wood Anemone (*Anemone nemorosa*) and Marsh Marigold (*Caltha palustris*)
Pen-and-ink drawing by Leonardo da Vinci, *c.* 1505. Windsor Castle

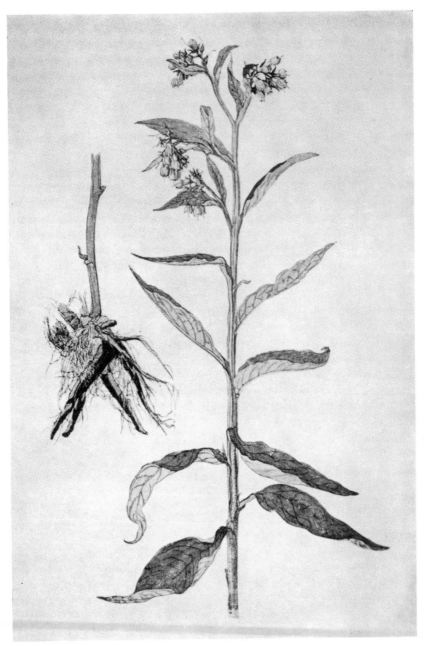

Plate X Comfrey (*Symphytum officinale*)
Water-colour drawing by Hans Weiditz, 1529. Botanical Institute, Berne

Leonhart Fuchs was born at Wemding, in Bavaria, in the year 1501. His early career was brilliant : matriculating at Erfurt University at the age of twelve, he earned his livelihood for a time as a teacher ; then, returning to his studies, he graduated in Classics at Ingolstadt and took his doctor's degree in Medicine. Munich, and the universities of Ingolstadt and Tübingen, successively availed themselves of his medical services. His work during the plague epidemic in 1529 set a seal upon his reputation, and soon his fame spread far beyond the borders of his own country.

The celebrated *De Historia Stirpium* was published at Basle by the Isingrin Press, and the measure of its popularity may be gauged by the frequency with which its plates were used or adapted by other writers. Fuchs has also dealt generously with the artists whose work so substantially contributed to the success of his book : a full-page plate shows Albrecht Meyer, who drew the plants from Nature ;[1] Heinrich Füllmaurer, who transferred the drawings to the wood blocks ; and Veit Rudolf Speckle, who did the cutting. Meyer is shown at work upon a drawing of a corn-cockle ; but one may venture to doubt whether the distorted sketch which he is represented as making, should be interpreted, as has been suggested, as a sly dig on the part of one of his two collaborators.

In making a comparison between the *Herbarum Vivae Eicones* and the *De Historia Stirpium*, a first glance might lead one to believe that almost everything favoured the superiority of the latter. We are dazzled by Fuchs's splendid folio pages ; by his crisp, white paper ; by his spacious designs ; by the fine printing and layout of the book ; and by the sheer quantity of his illustrations—more than twice as many as those in Brunfels. When we further recollect that this book was to have been but the first of three similar volumes, it is impossible not to admit the magnitude and daring of his conception, and the importance of what he actually achieved. But it must not be forgotten that Brunfels was the pioneer. Weiditz's noble full-page drawings of water-lilies—which Fuchs's artists did not even attempt to better, but adapted rather clumsily to their own purpose—gave a lead which was eagerly followed, but set a standard which was not to be surpassed.

The woodcuts in the *De Historia Stirpium* fill the whole of the folio page. If at first sight the contours seem a little thin to support so large

[1]The so-called " original " drawings of the plants, now in the British Museum, are early, and rather feeble, copies.

FIG. 24—Pasque-flower (*Anemone pulsatilla*)
Woodcut from Brunfels, *Herbarum Vivae Eicones,* 1530

a drawing executed wholly in outline, we must remember that the plates were intended to be coloured. Moreover, Fuchs, as he explains in his preface, was particularly anxious that no shading should detract from the clarity of the figures :

" As far as concerns the pictures themselves, each of which is positively delineated according to the features and likeness of the living plants, we have taken peculiar care that they should be most perfect ; and, moreover, we have devoted the greatest diligence to secure that every plant should be depicted with its own roots, stalks, leaves, flowers, seeds and fruits. Furthermore, we have purposely and deliberately avoided the obliteration of the natural form of the plants by shadows, and other less necessary things, by which the delineators sometimes try to win artistic glory : and we have not allowed the craftsmen so to indulge their whims as to cause the drawing not to correspond accurately to the truth. Veit Rudolf Speckle, by far the best engraver of Strasbourg, has admirably copied the wonderful industry of the draughtsmen, and has with such excellent craft expressed in his engraving the features of each drawing, that he seems to have contended with the draughtsmen for glory and victory."

In the face of such warm appreciation, it may seem a little ungracious to point out that Speckle's line is often too rigid and wiry to be suitable even as a boundary for water-colour wash ; or that his draughtsmen, for all their skill and ingenuity, never approached Nature with quite the same humility as did Weiditz.

Fuchs's artists tended to idealise their plants as the Greek sculptors idealised their heads; Weiditz seizes upon their particular characteristics and records them with the ruthlessness of a Roman portraitist. Fuchs's teasel (*Dipsacus fullonum*), for instance, impresses the spectator by its vigorous growth, its splendid symmetry ; but Brunfels's modest plant with its shrivelled leaves shows more subtle observation, though to have selected an imperfect specimen may possibly serve a less useful purpose botanically (see Fig. 26). As Arber observes, " the drawing which is ideal from the standpoint of systematic botany avoids the accidental peculiarities

FIG. 25 — ' Asparagus.' Woodcut from Rösslin, *Kreutterbüch*, 1533.

FIG. 26—Fullers' Teasel (*Dipsacus fullonum*)
(*a*) Woodcut from Fuchs, *De Historia Stirpium*, 1542
(*b*) Woodcut from Brunfels, *Herbarum Vivae Eicones*, 1531

of any individual specimen, seeking rather to portray the characters fully typical for the species." Hence in her opinion " the illustrations to Fuchs's herbals (*De Historia Stirpium*, 1542, and *New Kreüterbüch*, 1543)

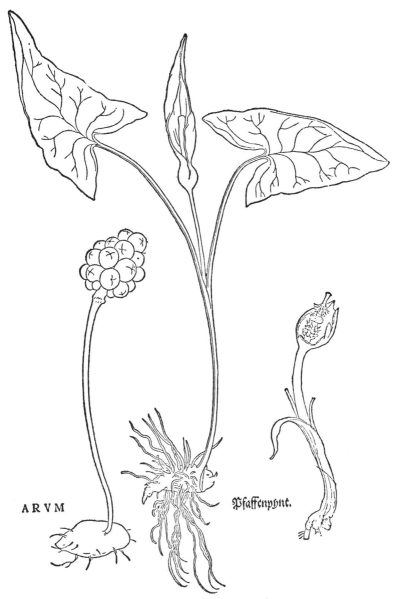

ARVM Pfaffenpynt.

FIG. 27—Cuckoo-pint (*Arum maculatum*)
Woodcut from Fuchs, *De Historia Stirpium*, 1542

represent the high-water mark of that type of botanical drawing which seeks to express the individual character and habit of each species, treating the plant broadly as a whole, and not laying more stress upon the reproductive than the vegetable organs." Yet how low Fuchs's artists could sometimes sink, can be seen by observing the articulation of the stems in the figure of " Geranium Tertium " (*Geranium robertianum*).

But many of Fuchs's plates are undeniably admirable, and fully merit the praise bestowed on them by Arber, and by Morris and Ruskin —both of whom purchased copies of the book from Mr. Quaritch. Among the most interesting figures may be mentioned that of the wild arum (*Arum maculatum*) (Fig. 27), with its excellent drawing of the fruit and the careful dissection of the flower. The varied treatment of the graceful fronds of the asparagus (*Asparagus officinalis*) (Fig. 28) and the thick ribbed leaves of the cabbage (" Brassicæ quartum genus ") shows that the artists were equally at home in dealing with plants of widely differing character and habit. Sometimes a climbing plant is represented as forming an all-over pattern which anticipates the flowered wallpapers so popular in the nineteenth century. A certain archaism still lingers in the treatment of the trees, whose heads are frequently distorted to conform to the rectangular contours of the block, or are curved so that they may be included within the minimum space.

A convention, born of economy, which occurs frequently in Fuchs's herbal (but is not confined to this) is that portrayal of a plant in flower and fruit at the same time, or with several kinds of flowers (varieties) springing from the same root. One figure, for instance, shows three distinct species of deadnettle (*Lamium album, L. maculatum* and *L. galeobdolon*) thus united, and the unwary may easily be misled.

Fuchs's plates were to have a far-reaching influence on botanical illustration for many years to come, and in the preface to one of his later editions he complained bitterly of the way in which his plates had been pirated. David Kandel, a young Strasbourg engraver, adapted some of them for Jerome Bock's[1] *Kreuter Buch* (1546), though many of the figures in this interesting work are original. Reduced blocks of Fuchs's designs, made for the octavo edition of his work published in 1545, were copied and used in England to illustrate

[1]Bock being the German for " he-goat," he preferred the Graeco-Latin disguise of " Tragus."

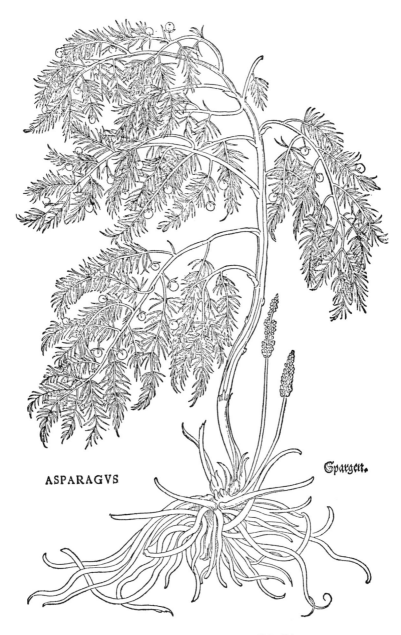

ASPARAGVS

Spargett.

FIG. 28—Asparagus (*Asparagus officinalis*)
Woodcut from Fuchs, *De Historia Stirpium*, 1542

Turner's *New Herball* (1551-68); in Antwerp for the two editions of Dodoens's *Crüÿdeboeck* (1554 and 1563);[1] for the French translation of Dodoens prepared by Clusius (1557); for Lyte's *Nievve Herball* (1578); and in many other books. Designs based on the plates were used in countless works during the sixteenth and seventeenth and even into the eighteenth centuries, and the actual blocks employed in the folio edition of the *De Historia Stirpium* made their final appearance as late as 1774, Salomon Schinz's *Anleitung zu der Pflanzenkenntniss*.

[1] A magnificent hand-coloured copy of the first edition of Dodoens's *Crüÿdeboeck* was bought at the Krelage sale (1948) for the *Prentenkabinet* at Amsterdam. The various title-pages are decorated with original designs of great beauty, and the painting of the plates is faultless throughout. The painted title-pages are signed H(ans) L(iefrinck), and dated 1567. One or two other finely coloured copies of sixteenth-century herbals have survived.

THE DECLINE OF THE WOODCUT

D URING THE fifteenth century Italy had played an important part in the diffusion of botanical knowledge. The work of the Venetian herbalists has already been mentioned ; but of far greater significance was the publication of printed editions of the manuscripts of the great classical botanists—Pliny in Latin, and Dioscorides and Theophrastus in Latin and Greek. Since the early years of the century, however, Italy had contributed little or nothing to the development of botanical illustration. The cuts in the Venetian edition of the *Latin Herbarius* were probably derived from German sources, and some of those which illustrated the work of the great sixteenth century botanist, Mattioli, owed a similar debt to northern art.

Pierandrea Mattioli, or Matthiolus (1501-77), was born at Siena, but passed his youth in Venice where his father practised medicine. Though destined for the law, the boy soon showed that his tastes lay elsewhere and was allowed to study for his father's profession. After practising in Siena, Rome and Görz, he was called to Prague, where he served as physician to the Archduke Ferdinand, and later to his brother the Emperor Maximilian II. He died at Trent of the plague, at the age of seventy-six. His name is commemorated in the genus Matthiola (stock).

Among Mattioli's friends may be mentioned Ogier Busbecq, who was instrumental in securing the Anician *Codex Vindobonensis* for the Emperor Ferdinand I (see p. 10). In a letter dated 1562, Busbecq writes : " I brought back from Turkey some drawings of plants and shrubs which I am keeping for Mattioli ; but as to plants and shrubs

FIG. 29—Daffodil (*Narcissus pseudo-narcissus*). (*a*) Woodcut from Brunfels, *Herbarum Vivae Eicones*, 1530. (*b*) Woodcut from Mattioli, *Commentarii*, 1554

themselves I have none, for I sent him many years ago the sweet flag [*Acorus calamus*] and many other specimens." Among the latter were the lilac and the horse-chestnut, these being, with the tulip and the mock-orange, Busbecq's most important introductions into Western Europe. The ambassador also provided Mattioli with two manuscript copies of the writings of Dioscorides, the author who was to prove the chief inspiration of the Italian botanist.

Mattioli's most famous work, the *Commentarii in sex Libros Pedacii Dioscoridis*, was first published at Venice in 1544. This edition in Italian was followed ten years later by a Latin version, illustrated with

562 small woodcuts of uniform size, more than five hundred of which were of plants. Most of these woodcuts are very different in character from those in Fuchs's and Brunfels's herbals, far more use being made of shading ; but that Mattioli's artists were sometimes directly indebted to their illustrious predecessors is demonstrated by the rather crude adaptation of a figure from Brunfels, reproduced in Fig. 29. Judged as a whole, the Mattioli woodcuts are somewhat commonplace ; yet the phenomenal success of the venture can be gauged from the fact that more than thirty thousand copies of the early editions are said to have been sold. In all, more than forty editions were published.

Four of the later editions—in Czech, German, Latin and Italian, published in Prague (1562) and Venice (1565 and 1585)—contained, however, a new set of large-sized figures which are of considerable interest. As the preface informs us, they are the joint work of Giorgio Liberale of Udine and of a German named Wolfgang Meyerpeck. These woodcuts are similar in character to the earlier ones, but far more accomplished and impressive. Shading is extensively used, and the details are executed with great skill. They are not dependent upon colour as are those of Fuchs ; but that they were sometimes painted we know, for Wotton expressly states that it was a *coloured* copy that he bequeathed in his will to Queen Henrietta Maria.[1] Two sumptuous copies survive, printed upon grey paper and illuminated with silver ; one of these is in the State library at Dresden ; the other, partially illuminated, is in the possession of Sir Sydney Cockerell. Among the finest illustrations must certainly be included those of trees, especially conifers ; the baffling intricacy of their detail never proved too difficult a task for either draughtsman or engraver (see Pl. XI, p. 64). Yet at times an almost irresistible desire to fill every available square inch of the block resulted in a heaviness which recalls the worst kinds of Victorian chintz or wallpaper (see Fig. 30) ; in such figures we find neither the grace and elegance of Fuchs, nor the Gothic vigour of Brunfels, only a rather dreary and lifeless stolidity. For all their skilfulness, the illustrations to Mattioli mark the beginning of the decline of wood-engraving.

[1] The colouring of many copies of Fuchs, and also some of Brunfels, is authentic, in that they were issued by the publisher in a coloured state based upon the artist's original coloured drawings made from living specimens. It seems unlikely that the drawings used by Mattioli were coloured ; probably the owner of a copy sometimes painted it himself.

Moreover, Mattioli's figures are not always wholly reliable. Many were made from dried specimens soaked in warm water, a procedure which left its mark on the resultant drawing. In one of his letters Mattioli records that an artist employed by him lost the specimens that he had been given to draw, and to escape punishment, drew them from memory. Probably something of the kind happened on other occasions but escaped detection ; at all events, inaccurate figures occur both in the large and the small editions, and were presumably passed by Mattioli, who kept no specimens as a check.

The woodcuts in other Italian herbals, such as Castor Durante's *Herbario Nuovo* (1585), Porta's *Phytognomonica* (1588), and Alpino's *De Plantis Aegypti* (1592), though for the most part original, are for our purpose relatively unimportant since they add little to the development of botanical illustration. The *Tractado* (1578) of the Portuguese botanist Acosta was based upon a work by de Orta and illustrated with moderate woodcuts, made from nature, of Indian plants. Spanish botanists, exploring the flora of the New World, also failed to add anything of value to the development of plant iconography. Monardes, in a book published in 1569-71, gives us the first printed illustration of the tobacco plant;[1] and in the posthumously published *Thesaurus* (1651) of Francisco Hernandez, physician to Philip II of Spain, we have an interesting figure of the dahlia,[2] or " cocoxochitl " as he called it (Fig. 31), which was already cultivated in Mexico in single and double forms of various colours. Hernandez,[3] who was in Mexico from 1571 to 1577, was also responsible for the first illustration of a tigridia, another plant not introduced into Europe until the end of the eighteenth century. The earliest printed figure of this flower occurs in l'Obel's *Plantarum seu Stirpium Historia* (1576), and is based on a coloured drawing given him by Jean de Brancion who presumably had it from a Spanish friend. Many hundreds of Hernandez's drawings, once preserved in the Escorial, were destroyed by fire in 1671. In spite of the artist's careful and accurate drawing, Gerard—who not only swallowed the story of the goose-bearing barnacle tree, but claimed personal experience

[1] See an article by Singer in the *Quarterly Review* ; July, 1913.
[2] Named after the Swedish botanist Andreas Dahl, a pupil of Linnæus.
[3] Linnæus named the genus Hernandia after him : " *Hernandia* is an American tree, with the handsomest leaves of any, and less conspicuous flowers—from a botanist who had supreme good fortune, and who was highly paid to investigate the natural history of America ; would that the fruits of his labours had corresponded to the expenditure ! " (*Critica Botanica :* transl. Arthur Hort.)

FIG. 30—Comfrey (*Symphytum officinale*)
Woodcut from Mattioli, *Commentarii*, 1565

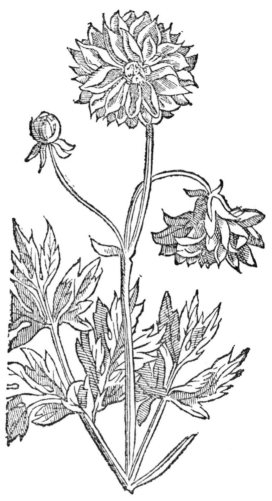

FIG. 31—' Cocoxochitl ' (*Dahlia* sp.)
Woodcut from Hernandez, *Thesaurus*, 1651

of it—scornfully dismissed the beautiful tigridia as " meere fiction."

A curious manuscript herbal (the *Badianus Herbal* ;[1] Vatican Library) made in 1552 by Aztec artists at the Roman Catholic College of Santa Cruz, contains gay but highly stylised little paintings of

[1]See Emmart.

Mexican plants. A free version of this manuscript, probably made in Italy about the year 1600, is in the Royal Library at Windsor.

We must now turn to Flanders, where, during the second part of the sixteenth century, the famous Plantin publishing house issued at Antwerp the numerous herbals of three of the greatest botanists of their day—Dodoens, de l'Écluse and de l'Obel. These three men worked side by side without rivalry or petty jealousies, and the blocks which illustrated their herbals were drawn from what was virtually a common pool under Plantin's charge ; it will therefore be simpler to discuss their figures together. But first, a word may be said about the careers of each of them.

Rembert Dodoens (Dodonæus) was born at Malines in 1517, and after studying medicine at Louvain pursued his education in France, Italy and Germany. Like Mattioli and de l'Écluse he was for a time in the service of the Emperor Maximilian II and afterwards of Rudolf II. Later he worked in Cologne and Antwerp ; and in 1582, three years before his death, became Professor of Medicine at Leiden. His first work, *Crüÿdeboeck*, was published by van der Loe in 1554 and illustrated in the main, as we have already mentioned, with the small woodblocks which had been used in the octavo edition of Fuchs ; all his later books, including his collected works which were published in 1583 under the title of *Stirpium Historiae Pemptades Sex*, were produced and issued by Plantin.

Charles de l'Écluse (Carolus Clusius), Dodoens's junior by nine years, was a native of Arras, at that time in Flemish territory. As was the custom of the day, he studied at various universities, and finally under the famous teacher Rondelet at Montpellier. De l'Écluse's life was not an easy one. When his parents were persecuted for their Lutheran views and their belongings confiscated, he reduced himself to penury to rehabilitate them. His health was always precarious, and he suffered from " an extraordinary proneness to fracture and dislocation of the limbs". Yet he triumphed over all his adversities. A true figure of the Renaissance, he could boast, besides his botanical knowledge, " an intimate acquaintance with Greek, Latin, Italian, Spanish, Portuguese, French, Flemish, German, law, philosophy, history, cartography, zoology, mineralogy, numismatics, and epigraphy" (Arber). He wrote an exquisite humanistic hand.

Science benefited by his roving disposition : an audacious expedition to Spain and Portugal with two young members of the

Fugger family resulted in the discovery of two hundred new species and the publication, in 1576, of his first work, *Rariorum aliquot Stirpium per Hispanias observatarum Historia* ; his service in the court of the Emperor Maximilian II gave him the opportunity of investigating the mountain flora of Austria and Hungary, which provided the theme for his second book, *Rariorum aliquot Stirpium per Pannoniam, Austriam et Vicinas Historia* (1583). Later, when at Leiden, he published his complete works in a single folio entitled *Rariorum Plantarum Historia* (Antwerp, 1601).

De l'Écluse's work was practical and descriptive, and he added little to the knowledge of classification. But it remains of high value even to-day, on account of his genius for detecting the essential specific features of plants and, in spite of the limited scientific terminology of the day, for giving recognisable descriptions of them. Again and again, in attempting to ascertain the correct application of names given by Linnæus, the inquirer is led back to de l'Écluse's work, which can be described as the starting point of our modern knowledge for many genera. His description and the associated illustrations thus help to typify the species of later authors.[1] Moreover, his enthusiastic cultivation of foreign plants, particularly those from Turkey and the Levant, prepared the way for the splendid gardens of seventeenth century France, Germany, Austria, Flanders and Holland ; and his introduction into the Low Countries of the potato rendered no less a service to their board. His death in 1609 is commemorated in the felicitous epitaph :

> *When Clusius knew each plant Earth's bosom yields,*
> *He went a-simpling in the Elysian fields.*

An especial interest attaches to the work of Mathias de l'Obel (de Lobel ; Lobelius), because a large part of his life was spent in England, where he was in charge of Lord Zouche's botanical garden at Hackney. Born at Lille in 1538, he became a favourite pupil of Rondelet, who bequeathed him all his manuscripts. De l'Obel collaborated with a Provençal botanist named Pierre Pena in the composition of his most famous book, *Stirpium Adversaria Nova* (1570), which was dedicated to

[1] See Stearn, W. T., on Allium in *Herbertia* *11* : 14-15 (1946), on Tofieldia in *J. Linn. Soc. Bot. 53* : 194-98 (1947), Bowles, E. A., on Anemone in *J. Royal Hort. Soc. London, 73* : 58-69 (1948).

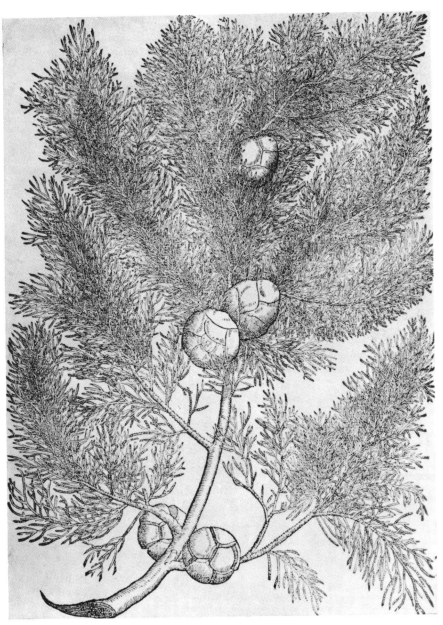

Plate XI　　　　　CYPRESS (*Cupressus sempervirens*)
Woodcut from Mattioli, Commentarii, Venice, 1565

b

Plate XIIa.

Queen Elizabeth ; it is an important landmark in the history of classification. In 1581 de l'Obel became physician to William the Silent, and after the latter's death worked for a time in Antwerp ; but the closing years of his life were passed in England, where he made a valuable study of the British flora and was appointed botanist to James I. He died in 1611 at Highgate, deserving a better fate than that of being commemorated by a genus which, though it has many noble species, is usually associated with the horrors of Victorian summer bedding.

Plantin's services to printing in general, and to the publication of botanical books in particular, are too well known to need my praise. But far less known is the work of Pierre van der Borcht (1545-1608), the principal artist who provided botanical drawings for the house of Plantin. Van der Borcht fled from his native town of Malines when it was plundered in 1572, and was given full-time employment by Plantin, for whom he had already been working as a free-lance. There is little doubt that van der Borcht was largely responsible for the magnificent series of natural history paintings, now in the Preussische Staatsbibliothek, Berlin, to which attention and criticism was first directed just before the second World War.[1]

This wonderful collection undoubtedly forms the most important corpus of sixteenth-century flower-paintings in existence. Of the 2117 figures which it contains, no less than 1856 are of plants ; of those, all but a handful in the last volume must almost certainly have been made for de l'Écluse, and some six hundred of them were actually used in the making of the wood-blocks which illustrate various works of the Plantin Press. From internal evidence, it seems likely that most of the paintings were made between the years 1565 and 1573.

Where the drawings could be made from living specimens, they

[1]One page of this work is reproduced in Arber's *Herbals* (2nd Ed., 1938) ; others may be seen in *Gartenflora* (1936 and 1937). In order to give some idea of the colour, I have made a copy of one of the two colour-plates which illustrate an article by Hans Wegener in *Medizinische Mitteilungen* (1936).

PLATE XIIa
PRAYER BOOK. Illuminated by Georg Hoefnagel (1542-1600) for Albrecht V, Elector of Bavaria. · Staatsbibliothek, Munich

PLATE XIIb
PRAYER BOOK. Illuminated by an unknown artist ; Italian, *c.* 1700. Biblioteca Nazionale Centrale, Florence

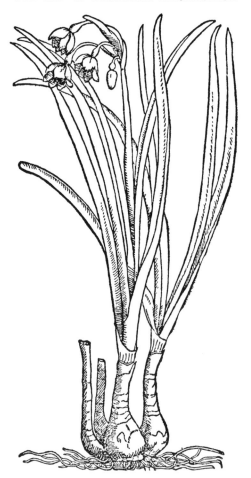

FIG. 32—Loddon Lily (*Leucojum aestivum*)
Woodcut from de l'Écluse, *Rariorum . . . per Pannoniam . . .*; 1583

were finished in full colour ; but where pressed plants had to be used,
the artist preferred to work in black and white only, to avoid error.
Flowers from all parts of Europe are represented, together with many
from India and America, particular attention being given to medicinal
plants. The collection contains no less than four paintings of *Nerium
oleander*, one of which is shown on Plate 5 (p. 68). Unfortunately, I have
no first-hand knowledge of the paintings, nor of their fate since the

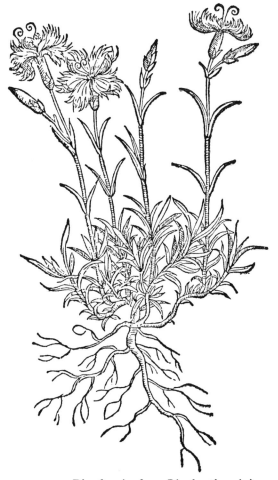

FIG. 33—Dianthus (perhaps *Dianthus plumarius*)
Woodcut from de l'Écluse, *Rariorum . . . per Pannoniam . . .*; 1583

war ; but Wegener's account of them leaves us in no doubt as to their great beauty and importance. Several original wood-blocks, drawn upon by van der Borcht but never engraved, are in the Plantin Museum, Antwerp, and have been described by Wijngaert (1947). A collection of paintings of fungi, made for de l'Ecluse in Hungary, is now in the Leiden University Library ; it has been published in facsimile by Istvánffi (1900).

Lord Middleton possesses a fine manuscript florilegium (now on loan to Nottingham University) which dates from the sixteenth century. It appears to be of Flemish origin, and in part to be connected with the works of de l'Obel. Lord Middleton is a descendant of Francis Willughby (1635-72), the pupil and friend of Ray ; the volume was once in the possession of the latter, and was presumably acquired by him on his continental travels. Mr. A. H. G. Alston and Mr. James Wardrop kindly examined the book for me, and the following information is drawn from the notes which they made. The drawings are not the work of one artist. A few, larger in scale and cut down to fit the book, are inscribed in Italian and may have been made by an Italian master for his pupil. The main group of paintings appears to be by one hand, and the plants included in them would agree with a flora to be found in the neighbourhood of Dunkirk ; the handwriting suggests the first, rather than the second, half of the sixteenth century. That the writer knew some classical botany may be inferred from the fact that he (or she) labelled the periwinkle as a clematis. A drawing of a cyclamen in the later part of the book, apparently, by another artist, is a copy in reverse of (or the original drawing for?) the corresponding figure in de l'Obel's *Plantarum seu Stirpium Historia* (1576). Most of the pictures are vigorously executed in gouache; they are reasonably accurate botanically, and very decorative (see Pl. 6, p. 69).

Among the most interesting of the original drawings still preserved in the Plantin Museum is the well-known study of the potato, which was sent to de l'Écluse in 1589 by Philippe de Sivry " Lord of Waldheim and Governor of the town of Mons". De l'Écluse mentions this drawing in his *Rariorum Plantarum Historia*, but uses another study of the plant to illustrate his text. The potato illustrations of de l'Écluse and of Gerard (1597) are of great importance for understanding the history of this crop.[1]

The woodcuts of the de l'Écluse group are small and neatly cut, and often include the fruit as well as the flower ; the Loddon lily (*Leucojum aestivum*) shown in Fig. 32 and the dianthus (Fig. 33) are average examples. Among the illustrations to Dodoens's *Pemptades* are several which have been derived from those made more than a millennium earlier for the Anician *Codex* (see Fig. 34). The amusing woodcut of the tobacco plant (Fig. 35), showing a negro smoking a large pipe, is from Pena and de l'Obel's *Stirpium Adversaria Nova*.

[1]See Salaman, R.N., *The History and Social Influence of the Potato* (1949).

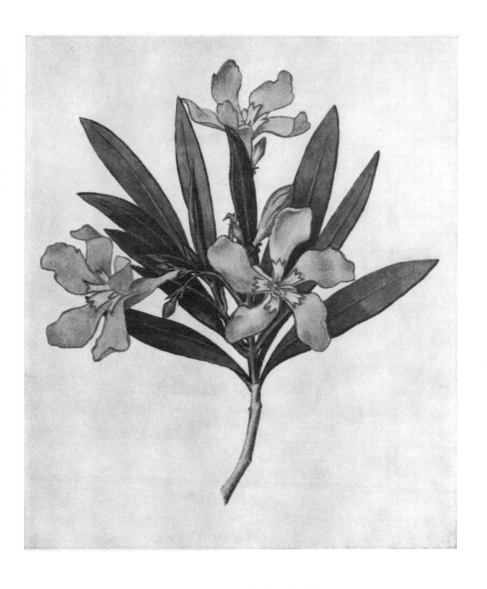

Plate 5 OLEANDER (*Nerium oleander*)
Water-colour drawing, probably by Pierre van der Borcht, *c.* 1570
(From a copy made by W. Blunt)
Staatsbibliothek, Berlin

Plate 6 MOUNTAIN KNAPWEED (*Centaurea montana*)
Water-colour drawing, Flemish, 16th century. Collection of Lord Middleton

The figures associated with the works of the botanists Gesner and Camerarius are also inextricably confused, and must be treated as forming a single group. Conrad Gesner, or Gessner, a Swiss, was born in humble circumstances in Zürich in 1516. His natural talent, and the liberality of Zürich University in providing him with two travelling scholarships, gave him the necessary start in life, although he was more than once obliged to combine study with teaching. He died of the plague in 1565, leaving unfinished his great *Historia Plantarum*, a companion to his *Historia Animalium*. The 1500 drawings which he had assembled for this purpose, most of them original, passed after various vicissitudes into the hands of the German botanist Joachim Camerarius the Younger (1534-98), son of the famous classical scholar, who used some of them, together with his own blocks, to illustrate various works which he wrote or edited. In the eighteenth century, others of the unused drawings and blocks came into the possession of the celebrated Nuremberg doctor, Christoph Jakob Trew (1695-1769), and a further selection was published by Schiedel. A part of Trew's collection has recently been brought to light in the Library at Erlangen.

Treviranus (1855) considered the illustrations from Camerarius's *Hortus Medicus* (1588) to be the best botanical woodcuts ever made. This is higher praise than I would care to bestow ; but the plates in this little book (see Fig. 36) are certainly accurate and well engraved, and contain excellent botanical details. Among the artists employed by Camerarius (who was himself a competent draughtsman) were Brechtel, Amman, Peterlin, and the author's nephew Joachim Jungermann ; Peterlin, and an unknown Zürich engraver, were responsible for transferring them to the wood-block.

The last book of importance to be illustrated by wood-blocks was the ill-fated *Campi Elysii* which Olof Rudbeck (*b.* 1630), later assisted by his son, prepared and began to issue at Uppsala in 1701. The work was intended to provide, in twelve volumes, illustrations of all the plants then known ; eleven thousand drawings had been made, and in part engraved and printed, when almost the whole material was destroyed by fire (1702). There are only two known perfect copies of the first volume ; both these are now in Sweden. The copy at the Oxford Botanic Gardens is a lithographic facsimile of the first volume, the original having been returned to Uppsala in 1862 by the University authorities.[1] A copy of the second volume (which was actually the

[1]See Guiney (1949).

first to be published and of which several copies survived the fire) is in the library of the Linnean Society : its illustrations are vigorous and effective, but often rather crude and misleading ; they cannot for a moment stand comparison with sixteenth century work.

FIG. 34—' Hippophaës ' (Sea Buckthorn, *Hippophaë rhamnoides*)
Woodcut from Dodoens, *Pemptades*, 1583

Since the present book is devoted to the development of plant iconography, it will not be necessary to dwell upon those herbals which, though of importance in themselves, are illustrated with inferior or derivative figures. We shall find that France during the sixteenth century, and England during the sixteenth and seventeenth centuries,

contributed practically nothing to the development of botanical book-illustration.

The woodcuts in the French edition of Mattioli's *Commentarii* (Lyons, 1579), which were used again in d'Aléchamps's massive

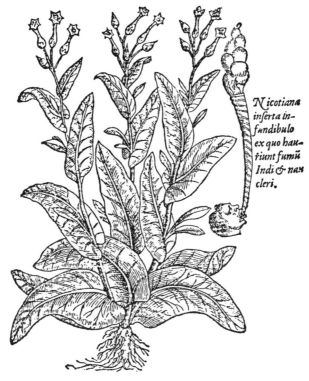

Nicotiana inferta infundibulo ex quo hauriunt fumū Indi & nau cleri.

FIG. 35—Tobacco Plant (*Nicotiana tabacum*)
Woodcut from Pena and de l'Obel, *Stirpium Adversaria Nova*, 1570

Historia Generalis Plantarum (1586-87),are largely copied from Mattioli, Fuchs and Dodoens, but present one curious feature : the engraver, afflicted apparently by a *horror vacui*, has decorated the blank spaces of his blocks with insects and falling flowers (see Fig. 37). The adventurous traveller Pierre Belon (1517-64) enlivened the pages of his *De Arboribus* (1553) and the entertaining account of his travels, published in the same year, with attractive woodcuts which include some of trees and plants.

The illustrations in *The Grete Herball* (1526) are derived from the German *Herbarius* and other contemporary works ; those in Turner's *A New Herball* (1551-68) are mostly from Fuchs ; those in Lyte's *A Nievve*

FIG. 36—' Astragalus sylvaticus ' (*Lahtyrus montanus*)
Woodcut from Camerarius, *Hortus Medicus*, 1588

Herball (1578) are from Fuchs and Dodoens. One of the very few original plates in the first edition of Gerard's popular *Herball* (1597) is that of the potato ; almost all the remainder are printed from the blocks used in the *Eicones Plantarum* of Tabernæmontanus, who had himself borrowed their designs from the usual sources. Johnson's scholarly edition of Gerard (1633) was illustrated with 2677 blocks from the collection accumulated by Plantin. Parkinson's *Paradisus*

L I L I V M Convallium.

FIG. 37—Lily of the Valley (*Convallaria majalis*)
Woodcut from d'Aléchamps, *Historia Generalis Plantarum*, 1586-87

(1629) contains full-page wood-block illustrations in which a number of plants are grouped together. Some are original, many are borrowed ; but all are crudely cut and unworthy of the delightful text that accompanies them.

In the Tollemache Trust (Helmingham MS. 78), and now on

deposit in the British Museum, is an English manuscript florilegium dating from the early part of the sixteenth century. The flowers in it are arranged alphabetically, grouped four together on a page, and treated decoratively ; they may have been intended for the use of tapestry or needlework designers. Besides the twenty-four pages of flowers there are twelve devoted to birds and other animals, and two of ribbon-letter alphabets similar to those in the writing book of Lodovico Vicentino (1523). A somewhat similar book of about the same date, containing line drawings of sixty-eight English wild flowers, is in the British Museum (Add. MS. 29301).

SOME FLOWER PAINTERS OF THE LATE SIXTEENTH CENTURY

D URING THE second half of the sixteenth century, while the botanical wood-block steadily fell from grace, a growing interest in floriculture was creating the flowers which were to provide the chief stimulus for the artists of the next generation. Some idea of the progress made can be gauged from the fact that whereas Fuchs only listed about 500 plants and Mattioli 1200, Caspar Bauhin, in his *Pinax* (1623), records over 6000 varieties.

The German native flora, for instance, which was grown almost in its wild state even in late medieval gardens, was considerably improved. *Viola odorata, Papaver rhoeas* and *P. somniferum, Scabiosa purpurea, Centaurea cyanus,* lychnis and columbine were raised in various colours single and double. *Anemone hepatica* and *A. coronaria* from the Balkans, both variable in the wild, were also grown in several colours. Pink and red forms of *Convallaria majalis* were obtained, and double varieties of primrose. By the year 1600, more than sixty varieties of dianthus were available ; and *Viola tricolor* had attained to a standard which was scarcely improved upon until the beginning of the nineteenth century. Efforts were even made to derive a garden plant from that unpromising and persistent weed *Plantago major*.

Still greater interest was shown in foreign plants. The oriental hyacinth (*Hyacinthus orientalis*), brought from Constantinople to de l'Écluse at Vienna, was quickly developed, and by 1580 a number of varieties were listed in Holland ; a double variety is figured in 1613 ; and a few years later, sixty-nine kinds are mentioned by Caspar Bauhin. The popular crown imperial (*Fritillaria imperialis*), already a

cultivated plant for many years in Turkey, was another of de l'Ecluse's successful introductions. He also imported species of narcissus and experimented with native kinds ; soon varieties were produced which ranged in colour from bright yellow to deep orange. The ranunculus, anemone, iris and tulip also owed much to his labours and enthusiasm. The latter flower had a vogue in the early part of the seventeenth century which led to the celebrated " Tulipomania "—a melodramatic episode which cannot be discussed here.[1] Many of the introductions from Constantinople were presumably made through the agency of Venetian merchants on behalf of wealthy patrons of horticulture, often flower-loving ladies, at Vienna. This seems evident from de l'Écluse's text ; for instance, the label accompanying one of his plants reads : " Tusai [crown imperial], fior Persiano rosso o discolorito, con la testa abasso". The flowers seem to have been sent at the instigation of Austrian diplomats at Constantinople who presumably used the best commercial channels.

This passion for the cultivation of garden plants—the pursuit, in other words, of the *beautiful* rather than the *useful*—was soon felt in all those countries where the herbal had flourished. Throughout Europe, the fenced medieval garden, with its emphasis on herbs and vegetables, was giving place to the formal Renaissance garden having intricate parterres, bright with lilies, amaranthus, hollyhocks, marigolds, peonies, carnations, gladioli and crown imperials. In France, where the chief patrons of the new cult were the King and the court, royal gardens had sprung up at Fontainebleau, at Chambord, at the Louvre ; at Alençon, Marguerite, sister of François I, had replanned the parterres ; Cardinal du Bellay at the Abbaye de Saint-Maure, and Cardinal de Lorraine at the Château de Meudon, had found solace in retirement by laying out the grounds in conformity with the taste of the day. From the New World now came the giant sunflower, marvel of Peru, tobacco plant, evening primrose, Michaelmas daisy, nasturtium, *Lobelia cardinalis* and " African " marigold to swell the native flora already enriched by choice plants from southern Europe and the Near East. The natural corollary of this growing enthusiasm was the demand created by wealthy amateurs for sumptuous picture-books in which their favourite flowers would be presented with all the technical brilliance which the artists of the high Renaissance had at their command. Painters—and, as we shall see later, etchers and

[1]See Blunt, W., *Tulipomania* (King Penguin, 1950).

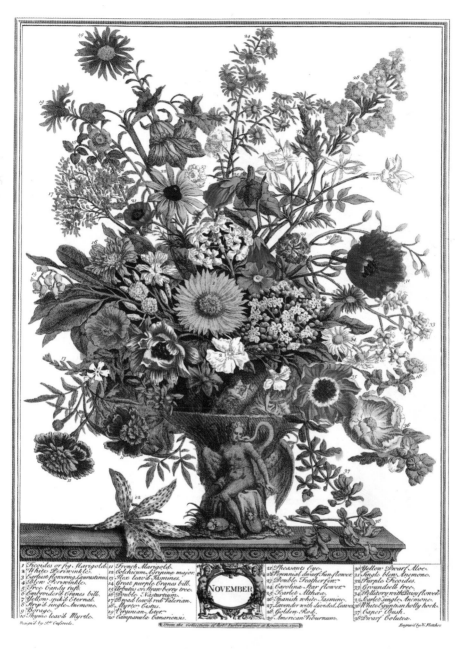

Plate A 'NOVEMBER'
Hand-coloured engraving by H. Fletcher after a painting by Pieter Casteels;
from R. Furber, *Twelve Months of Flowers*, 1730

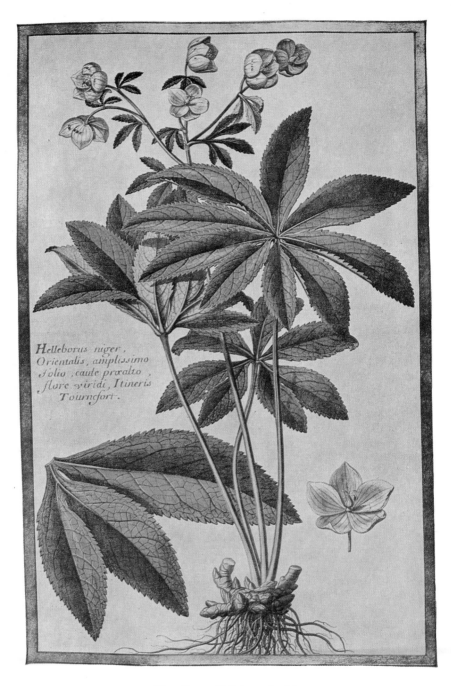

Helleborus niger,
Orientalis, amplissimo
folio, caule proalto,
flore viridi, Itineris
Tournefort.

Plate B Helleborus kochii
Water-colour drawing by Claude Aubriet (1665–1742)

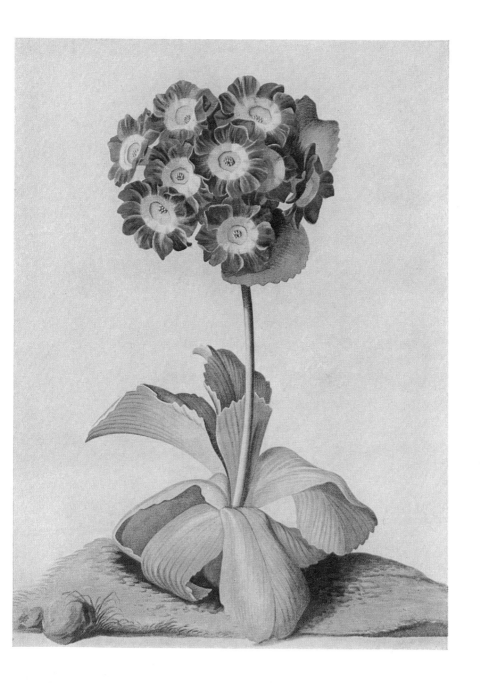

Plate C Auricula 'Duke of Cumberland'
Water-colour drawing by Georg Dionysius Ehret, 1740

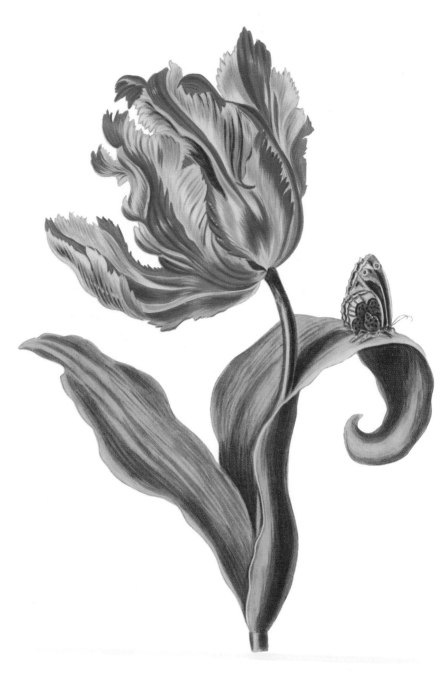

Plate D PARROT TULIP
Hand-coloured engraving by A. L. Wirsing;
from C. J. Trew, *Hortus Nitidissimis* . . . , 1750–86

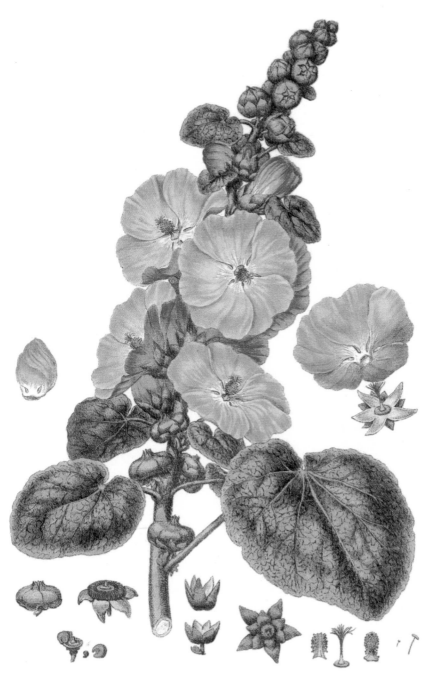

Plate E Hollyhock (*Monadelphia polyandria* [*Alcea*])
Hand-coloured engraving by John Miller;
from *Illustratio Systematis Sexualis Linnaei*, 1777

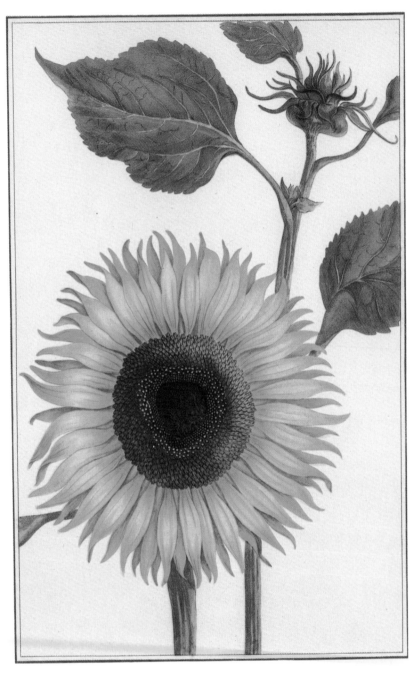

Plate F SUNFLOWER
Hand-coloured engraving by De Sève; from *Recueil de Vingt Quatre Plantes et Fleurs*, c. 1773

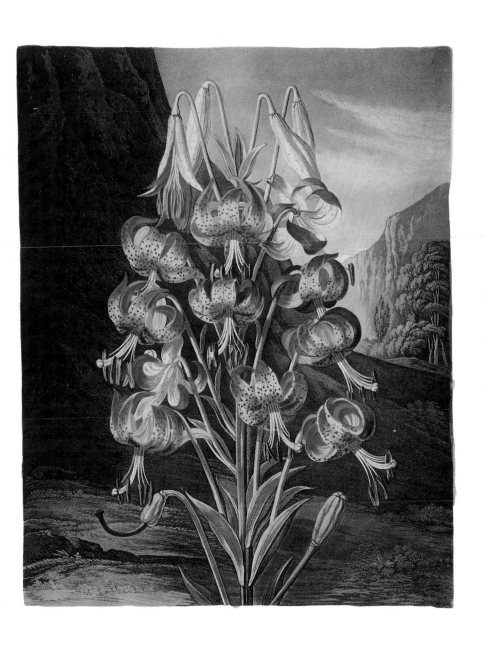

Plate G THE SUPERB LILY (*Lilium superbum*)
Mezzotint by Earlom after a painting by P. Reinagle; from R.
Thornton, *Temple of Flora*, 1799–1807

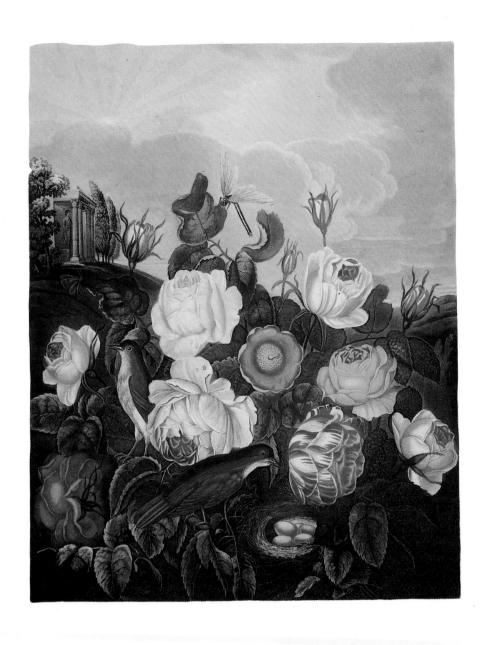

Plate H ROSES
Mezzotint by Earlom after a painting by R. Thornton; from R.
Thornton, *Temple of Flora*, 1799–1807

Plate I Althaea frutex
Hand-coloured etching by J. Edwards;
from *A Collection of Flowers drawn after Nature,* 1801

Plate J BOUQUET OF DIGITALIS, CLEMATIS, PANSIES, MARIGOLDS,
PEONY, POPPIES AND THREE-COLOURED BINDWEED
Stipple engraving by L. C. Ruotte after a painting by J. L. Prévost;
from J. L. Prévost, *Collection des Fleurs et des Fruits . . .* , 1805

Plate K 'AMARYLLIS BRASILIENSIS' (*Hippeastrum* sp.)
Stipple engraving by Bessin after a painting by P. J. Redouté;
from P. J. Redouté, *Les Liliacées*, 1816

Plate L *Rosa centifolia Bullata*
Stipple engraving by Langlois after a painting by P. J. Redouté;
from P. J. Redouté, *Les Roses*, 1817–24

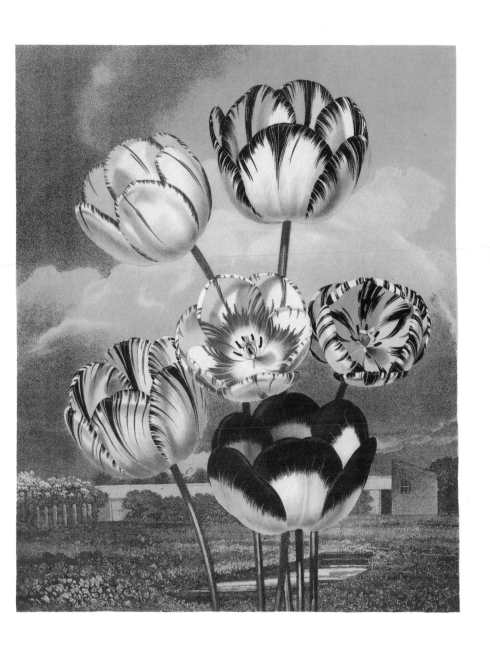

Plate M TULIPS
Aquatint and stipple engraving by J. Hopwood and F. C. Lewis after a
painting by T. Baxter; from S. Curtis, *The Beauties of Flora*, 1806–20

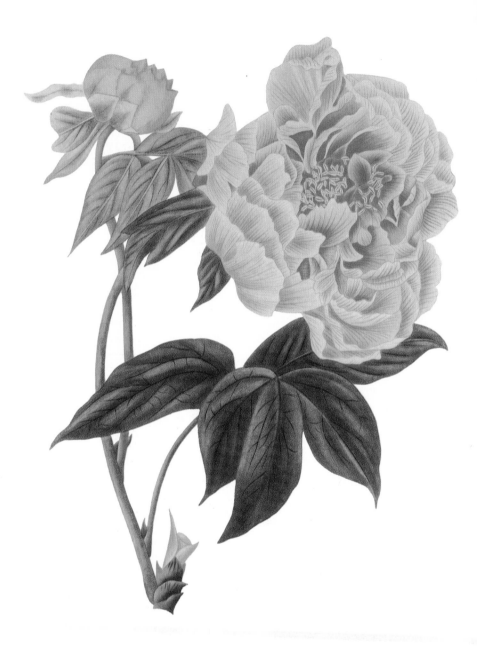

Plate N CHINESE TREE PEONY
Hand-coloured aquatint by Miss Smith [of Adwick Hall];
from *Studies of Flowers from Nature*, 1820

Plate O Epidendrum vitellinum
Hand-coloured lithograph by M. Gauci after a painting by Miss Drake;
from J. Bateman, *Orchidaceae of Mexico and Guatemala*, 1837–41

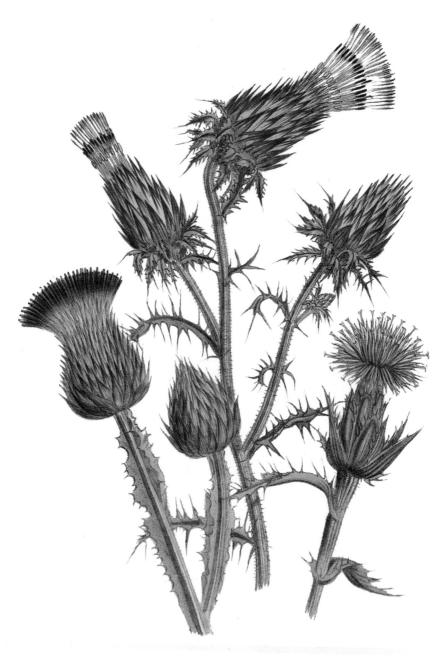

Plate P THISTLES
Hand-tinted lithograph after a painting by Mrs. Jane Webb Loudon;
from *The Ladies' Flower-Garden of Ornamental Perennials*, 1843–44

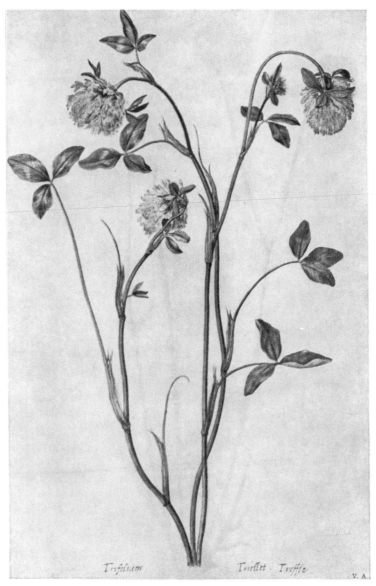

Trifolium Trueflet · Truffle

V. A.

Plate 7 RED CLOVER (*Trifolium pratense*)
Water-colour drawing by Le Moyne de Morgues, *c.* 1570
Victoria and Albert Museum, London

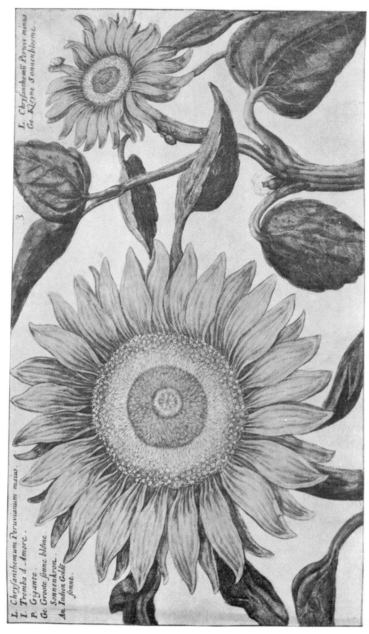

Plate 8 SUNFLOWERS (*Helianthus annuus*). Hand-coloured engraving by Crispin de Passe from his *Hortus Floridus*, 1614

engravers—soon came forward to supply the needs of such patrons in France, Flanders and north Germany.

At the same time, stimulated by the foundation of botanic gardens at Pisa (1543), Padua (1545), Florence (1545), and Bologna (1567), Italian artists were again producing paintings of definitely scientific character. In Austria and southern Germany yet others, deriving their inspiration from the illuminated manuscripts of the Bruges-Ghent School, decorated the pages of missals with studies of individual plants. In the present chapter we shall consider the work of those painters of the second half of the sixteenth century who were not primarily concerned with making drawings for the printed book.

Among the important centres of botanical art at this time must be counted the courts of the Bavarian Wittelsbachs and Austrian Hapsburgs, especially those of the Archduke Ferdinand of Tirol, of his brother-in-law, Albrecht V, Duke of Bavaria, and of his nephew the Emperor Rudolf II, patrons of science and the arts and the greatest collectors of their age; and among the artists whom they employed was Georg Hoefnagel, one of the most accomplished miniaturists of his day.

Before discussing Hoefnagel's work, mention may be made of a large collection of drawings at Erlangen University (MS. 2362) entitled *Magnarum Medicine Partium Herbariae et Zoographiae Imagines*, compiled in Nuremberg in 1553 by Georg Delinger and Samuel Quicchelberg. The former of these was a chemist, the latter at one time Curator of Albrecht V's museum. This big folio contains many fine and decorative paintings of plants by Delinger, Quicchelberg and other Nuremberg artists. In the eighteenth century, the volume came into the possession of the famous Dr. Trew, who wrote of the flower-paintings which it contains: "Many, we must admit, are not very naturalistic; but with the majority there is no fault to find. The work deserves respect, for the collection, which testifies to great industry, was made before the days of Gesner."

Georg (Joris) Hoefnagel (1542-1600) was the son of a wealthy Antwerp diamond merchant. As a young man he studied under Jan Bol, and travelled in connection with his father's business, visiting France, Spain, and England (where he is said to have painted the *Wedding feast in Bermondsey*, now at Hatfield House). Painting, indeed, soon occupied his whole attention, and his father allowed him to leave

Table showing some of the descendants of
Maximilian I, Holy Roman Emperor

the family business. The sack of Antwerp by the Spaniards in 1576
left his father (whose politics were suspect) almost penniless, and Georg
set out from the ruins of his native city to seek his fortune elsewhere.
With his travelling companion the great geographer Ortelius, for
whom he made many topographical drawings, he visited Germany
and Italy, chance taking him to Venice in time to be a spectator of
the destruction of the Ducal Palace by fire in 1577. In Rome he studied
the work of the octogenarian miniature painter Giulio Clovio,
which profoundly impressed him and had an important influence on
his development.

At Augsburg the two travellers had lodged with the Fuggers, who
had already shown Hoefnagel's work to Albrecht V, Duke of Bavaria;

the painter now returned to Munich to enter the latter's service, making for him a beautiful illuminated book of prayers (see Pl. XIIa, p. 65). For the Archduke Ferdinand of Tirol, a nephew of the Emperor Charles V, Hoefnagel next created what is probably his chef d'œuvre —the immense *Missale Romanum* which occupied him from 1582 to 1590. This bulky folio—it is no less than seven inches thick—was placed in the Archduke's magnificent collection of curios at Schloss Ambras,[1] and is now in Vienna. Hoefnagel's fame soon reached the ear of the Emperor Rudolf II, who summoned him to Prague to work for his Cabinet in the Hradčany Palace. Either here, or in Vienna, were painted the wonderful *Four Kingdoms of Living Creatures* and the border decorations to the *Schriftmusterbuch*, or " Writing Copybook," of Georg Bocskay (written in 1572, illuminated 1591-94).

Hoefnagel was an artist of wide interests and very great ability. A passionate student of Nature, he lived up to the motto which he chose for himself : *Natura Sola Magistra*. In his splendid manuscripts he perpetuated the traditions of the Flemish miniaturists of the opening years of the sixteenth century. But no longer are the flowers set formally within rigid borders : Hoefnagel strews them casually, though still rather rigidly, upon the white vellum margins and treats them with a naturalism to which even Bourdichon himself never aspired, though, like the Frenchman, he occasionally takes liberties with the colours. His industry must have been immense : the *Four Kingdoms* contains no less than 1339 miniatures of animals and fishes ; the *Missale Romanum*, which is now in Vienna, over 1200 pages with 500 miniatures and 100 illuminated borders. That his influence long continued to be felt, or at any rate enjoyed a revival, is attested by a fine Prayer Book, illuminated about the year 1700 by an unknown artist and now in Florence (see Pl. XIIb, p. 65).

Of particular interest are the representations in Hoefnagel's manuscripts of Mexican and Peruvian plants, many of which are seen for the first time in his borders. The lesser nasturtium (*Tropaeolum minus*) and tobacco plant (*Nicotiana tabacum*) are finely painted; so also is *Tradescantia virginiana*, a plant not shown elsewhere until Parkinson's day (1629) and not, as the *Dictionary of National Biography* patriotically asserts, first introduced into Europe by the elder Tradescant. Hoefnagel

[1]A full account of the Archduke's collection will be found in *Die Kunst- und Wunderkammern der Spätrenaissance* by Julius von Schlosser. It is interesting to note that it contains a fine Chinese scroll-painting of flowers.

gives us, too, what is probably the earliest figure of the marvel of Peru (*Mirabilis jalapa*), a flower which was to have great vogue in Europe in the seventeenth century, and of *Ipomoea purpurea*. To him also is attributed the first picture of the dodo.

In 1592, at the age of seventeen, Jacob Hoefnagel, Georg's son, published a book of engravings entitled *Archetypa Studiaque Patris G. Hoefnaglii*. The fifty-two plates show flowers, insects and other animals distributed at random upon the page and very delicately engraved. Most of the plants are taken from the margins of the *Missale Romanum*.

Another botanical artist who, like Georg Hoefnagel, worked for Rudolf II, was Daniel Fröschel (*d.* 1613), but he remains a very misty figure. Almost equally little is known of Hans Hoffman (*d. c.* 1591), who made copies of some of Dürer's flower drawings, and by whom there exists at Bamberg an apparently original study of peonies, dated 1582.

The work of Ligozzi, and a fine Venetian herbal—Pietro Michiel's *I Cinque Libri di Piante* (St. Mark's Library ; It. ; 1126-30)—show that Northern Italy at this time can well hold her own in the field of European botanical illustration.

Michiel (1510-66), a Venetian patrician, was for a time in charge of the Botanical Gardens at Padua ; in 1555 he returned to Venice where he cultivated his garden which contained many Levantine plants. Among his numerous introductions into Italy may be mentioned the white form of the oleander. Of the artist, Domenico dalle Greche, who produced the majority of the thousand paintings which illustrate these five noble volumes, nothing seems to be known. His " Spatola phetida " (*Iris foetidissima*) is remarkable for the beauty of its study of a seed-pod ; and his *Tulipa sylvestris* and *T. praecox* must be among the earliest known drawings of tulips. Some of the pages are rather crude, but amusingly enlivened by the introduction of birds, insects, and naïve little landscapes ; others are almost as good as those in Rinio's

PLATE XIIIa
ANEMONE (*Anemone coronaria*). Water-colour drawing by Giacomo Ligozzi (1547-1626). Uffizi, Florence

PLATE XIIIb
LADY ORCHID (*Orchis purpurea*). Water-colour drawing by Pietro Michiel, *c.* 1570, *I Cinque Libri di Piante*. St. Mark's Library, Venice

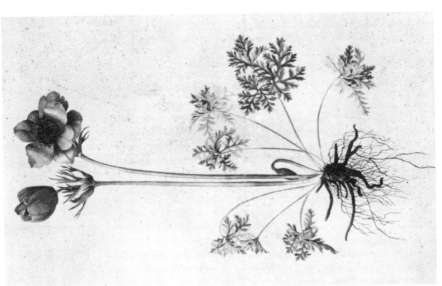

Plate XIII a

b

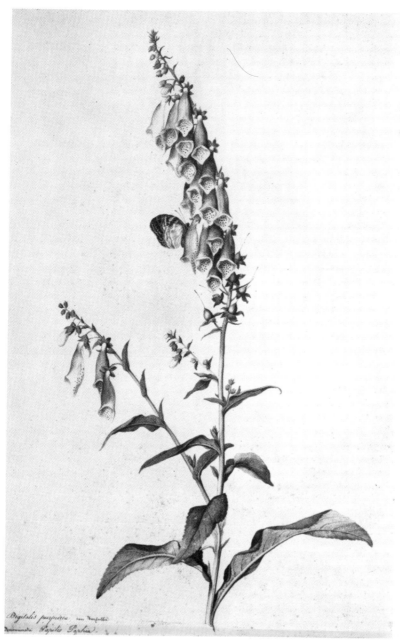

Digitalis purpurea im Vrefathi
Papiles Parhia

Plate XIV FOXGLOVE (*Digitalis purpurea*)
Water-colour drawing by Giacomo Ligozzi, 1568. Uffizi, Florence

herbal, and more forceful in treatment. The study of *Orchis purpurea* (see Pl. XIIIb, p. 80) is vigorously drawn, but the form and growth of the flowers are not properly understood.

The Veronese artist Giacomo Ligozzi (*c.* 1547-1626), who became court painter in Florence to the Grand Duke of Tuscany and others of the Medici princes, was well known in his day for his work in oils and tempera. But of far greater interest and originality are his brilliant water-colour drawings of plants and fish, many of which are preserved in the Uffizi Gallery (of which he was Superintendent) and in the University Library at Bologna. His contemporary, Aldrovandi, who founded the Natural History Museum at Bologna, describes him as " a most excellent artist who has no other care day or night but to paint plants and animals of every kind." An exhibition of his natural history paintings was held at the Uffizi in 1924, and an account of it may be found in *Dedalo* of that year. His study of a foxglove (see Pl. XIV, p. 81) made in 1568, is a most careful piece of observation, and so modern in feeling that it could well have served for a plate in Curtis's *Flora Londinensis* ; a branch of figs, with exotic birds, recalls the work of Audubon ; and the red valerian (*Kentranthus ruber*) shows a wonderful appreciation of the habit of the plant. A smaller drawing, of an anemone, is reproduced on Plate XIIIa (p. 80).

Among the other natural history artists associated with Giacomo Ligozzi and the Medici courts were his son Francesco ; the animal painter Lorenzo Benini ; Cornelio Svinto (Suintus) who specialised in birds ; and Giacomo's pupil Andrea Budino.

The florilegium in France and Flanders did not develop extensively until the advent of metal-engraving ; but the flower paintings of Jacques Le Moyne de Morgues, though some of them were utilised for a printed flower-book, may perhaps be mentioned here. Le Moyne, who was born at Dieppe, came of the Calvinistic branch of a good French family. As artist and cartographer, he accompanied Laudonnière upon the expedition made in 1564 to relieve the French colonists in Florida. His instructions were " to map the sea coast, and lay down the position of towns, the depth and course of rivers, and the harbours ; and to represent also the dwellings of the natives, and whatever in the province might seem worthy of observation". In the celebrated *Collectiones*, published by Theodor de Bry and illustrated with his own engravings after drawings by Le Moyne, the latter describes the

horrors of the treacherous attack made by the Spaniards upon Fort Carolina, the subsequent brutal slaughter, and his terrible journey through swamps to the relative security of Hawkins's " ill-manned and ill-provisioned " ship. Returning to France, Le Moyne was soon obliged to fly from the yet more horrible massacre of St. Bartholomew. England welcomed him : Raleigh, ever the friend of the Huguenots, provided him with lodgings in Blackfriars and took him into his service ; the Sidneys earned his gratitude, and to Lady Mary Sidney, the mother of Philip, he dedicated his *Clef des Champs* in affectionate

terms. Le Moyne died in 1588, the year which also witnessed the deaths of Sir Philip Sidney and both Sidney's parents.

La Clef des Champs was published in Blackfriars in 1586. It was designed, its author tells us, to be of service to those who " *ayment et désirent d'apprendre choses bonnes et honnêstres* " — namely, painting, sculpture, goldwork, embroidery and tapestry. It contains about a hundred little woodcuts, square in shape and decoratively treated, grouped two together upon a page (see Fig. 38). A few are of birds and other animals, but the majority portray fruit and flowers.

FIG. 38—'Blew Bottles' (Cornflower, *Centaurea cyanus*). Woodcut by Le Moyne de Morgues from his *La Clef des Champs*, 1586

Twenty-five years ago, the attention of Mr. Spencer Savage, Librarian of the Linnean Society, was drawn to a book of water-colour drawings of flowers and fruit, exhibited at the Victoria and Albert Museum as a choice example of early binding. One of the drawings he found to be signed " demorogues " (i.e. de Morgues) ; but internal evidence left no doubt that these delightful works were from the hand of Le Moyne, a number of them having been used in making the illustrations to his *Clef des Champs*. The drawings, which have now been removed from their binding and mounted separately, rank among the most charming flower studies which have survived from the sixteenth century, though from the botanical point of view they are sometimes far from faultless. They are so obviously a labour of love.

To place one of them beside a brilliant show-piece by Ehret, is like confronting the soulless acres of a giant Rubens with some lovingly wrought little Flemish Primitive. By comparing Le Moyne's delicate, sensitive studies with the relatively crude woodcuts in his printed book, we can appreciate our good fortune that some, at any rate, of the original drawings for early herbals and florilegia have escaped destruction.

Many of the fruit paintings are particularly successful. Among those of flowers may be mentioned the daffodil, snowdrop, violet, lily of the valley, daisy, marigold, foxglove, periwinkle, scabious, poppy, clover (see Pl. 7, p. 76), lavender, stock, iris and rose. The flowers represented give no clue as to whether the drawings were made in France or England. But Mr. Savage observes that the watermark of the paper is the same as that used in Paris and Arras in 1568. Moreover, another and similar florilegium in a private collection in England, which was made in France between 1570 and 1574, contains a misunderstood copy of one of Le Moyne's figures. We can therefore be fairly certain that the Victoria and Albert drawings were made in France before the flight of Le Moyne in 1572.[1]

Contemporary with the work of Le Moyne is a small group of botanical drawings made by John White (or With) in Virginia in 1585 and 1586. Acting under instructions from Raleigh, one hundred and eight men were landed by Grenville on Roanoke Island, off what is now N. Carolina; among them, in the capacity of artist and cartographer, was White. They remained on the island until June of the following year, when they were thankfully carried back to England by Drake's fleet. White was placed in charge of a second expedition to Roanoke Island in 1587. Returning home once more for supplies, he was prevented by the Spanish wars from sailing west again until 1590. He arrived to find that the whole colony had perished, among them his daughter, and his grandchild Virginia Dare—the first English child born in the New World. Thus ended Raleigh's calamitous attempts to effect the permanent colonisation of Virginia. White himself retired to Raleigh's estates in Munster, and was last heard of there in 1593.

A number of White's drawings, some of which were used by de Bry in the first part of his *Grands Voyages*, are in the Print Room of the British Museum. Among the botanical studies are what must almost

[1]For Le Moyne de Morgues see also p. xxxii.

certainly be the first figure of the banana; a gentian (*Sabbatia gracilis*); and an *Asclepias* species, entitled "wysauke," which served Gerard for the woodcut that he calls "wisanck." These drawings were considerably damaged in a fire at Sotheby's in 1865.

But interesting, and often attractive, as is the work of the artists discussed in this chapter, only that of Ligozzi is of a quality to stand comparison with the great collection of paintings made for de l'Écluse by van der Borcht and the other unknown draughtsmen who were associated with him.

[1]White's botanical drawings are reproduced in colour in Stefan Lorant, *The New World*: New York, 1946.

CHAPTER 8

THE EARLY ETCHERS AND METAL ENGRAVERS

HE DECLINE of the botanical woodcut, gradual enough at first, rapidly accelerated when metal plates began to be employed for the making of flower-books.

In wood-engraving, as we have already seen, the raised portion of the block receives the ink while the parts which are cut away escape contact with the roller ; in the two forms of metal-engraving now under consideration—line-engraving and etching—it is the *intaglio* or sunk parts of the plate which print, the surface being wiped clean.

Both line-engraving and etching had many years of history behind them when they were first harnessed to the service of botanical illustration : line-engraving, developed in Italy and Germany during the fifteenth century, had already attained technical perfection in the hands of Schongauer and Dürer a century earlier ; etching, invented about the year 1500, was to find its greatest exponent in Rembrandt in the middle of the seventeenth century. The two processes, though often employed upon the same plate, are quite distinct and must be separately described.

In line-engraving, the most important tool is the burin—a steel bar tapering to a lozenge shape at the cutting end and having a wooden handle formed like a mushroom with one side cut away. The burin acts as a plough—turning up a shaving of metal which is brushed away, and leaving a furrow in the copper ; it is unique, however, among the instruments used by the artist in that it is *pushed* instead of being pulled. Considerable practise is needed to overcome the manual difficulty that this involves, and even in the most skilful hands the

burin line has a certain austerity which is at once its strength and its danger.

In etching (from the German *ätzen*, to eat or corrode), on the other hand, the engraving is done by acid which *eats* into the copper. Upon a metal plate protected on both sides by a thin layer of acid-

FIG. 39—Cyclamen. Playing card ; engraved on metal by the Meister der Spielkarten, *c.* 1445

resisting varnish, the drawing is made with a needle which, since it merely removes the varnish, can be used as freely as a pencil. The plate is then immersed in a bath of dilute nitric acid which " bites " the lines, various devices being employed to control their depth. Finally, the varnish is removed with turpentine.

Both etched and burin-engraved plates are printed in the same way ; indeed, the two processes are not infrequently used on the same

plate. Printing ink is forced into the lines with a heavy dauber, and then removed from the surface with a pad of muslin or the palm of the hand. The plate is now laid face upwards upon the bed of a roller press, and a piece of paper placed in contact with it ; then both are passed between the rollers, blankets providing the necessary resilience, and the paper forced into the inked lines. On removing the paper from the plate, the lines will be seen to stand out in relief on the print ; this gives a richness of tone which is unobtainable with the wood-block.

Engraved metal plates, we can now appreciate, require a separate and more laborious form of printing than the accompanying text.

This added considerably to the cost of production of botanical books, a disadvantage which did not, however, deter the wealthy amateurs who ordered and paid for them. Such plates, moreover, can never form so integral a part of a book as the humbler wood-cut; but this loss of unity was largely compensated for by the additional precision and detail which the copper plate made possible.

FIG. 40—Tulips. Engraving from Camerarius, *Symbolorum . . . Centuria*, 1590

The earliest metal engravings of flowers appear to be those found upon playing cards made about 1440-50 by the Meister der Spielkarten and other German artists. These curious prints (see Fig. 39) are of particular interest in that they precede even the first known botanical woodcuts. Almost a century and a half elapses before the publication of a small book of emblems by J. Camerarius the Younger, which contains about a hundred attractive little etched roundels of plants set against landscape backgrounds (see Fig. 40). The book bears the date 1590 upon the title page, though the preface is dated 1593. Adrian Collaert's *Florilegium*, which is undated, appeared about the same time.

The first strictly botanical book with intaglio prints from metal plates—Fabio Colonna's *Phytobasanos* (Plant Touchstone)—must be mentioned here, though from its subject-matter it deserves to be

placed among the herbals. Fabio Colonna (Fabius Columna), the son of a wealthy and distinguished amateur of literature and the arts, was born at Naples in 1567. By profession a lawyer, Fabio was a man of many interests. A mere chance turned his steps in the direction of botany : finding conventional treatment of no avail for the epilepsy from which he suffered, he looked to Dioscorides for aid, and at last identified as valerian the herb which the Greek recommended. The cure proved successful, though it has been plausibly suggested that exercise, fresh air, and the distractions of botanizing were more responsible for his recovery than the drug itself.

Phytobasanos, the by-product of Fabio's study of ancient botany, was published in Naples in 1592. The work set out to improve the knowledge of the plants listed by Dioscorides and other classical authors ; it was followed in 1606 by the first part of another work, *Ekphrasis* (Exposition), completed in 1616 and published in Rome. Fabio's writings, says Johnson in his preface to Gerard's *Herball*, show him to be " a man of an exquisit judgment."

In discussing the illustrations, the two works may be considered together, for the plates of 1616 show no appreciable advance upon those made for the *Phytobasanos* in 1592. They are executed in pure etching, with no support from the burin ; small and unpretentious though they are, they have considerable charm, and the informality that is characteristic of that medium. Moreover, they are botanically accurate, with separate details of flowers and fruit frequently shown. Very little shading is used. The etchings are set within heavy borders which are printed with the type, an unconventional device which is not wholly satisfactory. The original drawings for these works came to light in Naples during the nineteenth century ; it is believed that Colonna made them himself, and was his own engraver. If the portrait of him at the beginning of the *Ekphrasis* is his own work, as seems probable, he must have been an artist of considerable skill. Fig. 41 shows the engraving of " Malinathalla " (*Cyperus esculentus*) from the *Phytobasanos*.

The first important florilegium, *Le Jardin du très Chrestien Henry IV*, published in 1608, is a work of great beauty ; it is all the more surprising, therefore, that it appears to have met with little or no recognition in modern times. That contemporary critics thought highly of it is a known fact, and is further testified, as we shall see later, by the unacknowledged use that was made of the plates by other artists.

The author, Pierre Vallet, styles himself *brodeur ordinaire* to the

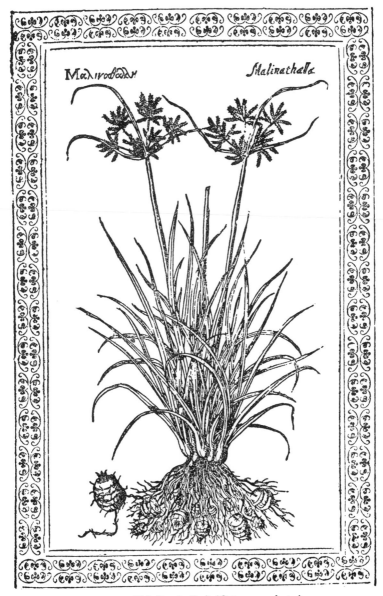

FIG. 41—'Malinathalla' (*Cyperus esculentus*)
Etching with woodcut border by Colonna from his *Phytobasanos*, 1592

king, and was also employed in he royal gardens. Born at Orléans about the year 1575, he came in due course to the capital where he executed many engravings, the most celebrated being his illustrations to the love story of Theagenes and Chariclea. Here he received court appointment, and made the acquaintance of Gerard's friend "that excellent herbarist, that painful and most curious searcher of plants and simples," Jean Robin, who directed the Royal Gardens of the Louvre which Henri IV had laid out about the year 1590.

Marie de Médicis, consort of Henri IV, had a passion for flowers. Van Mander relates that when the States General of the Netherlands wished to make her a gift, they bought and presented to her a little flower-piece by Jacob de Gheyn. She found pleasure in the rarities which were cultivated by Robin in his little garden at the western end of the Ile de la Cité. She set the fashion, soon followed by the ladies of the court, for embroidery with floral designs; and Vallet's florilegium, which was dedicated to her, was primarily intended to serve as a pattern-book. In view of the purpose for which the plates were made, it is curious to find that they are treated with complete naturalism and botanical accuracy.

Vallet appears to have been both the draughtsman and the engraver of his book. In a fulsome preface, he is declared to be the equal not only of the greatest Greek and Roman craftsmen, but of Nature herself:

> *Tout ce que Nature peut faire,*
> *Vallet le faict avec la main,*
> *L'artifice Grec ou Romain*
> *Ne le scauroit mieux contrefaire*

There is also reference to his embroidery work, and to his painting on vellum:

> *Soit qu'en soye ou en or tu traces des portraits,*
> *On croit que la Nature et non l'art les ait faicts,*
> *Soit que sur du velin ton craion vueille faire*
> *Quelque artiste dessein, loüable tu te rends,*
> *Tu es né un soleil, et élu à portraire,*
> *De quoy contenter l'oeil et le désir des grands.*

The words in roman type form an anagram of *Pierre Vallet Orléanois.*

The plates of *Le Jardin* (see Pl. XVa, p. 96), of which there are seventy-five, include some of plants brought by Jean Robin the Younger from a botanizing expedition in 1603 to Spain and the islands off the coast of Guinea. They are executed with the needle, occasionally supplemented by the burin, but the most successful plates are in pure etching ; the use of small dots to produce gradations of tone is particularly effective.

The *Florilegium Novum* (1611) of Johann Theodor de Bry (1562-1620) contains many well engraved plates, and it is obvious from his portrait of Caspar Bauhin, which serves as a frontispiece to the *Theatrum Anatomicum* (1605), that we are dealing with a highly skilled craftsman. But I have nowhere seen it mentioned that a number of the line-engravings in the *Florilegium Novum* are directly copied from Vallet's etchings (and consequently appear reversed). A comparison of the two shows, I believe, that the quality of the original etchings is not improved upon in the engravings, admirable though the latter frequently are. An enlarged edition of de Bry's work was produced by his son-in-law Matthew Merian in 1641 and entitled *Florilegium Renovatum* ; many of the additional plates are derivative. De Bry was the son of the better known Theodor de Bry and nephew of Johann Israel de Bry, joint illustrators of the *Collectiones* (1590-1634).

In 1612, Emanuel Sweert (*b.* 1552) published a florilegium at Frankfurt-am-Main. Sweert, who was a Dutch florist, was at one time employed by the Emperor Rudolf II as Præfectus of his gardens. It is not known whether he himself was the artist, or merely the editor, of this ornate book, which was produced at the instigation of his royal master. The work was at the same time a picture-book of plants and a sale catalogue, for although no information was given as to the prices of the plants, the reader was informed that they could be purchased during the Frankfurt Fair at the author's shop opposite the Römer, and subsequently in Amsterdam. The plates are mostly of poor quality, especially those of the second section. It is hard to understand why Garidel, writing at the beginning of the eighteenth century, should describe them as " among the most exact and faithful that exist, if we exclude a few drawn by a less skilful hand." In spite of the author's assurance on the title-page that the plants are " drawn from life," many are directly imitated from de Bry. Sweert's " Martagon pomponii præcox multiflorum," for instance, is a reversed copy of de Bry's " Lilium Rubrum præcox," which is in its turn a reversed copy

of Vallet's "Martagum Pomponeum." Vallet's rather ingenuous arrangement of the flower-buds on the left had already been modified by de Bry, and the drawing now deteriorates under the incompetent hand of Sweert or his engraver. It is, incidentally, of some importance to bear in mind, when engraved work is under consideration, that the engraver can do much towards spoiling a good drawing, and almost as much towards improving upon an inferior one ; the three bulbs of lilies, shown in Fig. 42, are engraved by artists of varying degrees of incompetence from drawings which were presumably of very similar quality.

Another fine work which, like that of Vallet, has been strangely neglected, is the *Specimen Historiae Plantarum* of Paul Reneaulme

FIG. 42—Lily bulbs showing the technique
of three different engravers ; from Sweert, *Florilegium*, 1612

(Renealmus) (1560-1624), published in Paris in 1611. The author, a native of Blois, is mainly remembered for his irascibility. He was in advance of his time ; but his work, which was intended to be provocative, created no stir. Arber, while allowing that the engravings are good, regrets that their effectiveness is marred by the transparency of the paper. The book, admittedly, is not calculated to attract a casual observer : a slim octavo volume with but twenty-five plates, claiming little attention as it stands in the library shelves. Its etchings, however, are of the highest quality—exquisitely sensitive and extremely personal in treatment. They are assuredly the work, not only of a great lover of nature, but of a great master of the etcher's craft. It would be as impertinent to attempt to colour them as it would be to apply a water-colour wash to the etchings of Rembrandt. If

Reneaulme's work has any forerunner, we may find it perhaps in the little etchings of Colonna, though the latter appear sadly amateur in such company. Our reproduction (Pl. XVb, p. 96) shows his etching of a dianthus ; and Fig. 43 gives an enlarged detail of that of the fritillary (*Fritillaria meleagris*) which, curiously enough, is technically reminiscent of the work of Aubrey Beardsley. The first plate, of oak leaves, is not original, being derived from d'Aléchamps's *Histoire des Plantes* and C. Bauhin's *Phytopinax*.

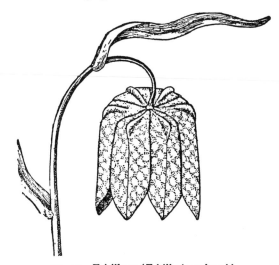

FIG. 43—Fritillary (*Fritillaria meleagris*)
Enlarged detail of etching from Reneaulme's *Specimen Historia Plantarum.* 1611

Another set of engraved plates (see Fig. 44) was made in France, somewhere about the year 1600, from drawings by Pierre Richer de Belleval (*c.* 1558-1632), founder in 1593 of the Montpellier botanic garden. Belleval used to wander through Provence and Dauphiné in search of plants, " now with the pen, now with the pencil in hand, seeing and examining everything for himself, climbing the steepest summits . . . describing and drawing the new plants that he gathered in these remote and lonely places " (Gilibert). From these drawings, some five hundred plates were etched and engraved under his direction. Had they been published during his lifetime, they would have been a most important contribution to the study of the European flora ; to-day they would probably be almost unknown but for Gilibert, who

2.S. FRITILLARIA ωλατυφυλλανϑομήλινος

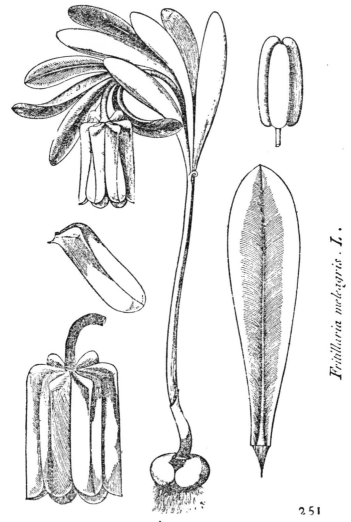

251

FIG. 44—'Fritillaria πλατυψυλλανθομήλινος' (*Fritillaria delphinensis* var. *moggridgei*)
Engraving after a drawing by Pierre Richer de Belleval, *c.* 1600

made use of some of them to illustrate his edition (1787) of Rozier and
Clarette de la Tourette's *Démonstrations Élémentaires de Botanique* and

his own *Exercitia Phytologica* (1792). Belleval's plates are small, stiff and formal ; at times rather quaint, but good likenesses on the whole of the species. They can be recognised by his peculiar system of nomenclature in which a Latin generic name is followed by a Greek specific epithet.

The two immense volumes of Besler's *Hortus Eystettensis*—described by Sir Thomas Browne as the " massiest " of herbals, and, according to Arthur Harry Church, requiring a wheelbarrow to take them about —were published at Eichstätt (about forty miles south of Nuremberg) in 1613. Basil Besler (1561-1629) was a Nuremberg apothecary who, Johnson tells us in his preface to Gerard's *Herball*, " set forth the garden of the Bishop of Eystet in Bavaria, the figures being very large, and all curiously cut in brasse, and printed upon the largest paper . . .". The author was fortunate in his patron, Johann Konrad von Gemmingen, from 1595 to 1612 Prince Bishop of Eichstätt. Bishop Konrad was a keen lover of flowers ; he placed Besler in charge of the gardens surrounding his residence on the Wilibaldsburg of Eichstätt, encouraged him in his project, and laid out three thousand florins to cover the cost of the book. Dr. Hieronymus Besler, the author's younger brother, put his knowledge of Latin at Basil's disposal and helped him with the prefaces.

Besler tells us that he worked intermittently for sixteen years on the drawings, though the major part of the engraving seems to have been done between 1610 and 1612. At least six engravers, of whom the most important was Wolfgang Kilian (1581-1662) of Augsburg, collaborated in making the 374 plates, upon which are portrayed more than a thousand flowers representing, according to Schwertschlager, 667 species. These are arranged by seasons, and separate botanical details are not shown. Though the quality of the burin work is coarse and mechanical throughout, this defect is much redeemed by the splendidly decorative arrangement and treatment of the plants illustrated (see Fig. 45). The designs are really impressive, and the invention rarely flags ; the rhythmic pattern of the roots, the calligraphic possibilities of lettering, are fully explored and utilised ; and the dramatic effect of the whole is enhanced by the noble proportions of the plates, which, when coloured, make decorations that remained unrivalled until the publication nearly two centuries later of Thornton's *Temple of Flora*. Since the original drawings have vanished, it is difficult to assess how the credit for the work should be divided between

the artist and the engraver. It should not be overlooked that in Besler's plates botanical accuracy is often sacrificed to decorative effect, so that it is not always possible to identify his plants with the same confidence that one identifies those in the less pretentious woodcuts of de l'Écluse. The original plates for the *Hortus Eystettensis* remained at Eichstätt until 1800, when they were carried off by the French to be used as scrap metal ; they escaped this fate, but have once more disappeared.

While the production of the book was still in progress, Bishop Konrad distributed a number of separate sheets of it among his friends. He himself did not live to see the work issued as a whole, a fact which accounts for the dedication being dated 1612. His successor as Prince Bishop appears to have had no interest in horticulture, and within a few years the garden which had been created with so much love and care had fallen into neglect.[1]

Though the preface of the *Hortus Eystettensis* contains a threat of legal action with heavy fines against any who should publish pirated editions or break up copies to sell piecemeal at fairs—(might all those who now destroy fine botanical books to make lampshades and table-mats, render themselves equally liable !)[2]—it is by no means certain whether Besler and his engravers can wholly escape a charge of plagiarism. A comparison of his *Papaver flore pleno rubrum* with the corresponding figure in de Bry's *Florilegium Novum*, for instance, shows a similarity which cannot be due to chance alone. It is always possible, however, that although de Bry's work was published two years earlier,[3] he may have had access to some of the engravings distributed by

[1]Joseph Schwertschlager, its historian, gives 1597 as the year of its establishment as a botanical garden. From 1612 onwards it declined. After the capture of the Wilibaldsburg of Eichstätt by the Swedes in 1633, it degenerated into an ordinary vegetable garden.

[2]But we must make an exception of the great Linnæus, who papered the walls of his bedroom and study at Hammarby with engravings after the work of Ehret and other botanical artists.

[3]Arber and other authorities give 1612. The Kew copy, however, is dated 1611.

PLATE XVa
M A R T A G O N L I L Y (*Lilium martagon*). Etching by Pierre Vallet from his *Le Jardin du très Chrestien Henry IV*, 1608

PLATE XVb
P I N K S (*Dianthus* spp.). Etching from Paul Reneaulme, *Specimen Historiae Plantarum*, 1611

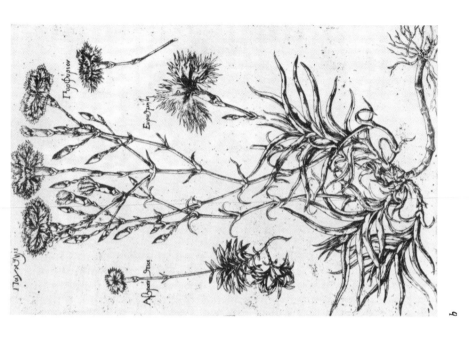

b

Plate XV a

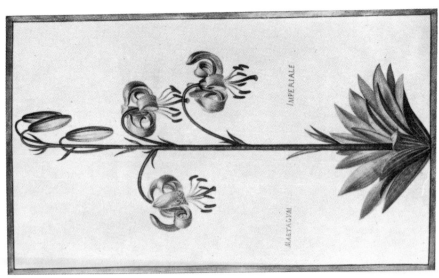

Plate XVI a

Bishop Konrad. The use that the Frenchman made of Vallet's work certainly renders him open to suspicion.

In comparison with the work of Vallet and Reneaulme, the *Hortus Floridus* of Crispin de Passe, admirable though it is, has received almost exaggerated praise. Mr. Savage, in his interesting article on Passe in the *Transactions of the Bibliographical Society* (1923), finds him "*facile princeps*" among the flower-engravers of the early seventeenth century. (He does not even mention Reneaulme in his list, which, however, includes Vallet.)

Crispin de Passe the Younger (Crispijn vande Pas; Crispinus Passeus) came from a celebrated family of Dutch engravers. He was born at Cologne, probably about the year 1590; at all events he was still a very young man when the *Hortus Floridus* was published in 1614, for the work is described as his " first fruites," and his death did not take place till more than fifty years later. In 1617 he moved from Utrecht, where he had been living for five years, and settled in Paris as representative of his father's engraving house. Here he was appointed Professor of Drawing at the *Maneige Royal*, a school for the education of the royal pages and other scions of the aristocracy. During the next twelve years he engraved the plates for a number of books, his most important work being his illustrations to A. de Pluvinal's *Maneige Royal* (1623). In his later years, which were spent in the family house in Holland, he produced little independent work, and there is reason to believe that he died insane.

The *Hortus Floridus* is an oblong quarto volume containing upwards of two hundred plates wholly engraved with the burin. Though the large majority of them are the work of Crispin, the inscriptions on several of the plates show that he was assisted by two of his brothers. The main section of the book is divided into four parts, corresponding to the four seasons; this is usually followed by an " Altera Pars," the engravings of which are probably earlier in date, and, as a whole, certainly inferior in quality.[1] In some copies, the section devoted to

[1]An earlier date is suggested both by their inferiority and by the total absence of tulip plates. There are grounds for supposing that the Altera Pars may have been first issued as a separate volume.

PLATE XVI
(*a*) M A R T A G O N L I L Y (*Lilium martagon*) and (*b*) D O G ' S - T O O T H V I O L E T (*Erythronium dens-canis*) and L A D Y ' S S L I P P E R O R C H I D (*Cypripedium calceolus*). Water-colour drawings by Daniel Rabel (1578-1637). Bibliothèque Nationale, Paris

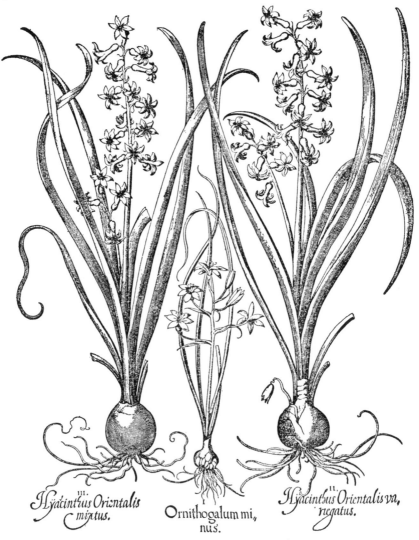

FIG. 45—Hyacinths and Ornithogalum
Engraving from Besler, *Hortus Eystettensis*, 1613

spring flowers contains a number of additional plates of tulips, the most
fashionable flower of the day. The short text which accompanies the
pictures was originally published in Latin ; but editions with French,

Dutch and English texts appeared almost immediately, the English version being issued at Utrecht in 1615. The engravings are now available to students in a twentieth-century reprint.

The most striking feature of the figures is the degree of atmosphere that has been achieved with so difficult and mechanical an instrument as the burin. A comparison with the work of Sweert or Besler makes this doubly apparent, and even the best plates of de Bry look a little stiff and formal beside those of the *Hortus Floridus*. In many of de Passe's plates the plants are shown growing in the soil, the artist's eye-level being chosen so low that the flat Dutch landscape gives place to a plain sky against which the flowers and leaves are firmly patterned. The book, like Camerarius's *Symbolorum . . . Centuria*, thus anticipates Thornton's *Temple of Flora*.

Delightful touches of humour enliven de Passe's work : bees and butterflies hover about the flowers ; insects crawl among the leaves ; a little mouse gnaws contentedly at an uprooted corm. The artist, we feel from his self-portrait no less than from his flower plates, must have been a gay and congenial companion ; the keen eyes and quizzical glance give no presage of the tragedy which was to overcloud his latter years.

The English version of the *Hortus Floridus* was made by a certain Thomas Wood, about whom nothing else seems to be known. It is entitled :

A GARDEN OF FLOWERS

Wherein very lively is contained a true and perfect discription of al the flowers contained in these foure followinge bookes. As also the perfect true manner of colouringe the same with theire naturall coloures, beinge in theire seasons the most rarest and excellentest flowers, that the world affordeth : ministringe both pleasure and delight to the spectator, and most espetially to the well affected practisioner.

All which to the great charges, and almost incredible laboure and paine, the diligent Author by foure yeares experience, hath very Laboriously compiled, and most excellently performed, both in theire perfect Lineaments in representing them in theire coper plates : as also after a most exquisite manner and methode in teachinge the practisioner te painte them even to the liffe.

Faithfully and truely translated out of the Netherlandisch

originall into English for the comon benifite of those that under-
stand no other languages . . . all at the Charges of the Author.
 Printed at Utrecht, by Salomon de Roy, for Crispian de Passe,
1615.

The work opens with an acrostic poem of little literary merit,
entitled *The Booke to his Readers*

C *ome hether you that much desire,*
R *are flowers of dyvers Landes :*
I *represent the same to you,*
S *et downe unto youre handes.*
P *resentinge them unto your vew,*
I *n perfect shape, and faire :*
A *nd also teach to coloure them,*
N *ot missinge of a haire.*
V *singe such couloures as requires,*
A *master workemans will :*
N *ot swarvinge thence in any case,*
D *eclaringe there his skill.*
E *ach flower his proper lineament,*
P *resentes from top to toe :*
A *nd shewes both Roote, budd, blade, and stalke,*
S *o as each one doth growe.*
S *paringe no paines, nor charge I have,*
E *ach seasons flower te passe :*
I *n Winter, Somer, Springe and fall.*
U *ntill this compleate was.*
N *ow use this same for thy delight,*
I *njoy it as thou wilt :*
O *f blotts and blurrs most carefully*
R *efraine, or else t'is spilt.*

 Elaborate instructions follow for the painting of the plants, colours
such as " masticott," " verdigreece," " lack," " maydens blush,"
" omber," and indigo being in frequent demand. For " the mary
golde of the sonne and the lesser marigolde of peru " (see Pl. 8, p. 77)
the artist is advised as follows : " The leaues that stand rounde about
are of a faire masticott coloure, and if the masticot be not of a high-

Plate 9 *Centaurea, Nigella, Muscari,* etc. Water-colour drawing, probably by Le Roy de la Boissière. Poitiers, 1608. Collection of William Price, Esq.

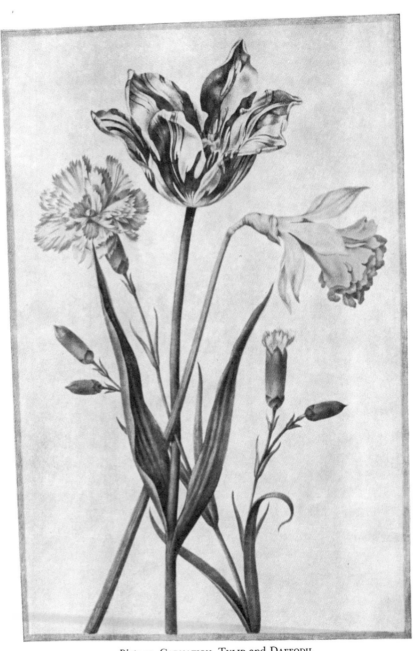

Plate 10 CARNATION, TULIP and DAFFODIL
Water-colour drawing, probably by Nicholas Robert (1614 – 85). British Museum

coloure, it must be tempered with a little lack, made shyninge, and shadovved with sad yellow, the innermost must be of a berry yellow there must be regard had in toppinge the starrs vvith the former coloure, the cowne within is the saddest of all, the leaues that come after the yellovv leaues, must very evidently appeare, because they are greene, these leaues and the steale must be shadowed vvith sad yellow and ashcoloure, and topt with white and masticott."

Each season is prefaced by a quatrain calculated to keep the artist's enthusiasm from flagging. Before " Summer," we read :

> *How carefull-diligent I have bene,*
> *These coloures to expresse :*
> *In painefull paintings of the same*
> *Good reader use no lesse.*

Winter is reached : one last effort, and the task will be accomplished :

> *If hethertoe (my friende) you have*
> *Performde the taske in hand :*
> *With joy proceede, this last will be*
> *The best, when all is scande.*

A jingling " envoie " concludes the work, and we must agree with Thomas Wood's verdict that young de Passe has done his task well :

> *You will confesse and graunt with mee,*
> *This youth deserves much praise.*

Most of the plates in the Altera Pars, as has already been stated, are unworthy of the rest of the book : the engraving is coarser, and many of the drawings are not original. One would prefer to believe that the work was not that of Crispin, but the facts fail to bear this out. It seems probable that the plates were made by Crispin when still a mere boy, and were copies of various drawings and engravings placed before him by his father. As the performance of a young apprentice, therefore, they must not be judged too severely. Moreover, there are several flowers—notably the " Lilium rubrum " and " Lilium album "—which are engraved with a degree of skill that places them almost in the same class as those in the main body of

the book. R. G. Hatton, in his *Craftsman's Plant-book*, was the first to point out that many of the plates in the Altera Pars were derived from Jacques le Moyne's *La Clef des Champs* ; and Savage draws attention to Adrian Collaert's *Florilegium* (*c.* 1590) as the source of the snippets of flowers and *rinceaux* which de Passe uses.

The influence of the *Hortus Floridus*, Savage adds, was felt for many years to come. Jean Franeau reversed some of the plates for his *Jardin d'Hyver* (1616) ; Parkinson made free use of them for his famous *Paradisus*, and the details are borrowed again in the *Orpheus* (1630) attributed to John Payne ; Anselm de Boodt's *Florum, Herbarum, ac Fructuum Selectiorum Icones* (Bruges 1640), is an unacknowledged reissue of the plates of the Altera Pars in a changed sequence ; and as late as 1757, John Hill copied the figures in his *Eden*.

Another attractive book which dates from the early years of the seventeenth century is Langlois's *Livre des Fleurs* (1620). The plates, which are drawn in a very individual manner, are sometimes engraved and sometimes etched ; they show birds and insects as well as flowers.

One more work must be mentioned here, though its etched plates are carried out in the manner of Reneaulme rather than in that of de Passe :—*Canadensium Plantarum Historia* (1635) by Jacques Philippe Cornut (Cornutus). Its author was never himself in Canada, but acquired his plants from Morin[1] and Robin. Among its pleasant, unpretentious illustrations is to be found the first figure of the Guernsey lily (Fig. 46), drawn from a plant which had flowered in the garden of Jean Morin the previous October. This attractive flower did not reach England until nearly fifty years later. The dramatic story of its introduction into this country is well known. During the reign of Charles II, a ship returning from Japan with bulbs in her cargo which had been taken on board at Cape Town, was wrecked off Guernsey. Several years after this "very singular, melancholy Accident . . . the Flowers appear'd in all their Pomp and Beauty "[2] upon the sandy sea-shore. The Hon. Charles Hatton, the Governor's second son, was a keen botanist, and despatched a number of bulbs to England.

The early years of the seventeenth century had been of major

[1]John Evelyn, the Diarist, when he visited Morin's garden and museum in 1644, observed that the latter had " caused his best flowers . . . to be painted in miniature by rare hands, and some in oyle."

[2]Douglas, James, *Lilium Sarniense* (1725).

NARCISS. IAPONICVS RVTILO FLORE.

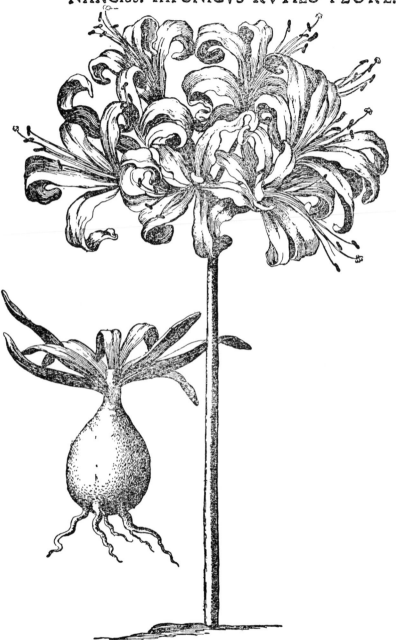

FIG. 46—Guernsey Lily (*Nerine sarniensis*)
Etching from Cornut, *Canadensium Plantarum Historia*, 1635

CHART OF ARTISTS

N.B.—The continuous lines indicate direct copying; the dotted lines only show some similarity of attitude or technique. The more important names are in capital letters.

importance in the development of botanical illustration. In the short interval between the appearance of Vallet's *Florilegium* in 1608 and de Passe's *Hortus Floridus* in 1614, a new era had opened. Then the Thirty Years' War intervened; not until the publication of the first plates of Nicolas Robert's *Recueil des Plantes*,[1] was the supremacy of these pioneers of botanical engraving to be seriously challenged.

[1]Some of these first appeared in Dodart's *Mémoires* (1676).

RABEL, ROBERT AND AUBRIET

THROUGHOUT THE seventeenth century, while England was probably making the most important contributions to the science of botany, it is to the Continent—and especially to France and Holland—that we must continue to turn for the main development of botanical illustration.

In France, wealthy amateurs in increasing numbers were forming cabinets of curios, a section of which was usually devoted to objects of natural history. Gaston d'Orléans, the younger brother of Louis XIII, who is generally dismissed by historians as nothing better than an intriguer, a traitor and a coward, inherited through his mother, Marie de Médicis, the virtues no less than the vices of the Medici. He was a man of taste, a keen botanist and a passionate collector. At Blois, which he refashioned with the aid of Mansart's genius and the Montpensier millions, he established a botanic garden and a private menagerie. Inspired, perhaps, by the memory of Anne of Brittany, who also lived at Blois, he engaged the artist Nicolas Robert to paint upon vellum the most curious flowers and animals in his collection.[1]

[1]Tout ce que la terre féconde,
Produit de plantes dans le monde
Est enfermé dans ces beaux lieux,
Et Gaston le connaît des mieux
Jusques-là qu'il en fait la nique
Aux plus fins en la botanique.
Un jour que ce prince royal
Conférait à l'original
Quelques fleurs en mignature
Peintes par ce docte en peinture
Robert que l'on vante si fort . . .
Bouillon.

These drawings, together with some made a few years earlier by Daniel Rabel, became the nucleus of the magnificent collection which, growing steadily through the years, now fills more than a hundred volumes in the library of the Muséum National d'Histoire Naturelle, Paris, and is known as the vélins du Muséum.

The history of this collection, to which we shall frequently have occasion to refer, may briefly be sketched here. On the death of Gaston in 1660, the drawings passed into the hands of his nephew, Louis XIV, and were placed in the Louvre. Louis XV, soon after his accession, had them transferred to the Bibliothèque du Roi (Bibliothèque Nationale), where they were studied with interest by Antoine de Jussieu. By 1767 they filled seventy volumes. The majority of these were removed at the time of the Revolution to the Muséum of the Jardin des Plantes (as the Jardin du Roi, founded in 1635 by Guy de la Brosse, was now renamed) ; and here they have found a permanent home. Few Parisians, and fewer tourists, trouble to look at them, or are even aware of their existence, though an exception must be made of Dom Pedro II, Emperor of Brazil, who on his visit to Paris in 1867 spent several hours in a careful examination of the finest of them.

Rabel and Robert's work, so consummate in its perfection, was but the full flowering of a humble bud which had been long maturing. Their style derives both from the cruder traditions of the herbal proper and from the more refined traditions of the illuminated manuscript with its exquisite floral borders. In the second half of the sixteenth century, painters such as Hoefnagel and Le Moyne de Morgues had shown such a fusion to be possible ; and in a florilegium made in 1610 by Jean Le Roy de la Boissière of Poitiers, we can trace the immediate ancestry of Robert's technique.[1] This fine volume, which was purchased by the Muséum in 1888 for a modest sum from a Paris clock-maker, contains a series of paintings of the popular garden flowers of the day. More than forty tulips are shown, unfortunately unnamed ; and among the most successful plates may be mentioned those of irises, peonies, fritillaries and carnations. Form is suggested by parallel hatchings, a device derived from illuminated manuscripts and brought to perfection by Robert.

No less attractive is a similar florilegium made at Poitiers in 1608 and now in the possession of Mr. William R. Price who has kindly allowed

[1] A German florilegium, made in the same year by Sebastian Schedel, is at Kew.

me to reproduce the beautiful painting shown on Plate 9 (p. 100). Though the title-page of this book bears the signature " van Kuyk," it displays the arms of Le Roy ; the latter is therefore without doubt responsible for the flower-pictures.

Daniel Rabel (1578-1637), " ingénieur ordinaire pour le Roy en ses provinces de Brië et de Champagne," is most likely to be remembered to-day—if he is remembered at all—by his designs for the ballet. Yet in his own age he was no less famous for his work in portraiture, landscape and genre—and, most especially, for his triumphant paintings of flowers. Distinguished pupils received instruction from his hand, among them the sons of the duc de Nevers.

A pupil of his father, Jean Rabel, we first hear of Daniel in Madrid, where he had been sent by Marie de Médicis to make a portrait of Anne of Austria, the fiancée of her son Louis XIII. An engraving exists of the artist at work on this very picture. In 1622, Rabel published his *Theatrum Florae*, some of the drawings for which are preserved in the Bibliothèque Nationale in an album which is one of the miracles of early flower-painting. The album bears the date 1624—no doubt in error, for it is inconceivable that the drawings were copied, as has been suggested, from the engravings. The plates of the *Theatrum Florae*, which are similar in type to those of Vallet or de Bry, are good, but in no way outstanding ; the immense superiority of Rabel's paintings over his engravings makes clear how great is our loss that no original flower-paintings by de Passe, Reneaulme or Vallet have survived.

The poets of the day sang the praises of Rabel's art. Scudery, in his sonnet : " Des oyseaux peints en miniature par Rabel," describes the birds—with no great measure of originality—as so lifelike that if the window were to be opened they would fly away. (These paintings of birds are unfortunately lost.) Malherbe chose to celebrate the painter's flower-pictures, and it was the famous album, which we can still admire to-day, that drew from him the following sonnet :

> *Quelques louanges non pareilles*
> *Qu'ayt Apelle encore aujourd'huy,*
> *Cet ouvrage plein de merveilles*
> *Met Rabel au-dessus de luy.*
> *L'Art y surmonte la Nature*
> *Et si mon Jugement n'est vain,*

Flore lui conduisoit la main
Quand il faisoit cette peinture
Certes il a privé mes Yeux
De l'objet qu'ils aiment le mieux,
N'y mettant point de Marguerite ;
Mais pouvoit-il être ignorant
Qu'une fleur de tant de mérite
Auroit terni le demeurant

The reference to the marguerite, which Malherbe suggests has been omitted from the book since its beauty would have outshone the other flowers, is believed to be a subtle compliment to Marguerite de Valois. Marguerite, however, died in 1615 ; and since such flattery would have been wasted upon the dead, it is not improbable that the paintings were made ten years or more before the date inscribed upon the cover.

The album is splendidly bound in red morocco, and bears the royal arms. On turning its pages we are immediately struck by the wonderful freshness of the colours, applied in transparent washes with only the rarest use of opaque tones. This technique has its dangers ; but Rabel has performed the difficult task of retaining delicacy without sacrificing strength. Though by his employment of hatching he recalls Robert, in the transparency of his tones he seems to anticipate Redouté ; and the painting of *Canna indica* is curiously reminiscent of the work of the latter artist. Many of the figures include, as was customary, butterflies and other insects painted with no less care and affection ; the whole volume, indeed, speaks a passionate love of Nature, though the paintings are technically rather unequal in quality. Each page is enclosed within a narrow gold border, the name of the plant being also written in gold. The flowers chosen for illustration are once again the familiar favourites of the early seventeenth century gardeners ; and the decorative qualities of the ever-popular martagon lily (Pl. XVIa, p. 97) have inspired one of the finest sheets in this lovely book. The dog's-tooth violet (*Erythronium dens-canis*) shown in Plate XVIb (p. 97) is drawn with wonderful delicacy and precision. A comparison of style makes it virtually certain that the early drawings in the Muséum collection, bearing the dates 1631 or 1632 but no name, are also the work of Rabel.

Nicolas Robert (1614-85) must ever be remembered for three important contributions to botanical art :—for the famous *Guirlande de*

Helleborus niger,
Orientalis, amplissimo
folio, caule præalto,
flore viridi, Itineris
Tournefort.

Plate 11 *Helleborus kochii.* Water-colour drawing by Claude Aubriet (1665 – 1742)
Natural History Museum, London

SEE ALSO COLOUR PLATE B

Plate 12 GENTIAN (*Gentiana excisa*)
Water-colour drawing by S. Verelst (1644 – 1721)
Royal Botanic Gardens, Kew

Julie ; for his flower paintings on vellum for Gaston, and subsequently for Louis XIV ; and for his share in the *Recueil des Plantes*—the finest collection of flower engravings made during the seventeenth century.

Robert's name first occurs as the illustrator of a small book of etchings of flowers entitled *Fiori Diversi* (Rome ; 1640). His father was an inn-keeper at Langres, and the circumstances in which the young man was enabled to make the journey to Italy remain unknown ; but he must already have made some reputation for himself, for the following year he was chosen to illustrate a book of unusual interest and importance—the *Guirlande de Julie*.

For the story of the creation of this historic work we must turn to the Hôtel of Mme de Rambouillet,[1] the centre of Parisian taste and culture under Louis XIII. To her brightly lit salon, with its rare works of art, its perfumed air and its magnificent baskets of flowers, flocked the poets who heralded the greater age of Racine and Molière, drawn irresistibly by the charm of its hostess, and the wit, beauty and virtue of her daughter, Julie d'Angennes. The years passed ; one by one Julie's suitors were rejected, till the baron de Sainte-Maure—the future duc de Montausier—came, and conquered. Julie made her own terms : he was to become a Catholic ; he was to wait her own good time. This was in 1641 ; then Sainte-Maure marched away with the army under the command of maréchal de Guébriant and was taken prisoner. Released at last, it was not until 1645 that the marriage was finally celebrated. The bridegroom was now thirty-five, the bride thirty-eight.

Before Sainte-Maure set out for the wars, he had given his fiancée, as a birthday gift, an album of flowers—the *chef d'œuvre de la galanterie* known as the " Guirlande de Julie." In the making of it, Nicolas Robert had collaborated with Jarry, the greatest calligrapher of the day, who had inscribed the madrigals written for the occasion by the poets of the Rambouillet circle. Even Corneille himself had deigned to contribute six poems—discreetly signed with an initial only.

The album, after passing through many hands, including those of an English bookseller, is now the property of a French collector who kindly allowed me to examine it. The flowers are painted upon vellum with all the skill that the young artist could command, and are chosen from among the most beautiful in the garden, such as the

[1] The floral panels in the Château of Ancy le Franc, Burgundy, were presumably also carried out under the influence of " Les Précieux " (see Durfort ; 1937).

lily and the rose ; the anemone, hyacinth and carnation ; the popular tulip and the splendid crown imperial. Upon the title-page, the flowers are used again to form a garland of the utmost beauty, encircling the name of her to whom the precious gift was offered. Though Robert's later paintings were to be more brilliant and spectacular, and more botanically accurate, he never produced anything more charming than this delightful little florilegium.

Overnight Robert found himself famous ; shortly afterwards, when Gaston d'Orléans was seeking for a painter to make a permanent record of his collection, his eye naturally fell upon the young painter of the celebrated *Guirlande*.

To form a true impression of the diversity and brilliance of Robert's talent as a painter, it is necessary to study his work at the Muséum of the Jardin des Plantes, though two volumes[1] in the British Museum (misleadingly labelled *Roberts's Drawings*) give some impression of his technical methods (see Pl. 10, p. 101). Outline is reduced to a bare minimum, and, as in medieval illumination, the neutral tone of shadows is often disregarded. Form and texture are suggested by an infinity of finely hatched strokes. Finally, the beauty of the pages is enhanced by the judicious use of gold in the borders and lettering. Robert received payment at the rate of twenty-two livres a drawing. At the time of Gaston's death in 1660, the collection filled five large folio volumes. The majority of the drawings are of flowers, though there are also many of birds and other objects of natural history.

Appointed in 1664 to the post of " peintre ordinaire de Sa Majesté pour la miniature," Robert continued in Paris and at Versailles the work he had begun at Blois. Colbert bestowed his patronage upon him, and commissioned, for his private collection, replicas of many of the drawings. In the making of the latter, which are now in the National Library in Vienna, the artist was largely assisted by his pupils Le Roy, Villemont and Bailly.

It is believed to have been the great Scottish botanist Robert Morison, for ten years Superintendent of Gaston's gardens at Blois, who first persuaded Nicolas Robert to interest himself in scientific botanical illustration. In the years spent at Blois, the latter had

[1]It is difficult to say how much of the work in these volumes—which ranges, incidentally, from tulips to Siamese twins—is by Robert's own hand. Major Broughton possesses a pretty, and unquestionably genuine, little florilegium made by Robert at Lyons in 1643. A florilegium containing a number of very fine paintings attributed to Robert was sold at Christie's in 1948.

learned to become more than a mere purveyor of floral beauty ; it was fitting, therefore, when the newly founded *Académie Royale des Sciences* decided to publish a History of Plants, that he should be chosen as its chief illustrator.

The idea had originated with Perrault in 1667. When Dionys Dodart (1634-1707) was elected to the *Académie* in 1673, the proposal took definite shape, and at the end of 1675, the latter's *Mémoires pour servir à l'Histoire des Plantes* was published by the Royal Press. This volume, a large folio, was planned as the prelude to a vast work whose publication was delayed for many years. Its thirty-nine plates were engraved from drawings by Robert, made for the most part from life ; in the case of several rare plants, he was obliged to adapt paintings which he had previously made on vellum at the Jardin du Roi. Robert, in his *Fiori Diversi* and more particularly in another volume entitled *Diverses Fleurs* (*c.* 1660), had already shown his skill as an engraver. In this more exacting task he was now assisted, or perhaps directed, by the engraver Abraham Bosse (1602-76), whose famous " Parables " give so vivid a picture of French life in the middle of the seventeenth century.

The production of plates was carried on with enthusiasm, and by 1692 a total of 319 had been engraved. Although Robert had died in 1685, the major part of the work was his ; Bosse, and later the able draughtsman and engraver Louis de Châtillon (1639-1734), were responsible for the remainder.

The plates were transferred to the Imprimerie Royale ; but before the printing of them had made much progress, the exigencies of Louis's wars put a brake on the publication of all such works. The plates were published without letterpress in 1701. During the eighteenth century, minor alterations were made to the plates and botanical details were added ; but it was not until a century after its inception that the work was finally issued with text, in three magnificent volumes. It was never sold to the public, and is therefore a great rarity ; but a copy, sumptuously bound in red morocco and bearing the arms of Mme de Pompadour, may be seen in the Natural History Museum,[1] and two further copies are in the Lindley Library.

In the preface to Dodart's *Mémoires* the intention of the illustrations

[1]The volumes of this edition were printed in 1788. Mme de Pompadour had died in 1764, and her brother and heir in 1781 ; it has been suggested that the arms were added by the binder to enhance the value of the book.

is clearly defined. Wherever possible, the plants were to be portrayed life-size ; if larger, but not more than twice the size of the page, they would be represented as cut in two ; if still larger, some detail would be given full-scale, so that the true size of the plant could be better appreciated. Moreover, all the technical resources of engraving were to be fully utilised. The preface continues : " Since printing in colour is not employed yet, and since painters waste much time and are not always successful, we thought we could, in future, supply to some extent what was lacking in an engraving, by taking care to indicate, as far as is feasible, the depth of the colour. Thus a distinction would be made between brownish-green and pale green, between white and dark-coloured flowers . . ."

The book is a landmark in botanical illustration. No less an authority than van Spaëndonck, speaking in an age which knew the lovely work of Ehret and Redouté, proclaimed it the finest in the world. Most remarkable of all, perhaps, are the engravings made by Châtillon, the exquisite delicacy of which defies adequate reproduction on a reduced scale. He is particularly successful with pubescent plants, while the vigorous, almost brutal line of Bosse is better suited to coarser types of growth. Robert's engravings steer a middle course, and he never shows the refinement of Châtillon. We can better understand the value of his contribution when we study his original drawings for the plates. These, which are preserved in the Muséum, are executed in sanguine on tissue paper laid down on stronger paper, and are remarkable for their beauty and freshness. The original metal plates are now in the Louvre, and modern " pulls " from them can be purchased through the Chalcography department.[1] Bosse's fine study of the horse chestnut (*Aesculus hippocastanum*), a tree which was first introduced into western Europe in the seventeenth century, is shown on Plate XVII (p. 112).

Since the plates in this work were made from living plants, they constitute a valuable record of what was then in cultivation. The same is even more true of the *vélins* ; these depict many garden forms in colour, and deserve study by anyone engaged on the history of cultivated genera.

Robert's successor, Jean Joubert of Poitiers, was by ordinary

[1] Twenty impressions from these plates, printed on vellum and painted in water-colour by P. J. and H. J. Redouté, were in the collection of the late Mrs. J. P. Morgan. (See White, V. V.)

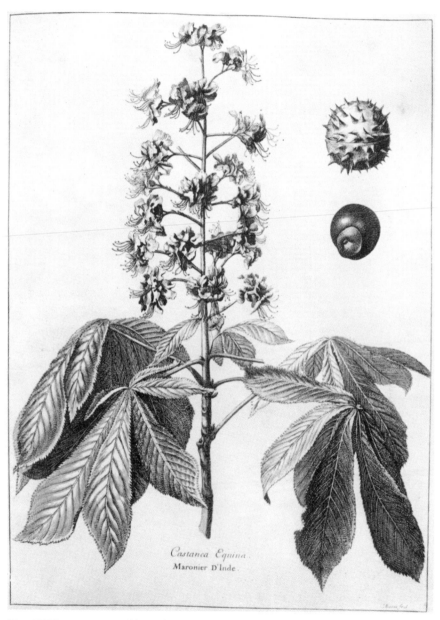

Castanea Equina.
Maronier D'Inde.

Plate XVII　　　　　　　Horse Chestnut (*Aesculus hippocastanum*)
Engraving by Abraham Bosse (1602—76) from Nicolas Robert, *Recueil des Plantes*, (n.d.)

Plate XVIII Coltsfoot (*Tussilago farfara*)
Drawing in ink and wash by Claude Aubriet (1665—1742)
Lindley Library, London

standards a highly talented painter ; but it was his misfortune to follow and to precede two men of genius—Robert and Aubriet. He deserves, at all events, a better fate than to be dismissed, as he was by Antoine de Jussieu, in one ungenerous sentence. His paintings may lack the freshness of those of his predecessor and the crispness of Aubriet's touch ; not infrequently his tones are heavy, his forms "stodgy ;" but he was a conscientious and painstaking artist whose work has considerable botanical value. Besides making many hundreds of flower studies, Joubert also found time to decorate furniture, and to paint portraits and subject pictures in miniature. It was probably Joubert's work that Lister was shown when he was in Paris in 1698 : " He [Tournefort] also showed me ten or twelve single sheets of vellom, on each of which were painted, in water colours very lively [i.e. lifelike], one single plant, mostly in flower, by the best artist in Paris, at the King's charge. Those are sent to Versailles, when the doctor has put the names to them, and there kept : in this manner the King has above 2000 rare plants, and they work daily upon others. The limner has two louis's for every plant he paints."[1] An album of sanguine drawings by Joubert, once in the collection of Cardinal Dubois, is now in the British Museum (Add. MS 5287).

It was the good fortune of Aubriet, Joubert's successor, to work in close intimacy with the greatest French botanists of his day. " His whole life," wrote Bultingaire, " was passed in the company—one might almost say in the shadow—of such men as Tournefort, Vaillant and de Jussieu." We therefore find in his drawings a greater appreciation of plant structure than in those of any of his predecessors.

Claude Aubriet (1665-1742), a native of Châlons-sur-Marne, found his way as a young man to Paris, where he was engaged by Joubert to assist in the production of drawings for the royal collection. He soon attracted the attention of Tournefort, who commissioned him to make the engravings for his celebrated *Elémens de Botanique* (1694) which in its later Latin version, *Institutiones Rei Herbariae* (1700), had so far-reaching an effect on plant classification. These illustrations, made no doubt under Tournefort's direct supervision, are remarkable for the accuracy of their dissections. The great botanist was more than satisfied ; six years later, when he was setting out on his famous voyage to the Levant, he invited Aubriet to accompany him. " It frets a Man,"

[1] Lister, Martin, *A Journey to Paris in the Year 1698.*

Tournefort wrote, " to see fine Objects, and not to be able to take Draughts of them ; for without this help of *Drawing*, 'tis impossible my account thereof should be perfectly intelligible."

The official account of the journey may be read in Tournefort's *Relation d'un Voyage au Levant* (1717) ; but more intimate glimpses can be found in the informal correspondence of the two travellers. It reveals Aubriet as a simple and unassuming young man, none too well educated, but an industrious worker, a loyal companion and—in Tournefort's own words—" a good friend."

The two Frenchmen, together with a German doctor named Andreas Gundelsheimer, set sail from Marseilles in March 1700. After spending three months in Crete, they proceeded to visit no less than thirty-two islands of the Archipelago, braving pirates and storm-tossed seas. Wherever they passed, Aubriet's pencil was busy making records of plants, landscape, antiquities, and even of the dresses of the natives. " As for costume studies," he wrote to Joubert, " you know that they are hardly in my line ; but I hope they will be clear enough for more accurate drawings to be made from them."

On reaching Constantinople, Tournefort found a letter awaiting him from Fagon, Superintendent of the Royal Gardens : the first batch of Aubriet's drawings had arrived, and he was far from satisfied ; the work was too slight, and the greens the wrong colour. Aubriet defended himself politely but firmly : when a large number of new plants were discovered on the same day, it was impossible to make more than a rough sketch supplemented by colour notes. And Tournefort, rallying to his support, assured Fagon that with the aid of pressed plants it would be possible for the artist to prepare finished paintings on his return. Tournefort himself, indeed, was a little irritated at the demands made upon him by the authorities at home, who did not appear to appreciate the difficulties under which travellers laboured.

From Constantinople they journeyed along the shores of the Black Sea, in the company of a Pasha who took surreptitious peeps at Aubriet's work when his suite was not present. After visiting Tiflis and Erzurum, they returned to Smyrna across country, attached now to a caravan of merchants, armed to the teeth, who found the antics of the botanists a matter for much mirth. Between Ankara and Bursa, Aubriet had been struck down by a fever. By the time Smyrna was reached he was well on the way to recovery, but he still complained

of severe headaches ; Tournefort therefore thought it wiser to abandon his cherished plan of visiting Ephesus and Egypt on the way home. On June 3, 1702, after more than two years of absence, the travellers once more set foot on French soil.

Before Aubriet had left France, he had received the promise that he should in due course succeed Joubert ; four or five years after his return the latter died, and the promise was fulfilled. Meanwhile Aubriet was producing from his rough sketches of Levantine plants a series of finished paintings which remained for a century the most valuable material of its kind available to botanists.

With his rooms at the Jardin du Roi and a country cottage at Passy, Aubriet must have found life pleasant. His official work was not exacting, and he had leisure enough to make drawings for Vaillant's *Botanicon Parisiense* (1727) and to dabble in his new hobby, entomology. One day—there seemed so much time—he would produce his great work on the metamorphosis of insects. But the *magnum opus*, though he made many drawings for it, was never completed. In 1735, a few years before his death, he handed over his office to his pupil Madeleine Basseporte. In his will he requested that his funeral should be as simple as possible, the money thus economised being divided between charity and prayers for his soul. His name is commemorated in the popular Aubrieta (often mis-spelt " Aubretia ").

Aubriet's finest paintings are preserved in the Muséum and at Göttingen, but the Lindley Library of the Royal Horticultural Society has a handful of vellums, and a considerable number of delightful little monochrome sketches on paper, made, apparently, for the illustration of a book projected by Antoine de Jussieu but never written.[1] Plate XVIII (p. 113) shows Aubriet's drawing of coltsfoot (*Tussilago farfara*) from this collection. Aubriet's paintings on vellum are executed in opaque colour, and are more decorative and stylized than those of Robert. At times, indeed, he carries this conventionalisation of both form and colour dangerously far ; but, as in the case of Ehret, his great botanical knowledge always saved him from disaster. His forms have the sharpness of metal, and, with their strongly defined contours, seem to derive from the tradition of medieval illumination ; thus, we feel, might Bourdichon have painted had he lived two centuries later.

[1]Some of Aubriet's drawings in the Lindley Library are reproduced in The Royal Horticultural Society, *Lily Year Book* 12 (for 1948), Figs. 30, 31 (1949) ; Woodcock and Stearn, *Lilies of the World*, Fig. 32 (1950).

Aubriet's splendid study of a green hellebore (*Helleborus kochii*) is shown on Plate 11 (p. 108).[1] Our plate depicts the original coloured drawing from which was made the engraving t. 45, under the name *Helleborus orientalis*, in R. L. Desfontaines's *Choix des Plantes du Corollaire des Instituts de Tournefort*.

Considered from the point of view of the botanist, Aubriet's drawings of the plants of the Levant provide the most valuable evidence for the identification of plants listed but not described in Tournefort's *Corollarium* (1719). A number of these were published in Desfontaines's *Choix* (1808), and in F. H. Jaubert and E. Spach's *Illustrationes Plantarum Orientalium* (1842-57)—the most important illustrated work, next to Sibthorp's *Flora Graeca*, on the flora of the Near East (see pp. 196 and 228).

In this chapter we have traced the progress of official botanical art in France during the seventeenth and early eighteenth centuries ; the subsequent development of the school will be discussed at a later stage in the book. Meanwhile we must turn to the Low Countries, where floriculture, rather than scientific botany, controlled the destinies of flower-painting and directed it into new channels.

[1] Francesco Peyroleri (*fl. c.* 1730), draughtsman to the Turin Botanical Garden, made excellent monochrome drawings in a manner similar to Aubriet's. He contributed to the *Iconographia Taurinensis* (1732-), a collection of many thousands of botanical drawings now in the University Library, Turin.

HOLLAND: THE FLOWER-PIECE AND THE DUTCH INFLUENCE

N EVER have flowers figured more prominently in the minds and the daily lives of a people than they did in the Low Countries during the opening decades of the seventeenth century. Though the Tulipomania ultimately degenerated into what can only be described as a stock exchange gamble, it had its origins in a genuine and passionate love of flowers themselves—an enthusiasm which gave birth to the greatest school of flower-painting in the history of art. A detailed discussion of the flower-piece proper lies outside our province, but so great were the repercussions of the cult that we cannot afford wholly to ignore it. Moreover, a number of Dutch botanical studies have escaped the destruction that often seems to have attended such work when its immediate purpose had been fulfilled.

There is a story that at a time when rare flowers were costly and painters' charges moderate, an impecunious Dutch woman commissioned Jan Brueghel (1568-1625) to paint for her the flowers which she could not afford to buy. This, the legend asserts, was the humble origin of flower-painting in oils in the Low Countries. The earliest known flower-piece of the Dutch type is, however, a small study painted by Memling (c. 1490) on the reverse of a panel bearing a portrait.[1] It differs little in general character from the pots of flowers which van der Weyden and van der Goes not infrequently included in their figure compositions, and may perhaps have been intended for a similar purpose. Some seventy years were to elapse before the West-

[1]Thyssen Collection; Lugano. For a reproduction, see Max Friedländer; *Art and Connoisseurship* (1942).

phalian artist Ludwig tom Ring the younger painted the three stiff little flower-pieces which are now in the Landesmuseum at Münster (dated 1562 and 1565). Ring's contemporary, Lodewyck Jansz Valkenborgh (*b.* 1520 at Bois-le-duc), is said by van Mander to have painted flower-pieces, but they have not survived. Plate IIIc (p. 32) shows a detail from the picture of *Christ in the House of Martha and Mary* by Pieter Aertsen (1508—*c.* 1575). The flowers in this astonishing work are portrayed with a naturalism which was not to be found again in Dutch flower-pieces until late in the seventeenth century, and with a breadth of treatment which is clearly derived from Venice rather than from the North.[1]

Among the most interesting of the early flower-piece painters are Jan Brueghel, and his contemporaries Jacob de Gheyn the Younger and Georg Flegel.

Jacob de Gheyn (1565-1629) began as an engraver, but soon realised that only in painting could he find full scope for his talent. His greatest ambition was to become a figure painter. The Emperor Rudolf II purchased a flower-piece from him, as well as " a small book wherein de Gheyn had painted from life at different seasons of the year a number of little flowers in miniature, and many insects " (van Mander). This book, which contains some beautiful studies of roses, is in the collection of Dr. Lugt at Montreux. There is also a very fine pen and ink drawing of a rose, dated 1620, in the Berlin Print Room. De Gheyn designed the Palace gardens at the Hague for Prince Mauritz, and also made for him a large oil painting of a horse and groom.

Georg Flegel was born near Olmütz (now in Czechoslovakia) in 1563 and worked for many years in Frankfurt-am-Main where he died in 1638. He must count—if we accept tom Ring's tentative experiment —as the first German painter of flower-pieces; there is little doubt, however, that he acquired the taste for this kind of subject in Flanders. An album made by him of water-colour paintings of natural history subjects was acquired by the Berlin Print Room shortly before the last war ; among these, to judge from photographs, are some flower studies of considerable interest and importance. The flower-painter Jacob Marrell (1614-81), pupil for a time of Flegel, became the stepfather of Maria Sybille Merian whose work will be discussed later in this chapter.

But it is Jan Brueghel, and the artists who were his pupils or who

[1]See van Gelder (1936), and Bergström (1947).

Plate 13 YELLOW FLAG (*Iris pseudacorus*)
Water-colour drawing by P. van Kouwenhoorn, *c.* 1630. Lindley Library, London

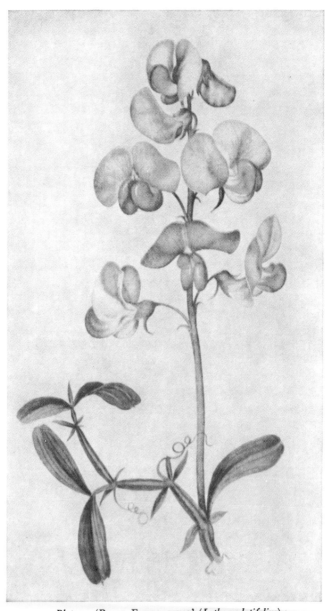

Plate 14 'PEASE EVERLASTING' (*Lathyrus latifolius*)
Water-colour drawing by Alexander Marshal, *c.* 1660
Windsor Castle

came under his influence—such as Ambrosius Bosschaert the Elder, Daniel Seghers[1] and van der Ast—who constitute as it were the Primitives of the Low Countries school of flower painting. Their work covers a period from about 1590-1650 ; Antwerp and later Utrecht were the principal centres in which the flower-piece developed. At first the flowers are rather stiffly drawn and formal in arrangement, grouped to form a façade with little depth ; the perspective of the pots is unreliable. Yet there is an engaging naïveté, an honesty of purpose, an obvious happiness in all that these artists paint. The scent still lingers about their pink and white roses ; their brightly striped tulips, their irises, fritillaries, hyacinths, daffodils and martagon lilies are wonderfully evocative of the greatest age of floriculture that the world has known. The foregrounds of these pictures are enlivened with little shells and other trifles. After the master's death, his pupils developed a freedom of treatment which he himself rarely attained, and a grace of expression which the virtuosi of a later age could never surpass.

The second period, corresponding roughly with the latter half of the seventeenth century, opens with the brilliant paintings of Jan Davidsz de Heem, and includes such famous names as van Aelst, de Lust, Osterwyck, Verelst, Schalken, Abraham Mignon and Walscapelle, and Rachel Ruysch who died at a great age as late as the year 1750. All trace of stiffness has now disappeared, and nothing is too difficult to be attempted ; sparkling glass and the glitter of silver they take in their stride. Yet there is still a certain and deliberate restraint in most of their compositions. With the advent of Jan van Huysum (1682-1749) the third phase is inaugurated. In his early work he is content to experiment within the limits set by his immediate predecessors ; but soon all reticence vanishes. With a skill never surpassed, he fills his canvases with great tumbled sprays of blossom tricked out with *trompe-l'œil* dewdrops, with gleaming leaves bearing insects so lifelike that one is perplexed by their immobility. This is painting in the Grand Manner, a superlative *tour de force* in baroque design, broad in conception yet highly finished in detail. Van Os, Gerard van

[1]John Rea, in his *Flora* (1665), refers to Seghers's despair at his failure to portray the tulip :

> *Once did that famous Jesuite try*
> *To copy out her Majesty ;*
> *But falling short of his desire,*
> *He left his Pencil to admire.*

Spaëndonck and his other pupils, Dutchmen and foreigners of many lands, attempted breathlessly to emulate his virtuosity ; but after his death the decline set in rapidly, though we shall meet van Spaëndonck again in his true *métier* of botanical draughtsman and teacher of the great Redouté and his contemporaries.

There is no doubt that the Dutch and Flemish flower-painters rarely if ever made their pictures direct from nature, but constructed them from drawings and studies. Bergström has demonstrated that flowers identically drawn, though variously coloured, frequently recur in different works by the same artist. Moreover spring, summer, and even autumn flowers jostle one another in these closely packed bouquets. A number of studies of individual flowers still survive, especially in Dutch and English collections, and in a few cases it has been possible to trace the pictures in which such studies have been used ; more patient research would doubtless reveal further examples.

As a characteristic botanical study of an artist who was first and foremost a painter of bouquets, I have chosen a brilliant little sketch of *Gentiana excisa* (Pl. 12, p. 109) by Simon Verelst (1644-1721).[1] Verelst was one of the many Dutchmen who sought his fortune in England. The Duke of Buckingham patronised him, and his pictures, Walpole tells us, fetched immense prices. But success went to his head : when he announced that he was the King of Painting, his vanity only provoked adverse comment ; when he added that he was also the God of Flowers, people began to titter ; but when he claimed equality with the King of England and demanded to converse with him " as man to man " for several hours, he was hustled into an asylum.

It is unnecessary to list all the Dutch artists who have left botanical studies. Among them may be noted Nellius, Abraham Bloemaert, P. Sanredam, Saftleven, Rochus van Veen, Verwer,[2] Adrian van der Velde, Rachel Ruysch, van Brussel, the ornithological painter Aert

[1] This water-colour drawing by Verelst, the original of which is now at the Royal Botanic Gardens, Kew, but belonged formerly to Sir Arthur H. Church (cf. *Kew Bull.*, 1916 : 162), has considerable historic interest in that it is one of the earliest portraits of that splendid and popular rock-garden plant, the mysterious *Gentiana excisa* Presl, non auct. (" *G. acaulis* " Sturm, non Linn., *G. gentianella* Farrer, *G. hortorum* Bergmans) which does not exactly match any wild species but is widespread in cultivation under the name *G. acaulis* applied by Linnaeus to *G. kochiana* and *G. clusii*, its probable parents (cf. A. Jakowatz in *Sitzungsber. Akad. Wiss. Wien, Math.-Nat.* 108 : 321, 343-347). The origin and history of this plant are unknown.

[2] See Altena (1930).

Schouman,[1] and the almost endless members of the van Huysum and van der Vinne families. The talented Carel Voet[2] (1670-1745) entered at the age of nineteen the service of the Duke of Portland and worked for him both in Holland and England ; he also made a book of drawings of insects for William III. Herman Hen(g)stenburg (1667-1726), an amateur who was by profession a pastry-cook, has left a handful of brilliant botanical paintings ; that of tulips, in Teyler's Museum at Haarlem, is one of the finest flower studies ever made in Holland (Pl. XIX, p. 128). A group of paintings made about 1690 by " S.D.M." in Beaumont's garden at The Hague is now in the State Herbarium at Leiden ; the artist's identity is not known, but on one of the drawings he states that he was seventy years old at the time.

The Dutch colonies in the East and West Indies, South America, India and the Cape acted as a great stimulus to botanical draughtsmen. Prince Mauritz of Nassau was accompanied to Brazil in 1636 by a band of scientists who founded the town that is now known as S. Antonio and created a zoological and botanical garden there. Seven volumes of natural history drawings made in that country by Albert van der Eckhout, Zacharias Wagner and other artists are now in the Staatsbibliothek, Berlin (Lib. Pict. A. 32-38), and the landscape paintings in oils by Frans Post (1612 ?-90) are full of interesting botanical details.[3] Hogeboom, Philip van Eyck, and a soldier named de Ruyter who was trained by the latter, worked during the closing years of the seventeenth century for the Dutch botanist Rumphius at Amboyna in the Dutch East Indies ; their drawings, now in the University Library at Leiden, were used by Rumphius for his *Herbarium Amboinense* (1741-55). Studies of Proteaceæ made in South Africa early in the eighteenth century, probably by Jan Hartog, one of the Head Gardeners of the Botanical Gardens at the Cape, are in the State Herbarium at Leiden. Some of these were used by Laurens van der Vinne the Younger, together with a few of his own sketches, in the composition of a large botanical oil-painting of considerable interest (see Pl. XX, p. 129). This picture, which was painted about 1737, belongs to Leiden University and is at present in the house of Professor J. N. Bakhuizen van den Brink in that city. Though the picture lacks design, it is of importance in that it anticipates the

[1]Major Broughton possesses a fine album of his flower studies.
[2]Four of Voet's drawings are reproduced by Scheffer (1938).
[3]See Sousa-Leão (1942).

methods employed by Thornton's painters to place plants in a landscape setting.[1] Some of Hartog's drawings of Proteaceæ were engraved for Boerhaave's *Index Alter Plantarum* (vol. 2 ; 1720), and his work was also of service to Weinmann (see Chapter 11). A number of Paul Hermann's vigorous monochrome water-colour paintings of Ceylon plants, made during the second half of the seventeenth century, are in the Natural History Museum, London. Botanically these are of great importance. Hermann died in 1695 and his collections passed through many careful hands before reaching the British Museum in 1827. In 1745 they belonged to a Danish apothecary who lent them to the great Swedish botanist Linnaeus. The latter, greatly excited by the glimpse they afforded of a tropical flora, wrote a book about them—*Flora Zeylanica* (1747). They thus contain the types of many Linnean species.[2] Further drawings by Hermann are at Oxford.

The German traveller Engelbert Kaempfer (1651-1716), in the capacity of Chief Surgeon to the Dutch Fleet, visited Persia (1684) and Japan (1690-92). He was the first to record such important flowers as *Lilium speciosum* and *L. tigrinum*, which he also drew with vigour and accuracy. Reproductions of four of his flower drawings, and a brief account of his travels, may be found in the Royal Horticultural Society's *Lily Year Book* for 1948 (see Stearn, W. T. ; 1949a).

Many " Tulip Books "—virtually sale catalogues commissioned by bulb dealers to enable them to display their wares to clients when the flowers were not in season—were painted in Holland during the Tulipomania and in the years which immediately succeeded it. Krelage has listed eighteen such volumes. Distinguished painters such as Frans Hals's pupil Judith Leyster (*c*.1610-60), and Jacob Marrell, found it profitable to undertake commissions of this kind ; but the majority of these books are copies and adaptations of Marrell's originals, made by hack artists of no great talent.[3]

[1] Other painters of the seventeenth and eighteenth centuries—Otto Marseus, Mathias Withoos and Peter Snyers for instance—placed plants in a landscape setting, but their purpose was less botanical. For full particulars of the flowers in van der Vinne's painting, see an article by van Ooststroom (1946).
[2] See Trimen, H., in *J. Linn. Soc. Bot.* 24 : 129-155 (1887).
[3] Judith Leyster's book, which is dated 1643, is in the possession of Dr. Hoog of Haarlem. Marrell's was purchased at the Krelage Sale (Amsterdam, 1948) for the Archives of Economic History, Amsterdam. A volume of water-colours entitled *Theatrum Tuliparum*, showing tulips which flowered in the Berlin Lustgarten in 1647-48, is now in the Staatsbibliothek, Berlin.

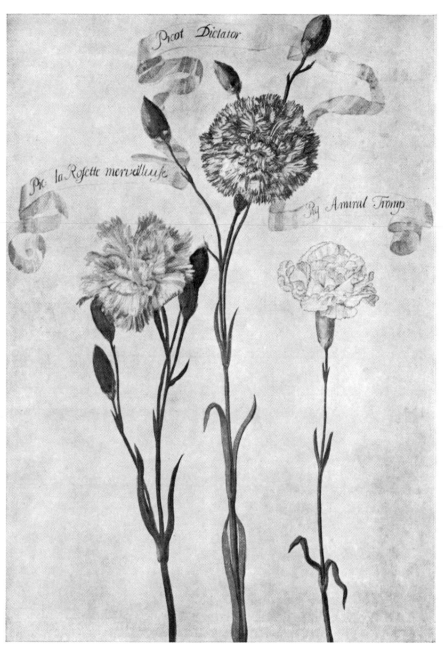

Plate 15 CARNATIONS. Water-colour drawing by Johann Simula, 1720
Natural History Museum, London

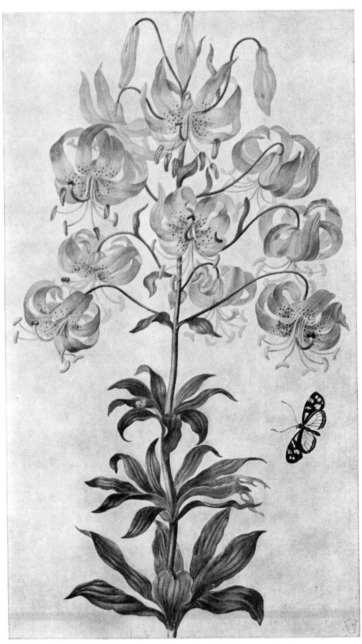

Plate 16 'Affrican Martagon' (*Lilium superbum*)
Water-colour drawing by Maria Merian (1647–1717). British Museum

Of considerable beauty and importance are a number of water-colour florilegia made during the seventeenth and early eighteenth centuries, either by amateurs for their own amusement, or, more often, by professional artists for wealthy patrons. Similar French work of this period has already been considered ; the florilegium painters of Holland, Germany and England, while rarely approaching Rabel in perfection, Robert in brilliance, or Aubriet in strength, produced none the less some admirable picture-books, of which a very full impression may be formed from the study of those in public and private collections in this country.

Earliest in date of those with which I am familiar would seem to be the florilegium made by Pieter van Kouwenhoorn, now in the Lindley Library. These paintings are so mature in style, recalling at moments the work of both Aubriet and Ehret, that were it not for the watermark upon the paper one would hesitate to attribute them to the first half of the seventeenth century ; but this evidence, combined with the fact that the only known Pieter van Kouwenhoorn, a glass painter, was the teacher of Gerard Dou from 1624 to 1626, would seem to be fairly conclusive. The flowers chosen are the usual favourites of the early seventeenth century Dutch garden, and Mr. Stearn tells me that they include no introductions which would indicate a later date for the book ; they are painted in body-colour with the greatest skill, finished down to the smallest detail, and faultlessly drawn. Plate 13 (p. 118) shows van Kouwenhoorn's splendid painting of *Iris pseudacorus*.

Captain Bruce Ingram possesses a rather similar flower-book, made at Leeuwarden by P. F. de Geest. Nothing is known of the artist ; but it is reasonable to suppose that he may have been a son of the Frisian painter Wybrand de Geest (*c.* 1591-*c.* 1660). The book is undated, but both the watermark of the guard-leaves and the varieties of tulips represented suggest that it must have been made about the year 1650. Probably the flowers that de Geest painted grew in the gardens which Willem Frederik of Nassau laid out at Leeuwarden in 1648. One of the plates of this book was reproduced in colour in *The Illustrated London News* (Sept. 25, 1948).

Less professional in character than van Kouwenhoorn's book, but no less attractive, is the florilegium made by Johann Walther for Count Johann of Nassau at Idstein. The castle of Idstein, near Frankfurt-am-Main, had been entirely reconstructed during the opening years of the seventeenth century, but by the end of the Thirty

Years' War the buildings had once more fallen into decay. Count Johann, on his return from exile in 1649, set about repairing the damage. He was a man of taste, with a passionate love of flowers : he founded a picture gallery, redecorated the church, and laid out a formal garden with a summer-house and shell grotto. The rarest flowers were planted, and Johann Walther the Elder, of Strasbourg, was commissioned to record them in paint. The two delightful volumes that he made, after passing in the eighteenth century through the hands of the great horticulturist Lord Bute, are now in the Victoria and Albert Museum, while replicas of the paintings, made for the artist's own collection, are in the Landesbibliothek at Darmstadt.

Walther's flowers, though well drawn, botanically fairly accurate, and vigorous and decorative in treatment, have not the perfection of finish that we find in the best seventeenth century French work ; but I know of few volumes so evocative of a past and golden age of horti-culture. The frontispiece shows us a panorama of the garden, with its trim parterres set with tulips and crown imperials, its edgings of box, its tubs of evergreens, its gilded statues and pavilions. In the fore-ground, proudly posed against the little paradise he had created, stands the Count himself with his wife and young daughter. He is dressed in black—a foil, as it were, to their rich crimson gowns and the brightness of the flowers. To their side the goddess Flora, in fluttering garments of gold and violet, descends to offer a brimming basket of red roses. Detailed paintings follow of the summer-house and grotto, the latter embellished with a fountain, and a painted ceiling with gods and goddesses representing the seven planets.

There are some two hundred pages of flowers, set out much as in Besler's plates but sometimes betraying an absence of his unerring instinct for design :—primulas, foxgloves, peonies, irises, roses, marvel of Peru, carnations—and a yucca which (he proudly notes) boasted 253 flowers on June 23, 1653. A good deal of body-colour has been used, and several of the paintings have been carried out in oils upon a dark-toned paper. Where plants are represented as growing in the ground, no attempt at a naturalistic treatment is made : cut sprays of blossom, stiff as sentries, rise from a boundless plain which is flat and green as a billiard table. The frontispiece of my book shows Walther's picture of a group of carnations, and another painting, of roses, has been used on the dust-jacket.

This charming garden, like that which Besler commemorated, had

its bright but all too brief years of glory. Count Johann's son did not share his father's interests : he disliked Idstein, built a castle for himself on the banks of the Rhine, and died without issue. After the middle of the eighteenth century Idstein rapidly declined, and in May 1795 the occupying French troops completed its desolation. But the memory of its garden lives for ever in the happy pages of the florilegium ; and we may take farewell of its genial creator in the quatrain which Walther inscribed in his honour :

> *Populus Alcida, Platanus gratissima Xerxi,*
> *Regibus Alcinoo et Cyro amor Hortus erat.*
> *Tantorum Heroum Comes æmulus ecce Johannes*
> *Pomonam et Floram Nassoviensis amat.*

Very little is known about Alexander Marshal, the painter of two beautiful folio volumes in the Royal Library at Windsor. The *Dictionary of National Biography* is silent about him ; but we learn from Walpole's *Anecdotes* that he made copies after Vandyke, and " painted on velom a book of Mr. Tradescant's choicest flowers and plants." This book can hardly be identified with the volumes at Windsor, for almost all the paintings in the latter are on paper. A note in an early nineteenth century hand mentions that they were made about 1680 at Haarlem for William of Orange, and adds the suggestion that Marshal might be the son of the Dutch flower-painter Otto Marcellis. All this seems highly improbable, for the only dated drawing—one of the last in the second volume—is stated to have been made in England in 1659. Moreover, the same hand that wrote this date has inscribed English names for most of the flowers, and there is every reason to suppose the writer to have been Marshal himself.

Though a few of Marshal's more formal flower-drawings are to be found in the British Museum, the Windsor volumes appear to be his only important surviving botanical work. Upon 159 sheets, he has portrayed upwards of a thousand different flowers, placed upon the paper without any attempt at design. They constitute, in fact, a botanical notebook, lovingly conceived and skilfully executed. There is an air of intimacy which recalls Le Moyne's little sketches. With such artists we share their own obvious pleasure in creation. Marshal gives first place to the fashionable flowers of the day—tulip,[1] dianthus,

[1] Sixteen of Marshal's drawings of tulips are reproduced in my *Tulipomania* (King Penguin, 1950).

rose, auricula, ranunculus, iris, hyacinth and narcissus. But rarer flowers are not forgotten: there is "the trew figure of ginger as it grew at Fulham;" the figure of *Colutea cruenta* anticipates by half a century the usually accepted date of its introduction; and the lovely Guernsey lily (*Nerine sarniensis*), "sent me by Generall Lambert august 29 1659 fro Wimbleton," is probably the first figure of the flower made in England. In the latter drawing brilliant use is made of touches of gold. Among the most beautiful of the paintings are those of fringed and laced pinks and carnations. Plate 14 (p. 119) shows Marshal's delicate study of an everlasting pea. He died at Fulham in 1682.

A north German florilegium rather like that which Walther made at Idstein was executed by Johann Simula in 1720 for Johann, Imperial Count of Dernatt. More than a thousand flowers are represented, the most popular, with the numbers of varieties shown, being: carnations (62), tulips (54), anemones (47), aloes (47), polyanthus (40), irises (39), hyacinths (35), fritillaries (30) and mesembryanthemums (24). Simula, who always used gouache, was quite a skilful painter with a good eye for colour; his perspective, however, is shaky, and his drawing of insects deplorable. Moreover, though he took considerable pains over the inflorescence, he was inclined to scamp the painting of the foliage. But he shows a pleasant fantasy in placing many of the succulents in Chinese pots, set against a landscape background. The heads of his pale-coloured flowers are surrounded—perhaps by a later hand—by small parallelograms of black paint, a device which serves its immediate purpose but which is not artistically successful. Scrolls containing the names of the flowers add to the decorative effect of the pages. Simula's painting of carnations is shown in Plate 15 (p. 122). The book—a bulky folio with silver clasps—was made at Syrhagen, and is now in the Natural History Museum, London.[1]

[1]The Berlin Staatsbibliothek possesses the following florilegia which, unfortunately, I have not had the opportunity of studying: (1) Florilegium of garden plants, mainly foreign introductions, made about 1640 by the Strasbourg doctor Gallius Luckius (M.Sgerm. fol. 222). (2) Florilegium illustrated by Antonius Carli, Court Painter to the Kurfürst Maximilian Heinrich of Cologne, painted about 1700. Tulips, carnations, etc. (Libri Pict. A.39). (3) *Kurioses Gewächs- und Blumentestament*, made about 1725 by a Mecklenburg gardener named Johann Georg Wagner, and containing 309 illustrations, many of succulents (Libri Pict. A.99). (4) A florilegium of about the same date, in 8 volumes, painted by a medical student named Kribbing (Libri Pict. A.44-51). A replica of this is in Dresden. (5) *Plantae Hortorum Vindobonensium*, consisting of more than 1400 water-colours of foreign plants cultivated in Vienna, painted between 1794 and 1824 (Libri Pict. A. 76-81). These are described by Wegener (1938).

Maria Sibylle Merian (1647-1717), though primarily an entomo-
logist, was certainly one of the finest botanical artists of the period
immediately following upon the death of Nicolas Robert in 1680. A
cosmopolitan—she was born in Germany of a Swiss father and a
Dutch mother—her art derived almost entirely from the great flower-
painters of seventeenth-century Holland.

Maria's father, Matthäus Merian the Elder, was an engraver of
some note. We have already mentioned his edition of the florilegium
of Johann Theodor de Bry, whose daughter he married and whose
business in Frankfurt he thereby acquired in 1624. Here his third child
Maria was born, twenty-six years after the birth of his eldest son
Matthäus.

When Maria was still in infancy her father died, and shortly
afterwards her mother married the Dutch flower painter Jacob Marrell.
Among Marrell's pupils were the famous Abraham Mignon (who had
also worked with J. D. de Heem) and Johann Graff of Nuremberg.
Maria early showed a talent for art, especially in the painting of
insects. Her mother at first opposed her in this ; but recollecting that
during her pregnancy she herself had enthusiastically collected " cater-
pillars, shells and stones," she agreed to her husband's wish that the
girl should be allowed to follow her bent. Maria now began to work
seriously with Mignon ; but when Graff returned in 1664 from six
years study in Italy, she became his pupil, and soon afterwards his wife.
Fontenai makes the curious suggestion that she married him in order
to regularise drawing in his company from the nude.

We know nothing of her early years of married life in Nuremberg ;
but in 1679 she published the first of three volumes on European
insects, illustrated with her own engravings coloured by herself with
the help of her younger daughter Dorothea. The insects are shown in
various stages of development, placed among the flowers and leaves
with which they are associated. The second and third volumes followed
in 1683 and 1717 respectively. The original drawings for the latter,
the work of Dorothea, are in the Library of the Zoological Gardens at
Amsterdam.

An attractive but less well-known work is Maria's *Neues Blumen
Buch* (1680), with delightful hand-painted engravings of garden
flowers. The copy in the Natural History Museum at South Kensington
is coloured with the greatest delicacy, no doubt by her own hand. It
was a grief to me to discover that most of the plates are in fact only

adaptations of those made by Nicolas Robert for his *Diverses Fleurs*. Maria was a skilled needle-woman, and this book of hers, like Vallet's florilegium, was intended to provide models for embroidery, and perhaps also for painting on silk and linen by a method of her own invention which was said to render the material reversible and washable.

In 1685, after seventeen years of married life, Maria left her husband and resumed her maiden name. According to one account, Graff's behaviour, discreditable but unspecified, forced him to fly the country ; but it seems more likely that the real cause was to be found in Maria's conversion to Labadism. At all events, in that year she joined this exclusive sect, which had been founded by the French pietist leader Jean de la Badie, and went with her two daughters to live in their community at the castle of Bosch, in the Dutch province of Friesland. The following year Graff went to Holland in a vain effort to wrest her from the clutches of the Labadists.

There happened to have been deposited in the castle a fine collection of tropical insects which had been brought back by H. v. Sommerdyck from Surinam. Maria wiled away the long Frisian winters in day-dreams of the tropical paradise ; she determined, Goethe tells us, to rival the exploits of the French naturalist Charles Plumier,[1] who, though just her own age, had already visited the West Indies and published his first work on the flora of America. In 1698, she set sail with her daughter Dorothea on the long and perilous voyage to South America.

Surinam at that time comprised the whole territory which is now subdivided into British, French and Dutch Guiana. Maria and her daughter spent nearly two years collecting and painting the insects and flowers there, the result of their labours being the magnificent *Metamorphosis Insectorum Surinamensium*, published in 1705. Most of the plates in it were engraved by Jan Sluyter and Joseph Mulder. Maria's health obliged her to return to Europe sooner than she would have wished ; but her elder daughter, Johanna, went out later to Surinam, furnished her with more drawings and specimens which were used to augment the second edition of the *Metamorphosis*, and remained there

[1] The works of Charles Plumier (1666-1704) were illustrated with his own clear, but rather crude, drawings, copies of which are in the Natural History Museum and at Kew. He insisted upon their being engraved on a large scale and in outline. They serve their purpose, but are not of much interest artistically.

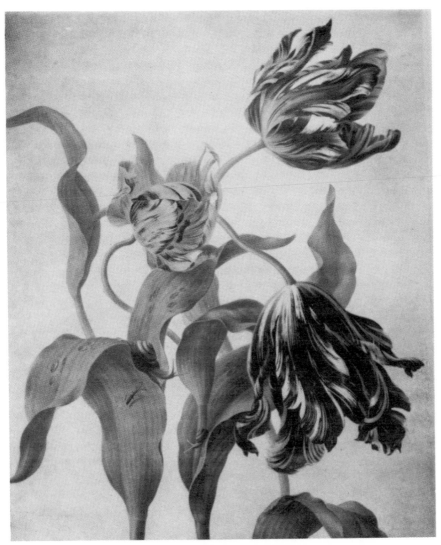

Plate XIX PARROT TULIPS
Water-colour drawing by Herman Henstenburg (1667—1726)
Teyler's Museum, Haarlem

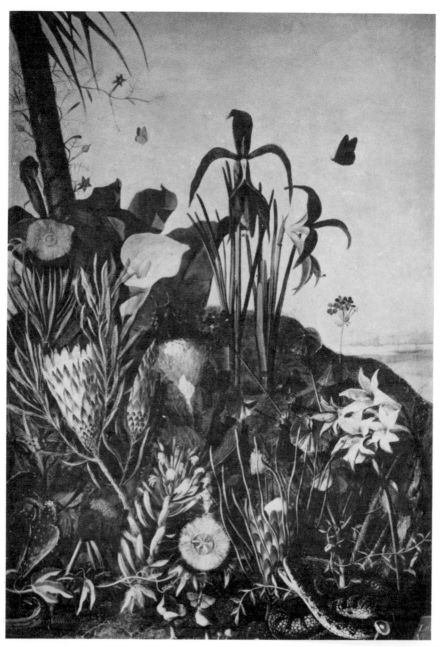

Plate XX PLANTS, mainly from SOUTH AFRICA
Oil painting by Laurens van der Vinne the Younger, *c.* 1737. Leiden University Fund

as the wife of a Dutch trader named Herolt.[1] Maria died in Amsterdam in 1717.

Maria Merian's paintings of tropical and European insects and the plants upon which they feed can be studied in this country in four superb folio volumes, two of which are in the British Museum and two in the Royal Library at Windsor. These include the originals and replicas of the plates in the *Metamorphosis Insectorum Surinamensium* and *Der Raupen Wunderbare Verwandelung*. More of her work is in Leningrad, and at Rosenborg Palace in Copenhagen. In the majority of her paintings it is obvious that the moths and butterflies have been her major interest. These are drawn with very great delicacy ; the flowers, lovely though they often are, rarely if ever attain an equal perfection. Characteristic features of her style are the use of fine line-work to facilitate the task of the engraver ; a preference for transparent colour, sometimes rather gummy in quality ; and a habit of using an *intenser* colour, rather than a more *neutral* tone, in her shadows. Our illustration (see Pl. 16, p. 123) of the "Affrican martagon"—actually the N. American lily, *Lilium superbum*—shows her power as a decorator, but gives only an imperfect idea of her meticulous craftsmanship.

According to James Duncan, who wrote a brief biography of Maria Merian in the *Naturalist's Library* (1836), she was on occasions both gullible and inaccurate. In Plate 16 of the *Metamorphosis*, which shows a branch of the cashew-nut tree (*Anacardium occidentale*), " she has reversed the ripe fruit, and placed it by means of an imaginary peduncle under the leaves, where it never grows." Moreover, Plate 49 presents a remarkable insect " composed of the body of a Tettigonia [leaf-hopper], surrounded by the mitred head of a lantern fly, the manufacture, in all probability, of some cunning negro, who doubtless turned the unique specimen to good account."[2]

James Britten (*The Garden* ; Aug. 28, 1920) has described an important florilegium which was made between the years 1703 and 1705 by " Mr. Kychious " (Everhardus Kickius) for the Duchess of Beaufort. The Duchess was a friend of Sir Hans Sloane, and a keen botanist. The book contains sixty-eight " life-size paintings of plants grown at Badminton. They are splendidly done and the colours as

[1] The British Museum has a skilful water-colour drawing of mice and gourds copied by Johanna after a picture of her mother's. Dorothea, besides being an artist, was a Hebrew scholar. They must have been a gifted family.

[2] A composite insect of this type, produced by an ingenious schoolboy for the benefit of his biology master, was aptly identified by the latter as a " humbug."

good as if done yesterday. A third of the plants figured are species whose first introduction to living collections has hitherto been believed to have taken place at a considerably later date." The book contains pictures of many succulent plants, and a large number of the flowers figured in it come from the Cape ; it would appear to be closely associated with Commelin's *Horti Medici* . . . (see p. 137), a work which is frequently cited by the artist. An unusual feature of the drawings is the representation of the roots of the plant beneath, and in part embedded in, the soil in which they are growing. Kickius, who was obviously a Dutchman, also worked for Sloane, but nothing else seems to be known of his career. This florilegium, and a second and inferior volume made rather later by Daniel Frankcom, a "servant" of the Duchess (and clearly a pupil of Kickius), are still at Badminton.

In an age in which flower-painters concerned themselves almost wholly with cultivated flowers, it is a surprise and a pleasure to encounter the work of Richard Waller (1650 ?-1715). He must, I imagine, have intended publishing a book dealing with our native flora ; but all that survives of his endeavour is a little group of some forty water-colours, about half of which are of grasses, and one engraving. The remaining studies include a number of plants which might seem to afford little scope for the artist—groundsel, stitchwort, yarrow, ragwort and snakeweed, for instance ; but Waller has painted these, in fresh and transparent water-colour, with the same affection that Dürer would have accorded them. Mr. W. H. Robinson has published in *Notes and Records of the Royal Society* (April, 1940) an account of the little that is known of the career of Waller, who appears to have been a city merchant by profession, a capable linguist and a man of great energy. In 1687 he became a secretary to the Royal Society, and papers contributed by him to the *Philosophical Transactions* show him to have been a student of botany, zoology and anatomy. As an artist he must therefore rank as an amateur ; but there is nothing amateur, in a derogatory sense, about his work, which reveals a sureness of touch and a sensibility that few professional painters of the day could command. On Plate 17 (p. 130) is reproduced Waller's study of Knapweed (*Centaurea nigra*) and Cornflower (*C. cyanus*). The folio containing his paintings is preserved in the library of the Royal Society.

No doubt many other florilegia made during this period are scattered about Europe both in private libraries and in public museums;

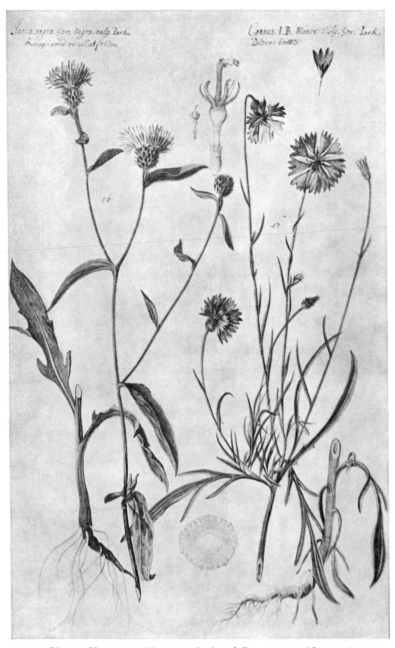

Plate 17 KNAPWEED (*Centaurea nigra*) and CORNFLOWER (*C. cyanus*)
Water-colour drawing by Richard Waller (1650? – 1715). Royal Society, London

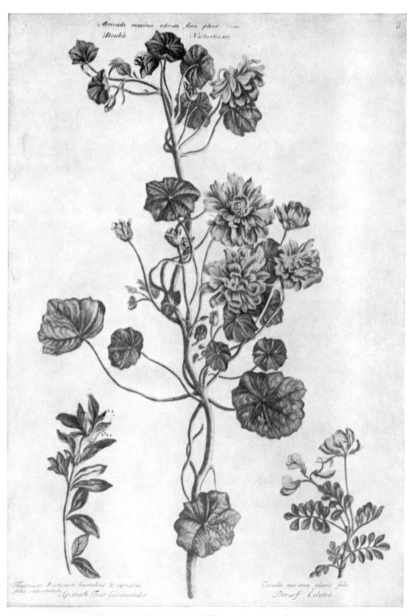

Plate 18 DOUBLE NASTURTIUM (*Tropaeolum majus flore pleno*), etc.
Colour mezzotint after Jacob van Huysum; from *Catalogus Plantarum*, 1730

but it is improbable that the continent can compete, either in quality or in quantity, with those to be found in English collections. These flower-books are a record of an age which can never return—an age when a whole nation went mad about flowers. But the memory of this great epoch is still alive in Holland, where the tradition of bulb cultivation remains the highest in the world ; and a pilgrimage to the bulb-fields is ever one of the greatest pleasures of a spring visit to that delightful and friendly country.

SOME BOTANICAL BOOKS
OF THE LATE SEVENTEENTH AND EARLY
EIGHTEENTH CENTURIES

O F THE various painters whose work we have just considered, the majority seem to have been rarely, if ever, associated with the printed book ; and Maria Merian, though her studies were mostly made for engraving, was an artist of such outstanding quality that her paintings can be judged on their own merits.

We must now draw attention to those artists of the late seventeenth and early eighteenth centuries who were primarily concerned with the making of drawings and engravings for authors of scientific botanical publications.

Jacobus van Huysum (c.1687-1740), a younger brother of the great Dutch flower painter, spent the last twenty years of his life in England, where he made the drawings for most of the plates in two famous, if rather overrated, botanical folios—John Martyn's *Historia Plantarum Rariorum* (1728-36) and the *Catalogus Plantarum* (1730) published by the Society of Gardeners. An album containing some of the original paintings for these two books is in the Library of the Royal Society, and there is more of this work in the British Museum (both at South Kensington and at Bloomsbury). Van Huysum lived at first in Chelsea with Robert Walpole, who employed him in making copies of Old Masters for Houghton ; but after two years " his drunken dissolute conduct occasioned his being dismissed " (Horace Walpole).

John Martyn (1699-1768) had succeeded the unsatisfactory Bradley[1] in the Chair of Botany at Cambridge. The *Historia* was

[1] It was said, rather unkindly, that Richard Bradley (*d.* 1732) obtained the Chair by fraud and lost it by idleness and incompetence. Bradley made his own

designed to figure a number of new plants growing in the Chelsea Physic Garden. Many of these had been introduced from Mexico and the West Indies by a young naval surgeon named William Houstoun (1695-1733), commemorated in the genus Houstonia, who had himself attempted to draw and engrave some of the plants.[1] Van Huysum's drawings were engraved by Kirkall in what is generally called " mezzo-tint printed in colour." The phrase is misleading. True mezzotint entails the roughening of the entire copper plate by a laborious process known as " rocking," for which a fine metal-toothed comb attached to a long rod is employed. A plate thus prepared would print jet black ; and the lights and half-tones are then obtained by scraping away the burr with a knife and polishing with a burnisher. Kirkall achieved a half-hearted imitation of true mezzotint by rather clumsily roughening the toned parts of the plate with a roulette and leaving the rest of it untouched. The so-called " colour-printing " was equally elementary : many of the figures are merely printed in a mossy green and touched with water-colour ; in a few of the others, two or three different coloured inks have been used in a single printing.

The book was issued in parts ; it failed to pay its way, and after fifty-two plates had been published it was discontinued. Unsatisfactory though its engravings were, we must remember that they are an im-portant landmark and the humble predecessors of the magnificent productions of Redouté and Thornton. Among the plates of particular interest may be mentioned the " Helleborine americana " (*Bletia verecunda*)—the first tropical orchid to be cultivated in England. This plant had been grown from the tuber of a " dried " specimen which, showing still some signs of life, was flowered in the garden of Admiral Sir Charles Wager within a year of planting.

The *Catalogus Plantarum* was published by the Society of Gardeners, a Guild or " Trade Union " which had been founded about 1724 to protect the interests of nurserymen. Owing to the confusion which had always existed over plant nomenclature, patrons not infrequently purchased under another name a plant which they already possessed,

drawings for his *History of Succulent Plants,* a work whose appearance was long delayed because " the Spirit of *Botany* was not powerful enough to pay the Expence of Engraving the Copper-Plates." The Spirit eventually engaged the services of a very second-rate engraver. But this work is of importance botanically, and its figures are cited by later authors.

[1]His rather amateur plates were later published by Philip Miller in a volume entitled *Reliquiæ Houstounianæ*.

and indignantly denounced the unfortunate nurserymen as " Knaves and Blockheads." The Society, which included among its twenty members such well-known horticulturists as Fairchild, Robert Furber and Philip Miller, met monthly at Newall's Coffee House in Chelsea to defend their joint interests and to name newly-introduced plants. Five or six years after the foundation, the members decided to publish an illustrated survey of their new introductions. Philip Miller, author of the valuable *Gardener's Dictionary* (1724, etc.), took charge of the work, and drawings for it were prepared by Jacob van Huysum and etched or engraved in " mezzotint " by Fletcher and Kirkall.

Of the four projected volumes—which were to include trees and shrubs, plants, and fruit—only the first was ever issued ; but since some of the plant plates had already been engraved, they were included among those of trees. The hand-coloured etched plates are adequate but not exciting ; the " mezzotints " are no better and no worse than those in Martyn's *Historia*. One of the " mezzotints," printed in green and brown inks and touched up with water-colours, shows the double nasturtium (Pl. 18, p. 131), which was subsequently lost to cultivation and only re-introduced quite recently. Robert Furber, writing in 1732, says : " This Plant we lately received from *Holland* ; but it was first raised in *Italy*, and many Contrivances were used before it could be brought to *Holland* ; it first bore a great Price, and was esteem'd as a great Rarity, and by planting it of Cuttings it is now become pretty plentiful. . . ."

If both these books have received somewhat exaggerated praise, the same may be said of Robert Furber's *Twelve Months of Flowers* (1730), a work which now commands a ludicrously high price in the market. Furber was a Kensington nurseryman, and his publication was a *de luxe* seed catalogue, the first ever produced in England. It is illustrated with twelve large hand-coloured engravings by H. Fletcher after paintings by the Flemish artist Pieter Casteels. Each plate represents one of the months of the year, and shows, in the manner of a Dutch flower-piece, the plants then in bloom. They are numbered and listed, but nothing so sordid as a price is mentioned. The auricula comes first in popularity (twenty-six varieties shown), followed by the

PLATE XXI
C O W S L I P (*Primula veris*). (*a*) Hand-coloured engraving by Elizabeth Blackwell, from her *A Curious Herbal*, 1737-39. (*b*) Coloured paper mosaic by Mrs. Delany, Windsor Castle

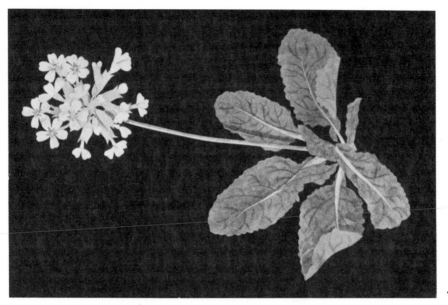

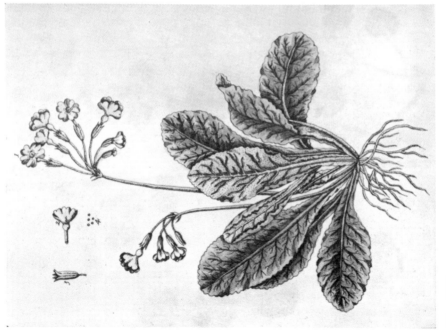

b

Plate XXI a

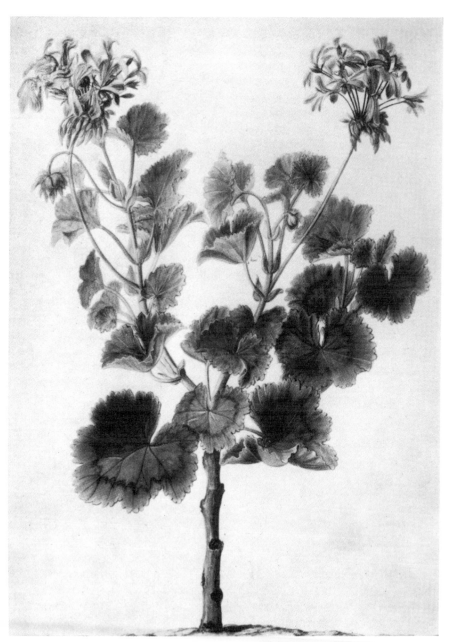

Plate XXII GERANIUM (*Pelargonium* sp.)
Water-colour drawing by Johan Moninckx, *c.* 1690. Hortus Botanicus, Amsterdam

anemone, hyacinth and rose ; and twenty-five American plants are included, among them the Virginia aster *(Aster grandiflorus)* " communicated by Mr. Catesby,[1] a very curious gentleman from Virginia."

Furber's large plates were certainly impressive in their way ; but there is little or nothing to be said for the reduced versions of them which appeared two years later in his *The Flower Garden Displayed*— a work " very Useful, not only for the *Curious* in Gardening, but the *Prints* likewise for *Painters, Carvers, Japaners,* etc., also for the *Ladies,* as Patterns for working, and Painting in Water-Colours ; or Furniture for the Closet." Yet versions of these almost worthless engravings appeared in no less than six publications issued between 1740 and 1760.

Amongst the many other illustrated books which appeared between 1680 and 1740 must be mentioned the works of Morison, Dillenius and Elizabeth Blackwell in England ; of van Rheede tot Draakestein and Commelin in Holland ; of Volckamer and Weinmann in Germany, and of Breyne at Danzig.

The Scottish botanist, Robert Morison (1620-83), is best remembered for his great systematic work, *Plantarum Historia Universalis Oxoniensis,* the first part of which appeared under the title *Plantarum Umbelliferarum Distributio,* in 1672, the third and last part being completed and published after his death by Jacob Bobart the Younger. Many of its illustrations are drawn and engraved by Michael Burghers, a Dutchman who settled in Oxford and was well known for his engravings of architectural subjects. The plates which he made for Morison contain many small figures crowded upon a page—a rather disagreeable economy ; but those of Gramineæ are finely engraved and well worth study.

The German-born botanist Johann Jakob Dillenius (1687-1747), who spent most of his life in this country and became the first Sherardian Professor at Oxford, himself drew and etched the figures for his *Hortus Elthamensis* (1732) and *Historia Muscorum* (1741). The former is an

[1]Mark Catesby (1679 ?-1749), author and illustrator of *A Natural History of Carolina* (1731-43). As an artist Catesby was a conscientious amateur. He always drew from the living plant " fresh and just gather'd." Finding it too costly to have his drawings engraved in Paris or Amsterdam, he took lessons in etching from " that inimitable Painter Mr. *Joseph Goupy* " and did the work himself. The original drawings for *A Natural History of Carolina* are in the Royal Library at Windsor. Though the large majority of them (including all those delightful ones showing fish among the branches of trees !) are by Catesby, a few are the work of Ehret.

illustrated catalogue of exotic and newly-introduced plants growing in the gardens of James Sherard at Eltham, the latter an important monograph on mosses. In his preface to the *Hortus Elthamensis* the author writes : " The figures, except where otherwise indicated, are all drawn from life and to the natural size. Let those who know the plants, and are not ignorant of pictorial art, be their judge ; for my own part I am satisfied that I have taken every care to make them accurate, and when I was certain that they were correctly drawn, I was prepared to undertake the work of engraving, however tedious, so that they might be accurately printed." That Dillenius took such pains over the accuracy of his plates has indeed been fortunate for later botanists. Linnæus based many of his names on Dillenius's work, which remains of permanent value for the interpretation of some Linnæan species. This is particularly true of his illustrations of mesembryanthemums. As an artist, Dillenius must be rated an unusually gifted amateur : in his *Hortus*, a comparison of his own engraving of a yucca (Pl. 323) with that of another yucca made by a professional German engraver (Pl. 324) clearly shows the limitations of an amateur technique. A copy of the book coloured by Dillenius himself was bequeathed by him to the Bodleian Library.

With Mrs. Elizabeth Blackwell, artist and engraver of *A Curious Herbal* (1737-39), we become entangled in a little drama of heroism, intrigue and torture which seems strangely out of place in the sober chronicles of botanical illustration. Dr. Alexander Blackwell, Elizabeth's husband, had abandoned medicine and was on the way to becoming a successful printer, when his prospects were suddenly blighted by a combination of London printers who resented the fact that he had never been apprenticed to the trade. Condemned to a debtors' prison, Alexander might have languished there indefinitely had not his wife gallantly come to the rescue. Learning from Sir Hans Sloane that a herbal of medicinal plants was needed, she took a lodging near the Chelsea Physic Garden and set about making the drawings and engravings which have made her famous. From his prison cell Alexander assisted with the text ; and so successful was their joint venture that two years later he was released.

It would be pleasant to be able to relate that the re-united pair lived happily ever after. For a time, indeed, all went well : we find Alexander acting as agent to the Duke of Chandos, and compiling a work on *A New Method of improving Cold, Wet, and Clayey Grounds* ; then

he turns up in Sweden, dividing his attention between agriculture and quack medicine. But eventually he contrived to become involved in a conspiracy to alter the Swedish succession. He was arrested, charged with treason, and condemned to be variously tortured and then broken alive on the wheel, a sentence which was finally commuted to one of decapitation. He remained in good spirits to the last : on the scaffold, " having laid his head wrong, he remarked jocosely, that being his first experiment, no wonder that he should want a little instruction."

The fate of Elizabeth is unknown. Her book had considerable success, and was re-issued, in an enlarged form with re-engraved plates, by Dr. Trew of Nuremberg in 1757-73. Her five hundred hand-coloured etchings, one of which is reproduced on Plate XXIa (p. 134), are not worthy of their reputation ; they are the work of an industrious amateur, and show no touch of genius.

Van Rheede tot Draakestein's *Hortus Indicus Malabaricus* (1678-1703) one of the most celebrated of pre-Linnean books, was published at Amsterdam in twelve bulky folios. Garidel states that the plates were drawn and engraved by Father Mathieu, a Neapolitan Discalced Carmelite ; but van Rheede himself, who was Governor of Malabar, may have had some hand in making the drawings. The engravings are very decorative, the line-work coldly brilliant ; their calligraphic quality compensates in part for their severity and lack of charm.

But a finer work from the Dutch presses is Commelin's *Horti Medici Amstelodamensis Rariorum Plantarum Descriptio et Icones* (1697-1701), with its sumptuous heraldic title-pages and its prim but beautifully hand-painted engravings. The original paintings made for the illustration of this and other books by the two Commelins, mainly the work of Johan and Maria Moninckx, may be seen in the Library of the Hortus Botanicus, Amsterdam. Many of the plants, like those of Walther, rise stiffly and rather comically from the soil, masquerading as little trees ; but the detail is very finely executed, and the engravers, who have taken considerable liberties with the drawings, have not succeeded in giving any idea of the quality of the originals. Johan's study of a geranium is shown on Plate XXII (p. 135). Jan Commelin was Director of the Amsterdam Physic Gardens ; he died in 1698, and the second volume of his work was completed by his nephew Caspar Commelin. Linnæus appropriately named the genus Commelina in their honour,

for, as he explains in his *Critica Botanica* : " *Commelina* has flowers with three petals, two of which are showy, while the third is not conspicuous : from the two botanists called Commelin : for the third died before accomplishing anything in Botany " (transl. Arthur Hort).

These expensively produced folios, like the drawings made for Rumphius at Amboyna and for Hartog at the Cape, reflect the interest shown by the Dutch in the flora of their colonial possessions.

Turning to Germany, Johann Christoph Volckamer's *Nürnbergische Hesperides* (1708-14) deserves mention although it deals primarily with fruit. The model for it was probably Ferrarius's *Hesperides* (Rome, 1646) ; but whereas Ferrarius's beribanded bunches of fruit and flowers are set against a plain background, Volckamer has filled in the lower part of his plates with delightful views of the gardens and palaces of Germany, Austria and Italy. Volckamer, who was a wealthy Nuremberg merchant, had a fine orangery, and engaged a variety of artists and engravers—among the latter being Paul Decker—to execute his plates, which are uncoloured.

Johann Weinmann was the director of the longest established pharmacy in Regensburg. His *Phytanthoza Iconographia* (1737-45), a vast work in eight folio volumes with over a thousand hand-coloured engravings representing several thousand plants (see Pl. 19, p. 142), forms an interesting and valuable eighteenth century florilegium. For many of the illustrations the engraver, J. J. Haid, attempted the mock mezzotint method used in England by Kirkall. Among the artists employed was Ehret, whose work will be discussed in the following chapter. As a whole, the volumes impress us more by their size than their quality ; but they are certainly a memorable achievement. There are some amusing plates of cactuses in brightly coloured pots.

The Danzig botanist Jakob Breyne (Breynius) illustrated his *Exoticarum . . . Centuria Prima* (1678-89) with some beautiful little plates, one of which is shown in Figure 47. A. Stech was responsible for making the drawings, which were engraved by Isack Saal.

In Germany during the eighteenth century, a number of books were illustrated by " nature printing "—a process discovered in the fifteenth century (see Fischer, 1929) and improved about 1730 by D. Bruckmann. Some of the various methods employed

Plate XXIII Thorn-apple (*Datura stramonium*)
Nature-printing from Von Ettinghausen, *Physiotypia*, 1853—73

Plate XXIV 'Ketmia indica' (*Hibiscus cannabinus*)
Water-colour sketch by Georg Ehret, 1742. Natural History Museum, London

are described by Henry Bradbury, himself one of the last exponents of the art, in his *Nature Printing and its Origin and Objects* (1856):

> The process adopted to produce such results at this period (1650) consisted in laying out flat and drying the plants. By holding them over the smoke of a candle, or an oil lamp, they became blackened in an equal manner all over; and by being placed between two soft leaves of paper, and being rubbed down with a smoothing bone, the soot was imparted to the paper, and the impression of the veins and fibres was so transferred. . . .

Linnæus in his *Philosophia Botanica*, relates that in America in 1707 impressions of plants were made by Hessel and later (1728-1757) Professor Kniphof at Erfurt (who refers to the experiments of Hessel) in conjunction with the bookseller Funke established a printing office for the purpose. He produced a work entitled *Herbarium Vivum* (1764). The range and extent of this very rare work in twelve folio volumes with 1200 plates, corroborates the curious fact of a printing office being required. These impressions were obtained by the substitution of printer's ink for lampblack and flat pressure for the smoothing bone. But a new feature at this time was introduced—that of colouring the impressions by hand according to Nature, a proceeding which though certainly contributing to the beauty and fidelity of the effect, yet had the disadvantage of frequently rendering indistinct and even of sometimes totally obliterating the tender structure and finer veins and fibres. Many persons at this time objected to the indistinctness of such representations and the absence of the parts of fructification. But it was the decided opinion of Linnæus that to obtain a representation of the difference of species was sufficient.

In 1748 Seligmann [Pritzel 9498], an engraver at Nuremberg, published, in folio plates, figures of several leaves he had reduced to skeletons. As he thought it impossible to make drawings sufficiently correct, he took impressions from the leaves in red ink, but no mention is made of the means he adopted. Two black and twenty-nine red plates of leaves had been already completed, and were published with eight pages of text in which his coadjutor Trew speaks of the physiology of plants and Seligmann of the preparation of leaf skeletons. The leaves represented on the plates were those of the Orange, Lemon and Shaddock, etc.

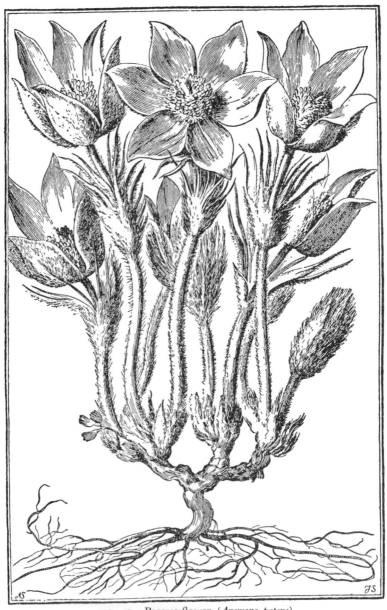

FIG. 47—Pasque-flower (*Anemone patens*)
Engraving from Breyne, *Exoticarum . . . Centuria Prima*, 1678-89

In the year 1763, the process is again referred to in the *Gazette Salutaire*, in a short article upon a " Recette pour copier toutes sortes de plantes sur papier."

About 25 or 30 years later Hoppe edited his *Ectypa Plantarum Ratisbonensium* and also his *Ectypa Plantarum Selectarum* ; the illustrations in which were produced in a manner similar to that employed by Kniphof. These impressions were found also to be durable but still were defective. The production of impressions could only take place very slowly as the blacking of the plants with the printer's ball required much time. Rude as the process was and imperfect as the result, it was nevertheless found that the figures thus produced were far more characteristic than any which artists could obtain. The fault of the method consisted in its limited application and in its incompleteness ; since the fragile nature of the prepared plant, if ever so carefully treated, would admit of but very few copies being taken and where any great number would have been required, many plants must have been prepared, a circumstance which in itself was a great obstacle.[1]

Some of these works illustrated by nature printing have considerable charm, especially where the process has been used to record grasses, ferns and delicately formed plants. In one or two of the later books, a return was made to black-and-white : the *Flora Berolinensis* (1757) is wholly printed in monochrome, as is also Hoppe's lovely *Ectypa Plantarum Ratisbonensium* (1787-93), one of the finest of the whole series. Copies of both these, as well as of Kniphof's[2] *Botanica in Originali seu Herbarium Vivum* ... (1747 ; Linnean name ed., 1757-64), can be seen at Kew. In the middle of the nineteenth century the method was still further improved upon by the craftsmen of the Vienna Imperial Printing Office. By passing the plant, under pressure, between a plate of soft lead and one of steel, an impression was obtained upon the lead from which an electrotype could be made. Von Ettingshausen and Pokorny's monumental *Physiotypia*, with one thousand monochrome plates, was printed thus and issued in Vienna between 1855 and 1873

[1] Quoted by Dunthorne, whose book is now so difficult of access that it seems worth while to reproduce the passage.

[2] It is somewhat ironic that the exponent of this rather sombre method of botanic illustration, Johann Hieronymus Kniphof (1704-63), should have his name commemorated in our gardens by the gay and brilliant red-hot pokers of the genus Kniphofia.

(see Pl. XXIII, p. 138). In England, the same technique was employed by Bradbury, with colour, when he came to make the illustrations for W. Johnstone's book on British seaweeds and for T. Moore's superb *Ferns of Great Britain and Ireland* (1857). These splendid Austrian and British volumes, whose plates record the smallest details of flowers and the finest venations of leaves, constitute the crowning achievement of nature printing; for though the "photoxygraphic" plates in the twenty-five volumes of the *Herbier de la Flore Française* of Louis Antoine Cusin (1824-1901) and Edme Ansberque (1828-1905), published at Lyons between 1867 and 1876, are of considerable botanic importance, they are æsthetically disappointing. It is certainly unlikely that the process of nature printing will ever again be put to serious scientific use.[1]

We may, perhaps, be allowed to conclude this chapter with a brief mention of fossil plants. These are of course the earliest images of vegetable life known to us; and since nature is the sole agent operating in their production they may in a sense be considered as a form of nature printing. Many illustrations of such plants will be found in the article on *Palaeobotany* in the *Encyclopedia Britannica* (11th ed., vol. 20; pp. 524 *et seq.*).

[1]For nature printing see *Typographia Naturalis—a history of nature printing* by Roderick Cave and Geoffrey Wakeman, Brewhouse Press, 1966.

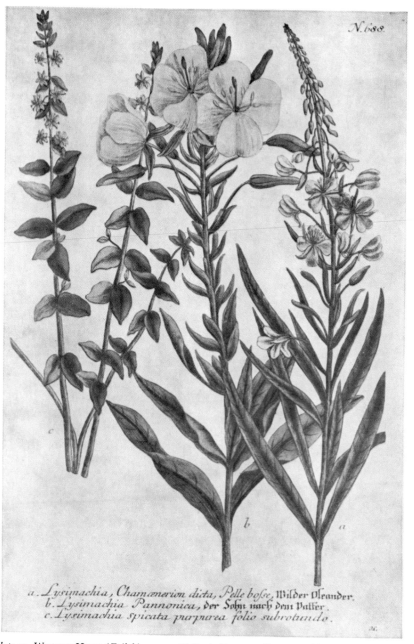

N.680

a. *Lysimachia, Chamænerion dicta, Pelle bosce, Wilder Oleander.*
b. *Lysimachia Pannonica, der Sohn nach dem Vatter.*
c. *Lysimachia spicata purpurea folio subrotundo.*

Plate 19 WILLOW-HERB (*Epilobium angustifolium*), EVENING PRIMROSE (*Oenothera biennis*) and
PURPLE LOOSESTRIFE (*Lythrum* sp.)
Colour mezzotint from J. Weinmann, *Phytanthoza Iconograhia*, 1734 – 45

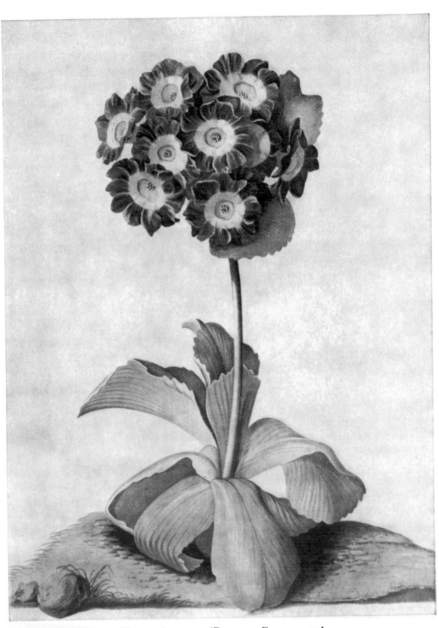

Plate 20 Auricula 'Duke of Cumberland'
Water-colour drawing by Georg Ehret, 1740
Victoria and Albert Museum, London

SEE ALSO COLOUR PLATE C

THE AGE OF EHRET

THE GENIUS of Georg Dionysius Ehret (1708-70) was the dominant influence in botanical art during the middle years of the eighteenth century.

Thanks to a brief autobiographical sketch which Ehret composed in 1758, and some notes left by his friend Dr. Trew, we are tolerably well informed about his early struggles and his gradual rise to fame and prosperity. His parents lived in humble circumstances at Heidelberg where they cultivated the land and sold garden produce. Here their son Georg was born. It was from his father that he received his first drawing lessons ; and when the boy was put to work as gardener's apprentice with his uncle at Bessungen, he continued with his drawing in the little leisure that these " three years of slavery " afforded him. About this time his father died, and shortly afterwards his mother married *en secondes noces* a man named Kesselbach who had care of the two gardens of the Elector of Heidelberg. Young Ehret was now given part charge of one of these gardens ; and it was while he was working there that he attracted the attention of the Margrave of Baden, who took him into his own service.

Ehret spent his leisure painting the Margrave's flowers—the latter was especially proud of his tulips and hyacinths—and so impressed his employer by his " youth, and enthusiasm for painting " that the preferential treatment he henceforward received aroused the jealousy of the other gardeners. Soon his position became intolerable, and he tendered his resignation. The Margrave cursed his staff for a pack of idle, meddling fools, and parted reluctantly with his young protégé.

Passing by way of Nuremberg ("to see their manner of gardening"),

Ehret reached Ulm and worked his passage at the oars to Vienna ; but after a short stay there, he returned to Regensburg. Here he made the acquaintance of Weinmann, for whose *Phytanthoza Iconographia* he was engaged, with starvation wages, to prepare drawings. Weinmann seems to have treated him very badly : when Ehret produced five hundred drawings and asked for his first year's salary, he was told that he should have furnished a thousand, and was sent away with less than half the pittance stipulated. Abandoning such unrewarding labour, he next entered the service of a Regensburg banker named Leskenkohl, with whom he remained for several years. Among other duties, he was given the dreary task of copying the plates of the *Hortus Malabaricus*.

Weinmann's treachery was soon " forgiven and forgotten ; " but Ehret could not conceal his satisfaction when his own collection of plants at last surpassed that of his former employer. The young man was also finding time for his own work, the first fruits of which were 560 drawings of plants which grew in the neighbourhood of Regensburg. These drawings were seen by Dr. Trew, a wealthy Nuremberg physician keenly interested in botany and bibliography, who at once recognised Ehret's talent and who was to become his lifelong patron and friend. Ehret's sketches, being " mostly of common plants on ordinary small writing-paper," were of no use to him ; but he found a purchaser for them, and himself commissioned an unlimited number of large-sized paintings of rare flowers. In 1732 Trew received a first batch of eighty paintings, and soon afterwards artist and patron met at Nuremberg.

Copying the plates of the *Hortus Malabaricus* proved tedious work, and Ehret began to realise that he was wasting valuable time ; after completing the third volume he cut himself adrift and set out once more on his travels. Whenever he stopped he made paintings of the most interesting plants that he came across and despatched them to Trew. At Basle he spent a year helping a certain Herr Burckhardt to lay out a new garden, and met again his old friend the Margrave of Baden who had been driven from his castle by the French. Armed with letters of introduction he next set out for Paris, stopping on the way at Lausanne, Geneva, Lyons and Montpellier. The latter town was in the grip of a heat wave, and the gardens so parched that Trew only received three paintings from there ; but he tells us that the artist's technique had greatly improved. After botanising in Auvergne

Ehret continued on his way to Paris, often travelling on foot and alone. This solitude must have been of his own choosing, for we can clearly see from his pages how readily he made friends when he wished to do so.

Bernard de Jussieu, to whom Ehret bore a letter of introduction, received the young German kindly and fixed up a room for him in his garden-house. But the artist was anxious not to be a burden to his host. It had been his intention to proceed to Holland, and he wanted to be on his way ; at Jussieu's suggestion, however, he went first to England, the proud bearer of a passport signed by Louis XV himself and of a dozen letters of introduction.

In London he met Sir Hans Sloane, and Philip Miller[1] whose sister-in-law he was later to marry, and made a large number of drawings, two hundred of which were sent to Trew. But Holland still called him, and the following year we find him in Leiden. Linnæus[2] was at this time staying with the wealthy banker and garden-lover Cliffort near Haarlem, and Ehret tramped on foot from Leiden to meet the young Swedish botanist. " Linnæus and I were the best of friends," he wrote ; " he showed me his new method of examining the stamens, which I easily understood, and privately resolved to bring out a Tabella of it. . . . With this Tabella I earned some money ; for I sold it at 2 Dutch gulden apiece, and almost all the botanists of Holland bought it of me." It was republished, without acknowledgment of Ehret's authorship, in Linnæus's *Genera Plantarum* (Leiden, 1737) :—" when Linnæus was a beginner," noted Ehret, " he appropriated everything for himself which he heard of, to make himself famous."

Cliffort showed great interest in Ehret's paintings and bought a number of them, paying liberally and without haggling over the price. The artist was also engaged to make the drawings for Linnæus's description of the rare plants in Cliffort's garden (*Hortus Cliffortianus*; 1737). The engravings were made by Jan Wandelaar.

[1] The greatest gardener of his time, author of the monumental *Gardener's Dictionary* (1724, etc.) and *Figures of Plants* (1760 ; illustrated by Lancake, Ehret, etc.).

[2] It is obviously impossible, in a book dealing with the history of botanical illustration, to attempt to give even a sketch of the lives and works of all the botanists whose books have been illustrated with important plates. The reader who wishes to know more about Linnæus will have no difficulty in finding the information that he needs. Other distinguished botanists—e.g. John Ray—have been omitted because the illustrations to their works did not contribute anything of note to the progress of botanic art.

In 1736 Ehret returned to England, which was to be his home for the rest of his life ; as with his senior contemporary Handel, England and Germany can therefore claim a joint share in the development of his genius. In London his principal friend was Dr. Mead, the Royal Physician, who purchased two hundred of his drawings, at a guinea apiece, and did much to help him to become known. The Duchess of Portland[1] (Prior's " My noble, lovely little Peggy ") patronised him, and Sir Hans Sloane engaged him to draw figures for the *Transactions of the Royal Society.*

Ehret tells us all too little of his life in London, though we catch an occasional glimpse of his youthful enthusiasm, as, for instance, when he relates that one August he walked every day from Chelsea to Fulham and back, so as to study the opening of the buds of a new magnolia—clearly *Magnolia grandiflora*—in Wager's garden. By the middle of the century he had become a popular figure in London society : the " highest nobility in England " clamoured to receive instruction from him, and in his autobiography he proudly inscribes the names of the duchesses and countesses whom he numbered among his pupils. " If I could have divided myself into twenty parts," he adds, " I could still have had my hands full." Among all his other occupations he found time to make botanical drawings, and sometimes even to engrave them also, for three florilegia and various books of travel. During the season he gave lessons in London, and at the end of June began a round of visits to the great homes in England. It was while he was at the Portlands' that an emissary arrived from Copenhagen bearing an advantageous offer of a life appointment at the Danish court. Ehret was flattered ; but—with a glance, perhaps, at the stately galleries of Bulstrode and its charming hostess—he declined the honour. In 1750, he expressed the desire to " enter " the Botanic Gardens at Oxford (presumably in the capacity of draughtsman), and was elected without difficulty ; but, finding the petty jealousies of university life uncongenial, the following year—to the great delight of his London pupils—he resigned. In 1757, he was made a Fellow of the Royal Society, and was the only foreigner on the English list. This peculiar honour was not without its disadvantages, for he notes :

[1]The Duchess of Portland was an ardent patron of botanists and an enthusiastic collector of objects of natural history ; the sale by auction of her collection in 1786 lasted thirty-eight days. Her tastes were transmitted to many of her descendants. Her granddaughter, Louisa, Countess of Aylesford (1760-1832) made nearly 3000 flower studies ; these are now in the possession of the Countess of Dartmouth.

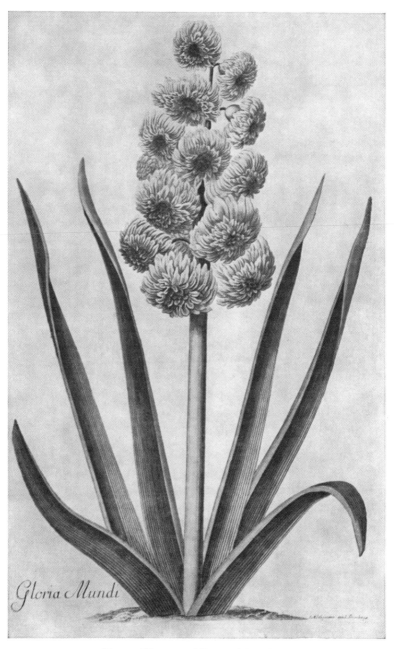

Plate 21 Hyacinth 'Gloria Mundi'
Hand-coloured engraving by M. Seligmann from Trew, *Hortus*, 1750 – 86

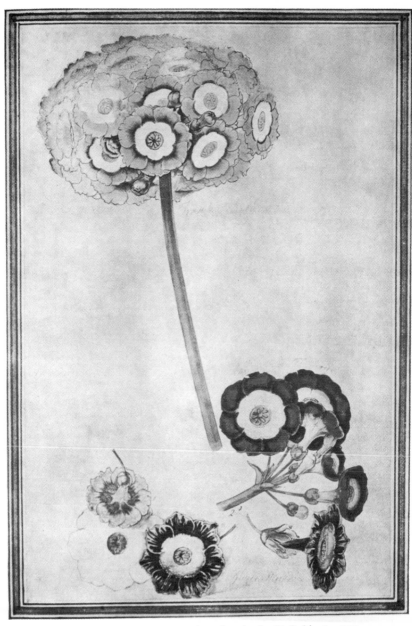

Plate 22 AURICULAS. Water-colour drawing by T. Robins, *c.* 1770
Collection of Major the Hon. H. Broughton

" N.B. But, according to English custom, I had to pay 25 guineas to the Society on my election. Foreigners [i.e. Foreign Members also resident in foreign countries] do not pay."

In the autobiography of Mrs. Delany, whose work we shall discuss in a moment, there are several references to Ehret in the closing years of his life :

Bulstrode. Oct. 4, 1768. Mr. Ehret is very busy for the Duchess of Portland, he has already painted above *a hundred and fifty English plants,* and now they are collected together their beauty is *beyond* what we have a notion of, particularly the water plants ! but poor Ehret begins to complain of his eyes, he has hurt them with inspecting leaves and flowers in the microscope in order to dissect them.

Sep. 17, 1769. Mr. Ehret . . . goes out in search of curiosities in the fungus way . . . and reads us a lecture on them an hour before tea, whilst her grace examines all the celebrated authors to find out their classes. This is productive of much learning and of excellent observations from Mr. Ehret, uttered in *such* a *dialect* as sometimes puzzles me (though he calls it English) to find out what foreign language it is.

Ehret died in London the following year, at the age of 62.

Ehret had an admirable habit of signing and dating his drawings ; it is therefore possible to trace the development of his style. The earliest painting that I have been able to discover, was made at Regensburg in 1730 : it is fairly large, and on good quality paper ; it may perhaps be one of the batch of drawings which Trew received in 1732. The workmanship is not very distinguished : the leaves and flowers are flat, the conception formal ; and the sprays of blossom are festooned with riband in the manner of Volckamer's *Nürnbergische Hesperides.* But by 1740 the artist had made himself complete master of his technique, and during the next ten years an endless flow of magnificent paintings came from his brush. This was his greatest and most productive period, for in later years his pupils made a great demand upon his time.

The finest work of the forties may best be studied in a group of wonderful paintings in the Print Room at the Victoria and Albert

Museum, while his later work is well represented at Kew. Major Broughton also possesses two splendid volumes of original paintings. Ehret shows himself equally at home with every kind of cultivated flower, though the gayest and most spectacular give the greatest scope to his genius. He has made particularly his own, the bright, flaunting flowers that Rapin[1] loved : the iris with its " endless pomp ; " the crown imperial's " gay gilded front ; " tulips that " emulate the vary'd agate's veins ; " the rose—" the garden's queen in all her glory ; " the " matchless pride " of carnations ; and the ranunculus's " rich attire." Amongst his most unforgettable triumphs are the auriculas, flecked with white meal and glowing with rich colour (see Pl. 20, p. 143). Two paintings at Kew, made during the last year of his life, show that, in spite of the trouble which his eyes had been giving him two years earlier, his sight remained virtually unimpaired and his hand unfaltering to the end.

Ehret always preferred vellum to paper, and body-colour to transparent wash, for his most important work ; and he not infrequently painted his smaller plants rather above life-size to enhance their impressiveness. His approach was a fine compromise between that of the artist and that of the scientist : he did not slavishly imitate what he saw, as do so many botanical draughtsmen with a purely scientific training ; nor did he allow his feeling for colour and design to distract him unduly from the fundamentals of plant structure. Artists and botanists alike, therefore, join in praising his work. If he has not the exquisite sensibility of Dürer, the enamel-like finish of Robert, or the poetic charm of Redouté, he has none the less his own particular qualities—a sureness of touch, vigour of handling, and an unerring instinct for design. At times his crisp, almost metallic forms recall the work of Aubriet.

Ruskin, in *Fors Clavigera*, laments the waste of " exquisite original drawings and sketches of great botanists, now uselessly lying in inaccessible cupboards." Such has been Ehret's fate : his pictures lie unseen and unsung, while the public pours extravagant praise upon (and pays fantastic prices for) the hack colour-plate books and sentimental trifles of the early nineteenth century. Ehret's pictures are splendid decorations and would look magnificent upon a wall ; is it too much to hope that the museums which own them will give the public more opportunity of becoming familiar with them ?

[1]Rapin, René, *Of Gardens ; a Latin poem* (transl. J. Gardiner, 1706 ?).

A number of Ehret's sketch-books, covering the years between 1746 and 1750, came into the hands of Sir Joseph Banks and passed with his extensive botanical collections into the archives of the British Museum. These books, which are now in the Natural History Museum, are the earliest records which we possess of the day-to-day jottings of a great botanical artist, and are therefore of unique interest. They reveal a delicacy and a sensibility which are sometimes sacrificed in the large finished paintings on vellum. Even the smallest and swiftest drawings —the study of a fir-cone or a seed-pod—show the close observation and sureness of touch of a great draughtsman. To handle the pages of these intimate little notebooks is to experience the infinite joy of making contact with the mind of their creator. Plate XXIV (p. 139) shows a study of " Ketmia " (*Hibiscus cannabinus*) from one of the larger sketch-books.

Ehret's most important engraved work is to be found in his own *Plantae et Papiliones Rariores* (1748-59), and in Trew's *Plantae Selectae* (1750-73) and *Hortus ... Amoenissimorum Florum* (1750-86). He furnished botanical drawings, some of which he also engraved, for Pococke's *Description of the East* (1743-45) ; Hughes's *History of Barbadoes* (1750) ; Ellis's *Natural History of the Corallines* (1755) ; Russell's *Natural History of Aleppo* (1756) ; and Browne's *Civil and Natural History of Jamaica* (1756). Many of the drawings had no doubt to be made from dried specimens. These travel books need not detain us long : Ehret, as an engraver, was usually competent but uninspired ; and the other engravers who collaborated with him were no better. But that he himself was well thought of by his contemporaries, is testified by the fact that Browne offered him, in vain, double the customary remuneration to engrave the drawings for his history of Jamaica.

The plates in *Plantae et Papiliones Rariores*, which were drawn, engraved and published by Ehret himself, are ambitious, and greatly superior to those in the travel volumes. They are skilfully etched, and the hand colouring is carried out with considerable care. Trew's *Plantae Selectae* contains a hundred figures, some showing plants which have little to recommend them beyond their novelty ; and portraits of Trew, Ehret, and the engraver Haid who was responsible for carrying out the flower-plates. There are interesting engravings of botanical details of the fig, magnolia, etc., but it is hard to agree with Nissen's verdict that it is " the finest botanical work ever printed in Germany."

Trew's *Hortus* is one of the most decorative florilegia of the mid-eighteenth century. It aimed at presenting "a complete collection of the most magnificent tulips and crown imperials; the sweetest hyacinths, daffodils, narcissi and jonquils; the most charming roses, carnations and snowflakes; and the loveliest lilies, fritillaries, ranunculuses, anemones and auriculas." Ehret was only one of the many collaborators; for Nuremberg, after London, was the most important centre of botanical art of the day, and the patronage of Trew had brought into being a fine team of local artists. Among these may be mentioned J. C. Keller, who was Professor of Drawing at Erlangen University; the court painter Nikolaus Eisenberger; Magnus Payerlein; G. W. Baurenfeind; and Dietzsch who usually worked in opaque colour upon a paper of deep nigger brown. Plate 21 (p. 146) shows F. M. Seligmann's figure of a hyacinth.

Johann Sebastian Müller (1715—*c.* 1790), another Nuremberg artist, left his fatherland for London where he changed is name to John Miller. There he embarked upon several ambitious botanical publications "not set on Foot meerly with a lucrative View;" but lack of funds soon put a stop to their continuance. He also worked for Philip Miller. John Miller made the excellent plates for the *Illustration of the Sexual System of Linnæus* (1777), a work which Linnæus himself considered "more beautiful and more accurate than any that had been seen since the world began" (see Pl. XXVa, p. 160). A fine copy with proofs before letters is at Kew. The plants represented are mostly common ones, arranged, of course, after the Linnean classes and orders. Miller's *Botanical Tables containing the Different Familys of British Plants*, which is said to have cost Lord Bute £12,000 and of which only twelve copies were printed, deserves mention, if only for its futility. One copy is in the Lindley Library. More than a thousand of Miller's original drawings are in the Natural History Museum, London. In 1772, John Frederick Miller, John Miller's son, and another botanical and marine artist named John Cleveley, accompanied Sir Joseph Banks in his expedition to Iceland.[1] The talented G. Metz (*fl.* 1775) was presumably another German artist attracted to England by the renown of Banks.

Most of the work of Ehret's aristocratic pupils seems to have perished, and we may reasonably doubt the seriousness of its loss. But several artists of distinction, who may or may not have studied

[1]Not Ireland, as stated in the *Dictionary of National Biography.*

with him, certainly came under the influence of his genius. Peter Brown (*fl.* 1758-99), court painter to the Prince of Wales, and Simon Taylor (*fl.* 1760-77) both worked at times in a manner close to Ehret's, though they never quite achieved his brilliance. Kew Herbarium and the Natural History Museum contain fine examples of Taylor's work.

One or two other English artists of the period deserve mention. William King of Totteridge painted the flowers in Collinson's garden with some skill, and James Bolton, the self-taught Halifax botanist, proved himself a talented amateur. Frederick Polydore Nodder (*fl.* 1777-1800), Botanic Painter to Queen Charlotte, made illustrations for Erasmus Darwin's *Botanic Garden,* and a number of delicate little plates for T. Martyn's *Flora Rustica*—a volume dealing with " plants useful or injurious to husbandry "—and other works. There are some skilful but rather stiff original drawings by him both at Kew and in the Natural History Museum.

Sydney Parkinson (*c.*1745-71), a woollen-draper by profession, owed his advancement to Banks, who sent him to draw at Kew. In 1768 he accompanied Cook, Banks and Solander round the world, making interesting records of the plants and animals of the South Seas. He died in 1771 in the Indian Ocean. Parkinson produced finished drawings from the rough sketches which he made in Tierra del Fuego and the Friendly Islands ; the rest of his sketches were redrawn and completed by Nodder, John Cleveley, John Frederick Miller, and the latter's brother James Miller. Though many engravings were prepared, Banks never published his account of the expedition ; but in 1905 James Britten had lithographs made from some of the plates, for his *Illustrations of Australian Plants collected in 1770 during Captain Cook's Voyage*. . . . All the rough sketches, finished drawings, engravings and lithographs are now in the Natural History Museum. The engravings are disagreeably mechanical, but many of the drawings, both in their rough and in their finished states, are of considerable beauty and interest. Johann Georg Forster (1754-94), another protégé of Banks's, accompanied Cook as artist on his second voyage (1772-75) ; his work is far inferior to that of Parkinson.

Of T. Robins (*fl. c.* 1768) I have been able to discover no bio-graphical details. This is doubly disappointing, for his work shows him to have been a botanical artist of a very high order. I can hardly bring myself to believe that the creator of the lovely album of paintings and the two big " Dutch " flower-pieces in Major Broughton's

collection is the same T. Robins who, thirty years later, drew the rather dreary illustrations to Sole's *Menthae*. Who, also, is the T. Robins who made topographical drawings of Bath ? Is he to be identified with either of these ?

Major Broughton's album contains over a hundred paintings, many of garden flowers newly introduced into this country. One is struck immediately by the modernity of the technique : a casual observer might well attribute the work to an artist of the twentieth century. The painting is mainly transparent, though effective use is sometimes made of thick dots of opaque white. The drawing is exceptionally sensitive and delicate, and the brushwork crisp ; the treatment decorative, but without sacrifice of naturalism. An unusual feature is the use of the finest possible coloured outlines to the leaves and flowers. It is interesting to compare Robins's study of auriculas (Pl. 22, p. 147) with Ehret's more finished painting of the same subject (Pl. 20. p. 143) ; each is, in its own way, perfect. The two "set pieces" are a considerable *tour de force*, and almost reconcile one to the use of water-colour for elaborate large-scale compositions of this kind. The works I have mentioned constitute, so far as I am aware, the whole known opus of this very attractive artist.

There are few more fascinating, or more ludicrous, figures in the scientific world of this period than " Sir " John Hill (1716 ?-75). Apprenticed as a youth to an apothecary, in due course he set up his own shop in London. But sighing uneasily after wealth and fame, he soon broke loose and embarked upon a series of enterprises which brought him neither the one nor the other. Garden-planning, botanizing, acting, play-writing, serious literature and the more scurrilous kinds of journalism proved equally unrewarding. He libelled Christopher Smart, who revenged himself in his *Hilliad* upon the " Pimp ! Poet ! Paffer ! 'Pothecary ! Player ! "; he abused Garrick, and was invariably worsted in a prolonged battle of wits. In 1759, he began his *magnum opus, The Vegetable System*, which was issued during the next sixteen years in twenty-six folio volumes containing 1600 engravings of 26,000 different plants. Financially, the enterprise was a total failure ; but Hill's perseverance did not go wholly unrewarded : in 1774, he received from the King of Sweden the Order of Vasa. To recoup his losses, " Sir " John now turned to quack medicine. " In a chariot one month, in jail the next," he made

and lost substantial sums with his " essence of waterdock," " tincture of bardana " and " pectoral balsam of honey." He died in 1775 from gout, a complaint for which he professed to have discovered a sovereign remedy.

One of Hill's books is not wholly without merit : his *Flora Botanica* (1760), a shoddy adaptation of Ray's *Synopsis*, was the first work by an English writer arranged according to the Linnean system. Moreover, the artists whom he employed to make the plates for his *Exotic Botany* (1759) and other illustrated folios certainly produced some highly decorative—if highly fanciful—flower pictures. There is no space here to list the rest of his seventy or eighty published works. The trouble with Hill—as Dr. Johnson told His Majesty—was simply this : he was " an ingenious man, but had no veracity."

Outside England and Germany, botanical art was making no conspicuous advance. In France, the noble traditions of the Jardin Royal were being to some extent maintained by Madeleine Basseporte, who had succeeded her master, Aubriet, in 1735 as *Peintre du Roy, de son Cabinet et du Jardin du Roy*. Mlle Basseporte (1701-80), the daughter of a wine merchant, at first supported her widowed mother by portrait painting, but soon found her *métier* as a painter of flowers. For many years she worked in close contact with Bernard de Jussieu, an alliance which gives her paintings botanical value. She became a figure of some importance at court : Louis XV used to watch her at work, and employed her to teach his children ; and Mme de Pompadour summoned her frequently to Bellevue, not only to paint flowers, but to give advice on interior decoration. Her success, which was greater than her talent justified, did not turn her head : she remained simple and warm-hearted, giving instruction without payment to a number of poor girls, several of whom, thanks to her help, made good careers for themselves. She herself painted to the year of her death, proudly inscribing "âgée de 80 ans " upon the last shaky productions of her brush. It is unfortunate for her reputation that so much of her later, and very inferior, work should have found a place in the Muséum alongside the wonderful paintings of Robert, Aubriet, van Spaëndonck and Redouté.

Perhaps the most impressive French botanical book of the period is François Regnault's *La Botanique* (1774) in three folio volumes illustrated with nearly five hundred hand-coloured etchings. Many

of these plates are the work of Geneviève de Nangis Regnault. The book deals with useful and decorative plants ; and the author engagingly describes the potato as " possibly the only good thing that ever came out of America." De Sève's *Recueil de Vingtquatre Plantes et Fleurs*, illustrated by himself, is also admirable. Pierre Bulliard's *Herbier de la France* (12 vols., 1780-95) is another attractive work, illustrated with coloured engravings which are both delicate and accurate ; many of them are printed from several colour plates, a technique rarely employed for botanical books. The curious plates in Gautier-Dagoty's *Collection des Plantes* (1767), which are printed by the Le Blond three-colour process, should also be studied.

No account of the botanical art of the period would be complete without some mention of the cut-paper flowers and silk embroideries of Mrs. Delany (1700-88).

" I have heard Burke say," wrote Dr. Johnson, " that Mrs. Delany was the highest bred woman in the world, and the woman of fashion of all ages." She moved gracefully through the great salons of the eighteenth century, and was at ease in the courts of kings. The Duchess of Portland (see p. 146), whose passion for natural history won the admiration of her contemporaries, was her intimate friend. At Bulstrode, Mrs. Delany botanised with her hostess and the worthy Mr. Lightfoot, author of the *Flora Scotica* ; or together the three would arrange the cabinets of birds' nests and eggs, sort the spars and minerals, or marvel at the strange wisdom of the Creator as they gazed at the " extraordinary *vegetable animals* . . . of the polipus kind " which not only survived, but multiplied, in their sea-water tanks.

The origin of Mrs. Delany's paper mosaics of flowers (see Pl. XXIb, p. 134), so much admired in their day, was as follows : " Having a piece of Chinese paper on the table of bright scarlet, a geranium caught her eye of a similar colour, and taking her scissors she amused herself with cutting out each flower, by her eye, in the paper which resembled its hue ; she laid the paper petals on a black ground, and was so pleased with the effect that she proceeded to cut out the calyx, stalks and leaves in shades of green, and pasted them down ; and after she had completed a sprig of geranium in this way, the Duchess of Portland came in and exclaimed, ' What are you doing with the geranium ? ' having taken the paper imitation for the real flower. Mrs. Delany answered, that ' if the Duchess really thought it so like the original, a

new work was begun from that moment ; ' and a work was *begun* at the age of 72, and *ended* at the age of 85, which no other person before or since has ever been able to rival or even approach." (Johnston, 1925.)

For her mosaics, of which there are more than a thousand in the British Museum and at Windsor, Mrs. Delany " used to procure various coloured papers from Captains of vessels coming from China ; and bought up odd pieces from paper-stainers in which the colours had run," so as to obtain " extraordinary and unusual tints." Sir Joseph Banks " used to say that he would venture to describe botanically any plant from Mrs. Delany's imitations without the least fear of committing an error." As an embroideress she was no less talented.

At last Mrs. Delany's sight became unequal to so exacting a pursuit :

> *The time is come ! I can no more*
> *The vegetable world explore ;*
> *No more with rapture cull each flower*
> *That paints the mead or twines the bower ;*
> *No more with admiration see*
> *Its beauteous form and symmetry !*
> *No more attempt with hope elate*
> *Its lovely hues to imitate !* . . .

Truth to tell, Mrs. Delany's work has received somewhat exaggerated praise. It was admittedly a remarkable performance for a woman of her age ; but the results are " quaint " rather than beautiful. Erasmus Darwin, in his *Botanic Garden* (1781), has summed up her achievement in fitting phraseology :

> *So now DELANY forms her mimic bowers,*
> *Her paper foliage, and her silken flowers ;*
> *Her virgin train the tender scissors ply,*
> *Vein the green leaf, the purple petal dye :*
> *Round wiry stems the flaxen tendril bends,*
> *Moss creeps below, and waxen fruit impends.*
> *Cold Winter views amid his realms of snow*
> *DELANY'S vegetable statues blow ;*
> *Smooths his stern brow, delays his hoary wing,*
> *And eyes with wonder all the blooms of spring.*

WEST AND EAST

T HE WORKS of two prolific authors, Nikolaus von Jacquin and Joseph Pierre Buc'hoz, flooded the publishing houses of Vienna and Paris respectively during the second half of the eighteenth century. Jacquin was a distinguished scientist and produced many fine books of lasting importance for the study of the South African, American and central European floras ; but his French contemporary is more memorable for the quantity than for the quality of his productions.

Nikolaus Joseph Jacquin (1727-1817) was born at Leiden, but sought his fortune, as did many Dutchmen at that time, in Vienna. His career is closely associated with the history of the gardens at Schönbrunn, just outside the capital. The laying out of these gardens in the park began in 1753, a Dutchman, Adriaan Stekhoven, being invited to undertake this at the instigation of Maria Theresa's Dutch physician, Gerard van Swieten. After its completion another Dutchman, Richard van der Schat, was appointed head gardener. He brought with him many plants from Holland, thus at once introducing into the Schönbrunn gardens plants of South African origin. It was while examining this collection that the young Dutch student Nikolaus Jacquin, then twenty-five years old and just completing his medical studies at Vienna, was presented to Maria Theresa's husband, the Emperor Francis I. He suggested that Jacquin should take charge of the gardens, but first dispatched him to the West Indies and Central America to procure new plants and specimens. Ants damaged Jacquin's herbarium material, and he therefore supplemented his descriptions and notes on the new species with water-colour drawings. These accordingly are the equivalent of type-specimens, a fact which accounts for the high scientific importance of Jacquin's rare edition of the

Selectarum Stirpium Americanarum Historia (*c.* 1780) illustrated with original water-colour drawings (see p. 158).

Schönbrunn under Jacquin's direction soon became one of the most celebrated gardens of its day. In due course, gigantic glass-houses were erected where, as a French traveller relates, " tropical birds, flying among the palm-trees, bamboos and sugar-canes, gave the illusion that the visitor had been transported into the heart of America."

In 1763 Jacquin left Schönbrunn to become Professor of Chemistry at Chemnitz near Dresden, but returned to Vienna five years later as Professor of Botany and Chemistry and Director of the University Botanic Garden. These appointments led to the publication, between 1770 and 1776, of the *Hortus Botanicus Vindobonensis,* of which 162 copies were printed.

After the loss of many plants in the Schönbrunn conservatories during a severe frost in 1780, an effort was made to obtain new plants by expeditions to foreign countries. Thus in 1786 Franz Boos and Georg Schall, two of the Schönbrunn gardeners, were dispatched to Mauritius to bring back a consignment of tropical plants. They reached Cape Town in May, 1786. The following year Boos went on to Mauritius, returning to the Cape in January, 1788, with his plants and then proceeding to Vienna where he arrived in July, 1788. Scholl remained at the Cape for twelve years, during which time he sent frequent consignments of bulbs and seeds to Vienna ; this accounts for the immense number of Cape plants figured in Jacquin's works. These plants appear to have come from the western side of Cape Province (from the Cape of Good Hope northward for about 250 miles to near Bowesdorp in Namaqualand).

Jacquin was created a Baron in 1806. After his death in 1817, his work was continued by his son.

Jacquin's first important illustrated book, *Selectarum Stirpium Americanarum Historia* (1763), contains nearly two hundred plates drawn by the author, engraved under his direction, and in some copies hand-coloured. It is a handsome volume ; but we must admit that the figures never rise above the level of average competence. The blame for this can hardly be laid at Jacquin's door, for his brilliant illustrated letters to Dryander (see Pl. 23, p. 158) show him to be a most accomplished and sensitive draughtsman. But no doubt he soon realised that he needed assistants to aid him in the great projects that he had in view ; like Trew, therefore, he began to gather round him

a team of draughtsmen to work under his immediate supervision. First among these was Franz von Scheidel (1731-1801), his companion, also, in many botanical rambles in the Austrian mountains. Jacquin describes him as *"in pingendo celerrimus"*; and he is said to have made more than seven thousand drawings of plants, besides many others of birds and other animals, and of minerals. He was responsible for the plates in the *Florae Austriacae . . . Icones* (1773-78), a splendid work in five folio volumes which ranks with the *Flora Danica, Flora Londinensis* and *Flora Graeca* among the finest books dealing with the wild flowers of a European country. In collaboration with Johann Scharf (1765-94), a talented young painter whose career was cut short by consumption, von Scheidel also made the drawings for Jacquin's greatest work on cultivated flowers: *Plantarum Rariorum Horti Cæsarei Schönbrunnensis Descriptiones et Icones* (1797-1804).

It is impossible to list more than a fraction of all the sumptuous productions for which Jacquin was responsible. Scheildel and Scharf had a hand in several of his other works; and among the remaining artists of his circle may be mentioned Martin Sedelmayer, Franz Hofer and Josef Hofbauer. One of Jacquin's most ambitious, if least successful, books was an *edition de luxe* of the *Selectarum Stirpium Americanarum Historia* (*c.* 1780), limited to some eighteen copies with original water-colour illustrations. Its flower-drawings are artistically worthless though botanically valuable, and the elaborate floral title-pages are interesting as being among the earliest work of Ferdinand Bauer.

Another Viennese publication—Joseph Plenck's *Icones Plantarum Medicinalium* (1788-1812)—deserves mention here. Many of the 758 large hand-coloured engravings which illustrate it are delightful, and very decorative in treatment.

In the Victoria and Albert Museum are twenty-four flower studies by Johann Knapp (1778-1833), an artist who worked at Schönbrunn and was associated with Jacquin. He is said to have made nearly a thousand flower and fruit paintings for the Archduke Anton, to whom he became Court Painter in 1804, and three hundred more for the Archduke Johann; but he is best remembered for a gigantic memorial oil painting of Jacquin, surrounded by plants, insects and minerals, which now hangs in the Natural History Museum, Vienna.

It was said, rather spitefully, of Joseph Pierre Buc'hoz[1] that he

[1]So christened, though he often styled himself Pierre Joseph Buc'hoz.

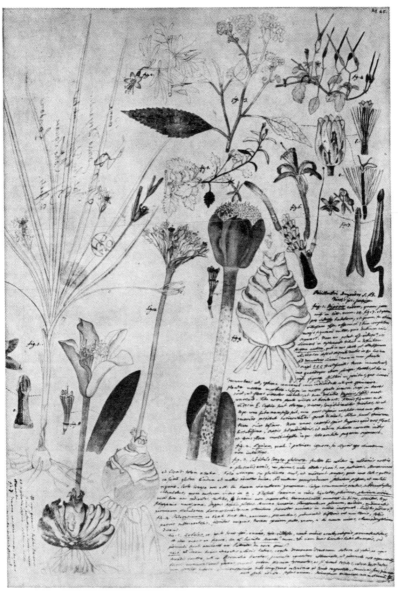

Plate 23 Various Flowers
Part of a letter from Nikolaus von Jacquin to Jonas Dryander, October 5, 1792
Natural History Museum, London

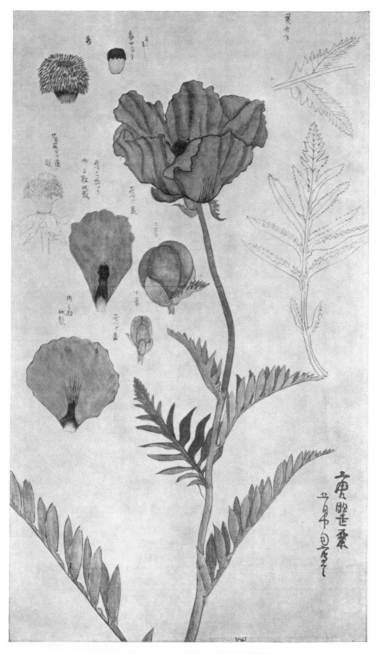

Plate 24 ORIENTAL POPPY (*Papaver orientale*)
Japanese water-colour drawing, modern
Victoria and Albert Museum, London

achieved two very remarkable records : that he wrote on all branches of natural science without understanding any one of them ; and that he compiled more than three hundred volumes (ninety-five of which were folios) and yet remained unknown. Buc'hoz is the Sir John Hill of France ; to-day he is not even remembered by the malodorous flower *Buchozia foetida* which l'Héritier maliciously named after him— almost the only gesture of recognition made by his contemporaries.

Buc'hoz (1731-1807) was born at Metz, and though destined for the legal profession, soon turned from law to medicine. At twenty-eight he was appointed physician in ordinary to Stanislaus, King of Poland ; but grandiose publishing schemes were stirring in his mind, and he relinquished the office. His first literary venture was a history of the plants of Lorraine, in thirteen volumes. This was followed by a ceaseless flow of miscellaneous publications : vast illustrated folios on botany ; books on mineralogy, agriculture, ornithology and medicine ; and innumerable tracts, pamphlets and brochures of every description. Each new work contained a prospectus heralding in pompous terms the splendours of his forthcoming productions. His material he drew shamelessly from the books of others, and it was said that no word he ever wrote contributed anything to the world's sum of knowledge. His descriptions were inaccurate, and men of science never quoted them ; the plant names he suggested were never adopted; on occasion he does not even seem to have been above inventing his flowers.[1]

Though he wooed his public assiduously, expatiating upon such enticing themes as " How to become rich and remain fit by cultivating vegetables," or revealing the secret of how to cure melancholy by music and venereal disease by herbs, it stubbornly refused to buy his works. Before long he was in financial straits. He tried publishing anonymously, but fared no better. The death of his wife and the outbreak of the Revolution reduced him to loneliness and penury ; but he was rescued from both by the generosity of a woman—a friend of his deceased wife's who had helped him in the production of his colour-plates. She received him into her house, and, " pour mettre plus de delicatesse dans les dons qu'elle lui faisait," married him. His declining years were devoted to the penning of violent diatribes in which the Republic, the whole universe even, was castigated for failing to recognise his genius.

[1]Buc'hoz, none the less, had one or two loyal supporters, and the verdict of his own age is not wholly free of spite.

Among the hand-coloured engravings which illustrate Buc'hoz's countless folios (see Pl. 26a, p. 163) we shall not expect to encounter much that is original. The most interesting are to be found in his *Collection Précieuse et Enluminée* (1776) ; *Les Dons Merveilleux* (1779-83) ; *Herbier* (1781) ; *Le Jardin d'Eden* (1783) ; and *Le Grand Jardin de l'Univers* (1785). In some of these works, considerable use is made for the first time of drawings of Chinese plants executed by native artists, and much of Buc'hoz's other work also has a distinctly oriental flavour. Though the resultant engravings are of no great botanical value, they have the decorative qualities which we always associate with Far Eastern art ; they may serve here as excuse for a digression, long overdue, upon flower-painting in the Orient—a subject which really demands a book to itself.

The Far East has not only provided us with many of the loveliest shrubs and flowers in our gardens ; it offers us a salutary object lesson in humility towards Nature.

To the Westerner, with his deep-rooted anthropocentric approach to life, Nature is often considered as little more than a handmaid to supply his needs. Flowers, birds and other animals, just as the mountains, the sea and the sky, are to him a background to human events, created for his enjoyment and deserving of no consideration when they cease to serve or distract him. He plucks the bluebells by armfuls, trails them behind his bicycle in the dust, wedges them into hideous vases, leaves the water unchanged, and ultimately discards them without a tear. In picking them he gratifies little but the collector's instinct ; in crowding them together he illustrates a misconception prevalent in the West that twenty flowers in a pot are twice as beautiful as ten.

All such generalisations are dangerous : we could find plenty of exceptions to such arrogance in the West, and no doubt plenty of examples of it in the East. But the fact remains that, from the earliest times, the Far Eastern tradition bears witness to what Laurence

PLATE XXVa
HOLLYHOCK (*Althaea rosea*). Hand-coloured etching by J. Miller, from his *An Illustration of the Sexual System of Linnæus*, 1777

PLATE XXVb
GLOBEFLOWER (*Trollius europaeus*). Hand-coloured engraving from the first volume of Oeder, *Flora Danica*, 1761-64

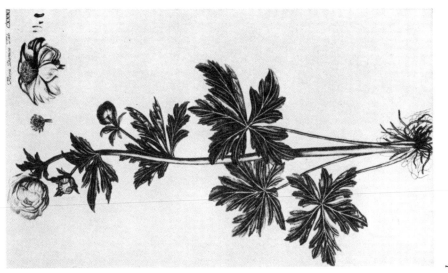

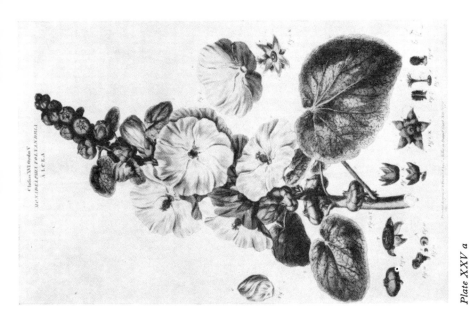

Plate XXV a

b

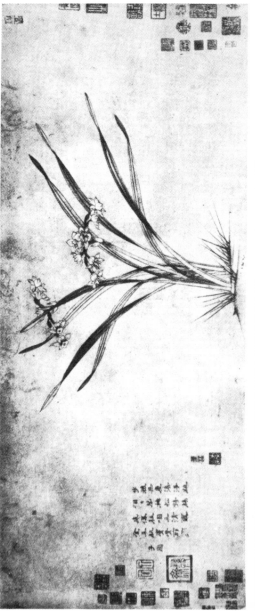

Plate XXVI a and b

Binyon[1] calls an " exquisite courtesy to Nature." This attitude is fostered by Taoism : " Flowers especially," says Binyon, " seemed, to those imbued with Taoist conceptions, to partake of an ideal existence. Their sensitiveness and vigour alike, the singleness of purpose in their expansion to the light, their bountiful exhalation of their sweetness, their sacrifice, their beauty, all made a particular appeal."

From China, this sense of man's intimate relationship with all nature spread to Japan. There is a well-known Japanese poem which tells of a girl who went to draw water from a well, but, finding that during the night a morning glory had twined itself round the rope, came away, her pitcher empty, to seek " gift-water " instead.

Binyon discusses the theme more fully. It might, indeed, be developed almost indefinitely ; but for our present purpose, it is only necessary to make it plain that the Chinese or Japanese artist approaches the painting of flowers with a humility that is rarely encountered in the West. The proof of this assertion may be found in the pictures themselves, and in the fact that flower-painting as an independent art, untainted by medical or other practical considerations, began in China as early as the seventh and eighth century A.D., and was carried on with growing enthusiasm through those centuries when, in the West, Nature was still an object of mistrust and even of fear.

The Chinese method of flower arrangement, developed in due course by the Japanese into an elaborate ritual, is designed to emphasise the growth of the plant. Reticence and rhythm are its other essentials : a single, curving spray of blossom may suffice for a bowl ; and the tousled bouquets of a van Huysum would be inconceivable in the Far East. The same simplicity, rhythm and sense of design are apparent in Chinese and Japanese flower-paintings throughout the whole long history of the art. The habit of a plant, often modified for the purpose of decorative effect, is always fully grasped ; though, when a very free

[1] See his brilliant little essay *The Flight of the Dragon*, and L. Cranmer-Byng's *The Vision of Asia* (Chapter 6), both published by John Murray.

PLATE XXVIa
NARCISSUS. Makimono, painted in water-colour by Chao Meng-chien, thirteenth century A.D.

PLATE XXVIb
PEONY AND OTHER FLOWERS. Border of a Mughal manuscript, c. 1610. Victoria and Albert Museum

type of brushwork is employed, the botanist may sometimes feel that simplification has been carried dangerously far.

During the T'ang Dynasty (A.D. 618-906), flower-painting became firmly established, though little authentic work of the period survives. Hsü Hsi, who was born towards the close of the Five Dynasties (907-60), was probably the most famous of all Chinese painters of flowers, fruit and birds. The Sung critic Liu Tao-ch'un tells us that Hsü Hsi " used to walk about his vegetable garden looking for subjects. Although his pictures only contained tufts of vegetables, young shoots and the like, his style surpassed that of the Old Masters." His method of work is thus described : " He started by drawing in ink the branches, leaves, pistils and petals of the flowers, and then he put in the colours. In this way he brought out the spirit and the structure before the final stage of the work, and his flowers became perfectly luxuriant, almost like the works of the Creator."

Of Chao Ch'ang, who lived at the beginning of the Sung Dynasty (960-1279), it was said : " All his paintings of plucked flowers give the impression of life and growth ; and his method of colouring was particularly subtle. Every morning, just as the dew was falling, he would wander round the flower beds with his brush and colours in his hand, painting as he walked. . . . He painted in successive washes of water-colour, never using solid or opaque pigment."

The eleventh century author Kuo Hsi, in his essay on landscape painting, emphasises the importance of carefully observing a plant before beginning to paint : " Those who study flower painting take a single stalk and put it into a deep hole, and then examine it from above, thus seeing it from all points of view. Those who study bamboo-painting take a stalk of bamboo and on a moonlight night project its shadow on to a piece of white silk on a wall ; the true form of the bamboo is thus brought out."

These Sung artists, it is evident, loved Nature passionately, and were wholly without condescension towards her. The meanest flower, the humblest insect, was thought a worthy subject of contemplation and study. Certain flowers, however, for their associations or their intrinsic beauty, were chosen again and again, and in those unhurried days it was possible for a painter to devote his whole life to portraying a single type of plant. Especially beloved were the plum which heralded the end of winter, the orchid, the bamboo which bent under the gale but did not break, the chrysanthemum, and the lotus which rose

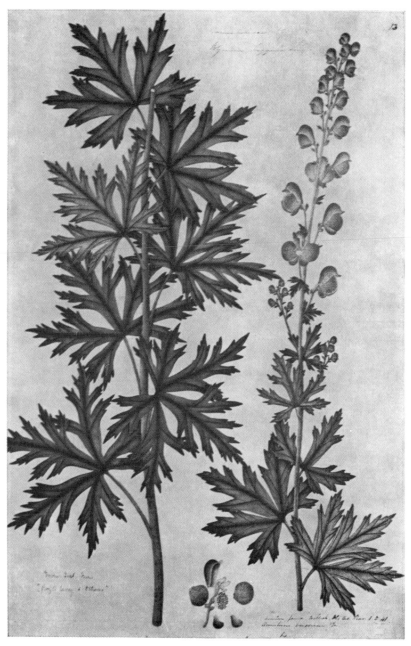

Plate 25 Aconitum falconeri
Water-colour drawing by Vishnupersaud. Indian, early 19th century
Kew Herbarium

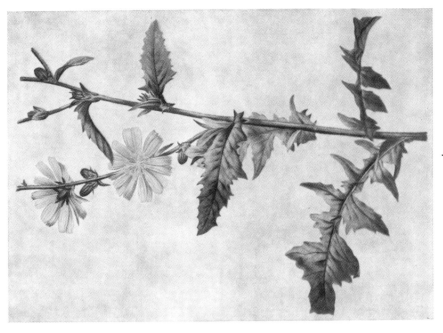

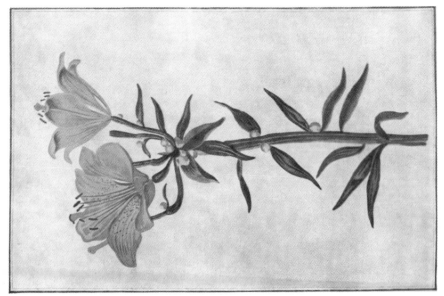

b

unsullied from the slimy bed of the pool. Plate XXVIa (p. 161) shows Chao Meng-chien's lovely—if slightly stylized—study of a narcissus, executed almost in monochrome ; many, indeed, of the finest paintings were made in ink only, without the use of colour.

Flower-painting probably reached its zenith in China in the tenth century, though much loving and skilful work was produced in later times. The Japanese, too, in their wonderful woodcuts and painted screens, made a contribution to botanical illustration which, though ultimately derived from Chinese sources, has a character and flavour of its own. In particular, the screens of Sotatsu (seventeenth century) and his school, with their exquisitely drawn grasses and flowers, have in their way never been surpassed. Works of a more strictly botanical nature include the *Ka-i* (1759) of Mitsufusa Shimada (pen-name Yonan Si), with some illustrations of shrubs by Ono Ranzan, the *Honzo Zufu* (1828) of Tsunemasa Iwasaki, and the *Somoku-dzusetsu* (1856) of Yokusai Iinuma, all three illustrated with effective woodcuts ; and the sumptuous *One Hundred Flowers* (Tokyo, 1931-34), illustrated with colour-woodcuts by Sugiura Hishui, must rank among the most decorative flower-books of the present century. Fig. 48, of the Japanese lily of the valley (*Convallaria majalis* var. *keiskei*), is taken from the *Somoku-dzusetsu*; this exemplifies the Japanese convention of representing the upper side of the leaf black and the lower side white. The modern drawing of a poppy (Pl. 24, p. 159) shows Western influence.[1]

The Middle East, whose poets sang the praise of the rose, the jasmine and the tulip, viewed nature with more Western aloofness. The Persian miniaturist loved flowers ; but he was, in the main,

[1]Present-day Japanese botanical draughtsmanship is well represented by Jinzo Matsumura, *Icones Plantarum Koisikavenses* (4 vols., 1911-21) ; Takenoshin Nakai, *Flora Sylvatica Koreana*, pts. 1-22 (1915-39) ; and Takenoshin Nakai, *Iconographia Plantarum Asiae Orientalis*, vols. 1-4 (1935-49). Examples of Chinese work will be found in Tchen-Ngo Liou, *Flore illustrée du Nord de la Chine*, fasc. 1-5 (1931-36) ; Hsen-Hsu Hu and Woon-Young Chun, *Icones Plantarum Sinicarum*, fasc. 1-3 (1927-29); Wen-Pei Fang, *Icones Plantarum Omeiensium*, vols. 1-2 (1942-46); and Hsen-Hsu Hu, *The Silva of China* (1948).

PLATE 26a
BULBIL LILY (*Lilium bulbiferum*). Hand-coloured engraving from J. P. Buc'hoz, *Les Dons Merveilleux*, 1779-83

PLATE 26b
SUCCORY (*Cichorium intybus*). Stipple engraving by Prot, after a painting by P. J. Redouté ; from P. J. Redouté, *La Botanique de J. J. Rousseau*, 1805

content to scatter the foreground of his paintings with stylized blossoms, and to relieve the monotony of his gold or lapis skies with formal boughs of pink almond. Here and there, however, by the sixteenth century, a pot of irises, a spray of roses or a clump of narcissi betrays a finer feeling for the individual form or habit of a plant. The first truly botanical studies date from the seventeenth century, and, like their counterparts in the West (whose influence they very possibly show), often include birds or butterflies. Shafi-i 'Abbassi's *Goldfinch and Narcissus*[1] (Bib. Nat. Paris), painted at Isfahan in 1653 for the private collection of Shah 'Abbas II, is a fine example of such work. The picture is dated August 1st, and cannot therefore have been made direct from nature. Many fairly naturalistic flower-paintings were also produced in Turkey during the eighteenth century.[2]

In India we find no true botanical illustration until Mughal times. The Mughal emperors were genuine nature-lovers, and under their rule the Iranian joy in gardens and flowers was directed into definitely scientific channels. The fascinating memoirs of the Emperor Babar (1483-1530), first of the line, reveal again and again the pleasure that he took in the beauty of spring blossom, the blue lines of hills at sunset, and the gold of autumn leaves. Moreover, though not himself an artist, it is clear that he appreciated the value and the difficulty of botanical painting. He shows an almost Chinese sensibility when he writes of an apple-tree in late autumn : " On each of its branches five or six scattered leaves still remained, exhibiting a beauty which the painter, with all his skill, might attempt in vain to portray." But under his great-grandson, Jahangir, an enthusiastic naturalist, there emerged a school of natural history painters which may be compared with the almost contemporary school that flourished in France under Gaston d'Orléans. Unfortunately for our purpose, most of the paintings which have survived are of birds and other animals ; but we know from Jahangir's *Memoirs* that his favourite artist Mansur had made more than a hundred botanical studies in Kashmir alone. Of his flower-paintings, the lovely study of tulips, now in the Habibganj Library, Aligarh District (Pl. XXVII, p. 176), appears to be the only

[1]Reproduced in colour in E. Blochet's *Musulman Painting XII-XVII Century*, Pl. CLXVIII (Methuen, 1929).
[2]Professor Süheyl Unver, of Istanbul University, has kindly given me the names of the following artists of this period : Levni ; Ali Uskudari ; Hezargradi zade Esseyit Ahmet Ataullah ; Abdullah Buhari ; Mehmet Yümni, and Esseyit Mehmet. There is a book of tulip paintings in the Library of Mühendis Ekrem Ayverdi.

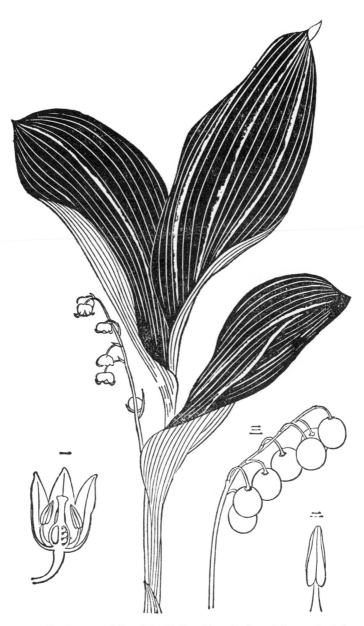

FIG. 48—Japanese Lily of the Valley (*Convallaria majalis* var. *keiskei*)
Woodcut from Iinuma, *Somoku-dzusetsu*, 1856

extant example. Floral work such as is found among the stone reliefs of Gandhara (second century A.D.), upon the sculptured dados of the Taj Mahal, and even in paintings as early as those upon the walls of the first cave at Ajanta (seventh century A.D.), is too decorative in treatment to come within the scope of this book ; so too are the floral borders of Mughal manuscripts, and I can only excuse myself for reproducing an example (Pl. XXVIb, p. 161) by the confession that I could lay my hands on nothing more appropriate to fill an awkward space.

Many hundreds of magnificent drawings made by Indian artists during the early part of the nineteenth century under the direction of British botanists such as Royle, Carey, Falconer, Wallich and Roxburgh (see p. 193) are now in the Kew Herbarium. Vishnupersaud's study of *Aconitum falconeri* (Pl. 25, p. 162) gives in reproduction but a slight idea of the patience and fine craftsmanship displayed by these Indian painters ; Chinese artists working under similar conditions at the same period are rarely their equals in skill or subtlety.

Thus we see that the East has made an original and very real contribution to botanical art, and has been an influence which, during the last two centuries, has not infrequently been felt in Western flower painting.

Returning to the West, we must now pass in brief review some of the other important botanical books that were produced on the Continent during the latter part of the eighteenth century.

The *Flora Danica* (Copenhagen, 1761-1871) ranks among the finest national floras ever compiled. The earlier plates, in particular, are extremely delicately engraved and beautifully coloured (see Pl. XXVb, p. 160) ; the later issues, however, were printed on an unattractive type of paper, and the colouring gradually deteriorated. The first artist employed was the younger Roesler, whose work was engraved by his father. C. F. Mueller succeeded them in both capacities. From 1800 until 1867, J. Bayer acted as draughtsman, and the last plates were made from drawings by C. Thornam.

The *Flora Danica* also inspired a remarkable achievement in ceramics. Theodor Holmskjold (1734-94), director of the Copenhagen porcelain factory, a pupil of Linnæus and a keen botanist, persuaded the Crown Prince of Denmark to commission a table-service in which each piece would be decorated with a plant copied from the *Flora*

Danica. The work was put in hand in 1790, but discontinued twelve years later after two thousand pieces had been produced.

In the Linnæus Museum at Uppsala, there is still preserved part of two oriental tea-services made for the great botanist and decorated with *Linnæa borealis*. When Peter Osbeck, one of Linnæus's pupils, went out to China in 1750, Linnæus asked him to place an order for a tea-set decorated with the lowly flower[1] which Gronovius had named in his honour. Unfortunately many of the pieces were broken in transport between Gothenburg and Uppsala, and a new set—the gift, it has been said, of the East India Company—was commissioned to replace it. Osbeck had especially asked that a print of *Linnæa borealis* " coloured with the true colours " should be sent to China so that the second set should be more correct than the first ; in fact, the pieces now at Uppsala are of two different sets, the one with the flowers accurately coloured and the other with bright red blossoms. Both, however, are based on the figure by Johan Leche in Linnæus's *Flora Suecica* (1745). Linnæus also used a less accurate figure of the same flower, copied from a print by the younger Rudbeck, on his earlier seals and for a set of wine-glasses ; these too are now in the Museum at Uppsala. When he received the patent of nobility in 1762, he had the plant placed above the helmet in his coat-of-arms.[2]

Wedgwood's Lotus service, made about 1781 by Josiah Wedgwood as a wedding present for Erasmus Darwin and for many years in the possession of Joseph Hooker, is another example of accurate botanical drawing upon ceramic ware. Other work of this kind was produced early in the nineteenth century by the Swansea factory, where the director, Lewis Weston Dillwyn, kept his craftsmen supplied with plates from back numbers of the *Botanical Magazine*.[3]

In Germany, Schmidel's *Icones Plantarum* (1762) contains a few effective plates by N. Gabler and many scientific dissections. Johann Kerner's *Figures des Plantes Economiques* (Stuttgart ; 1786-96) is delicately etched ; but his finest work, according to Brunet, is the excessively rare

[1] " *Linnæa* was named by the celebrated Gronovius, and is a plant of Lapland, lowly, insignificant, disregarded, flowering but for a brief space—from Linnæus who resembles it." (Linnæus, *Critica Botanica* ; transl. Arthur Hort.) The plant is also a native of north England and Scotland.

[2] Information kindly supplied by Dr. Uggla of Uppsala University. Photographs of the china, glass and seals will be found in *Linnémuseet i Uppsala* (Nordiska Museet ; n.d.).

[3] See *The Connoisseur* (Sept., 1947), and Lane (1946).

Hortus Sempervirens (1795-1830), consisting of seventy-one volumes of elephant folio size, each containing twelve original water-colours. Some volumes of this gigantic work are in the Lindley Library. Many of the drawings in them are derivative, and the impression left with the spectator is that of gallant but misdirected energy. Kerner also published two other works illustrated with original water-colours, and we must agree with Dunthorne that " it is difficult to realise that the hand of one man illustrated three books with original water-colour drawings, *not* engravings, a total of a thousand and forty drawings for each copy of *Hortus Sempervirens, Le Raisin* and *Les Melons.*" The plates of J. Mayer's *Pomona Franconica* (Nuremberg ; 1776-1801) have great charm ; and Georg Knorr's *Thesaurus* (1780), also published at Nuremberg, shows that the influence of Trew was still alive in southern Germany. From Hungary, Franz Waldstein and Paul Kitaibel's *Descriptiones et Icones Plantarum Rariorum Hungariae* (Vienna, 1799-1812) should be studied for its careful craftsmanship.

Holland produced several magnificently illustrated works, of which Schneevoogt's *Icones Plantarum Rariorum* (Haarlem ; 1792-95), with plates after paintings by P. van Loo and Hendrik Schwegman (1761-1816), is the finest. Its plates record new and rare plants cultivated in Holland, many of which were grown in the celebrated Voorhelm and Schneevoogt nursery at Haarlem.[1] The anonymous *Nederlandsch Bloemwerk* (Amsterdam ; 1794), with delightful tulips, hyacinths and auriculas, is mainly an adaptation of Nicolas Robert's *Diverses Fleurs.*

In Italy, Allioni's *Flora Pedmontana* (Turin ; 1785) contains skilful but rather mechanical engravings. A more impressive work, though rather coarse in quality, is the *Hortus Romanus* (1772-93) of Bonelli, for which Magdalena Bouchard was employed as artist. Pallas's *Flora Rossica*, published in Petrograd between 1784 and 1788, contains a hundred hand-coloured engravings after paintings by Carol Knappe.

Two Spanish floras, by Quer-y-Martinez and Cavanilles, show that in Spain the stiff and mechanical type of line-engraving had not yet given place to a more sensitive and enlightened technique. But in her colonial possessions in America, two large and important collections of botanical drawings were produced during the closing years of the eighteenth century : that made under the direction of Mutis in Colombia, and the so-called Sessé and Mociño drawings of Mexican

[1]See W. T. Stearn (1940).

plants. Official apathy in Spain has resulted in the complete neglect of the former and the total destruction of the latter.

José Celestino Mutis (1732-1808) was born at Cadiz. After studying medicine in Madrid, he set out, at the age of twenty-nine, for New Granada (Colombia) in the capacity of private physician to the newly appointed Spanish Viceroy. But botany, rather than medicine, was Mutis's real love ; again and again he appealed to Madrid for facilities to investigate the flora of Colombia, in particular the *Cinchona* (quinine) tree whose vast importance he recognised. At last, in 1783, a sympathetic viceroy achieved the impossible on his behalf, and Mutis found himself placed in charge of an important and well-equipped botanical expedition which was later supplemented by an institute of botanical research at Mariquita.

At Mariquita, a team of artists recruited from Quito—eventually as many as thirty in number—" worked like medieval monks, nine hours a day in complete silence " to make records of the plants collected, the final result being some 6,000 drawings, mostly in colour, " in natural size, and done in the utmost detail, showing all phases of the plants' growth, including the seeds and the roots" (Duran-Reynals; 1947). But Mutis perpetually postponed the day for setting in order and publishing his vast horde of accumulated data ; at the time of his death, though Linnæus and von Humboldt had recognised and proclaimed his genius, virtually nothing of his work had been given to the world. Caldas, his pupil and successor, who alone might have brought order out of the chaos which his master left behind him, unfortunately became involved in a revolt against the Government and was executed. The Institute, which by this time had been transferred to the capital, Santa Fé de Bogotá, was closed down, and its records eventually despatched to Spain in one hundred and five large packing-cases. " The Spanish Government," says Duran-Reynals, " which spent untold sums of money in the Botanical Institute, has never been able to spare the money to publish these unique records of scientific achievement ; " now, at long last, it is planned to publish 2800 of the drawings with the scientific collaboration of A. Caballero, A. Dugand and E. P. Killip.

From time to time one comes across references to the Sessé and Mociño drawings of Mexican plants at Geneva ; their rather dramatic history seems to be little known, and deserves therefore to be discussed in some detail.

In 1786, apparently at the instigation of Marten de Sessé y Lacasta (*d. c.* 1809), the Spanish Government issued a Royal Order for an expedition to New Spain (Mexico) " to make drawings . . . and illustrate and complete the work of Doctor Don Francisco Hernandez " (see p. 60). Sessé became the leader of this expedition, which included two artists, Juan de Dios Vicente de la Cerda and Athanasio Echeverria (commemorated in the genus Echeveria) ; and he later added to his staff José Mariano Mociño Suares Losada (*b.* 1757), a talented Mexican-born Spaniard with a great enthusiasm for natural history.[1]

The expedition was due to set sail for home in 1799, but it was not until 1803 that it once more reached Spain. By this time the artists had made more than two thousand partly-finished sketches. On their return, Sessé and Mociño were met by the same official indifference as had frustrated Hernandez, whose name was so significantly mentioned in the Royal Order. Sessé died about 1809, leaving Mociño with the precious drawings and manuscripts. Towards the close of the Peninsular War Mociño, whose sight was rapidly failing, took them out of Spain into France and ultimately reached Montpellier in abject poverty. He still carried with him about 1400 of the drawings which had cost so much money and effort to prepare.

At Montpellier, Mociño met Augustin Pyramus de Candolle (1778-1841). The great Swiss botanist found that Sessé and Mociño's text contained little of value, and that many of the drawings were incorrectly named ; it was therefore agreed that he should take the latter back with him to Geneva, to serve as a basis for a kind of flora of Mexico. Mociño's parting words were pathetic : " Allez, je vous confie le soin de ma gloire." In 1816, however, de Candolle received a letter from Mociño, saying that he could now return to Spain but must take with him the Mexican drawings which were legally the property of the King of Spain. With this request for their return, de Candolle could not but comply.

What ensued does great credit to the cultured city of Geneva, where the drawings had been much admired. When de Candolle, who held an important place in Genevese society, informed a woman of his acquaintance that he would be obliged to return them in ten days' time, she promised to get copies made. More than twenty persons, most of them women and amateurs but including among

[1]An account of the work done in exploration and collecting has been given by H. W. Rickett in *Chronica Bot.* 11 no. 1 (1947).

them one or two professionals, volunteered to undertake this labour of love. The sketches were divided between them, and setting to work with a will, they completed the self-imposed task in the allotted time. A first-hand account of this remarkable performance, which caused quite a stir in the city, will be found in de Candolle's autobiography.

De Candolle himself took the originals to Montpellier and handed them over to Mociño, now old and ill and almost totally blind. Mociño reached Barcelona, but died shortly afterwards. The precious drawings seem to have perished, unwanted and unappreciated ; but the copies at Geneva, studied by de Candolle and other botanists, provided much valuable information on the flora of Mexico and are to-day a treasured possession of the Conservatoire de Botanique in that city.

Among the volunteers who made these copies was a young man named Jean Christophe Heyland (1791-1866). Heyland, who was born at Frankfurt-am-Main and whose real name was Kumpfler, had been sent in 1803 to Geneva and apprenticed to his uncle, a well-known hairdresser, whose name he adopted. The boy's talent for drawing was soon apparent, and in due course he managed to obtain a commission to make sketches of theatrical costumes, a job which took him to London where he made good use of the cultural resources of the great city.

When de Candolle saw the copies of the Sessé and Mociño drawings which Heyland diffidently produced, he recognised the young man's promise as a botanical draughtsman and offered, if the idea of flower-painting from life appealed to him, to show him the work of Redouté. Heyland brought his first original botanical studies to de Candolle, and was more than astonished when the kindly professor not only accepted them but even paid him for them.

This fortunate encounter was the turning point in Heyland's career, and for the next twenty-four years he illustrated most of the work published by the great botanist. His finest drawings, however, are to be found in E. Boissier's *Voyage Botanique dans le Midi de l'Espagne* (1839-45). His black-and-white work is conspicuous for its economy of line ; usually one or two leaves are carefully shaded, while outline suffices for the rest. In 1849 Heyland left Geneva to become botanical painter at the court of the Archduke Rainier, Austrian Viceroy in Lombardy, whose garden was at Monza, near Milan. Here he lived happily and industriously for ten years. Some of the unpublished studies

which he made at this time came into the market some twenty years ago ; reproductions of two of them will be found in Nissen (1933).

Political events at last brought this pleasant existence to an end. Austrian rule did not long survive the battle of Magenta, and Heyland was obliged to return to Geneva. Unfortunately the day of the large botanical work with coloured plates was almost over ; Geneva could not support him in the way that Paris had supported Redouté and Turpin, with whom one is tempted to compare him, and he passed the last days of his life in straitened circumstances. He died at Genoa in August 1866.

The pursuit of Heyland has carried us far into the nineteenth century, and we must retrace our steps ; as the eighteenth century draws to its close, it is to France and to England that we must turn for the finest examples of botanical art. Van Spaëndonck, it is true, was a Dutchman, and his famous pupil Redouté a Belgian (though I hear that Luxembourg is now seeking to claim him for their national hero[1]); it was, however, in the countries of their adoption—France and England—that they developed to their full stature.

[1]St. Hubert, Redouté's birthplace, belonged at the time of his birth to the Duchy of Luxembourg ; in 1831, however, the western part of the Duchy, including St. Hubert, was incorporated in Belgium as the province Luxembourg, while the eastern part became the Grand Duchy of Luxembourg and remained independent of Belgium.

CHAPTER 14

THE AGE OF REDOUTÉ

"ASTOCKY figure with elephantine limbs ; a head like a large, flat Dutch cheese ; thick lips ; a hollow voice ; crooked fingers ; a repellent appearance ; and—beneath the surface— an extremely delicate sense of touch ; exquisite taste ; a deep feeling for art ; great sensibility ; nobility of character ; and the application essential to the full development of genius : such was Redouté, painter of flowers, who counted all the prettiest women in Paris among his pupils."[1]

The most celebrated flower painter of his day—the most popular, indeed, in the whole history of botanical art—came of a long line of Belgian painters, though France was to be the country of his adoption. Born in 1759 at St. Hubert in the Ardennes, Pierre-Joseph was the second of three brothers, all of whom became artists. At the age of thirteen, full of confidence in the training he had received in his father's studio, the boy set out with his knapsack to earn a living as itinerant artist. During the ten years which followed he led a precarious existence ; but his circumstances may have improved after the death of his father in 1776, for we hear of him interrupting the tedious business of providing for to-morrow's breakfast, and settling down to a year's serious training in Liége. Wherever he travelled, he seized the opportunity of studying the paintings of the great Flemish masters ; but his most unforgettable experience was a visit to Amsterdam, where the works of Jan van Huysum opened up a new world to him.

In 1782, Pierre-Joseph, now a young man of twenty-three, joined his elder brother Antoine-Ferdinand who was designing stage scenery

[1] J. F. Grille, *La Fleur des Pois* (1853). Quoted by Ch. Léger (1945).

173

in Paris. The two worked together for the new Théâtre Italien in the rue de Louvois ; but Pierre-Joseph's leisure was devoted to the painting of flowers. Several of his studies were engraved by de Marteau, who also gave the young man instruction in the technique of colour-printing.

Pierre-Joseph's search for rare flowers took him to the Jardin du Roi, where he soon attracted the attention of the wealthy botanist Charles Louis L'Héritier de Brutelle (1746-1800), a die-hard Linnean, who invited him to his house, gave him the run of his magnificent library, and instructed him in the characters needed by botanists. This fortunate meeting had far-reaching results : more than fifty of the plates in L'Héritier's *Stirpes Novae* (1784-85) are engraved after drawings by Redouté ; and when L'Héritier visited London in 1786, the painter joined him there[1] and collaborated in his *Sertum Anglicum* (1788), a study of the rare plants growing at Kew. It was for L'Héritier also that Redouté began the fine illustrations of succulent plants[2] which were published in A. P. de Candolle's *Plantes Grasses* (1798-1829).

[1]A painting of Canterbury bells, made by Redouté when in England, has recently been acquired by the Victoria and Albert Museum. Marlborough Fine Art and Rare Books, Ltd., Old Bond Street, London, possesses a volume of fifty-five paintings attributed to Redouté in his earliest manner.

[2]Since succulent plants cannot be adequately represented by herbarium specimens, the illustration of them is of great importance, and almost essential for their study. Richard Bradley's book has already been mentioned (see p. 132), and both Dillenius and Commelin included many succulents in their works. It was Redouté's mastery of perspective allied to his botanical exactness which made him so successful in dealing with such solid plants. Among later illustrations of succulent plants should be mentioned the drawings of Duncanson and Bond (see p. 212) ; Prince Salm-Dyck's *Monographia Generum Aloes et Mesembryanthemi* (1836-63), illustrated by the author ; Louis Pfeiffer and C. Friedrich Otto's *Abbildung und Beschreibung blühender Cacteen* (1838-50); and N. L. Britton and J. N. Rose's *The Cactaceae* (Washington, 1919-23), illustrated by M. E. Eaton (see p. 254) and other artists. These illustrations are based on plants in cultivation which have sometimes been so modified by moist and luxuriant conditions of growth as to bear scant resemblance to their wild progenitors. A special interest thus attaches to the drawings of Stapeliae published in *Stapeliae Novae* (4 parts, 1796-97) by Francis Masson (1741-1805), a Scots gardener and plant-collector sent out from Kew under Sir Joseph Banks. As Masson himself says, " The figures were drawn in their native climate, and although they have little to boast in point of art, they possibly exhibit the natural appearance of the plants they represent better than figures made from subjects growing in exotic houses can do." At the Cape Masson was befriended by Colonel Robert Jacob Gordon (1741-95), a Dutch soldier of Scottish descent who was a keen botanist and 108 of whose drawings of South African plants are now in the Prentenkabinet of the Rijksmuseum, Amsterdam : see Dyer, R.A., in *South African Biol. Soc.* Pamphlet 14 (1949).

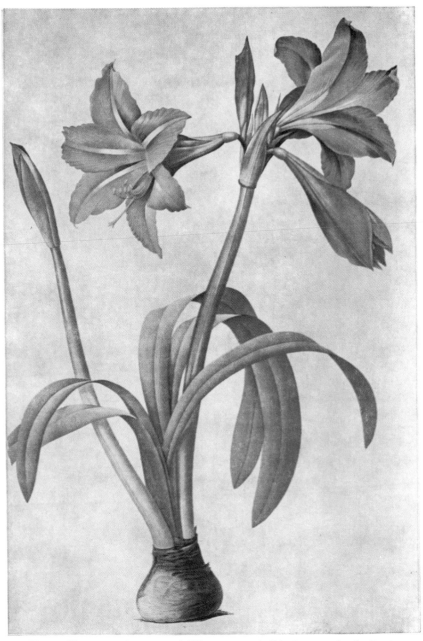

Plate 27 'AMARYLLIS BRASILIENSIS' (*Hippeastrum* sp.) Stipple engraving by Bessin, after a painting by P. J. Redouté; from P. J. Redouté, *Les Liliacées*, 1816

SEE ALSO COLOUR PLATE K

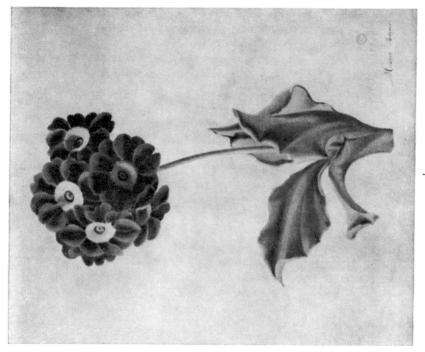

b

Plate 28a

It was doubtless on L'Héritier's recommendation that, on the very eve of the Revolution, Redouté was appointed Draughtsman to the Cabinet of Marie-Antoinette. The title was purely honorary. The Queen showed little interest in painting: it was said that, whenever she had occasion to pass through the picture galleries of the Louvre, she hastened her step. But she loved flowers; and during the dreary weeks of imprisonment in the Temple she sent for Redouté to paint a cactus which had particularly taken her fancy.[1]

Even more important than the influence of L'Héritier on the young painter was that of the Dutch artist Gerard van Spaëndonck (1746-1822), who had succeeded Madeleine Basseporte in 1774 as *Professeur de peinture de fleurs* at the Muséum. A follower of van Huysum, whose manner he imitated with considerable skill, van Spaëndonck had made some reputation for himself in Paris both as a painter and teacher. He knew, too, how to win the favour of the great ladies at Versailles, where his decorated snuff-boxes and other bibelots were soon the rage. Surprisingly enough, the storms of the Revolution, which reduced L'Héritier to penury,[2] passed van Spaëndonck by. His classes at the Jardin des Plantes were well attended both by serious students and by countless young girls who thus agreeably whiled away the aimless years between adolescence and matrimony.

Van Spaëndonck's engraved work, published during his lifetime, is limited to an album entitled *Fleurs dessinées d'après Nature* (*c.* 1800) which contains twenty-four magnificent drawings, brilliantly inter-

[1]This curious episode is related by Ch. Mirault in *Annales de la Société libre des Beaux-Arts*; Tome XIII, Année 1843. Pub. 1845. Quoted by Léger.

[2]L'Héritier, though he commanded a battalion of the National Guard and fought bravely, was later arrested on a trumped-up charge and thrown into prison. After his release he obtained a small post in the Ministry of Justice. He devoted his leisure to the compilation of a Flora of the Place Vendôme, where he lived—an undertaking which would appear to be even more unpromising than Lord de Tabley's Flora of Hyde Park. L'Héritier was assassinated in the streets of Paris in April, 1800.

PLATE 28*a*
CHRISTMAS ROSE (*Helleborus niger*). Water-colour by Pierre Turpin (1775-1840). Lindley Library, London.

PLATE 28*b*
AURICULA. Water-colour drawing by Marie Anne, *c.* 1840. Victoria and Albert Museum, London.

preted in stipple by P. F. Le Grand and other engravers (see Pl. XXVIII, p. 177). These are probably the finest engravings of flowers ever made. Hand-coloured copies, sometimes also colour-printed, exist, but in these forms the delicacy of the stipple-work is less apparent. After the painter's death, a memorial volume of lithographs from his drawings was produced by some of his pupils who, though not mentioned by name, are referred to as *"reconnaissantes"* and whose sex at least is determinable. But only when we come to study the little group of vellums which van Spaëndonck painted for the Muséum, do we realise the full importance of his achievement. Those made between 1780 and 1782 are executed broadly and vigorously in gouache. No paintings of 1783 have survived; but by 1784 he had completely changed his technique: he was then using pure water-colour with great virtuosity, and there is nothing in his new and highly finished work to distinguish it from Redouté at his best. Thus it becomes clear that Redouté was in fact the populariser and exploiter of van Spaëndonck's technical discoveries. Redouté, thanks to the patronage he enjoyed and to his tireless energy, has reaped the harvest which van Spaëndonck sowed; Redouté's name is known the world over, while that of his master is forgotten.

Van Spaëndonck gave every encouragement to Redouté, and to the latter's younger brother, Henri-Joseph, who now joined him at the Jardin des Plantes in the capacity of zoological draughtsman. In 1793, the two brothers were appointed to the staff of the Muséum. It was probably on van Spaëndonck's recommendation that Henri-Joseph was attached to the little group of scientists, artists and men of letters who followed in the wake of Napoleon's Egyptian campaign.

Redouté's connection with the court of Louis XVI had been brief and without profit; in Joséphine Bonaparte he was to find an enthusiastic and generous patroness. Joséphine, when she acquired Malmaison in 1798, determined to fill its gardens with the rarest plants that the Old and New Worlds could furnish.[1] With Ventenat as botanist, Mirbel as agent, and Redouté as artist, she poured out untold sums in the purchase and cultivation of choice flowers and in the publication of magnificent folios to record them for posterity.

[1]An interesting manuscript list, made for the Empress, of the plants growing in the Botanic Garden at Padua, is in the Sir John Soane Museum, London. See also Stearn, W. T. (1939), and the same author's "Bonpland's 'Description des Plantes . . .' " (*Journal of rhe Arnold Arboretum*, 23: 110-11; 1942).

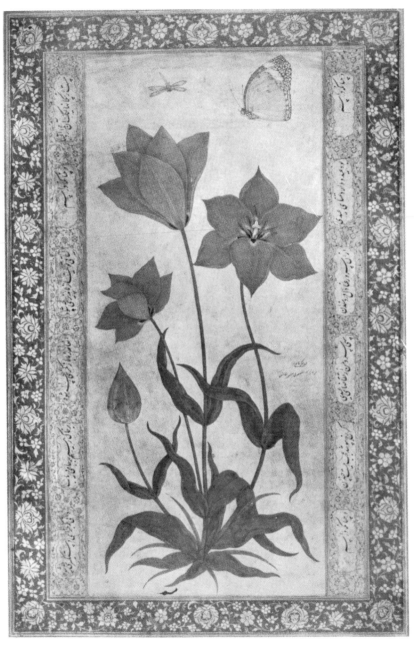

Plate XXVII Tulip (perhaps *Tulipa lanata*)
Indian miniature painting by Ustad Mansur, *c.* 1620. Habibganj Library, India

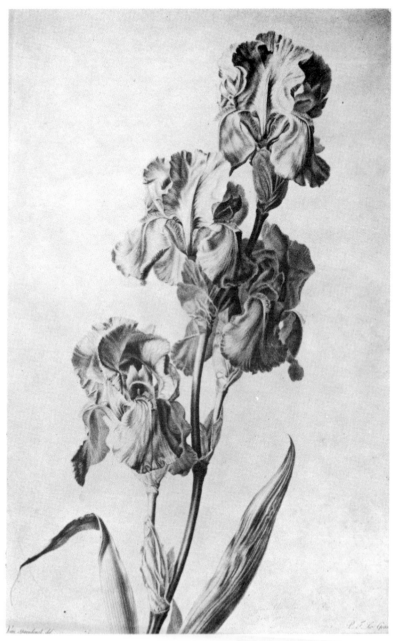

Plate XXVIII Iris (*Iris pallida*)
Stipple engraving by P. F. Le Grand, after a painting by Gerard van Spaëndonck;
from G. van Spaëndonck, *Fleurs dessinées d'après Nature*, c. 1800

Her debts, at the time of her death in 1814, amounted to nearly two and a half million francs. But posterity has much cause to be grateful. Ventenat's *Jardin de Malmaison*[1] (1803-04) and Bonpland's *Description des Plantes rares cultivées à Malmaison et à Navarre* (1812-17),[2] both illustrated by splendid coloured engravings after drawings by Redouté, are among the greatest monuments of botanical illustration. To this period belong also the eight wonderful volumes of *Les Liliacées* (1802-16), which equal in brilliance, if not in popularity, their famous successors *Les Roses* (1817-24). The original paintings for *Les Liliacées* were sold by auction in Switzerland shortly before the Second World War and are now in the collection of Mr. E. Weyhe, New York.

During the First Empire, Redouté had won fame and wealth. Joséphine paid him a salary of 18,000 francs a year, and he charged high prices for his other pictures. But he spent freely : a Paris house and an estate at Fleury-sous-Meudon were a heavy drain on his resources, and his financial position was becoming precarious.

After the death of van Spaëndonck in 1822, the Chair which he had occupied was abolished, and in his place two *Maîtres de Dessin* were appointed, one of these being Redouté. Many distinguished pupils hastened to take advantage of his tuition, either at the public courses in the Jardin or in their own homes. Among his private pupils were the two elder daughters of the duc d'Orléans—Princesse Louise[3] (b. 1812) and Princesse Marie (b. 1813). The latter, who died at the age of twenty-six, was also a sculptress of much promise. Major Broughton possesses an album of paintings made between 1826 and 1832 by Princesse Louise, who later became Queen of the Belgians. They are executed with considerable brilliance and, for the work of a young amateur, show exceptional promise. One might be tempted to suspect that Redouté himself had had a hand in them, were it not for the fact that the style does not very closely resemble that of his own work. Some of the sketches—the tulip (painted in October) and the crocus (painted in June), for instance—may have been based upon originals by the Master ; others, however, are expressly stated to have been made " d'après nature." Redouté's distinguished connections

[1]Redouté also made eighty-nine of the hundred plates for Ventenat's *Description des Plantes nouvelles* ; the original drawings for this work are at Malmaison.

[2]Nine of the plates are by Pancrace Bessa and one is unsigned ; the remaining fifty-four are by Redouté.

[3]Another Princess Louise—Queen Victoria's talented daughter—made some good flower paintings, two of which hang in the Director's office at Wisley.

brought him public recognition : in 1825, in company with a group of artists which included Ingres and Sir Thomas Lawrence, he was made a Member of the Légion d'Honneur.

In 1828, Redouté was visited in his studio in the rue de Seine by John Audubon, the famous American ornithological artist. Audubon showed his host the first parts of his great *Birds of America* (1827-30), which contains many incidental botanical details of much beauty ; Redouté produced his own drawings, and the two artists exchanged specimens of their work. Audubon mentions in his journal that Redouté sometimes received as much as 250 guineas for a single painting.

The opportune appearance of a new royal patroness, the duchesse de Berry, encouraged Redouté in the hope that his affairs could be straightened out. In 1828, after a good deal of rather ungenerous haggling, Charles X purchased the original paintings of *Les Roses*[1] for 30,000 francs on behalf of his daughter-in-law ; but even so substantial a windfall could not do more than delay the threatening disaster. Four years later we find the painter addressing an appeal to the new Queen begging her to accept three volumes of his drawings and to cast a pitiful eye upon his "*position embarrassante.*" But his affairs went from bad to worse : furniture, silver and paintings were sold in a vain attempt to keep the creditors at bay.

The old man remained undaunted. Now, in his eightieth year, he planned to paint his greatest picture—a vast flower-piece which would bring him 12,000 francs. But time would not wait : on June 19, 1840, as he was examining the corolla of a white lily which a young pupil had brought him, he had a stroke. He died the following day.

A wreath of roses and lilies which was laid upon his coffin bore the words :

> *O peintre aimé de Flore et du riant empire,*
> *Tu nous quittes le jour où le printemps expire.*

[1]In 1837, these paintings were put up for auction, but were withdrawn after the bidding had stopped at 15,000 francs. Brockhaus, in *Gartenflora* (1937), states that they were sold to an English purchaser a century ago for 36,000 francs. Another authority alleges that they were destroyed by fire during the Commune ; but twenty-four of the paintings came to light recently and were sold at Messrs. Sotheby's (Oct., 1948) for £1,800 ; they are now in the possession of Lord Hesketh. I have failed to trace the remainder.

Many hundreds of Redouté's finest paintings on vellum are in the Muséum, and only here can his original work be adequately studied. His technique, as has already been mentioned, was exactly modelled upon that evolved by his master, van Spaëndonck, about the year 1783. Pure water-colour, gradated with infinite subtlety and very occasionally touched with body-colour to suggest sheen, is Redouté's universal practice. This extreme delicacy of handling gives his work a feminine appearance when it is compared with Aubriet's robust line or even with the precise hatchings of Robert.

Yet had Redouté's work been confined to his vellum paintings, his name by now would have shared the obscurity that has overwhelmed his no less gifted contemporaries van Spaëndonck and Turpin. It was good fortune, no less than industry, which rescued him from oblivion and made his name a household word. Royal patronage, tireless energy, and the assistance of a brilliant team of stipple engravers and printers, made it possible for him to produce illustrated books which have few rivals in the whole history of botanical art.

Stipple engraving was developed in France during the eighteenth century, and exploited with great success by Bartolozzi and Ryland in England, where Redouté became acquainted with its possibilities. The process is simply that of etching by *dots* rather than by *lines*, the plate being often also worked upon with the bare needle or with the roulette ; it was admirably suited to give delicate gradations of tone and hence of modelling. Printing in colour was usually done from a single plate, the various colours being applied to the plate with a *poupée* or rag-stump and the copper being re-inked before every impression. The English, curiously enough, made practically no use of stipple for flower engravings ; but in France it was soon employed for the purpose, and methods of colour printing brought to a new perfection.

Redouté, who claimed to be the inventor of his particular method of colour printing, was accused of having appropriated it from others. He defended himself in the courts, and emerged triumphant : " The process which we invented in 1796 for colour printing consists in the employment of these colours *on a single plate* by a method of our own. We have thereby succeeded in giving to our prints all the softness and brilliance of a water-colour, as can be seen in our *Plantes Grasses*, *Liliacées* and other works." The value of his invention was recognised by the award of a medal from the hand of Louis XVIII.

We have already referred to Redouté's famous *Les Roses* and *Les Liliacées*, and to the two splendid volumes on the flowers of Malmaison ; scarcely less wonderful are the plates, so much admired by Ruskin,[1] for *La Botanique de J. J. Rousseau* (1805 ; see Pl. 26b, p. 163), and in the *Choix des Plus Belles Fleurs* (1827-33). A particularly fine copy of the latter book fetched £820 under the hammer in 1947. All these works are folios, the plates being printed in colour and retouched with water-colour until they have almost the quality of an original drawing. In an early work of Redouté's—Duhamel du Monceau's *Traité des Arbres et Arbustes*[2] (1801-17)—we can see how much is lost when the prints are not retouched by hand. The part played by the engraver can be well studied in *Les Roses*, for a whole world separates the beautifully gradated tones of those stippled by Charlin and the crude efforts of Chapuy. It must not be forgotten that a certain artificiality, a certain Empire elegance, is apparent in all Redouté's work. The best plates in *Les Roses*, for instance, may be triumphant as works of art ; but the botanist is better satisfied with Alfred Parsons's paintings for Willmott's *Genus Rosa* (see Pl. 43, p. 240).

From so many hundreds of exquisite sheets it is all but impossible to make a choice for reproduction. Plate 27 (p. 174) is a good example of Redouté's more spectacular work ; that of succory, from Rousseau's *Botanique*, shows his treatment of a homelier flower.

Among those who worked under van Spaëndonck or Redouté, or who based their style on the pure water-colour technique which Redouté learned from his master, may be mentioned Turpin, Poiteau, Bessa, Mme Vincent (*b.* 1786), Jaume-Saint-Hilaire, Chazal and Prêtre. Most of these artists were the equals of Redouté in technical skill, and given his opportunities might have won the same renown.

Pierre Jean François Turpin (1775-1840) was possibly the greatest natural genius of all the French botanical painters of his day. The son of a poor artisan, he learned the elements of drawing in the art school of his home town, Vire. At the age of fourteen he joined up in the batallion du Calvados, and five years later was shipped to San Domingo. Here he had the good fortune to make the acquaintance of a young

[1] " Please at once set your Paris agents to look out for all copies that come up, at any sale, of Rousseau's *Botanique* with coloured plates, 1805—and buy all they can get " (letter from Ruskin to F. S. Ellis, bookseller, May 7, 1878). Ellis did not succeed in finding any.

[2] An edition of Duhamel du Monceau's book, illustrated with woodcuts, had appeared in 1755.

botanist named Pierre-Antoine Poiteau (1766-1854) who fired him with an enthusiasm for natural history and became his lifelong friend. After various vicissitudes, Turpin met the German naturalist and explorer von Humboldt in New York in 1801, and the following year the two men returned together to France where they were joined by Poiteau. Turpin and Poiteau collaborated in some of the most important botanical publications of the early years of the nineteenth century, notably those of von Humboldt, Bonpland and Kunth.[1] Another work which they illustrated jointly was Duhamel du Monceau's *Traité des Arbres Fruitiers* (1808-35), one of the most splendid books on fruit ever produced. In all these productions Turpin was the dominant force. In particular, his drawings of botanical details have rarely been surpassed. The Lindley Library possesses the originals of Poiret and Turpin's *Leçons de Flore* (1819-20)—once the property of " un souverain de l'Allemagne "—and another volume of twenty-five delicate and highly-finished paintings. Pl. 28a (p. 175), from the later book, shows Turpin's exquisite little painting of the Christmas Rose (*Helleborus niger*). Turpin is said by Bénézit to be mainly self-taught, but his work shows great indebtedness to the tradition of van Spaëndonck and Redouté ; Goethe much admired it, and regretted that the artist was not at hand to make illustrations for the *Metamorphose der Pflanzen*.[2]

Pancrace Bessa (1772-1835) was patronised by the duchesse de Berry, to whom he gave painting lessons. Most of the original water-colours for his attractive *Herbier Général de l'Amateur* (1810-37), which were given by Charles X to the duchesse de Berry in 1826 and passed into the collection of her sister the Empress of Brazil, were sold by auction at Beverley Hills, California, in November, 1947. Forty-six more fine drawings are preserved in the Muséum, and there are others in Major Broughton's collection. His *Fleurs et Fruits* (1808) has magnificent folio stipple engravings ; but he frittered away too much of his time and energy upon small sentimental flower books which did not give his great talent full scope. The plates of Mme Vincent's *Études*

[1] Major Broughton possesses a number of fine original drawings made by Turpin and Poiteau for von Humboldt's *Monographie des Melastomacées* (1816-23).

[2] Curiously enough, Turpin seems to have arrived independently at much the same ideas as Goethe on the basic identity of foliar and floral organs, and designed in 1804 a large plate to illustrate them, which was published in his *Esquisse d'Organographie Végétale*. This work illustrates C. F. Martins's French translation of Goethe. However, in 1786 C. F. Wolff had published views rather similar to those developed by Goethe in 1790, and de Candolle independently came to the same conclusions early in the nineteenth century.

de Fleurs et de Fruits (*c.* 1820) are described by Dunthorne as " among
the most exquisite of all flower prints in their beauty and delicacy of
execution " ; Prevost's superb *Collection des Fleurs et des Fruits* (1805)
rightly receives equal praise ; and Jaume-Saint-Hilaire's *Plantes de la
France*, with its thousand pleasant little stipple plates, would shine in
any company less glorious. Jaume-Saint-Hilaire was no less dis-
tinguished as a botanist, and his introduction into France of *Polygonum
tinctorum*, which yields a valuable blue dye, was of considerable im-
portance. Antoine Chazal (1793-1854) was a versatile artist, for
besides his botanical work he also painted historical and religious
subjects and decorated porcelain and enamel. He made some good
drawings for his *Flore Pittoresque* (1825), and collaborated with J.
G. Prêtre and other artists in a splendid unpublished volume of
paintings of crocuses, made for the French botanist Jacques Gay and
now in the Library at Kew.

With the death in 1840 of Redouté and Turpin, the age of
spectacular French flower-painting drew to a close. But, as we shall
see later, for another half-century or more the great tradition of
French scientific draughtsmanship continued ; though the works of
this period are not " collectors' pieces," they are of very considerable
value to botanists and often show a quiet beauty that the true flower
lover will not fail to appreciate. Further, during all this period the
collection of *vélins* in the Muséum was steadily continued, the last
drawing, by Mellot, being added in 1905.

BIBLIOGRAPHICAL SYNOPSIS OF THE
BOTANICAL MAGAZINE

i) Vols. *1-42* (*First Series, 1-42*), tt. 1-1770, published 1787-1815 ; vols. 1-13 edited by William Curtis, 14-42 by John Sims.

ii) Vols. *43-53* (*New Series* I, *1-11*), tt. 1771-2704, published 1815-1826 ; edited by J. Sims.

iii) Vols. *54-70* (*New Series* II, *1-17*), tt. 2705-4131, published 1827-1844 ; edited by William Jackson Hooker.

iv) Vols. *71-130* (*Third Series, 1-60*), tt. 4132-7991, published 1845-1904 ; vols. 71-90 edited by W. J. Hooker, 91-130 by Joseph Dalton Hooker.

v) Vols. *131-146* (*Fourth Series, 1-16*), tt. 7992-8873, published 1905-1920 ; vols. 131-132 edited by William Turner Thiselton-Dyer, 133-146 by David Prain.

vi) Vol. *147* (" Cory " Volume), tt. 8874-8933, published 1938, edited by John Ramsbottom.

vii) Vols. *148-164*, tt. 8934-9688, published 1922-1948 ; vols. 148-156 edited by Otto Stapf, 157-163 by Arthur William Hill, 164 by Arthur Disbrowe Cotton.

viii) Vols. *165 et seq.*, N.S. tt. 1 *et seq.*, published 1948 *et seq.* ; vols. 165-167 edited by William Bertram Turrill.

THE BOTANICAL MAGAZINE

THE *Botanical Magazine*, founded in 1787 by William Curtis, has continued publication almost without interruption down to the present day. It has thus become a national institution of which Englishmen may justly be proud. I propose, therefore, to outline in a brief chapter its history during the one hundred and sixty years of its existence, leaving until later a detailed discussion of the life and work of the artists who contributed so much to its success.

William Curtis (1746-99) was born at Alton, Hampshire, in a house which has now been converted into a small museum in his memory. At the age of twenty, after serving his apprenticeship to a local apothecary, he set up business in London. Though far from affluent, he soon came to employ the aid of an assistant, and finally to sell out of the partnership altogether, in order to give himself the necessary time to follow his real inclination—the study of plants. Curtis's days were now passed in reading, collecting, cultivating his garden at Bermondsey, and exchanging ideas with men of like tastes. So successful were his labours, both practical and theoretical, that in 1772 he was appointed, at the early age of twenty-six, Præfectus Horti and Demonstrator to the Society of Apothecaries at Chelsea, an office in which Philip Miller, author of the *Gardener's Dictionary*, had been one of his predecessors.

Curtis was eager to share his knowledge with others ; when a projected course of lectures at Chelsea did not materialise, he arranged one of his own, on botany and horticulture, in the new garden which he had made for himself in " Lambeth Marsh "—almost on the site of the 1951 exhibition. Here he also cultivated some six

thousand species of plants. But his prime interest was in the British flora, especially in such flowers as grew in the neighbourhood of London. With the support of Lord Bute, he now embarked upon his first ambitious project, the *Flora Londinensis*—a series of figures and descriptions of the plants which grew within a radius of ten miles of the metropolis (see Fitter, R.S.R. ; *London's Natural History*, pp. 72-74).

The first part of the *Flora Londinensis* appeared in 1777, and in the same year Curtis, overburdened with work, resigned his post at Chelsea. For ten years he continued perseveringly at his congenial but unremunerative task ; by 1787, the results of his labours were two splendid folio volumes and a deficit which made the continuance of his venture impossible. He understood the cause of the trouble and he saw the remedy : if his clients refused to buy pictures of the unassuming plants that grew by the wayside, he would win their patronage with engravings of the bright exotics which filled their gardens. Thus, in 1787, the *Botanical Magazine* was born. As Curtis himself said, it brought him " pudding " whereas the *Flora Londinensis* had only brought him praise.

The title-page and preface of the *Botanical Magazine* : or *Flower-Garden Displayed* defined its aim, which was to illustrate and describe " the most Ornamental FOREIGN PLANTS,[1] cultivated in the Open Ground, the Green-House, and Stove." " The best information respecting their culture " was added, and the illustrations were " always drawn from the living plant, and coloured as near to nature, as the imperfection of colouring will admit." The first part, which contained three plates, was published on Feb. 1, 1787, and three thousand copies of it were sold at one shilling each. The price of subsequent parts, and the number of figures contained in them, fluctuated with the years, the average number of plates being about forty-five annually.

It has been suggested, but without any positive evidence, that some of the earliest drawings in the *Botanical Magazine* were made by Curtis himself[2] ; but William Kilburn (see p. 189) and James Sowerby (see

[1]Among the plants figured in the *Botanical Magazine*, however, are a few which are native or now naturalised in Britain, e.g. *Aconitum anglicum* (t. 9088 : 1926), *Centaurium scilloides* (t. 9137 : 1928), *Eranthis hyemalis* (t. 3 : 1786), *Impatiens glandulifera* (t. 4020 : 1843), *Impatiens glandulifera f. pallidiflora* (t. 7647 : 1899) and *Spartina townsendii* (t. 9125 : 1926).

[2]Some of the unsigned drawings in the first volume of the *Botanical Magazine* are now known to be the work of James Sowerby (see p. 190).

p. 190), joined the following year by Sydenham Edwards (see p. 192), were responsible for almost the whole work of the first twenty-eight years —most of it being by Edwards, with Sansom as engraver. On the death of Curtis in 1799, his friend John Sims (1749-1831) took over the general management and editorship of the Magazine ; under his direction, many South African plants, especially Iridaceae, figured in its pages.

After 1815, when Sydenham Edwards severed his connection with the Magazine, John Curtis[1] (see p. 223) and William Herbert were among the various artists who provided drawings until the advent of William Jackson Hooker (1785-1865), who took over the direction and illustration of the Magazine in 1826. During the long reign of William Hooker, who in 1841 became Director of the newly nationalised Royal Botanic Gardens at Kew, the connection between Kew and *Curtis's Botanical Magazine* (as it was now styled) became very close and intimate. Careful analyses and dissections now gave the work a truly scientific character, and Thornton's sneer in 1805 that it was merely " a drawing-book for ladies " finally became obsolete. In 1834, Walter Fitch (see p. 223) began to relieve Hooker of the burden of illustration ; soon he became the Magazine's only draughtsman, a position which he held until 1877. After 1845 he was also his own lithographer, and his work gained in quality by being directly reproduced and not merely transmitted through a line-engraver.

William Hooker died in 1865, and was succeeded by his son Joseph Dalton Hooker (1817-1911), under whom the last traces of the Linnean System vanished from the classification of plants in the *Botanical Magazine*. After the resignation of Fitch, various artists—including Joseph Hooker's daughter, Harriet Ann, later Lady Thiselton-Dyer (1854-1946)—held the fort until Matilda Smith (see p. 241) came to the rescue ; their work was lithographed by John Nugent Fitch (see p. 228), Walter Fitch's nephew.

Joseph Hooker resigned the editorship in 1904, and was succeeded by William Turner Thiselton-Dyer (1843-1928) who two years later handed over the charge to David Prain (1857-1944). In 1904, certain changes had been made in the Magazine : the title reverted once more to the *Botanical Magazine* ; the text, instead of being the work of the editor only, was shared among a number of writers, almost all of whom were on the staff of the Kew Herbarium ; and the number of illustrations was fixed at sixty for each year.

[1]John Curtis does not appear to have been related to William Curtis.

So far, the history of the *Botanical Magazine* is well known ; a more detailed account of the period down to 1920 will be found in Otto Stapf's article in the *Journal of the Royal Horticultural Society* (1925), from which most of the foregoing information is drawn. But its later history is less easily accessible, and therefore deserves fuller treatment.

After the first World War, the *Botanical Magazine* fell upon evil days : sales failed to meet the high cost of production—a state of affairs which has continued ever since—and by the end of 1920 Messrs. Lovell Reeve, its publishers since 1845, decided that they could not indefinitely produce it at a loss. They accordingly terminated the Fourth Series with the last part of volume 146 in December 1920.

But for the prompt action of a forceful and persuasive enthusiast, this might well have been the end. At a dinner on May 24, 1921, the first night of the Chelsea Show, Henry John Elwes (1846-1922)—well known as a horticulturist, naturalist and traveller—discussed with his carefully chosen guests the plight of the Magazine and the possibility of its continuance. The £250 necessary for the purchase of the copyright was subscribed at once, and the following day it was bought and handed over to the Royal Horticultural Society, which thereupon undertook the responsibility of publication. This was an extremely public-spirited act on the part of all concerned. After some unavoidable delay, publication was resumed in October 1922 with the issue of the first part of volume 148. A wealthy horticulturist, Reginald Cory (1871-1934), who collected finely illustrated flower-books as a hobby,[1] generously defrayed the cost of the " 1921 " volume (i.e. 147), which did not, however, appear until 1938.

The revived *Botanical Magazine* was placed under the editorship of Otto Stapf (1857-1933)—an extremely erudite and painstaking botanist and a good draughtsman—who was also responsible for the text. He was succeeded as editor by Arthur William Hill, Arthur Disbrowe Cotton, and the present editor William Bertram Turrill, and the task of preparing the text has again been shared among a number of writers.

From February 1787 to February 1948, all the plates in the *Botanical Magazine*, with the exception of a few chromolithographs in the belated 1921 Cory volume, had been coloured by hand. This laborious and costly process had long been an anachronism : the

[1] Cory bequeathed his magnificent collection to the Royal Horticultural Society, and it has been added to the Lindley Library.

increased complexity of the plates, and the growing scarcity of artists willing and able to colour them, finally made it imperative to break this long tradition. Volume 165 (April-Dec., 1948), which began a new series of plate-numbers, was accordingly issued with figures printed by a four-colour half-tone process which necessitated the use of a very smooth and rather glossy paper. For the next volume, a four-colour gravure process was adopted ; the method is expensive, but the results approximate to those obtained by hand-colouring.

During the last thirty years, most of the plates in the *Botanical Magazine* have been made by Miss Lilian Snelling (see p. 251) and—since 1932—Miss Stella Ross-Craig (see p. 251) ; other artists who have contributed drawings include A. Kellett, Matilda Smith, B. M. Baggs, W. E. Trevithick, Robert M. Adam, Otto Stapf and Gerald Atkinson.

From both the horticultural and botanical standpoint, there is a definite need for a publication containing detailed and accurate illustrations, preferably in colour, of plants that are new or little known, or that have not previously been adequately figured. Indeed, the whole history of botanical illustration is concerned with attempts to meet such a need. No other publication has succeeded so well, over so long a period, in providing such a record. As P. M. Synge has observed, " It is, indeed, the oldest current scientific periodical of its kind with coloured illustrations in the world, and in the beauty of production and the high standard of its contributions it can claim a unique place." The *Botanical Magazine* deserves, therefore, all the support that we can give it.

KILBURN, SOWERBY
AND SYDENHAM EDWARDS

I N FOLLOWING the development of the French school of botanical illustration we stepped far into the nineteenth century ; the history of the *Botanical Magazine* has brought us down to the present day : we must now retrace our path to consider the work of the British contemporaries of van Spaëndonck, Redouté and Turpin. Chief among these are Kilburn, Sowerby, Sydenham Edwards, and— greatest of them all—the brothers Francis and Ferdinand Bauer. The first three of these artists owed some share of their start in life to the patronage of William Curtis.

William Kilburn (1745-1818), the first artist engaged by Curtis, was the son of a Dublin architect. He was apprenticed to a local calico printer, but devoted his spare time to drawing and engraving. On his father's death he moved to London and settled in Bermondsey near the nursery garden of Curtis, who saw his drawings and persuaded him to assist, both as draughtsman and engraver, with the *Flora Londinensis*. Soon, however, Kilburn was enticed back into the more lucrative business of calico printing, where in due course he came to possess his own factory and made big money. Though it is stated in the *Dictionary of National Biography* that " the beauty of his designs established him as one of the most eminent calico-printers in Europe," I have not been able to trace any of his fabrics ; but he must have been a man of some influence in the trade, for it was he who persuaded Edmund Burke to introduce a bill to secure copyright for calico designs.

Plate 29b (p. 192) shows Kilburn's original drawing of the bee

orchis (*Ophrys apifera*) for the *Flora Londinensis*. The work is well done ; the drawing, if a shade mechanical, is faultless of its kind, and the painting skilful enough. Curtis laments that the bee orchis was already becoming scarce round London since " the curiosity of Florists . . . often prompts them to exceed the bounds of moderation, rooting up all they find, without leaving a single specimen to cheer the heart of the Student in his botanical excursions."

In our survey of the printed botanical book we have more than once had occasion to complain that the author, editor or publisher had unjustly stolen the thunder from the artist. Where James Sowerby is concerned, the reverse is the case. Sir James Edward Smith, who provided the text for Sowerby's celebrated *English Botany*, did not even allow his name to appear in the first numbers issued. James Sowerby (1757-1822), the first of a large family of artists who illustrated botanical and conchological books for nearly a century, studied at the Royal Academy Schools and was in due course apprenticed to the marine painter Richard Wright. After some initial hesitation as to what branch of painting he should make especially his own, Sowerby was attracted by the then popular art of flower painting ; and it was probably L'Héritier who first employed him for botanical illustration. For a time, however, until his *English Botany* began to pay, Sowerby was largely dependent upon portraiture and teaching for a living. Among his pupils was Mary Wollstonecraft Godwin. In 1787 he was engaged by Curtis to make drawings for the *Botanical Magazine*, and seventy or more of the plates in the first four volumes are his work. In addition, he drew and engraved about fifty of the plates in the fifth fasciculus of the *Flora Londinensis*. One hundred original paintings, entitled " Hortus Sylva Montis " and now in Major Broughton's collection, were made about 1787 from the plants growing in the garden of Curtis's friend Lettsom at Grove Hill, Camberwell ; some of these paintings were engraved for the first volume of the *Botanical Magazine*.[1]

At the same time Sowerby was also making fine drawings for Sir J. Smith's *Icones Pictae Plantarum Rariorum* (1790-93), for Aiton's *Hortus Kewensis* (1789), and for two works of his own—*An easy Introduction to Drawing Flowers according to Nature* (1788) and *Flora Luxurians* (1789-91). Of the last of these he modestly writes : " As all the Productions of the

[1] I am indebted to Mr. A. H. G. Alston, of the Natural History Museum, for his ingenious explanation of " Sylva Montis."

THE SOWERBY FAMILY

JAMES SOWERBY (1757-1822)
Naturalist and artist

JAMES DE CARLE S. GEORGE BRETTINGHAM S. CHARLES EDWARD S.
(1787-1871) (1788-1854) 1795-1842
Naturalist and Artist Conchologist and Artist

JAMES S. GEORGE BRETTINGHAM S. HENRY S. JOHN EDWARD S.
(1815-34) (1812-84) (1825-91) (1825-70)
 Conchological Artist Botanical Artist

Earth were designed for the Amusement or Convenience of its Inhabitants ; the most humble Attempt to display the Beauties of Nature should not be despised by those who, wrapped up in their own Pursuits, think every other insignificant."

It was no doubt the heavy work entailed in making, and probably also engraving, upwards of 2,500 drawings for the *English Botany* (1790-1814) which put a stop to Sowerby's active association with Curtis. The original drawings for the thirty-six volumes of this great book are now in the Natural History Museum, where they have been mounted, for purposes of comparison, side by side with the corresponding figures of the first and third editions of the printed work— the latter illustrated for the most part with inferior and crudely coloured lithographic copies of the original plates. Moreover, after 1797 he was occupied with another major work, *Coloured Figures of English Fungi*, for which he made 440 drawings and many models ; and after 1806 with engraving the majority of the plates for Sibthorp's *Flora Græca*. In his later years he also studied zoology, mineralogy and fossil shells, writing and illustrating works on all these subjects. It was fitting that a botanical genus—*Sowerboea*—should commemorate his labours ; but not every botanist has the distinction of giving his name to a whale (Sowerby's Whale : *Mesoplodon sowerbiensis*). Plate 30b (p. 193) shows Sowerby's original drawing of *Caltha palustris*, upon the margin of which Smith has written " this is an excellent sketch ; " Plate 30a (p. 193) gives the figure of *Erica tetralix* from the first edition of the *English Botany* ; it should be compared with Ruskin's drawing of the same plant (Fig. 49, and see p. 234).

Sowerby was a considerable scientist of wide interests, an artist of distinction, and a talented engraver. In his rapid sketches, his pencil line is swift and vivid. Towards the end of his life he was assisted by his eldest son James de Carle Sowerby, who inherited much of his father's skill ; he was responsible for some of the drawings for the later volumes of the *English Botany*, and for much of the work in the supplementary volumes. James de Carle's industry is attested by a collection of nearly ten thousand little drawings made to illustrate J. C. Loudon's *Encyclopædia of Plants* (1829).

Curtis had given employment for a time to both Sowerby and Kilburn, but each in due course had gone his own way ; Sydenham Teast Edwards (1769 ?-1819), however, was Curtis's own creation, and,

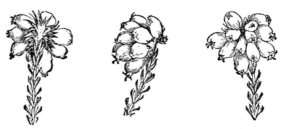

FIG. 49—Cross-leaved Heath (*Erica tetralix*)
From a drawing by Ruskin, *c.* 1883

until the latter's death in 1799, his inseparable companion upon botanical expeditions. Edwards was the son of a Welsh schoolmaster of Abergavenny. A friend of Curtis's, a Mr. Denman, chanced to see some copies of plates in the *Flora Londinensis* which the boy had made for his own amusement. Curtis was shown the drawings, and had young Edwards brought to London for instruction. His first plate for the *Botanical Magazine*—that of a bizarre carnation named *Franklin's* " *Tartar*," one of the few Florists' flowers admitted in the work— appeared in 1788 in the second volume, and during the twenty-seven years that followed, almost all the drawings in it were his. In fact, of the first 1721 plates, he seems to have been responsible for all but seventy-five. In 1815, as the result of a misunderstanding, Edwards severed his connection with the *Botanical Magazine* and started the rival *Botanical Register*, a course of action which brought upon him the reproaches of the Curtis family. His other work includes twenty-one plates for the sixth fascicule of the *Flora Londinensis,* and the illustrations

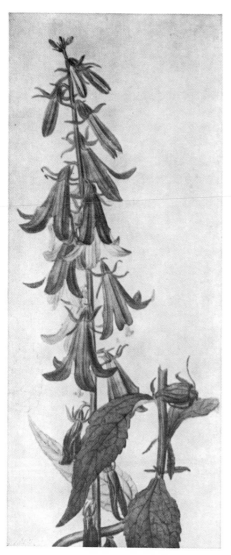

Plate 29a CREEPING BELLFLOWER (*Campanula rapunculoides*)
Water-colour drawing by John Curtis for the *Botanical Magazine*, 1826
b BEE ORCHIS (*Ophrys apifera*). Water-colour drawing by William Kilburn (1745 – 1818)
for Curtis's *Flora Londinensis*. Kew Herbarium

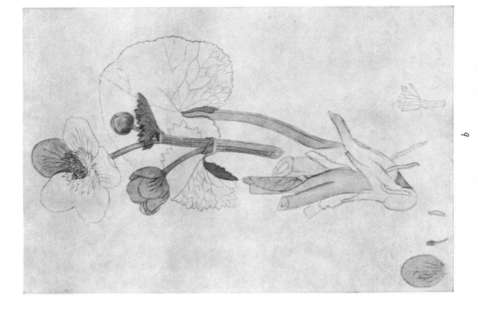

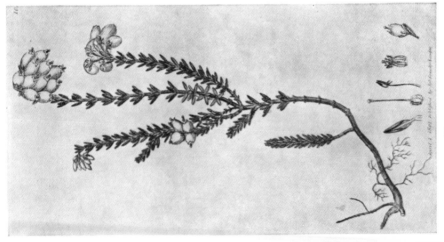

Plate 30a

b

to McDonald's *A Complete Dictionary of Practical Gardening* (1807).[1] The originals of the latter, many of which are of American plants, are in the Natural History Museum, London.

Sydenham Edwards was a conscientious and industrious artist, but his line lacks the swiftness of Sowerby's. In his early work his colour, especially his green, is sometimes harsh, and his hatched and stippled tone laboured until it becomes lifeless. His later drawings for the *Botanical Magazine*, which are now at Kew, and his plates in the *Flora Londinensis*, are much stronger and show a better understanding of the structure and habit of the plants portrayed (see Pl. 31, p. 196).

The work of the two Bauer brothers demands a separate chapter ; but a number of lesser English artists of the late eighteenth century cannot be left unnoticed.

William Roxburgh (1751-1815), who spent more than thirty years of his life in India, was an eminent botanist and a meticulous if rather arid artist. His *Plants of the Coast of Coromandel* (3 vols., 1795-1819) must rank among the most impressive publications of the age, though its plates, which were engraved from some of his large collection of native drawings, are often rather marred by a heavy and wiry outline. These plates form a valuable supplement to the *Flora Indica*, in which a large number of new species first detected by Roxburgh are recorded ; for though his descriptions are good, they do not always give all the details required by botanists to-day.

John Edwards (*fl.* 1768-95) of Brentford made some very decorative illustrations for his *British Herbal* (1770) and *A Collection of Flowers drawn after Nature and disposed in an Ornamental and Picturesque Manner*

[1] These plates were used again to illustrate *The New Flora Britannica* (1812), also published in the same year under the title *The New Botanic Garden*. The word " New " was presumably added to the latter to avoid confusion with Erasmus Darwin's poem *The Botanic Garden* (1789) ; but in 1825, Maund started a periodical entitled *The Botanic Garden*. The apparent absurdity of the " New " work preceding the original is thus explained.

PLATE 30a
CROSS-LEAVED HEATH (*Erica tetralix*). Hand-coloured engraving by J. Sowerby from his *English Botany*, 1790-1814

PLATE 30b
MARSH MARIGOLD (*Caltha palustris*). Water-colour drawing by J. Sowerby (1757-1822) for his *English Botany*. Natural History Museum, London

(1783-95) ; but in the main his work is too stylized to satisfy the botanist.

The indefatigable Margaret Meen (*fl.* 1775-1824) made many hundreds of very effective paintings of exotic plants at Kew and elsewhere. In spite of all her immense industry and patience, however, she never quite rises above the level of a very highly gifted amateur. A large collection of her work, once the property of the Earl of Tanker-ville, is now in the Kew Herbarium. A handful of water-colours in the Victoria and Albert Museum, by A. Power (*c.* 1800) of Maidstone, show him to have been a skilful exponent of the style of Ehret. William Bartram (1739-1823), son of John Bartram who was the first native American botanist, made careful studies of plants and animals in Florida and Carolina. Richard Anthony Salisbury (1761-1829), distinguished as a botanist, used his pencil with skill and delicacy, as is testified by his sketches in the Natural History Museum.

But the work of none of the artists whom we have mentioned in this chapter can stand comparison with that of Francis (Franz) and Ferdinand Bauer—two of the finest draughtsmen in the whole history of botanical art.

FRANCIS AND FERDINAND BAUER

THE NAME of Sir Joseph Banks (1743-1820) has more than once been mentioned in these pages. During the closing decades of the eighteenth century and the opening years of the nineteenth, he occupied an unique position in the English scientific world. In his youth he had shown a pleasing impartiality in electing to be educated at Harrow and Eton successively ; as a young man, his wealth and enthusiasm were ever at the disposal of any worthy cause; his house and collection in Soho were open to all who sought admission; and throughout his life he rendered incomparable service to the study of natural science by subsidising botanists, explorers and artists all the world over. Among those who sunned themselves in the genial rays of his munificence were the brothers Francis and Ferdinand Bauer, the greatest exponents of botanical drawing in England since the death of Ehret.

Like Ehret, the Bauers were artists of Germanic birth who made England the land of their adoption. Their father, who lived at Feldsberg near Vienna and was painter to Prince Liechtenstein, died when his three children were still in infancy. Joseph, the eldest, became in due course curator of the Prince's collection and passes out of this story. Francis (b. 1758) gave early sign of his talent, and a drawing by him of *Anemone pratensis* was engraved and published when he was only thirteen years old. Ferdinand, two years his junior, showed the same tastes ; when he was fifteen, Father Boccius, Abbot of Feldsberg, recognised his ability and engaged him to paint a large number of " miniature "—that is to say, highly finished—flower studies which later passed into the Liechtenstein collection.

In 1784 John Sibthorp, Sherardian Professor at Oxford, arrived

in Vienna to study the great Dioscorides manuscript, the *Codex Vindo-bonensis* (see p. 10), before setting out on a botanical tour of the Levant. Through the agency of Jacquin and Boccius, he made the acquaintance of Ferdinand Bauer and persuaded him to become his travelling companion. The two left Vienna in the spring of 1786.

After spending June in Crete, where " our botanical adventurers were welcomed by Flora in her gayest attire," the travellers sailed on among the Greek islands to Smyrna. The winter was passed at Constantinople ; and the following spring, after making a short excursion as far north as Belgrade, they set out for Cyprus.

Besides making innumerable botanical studies, Ferdinand had also found time to paint sketches of the country through which they journeyed. In December, after a summer and autumn spent in Greece, Sibthorp returned to Oxford bringing Ferdinand with him. Here the arduous task of sorting and classifying specimens went slowly forward, while Ferdinand prepared from his sketches the finished drawings which were later to form the illustrations for Sibthorp's celebrated *Flora Graeca* (1806-40).

It was no doubt at Ferdinand's suggestion that his brother Francis now visited England with the younger Jacquin. Francis had intended seeking his fortune in Paris, where, in spite of the Revolution, the pursuit of science continued without interruption ; but a meeting with Banks changed the whole course of his career. The latter had long realised the importance of attaching a permanent draughtsman to the Royal Gardens at Kew, of which he was virtually director ; in Francis Bauer he recognised his man. With the King's approval and his own characteristic generosity, Banks allotted Francis a liberal salary from his private purse and made arrangements for its continuance after his death. Thus Francis, who did not share his brother's taste for adventure, settled in 1790 at Kew, where he remained until his death fifty years later.

Ferdinand Bauer did not accompany Sibthorp upon his second expedition to the Levant in 1794-95, but continued work upon his Greek drawings. Sibthorp returned from the East a sick man : neither the tepid sea-water baths of Brighton, nor a drastic diet of asses' milk at Oxford, could arrest the melancholy progress of his disease, and he died the following spring. Flaxman designed his tomb ; but the *Flora Graeca* remains his true monument. After endless delays, the ten noble folio volumes appeared under the direction of Sir J. E. Smith

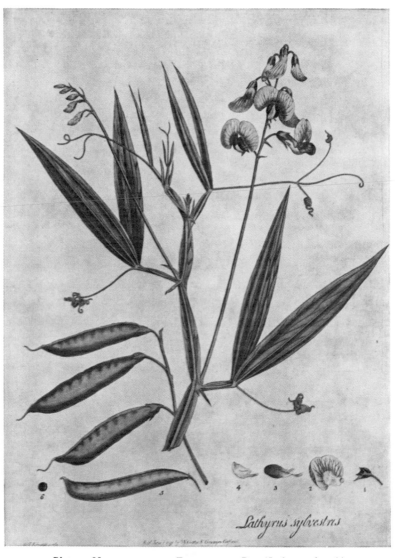

Lathyrus sylvestris

Plate 31 NARROW-LEAVED EVERLASTING PEA (*Lathyrus sylvestris*)
Hand-coloured engraving by Sydenham Edwards (1769? – 1819)
From W. Curtis, *Flora Londinensis*

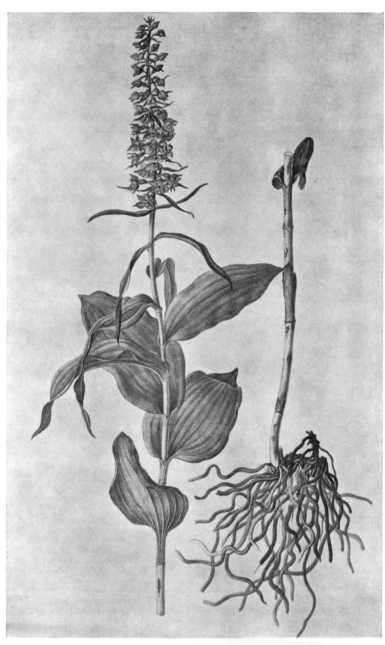

Plate 32 Broad-leaved Helleborine (*Epipactis helleborine*)
Water-colour drawing by Francis Bauer, August 2, 1811
Natural History Museum, London

and, after his death, under that of John Lindley. The last volume was not published until 1840. Only twenty-eight copies of the first edition were issued, at £254 a set. The total cost was about £30,000, this highly uncommercial proposition being made possible by a considerable sum of money set aside by Sibthorp for the purpose.[1]

Though Ferdinand did not return to the Levant, he still felt the wanderlust. In the autumn of the year 1800, when Matthew Flinders was making preparations for his audacious voyage of exploration to Australia, he invited the painter to accompany him as botanical artist, with a salary of £300 a year and rations for himself and his servant. Ferdinand accepted at once. The ship's company also included William Westall the landscape artist, and the young Scottish botanist Robert Brown who was to become " perhaps the greatest figure in the whole history of British botany."

The story of the adventurous journey, so rich in scientific dis- coveries of every kind, can be read in Flinders's own narrative and in his biography by Ernest Scott. Ferdinand's industry was colossal, and he seems to have remained unperturbed by the dangers and hazards of the long voyage. Only once—when the water poured into his cabin and destroyed a number of his drawings—do we hear of his temper being overtaxed ; but he was more fortunate than Westall, whose whole output first suffered shipwreck, and was then further damaged by a group of high-spirited young midshipmen (one of whom afterwards became Sir John Franklin) who drove a flock of sheep over the drawings as they lay drying on the coral sands of Wreck Reef. It was five years before Bauer reached England again, and five more before Flinders, who was held a prisoner by the French in Mauritius, obtained per- mission to return home. Geographical names in Southern Australia, such as Flinders Island, Cape Bauer, Point Westall and the Sir Joseph Banks group of Islands, still bear record of the discoveries of these brave pioneers and the generosity of the patron who helped to make them possible.

Some years after his return to England, Ferdinand began to prepare the plates for his *Illustrationes Florae Novae Hollandiae* (1813). It was a heavy task, for, as his brother Francis tells us, " Ferdinand could not find people capable either of engraving or colouring the plates

[1] A reprint of the *Flora Graeca* was issued by Henry Bohn between 1845 and 1856. This is a little inferior to the original issue ; it can be recognised by the watermark " 1845 " on many of the plates, even on those of the first volume.

properly, and was consequently obliged to execute every part of the work with his own hands, thus occupying far too much time. Very few, indeed, coloured copies has he been able to prepare and sell." Moreover, the moment was not propitious for such a venture ; for war had impoverished the patrons, who were in any case growing a little weary of the endless succession of costly botanical books which appeared year after year. Thornton's *Temple of Flora*, as we shall see, suffered a similar fate. After fifteen plates of the *Illustrationes* had been issued, the project was abandoned ; and Ferdinand, depressed by his failure, packed up his drawings and his herbarium, shook the dust of England from his feet, and returned to his fatherland. He had saved enough money to buy a small house near the gardens of Schönbrunn, and here he completed his series of finished drawings of Australian plants and animals. There were many pleasant botanical excursions in the Styrian and Austrian Alps ; and before his death in 1826, he relented and paid one more visit to his English friends, among whom would certainly have been old Sir Joseph Banks.

Francis lived on at Kew, making his splendid paintings of plants introduced by the travellers and navigators of the reign of George III. Queen Charlotte and Princess Elizabeth took lessons from him ; but the latter did not stay the course, for he proved " a better philosopher than courtier, and his services, which were given gratuitously, were soon dispensed with." The Queen, however, was an apter pupil, and tinted engravings of his drawings under the direction of the master. " There is not a plant in the Gardens of Kew . . ." wrote Thornton, " but has either been drawn by her gracious Majesty, or some of the Princesses,[1] with a grace and skill which reflect on these personages the highest honour ; " and James Pye, worst of Poet Laureates, embroidered the theme :

> *While Royal NYMPHS, fair as the Oreade race*
> *Who trod Eurotas' brink, or Cynthus' brow,*
> *Snatch from the wreck of time each fleeting grace,*
> *And bid its leaves with bloom* perennial *glow.*

Francis had not remained content to draw the mere outward

[1] A volume of flower paintings copied by Princess Charlotte Augusta (*c.* 1783) from the engravings illustrating John Miller's *An Illustration of the Sexual System of Linnæus* is in the Royal Library, Windsor.

appearance of plants ; he had become a highly skilled botanist, and his microscopic drawings soon became as famous as his flower studies. When Banks began his researches on blight, Francis was at his side ; his work on the structure of orchids (see Pl. 32, p. 197, and Pl. XXIXa, p. 226) was of first importance, though others took the credit ; and when Sir Everard Home was in difficulties over the anatomical structure of the foot of the common house-fly, it was Francis who came to the rescue with a brilliant series of drawings. Most of these tasks were unrewarded and even unacknowledged ; the only money he ever received, beyond his official salary, was fifteen guineas for a few articles in the cheaper Press on the smut in wheat. Francis died in 1840 at the age of eighty-two, happy to the last with his flowers and his microscope. He was buried in the churchyard at Kew, by the side of Gainsborough and Zoffany.

It must, perhaps, for ever remain an open question as to who was the greatest botanical artist of all time, though I myself would un-hesitatingly give first place to Francis Bauer. One thing, however, is certain : the last hundred years can show no artist of the calibre of either of these two brilliant brothers. Indeed the year 1840, which saw the death of Francis Bauer, Redouté and Turpin, marks the close of the great cycle which opened four centuries earlier with the first stirrings of the Renaissance.

The paintings of the two brothers are so similar, that it is sometimes difficult, especially in their later work, to differentiate between them. Ferdinand, in his Greek drawings, made considerable use of body colour, a practice which later he generally avoided. Francis, on the other hand, showed an early preference for pure wash. No flower, however complex, proved too difficult for their astonishing technical skill ; and no artist, with the possible exception of Turpin, ever rivalled them in the portrayal of botanical detail. Their patience and application were unparalleled. If we are tempted to feel that Francis was the more perfect craftsman, we must not forget the difficulties under which his more adventurous brother often had to labour.

The Oxford Botanic Garden is the fortunate possessor of the drawings, nearly a thousand in number, made by Ferdinand for the *Flora Graeca*. They show " the plants observed . . . in the environs of Athens, on the snowy heights of the Grecian Alp, Parnassus, on the steep precipices of Delphi, the empurpled mountain of Hymettus, the

Pentele, the lower hills about the Piræus, the olive-grounds about Athens, and the fertile plains of Bœotia." The Oxford Garden also has in its care three unpublished volumes of drawings of Greek fauna, and a group of monochrome landscape studies made during the same tour. Ten of the latter were engraved upon the title-pages of the volumes of the *Flora Graeca*. Plate 33 (p. 204) shows the original painting for the figure of "Helleborus officinalis" (*Helleborus cyclophyllus*). Possibly it became apparent in the course of publication that an artist with James Sowerby's botanical knowledge could engrave from an unfinished study, for many of the later drawings are only partially completed.

A number of drawings made by Ferdinand of Australian plants are now in the Natural History Museum, London.[1] They show a considerable advance upon his Greek work : the stippled colour is less dry and more controlled ; the texture of the browns is less gummy. The fifteen plates which he himself engraved from them are in stipple, supported by heavy outline to facilitate the painting. Good though the work is, it falls below the standard set by Sowerby in the *Flora Graeca*. Others of the drawings were used by S. L. Endlicher in his *Prodromus Florae Norfolkicae* (1833) and *Iconographia Generum Plantarum* (1837-41) ; though the plates in the latter work are not very exciting from an æsthetic point of view, their wealth of botanical detail gives them great scientific value. Ferdinand also made and engraved most of the plates for Lindley's *Digitalium Monographia* (1821) and some of those in his *Collectanea Botanica* published in the same year.

Ferdinand's fine illustrations to Lambert's *A Description of the Genus Pinus* (1803-42) provoked the admiration of Goethe, himself an enthusiastic botanist and not untalented draughtsman[2] (see Fig. 50). Again and again he returned with pleasure to the copy in the Royal Library at Weimar. He praises Ferdinand's skill in grading his tones so that the needles take up their true position in space and do not become merely " Chinese " in character—that is to say, reduced to a flat pattern. Solid forms, such as stems and cones, are given just enough substance to make them appear round, without upsetting the spatial balance of the whole. " It is a real joy," he says, " to look at

[1] Two thousand more unpublished drawings of Australian plants are in the Natural History Museum in Vienna. Many more drawings by Ferdinand and Francis Bauer are at Göttingen University.

[2] See Schuster (1924), which contains reproductions of Goethe's own sketches and of finished paintings made from them by Albert Stark ; see also Arber (1946).

these plates, for Nature is visible, Art concealed." The task of the modern botanical draughtsman, Goethe adds, is far more exacting than that of the artist of the old-fashioned florilegium : "The former may feel the same inspiration as one of our great Low Country flower painters ; but he is always at a disadvantage. The one had only to satisfy the lover of superficial beauty ; the other has to give truth—and through truth, beauty. The one had the easy task of pleasing the garden lover ; the other knows that the botanical accuracy of his work will be examined by a whole host of critical experts. . . ." Moreover, as science advanced, the botanist ceased to concern himself merely with useful, beautiful and sweet-smelling plants, and "embraced with equal affection the ugliest and most useless. And the artist was obliged to follow suit." To serve at the same time both Art and Science, he concludes, may well seem an impossible task. Ferdinand Bauer's work is proof that it can be accomplished.

FIG. 50—Horse Chestnut (*Aesculus hippocastanum*). Drawing probably by Goethe (1749-1832)

Four of the plates in Lambert's *Pinus* were by Francis Bauer, three by Sowerby, and one after Ehret ; the rest were the work of Ferdinand. A supplementary third volume, very inferior in quality, was added to the second edition, published in 1828. Some idea of contemporary prices can be gauged from the fact that these three folio volumes were issued at seventy-five guineas the set.

Francis Bauer's finest paintings may be seen in the Natural History Museum. In his engraved work he was less fortunate than his brother, and only in the thirty plates made for Aiton's *Delineations of Exotic Plants* (1796) can we appreciate the force of his draughtsmanship. Francis also furnished drawings for the *Transactions of the Horticultural*

Society. The lithographs which he made for his own *Strelitzia Depicta* (1818) are so elaborately hand painted as to be virtually original water-colours. Another set of lithographs, some of them transferred to the stone by an amateur, were designed by him for the *Illustrations of Orchidaceous Plants* (1830-38). These show botanical details only, and are of very inferior quality.

William Hooker (1779-1832)—an able botanical painter who seems to be unrelated to his more famous namesake Sir William Hooker, Director of Kew—was a pupil of Francis Bauer. He was official artist to the Horticultural Society of London, and the original paintings of flowers and fruit that he made for their *Transactions* can be consulted in the Lindley Library of the Royal Horticultural Society. Hooker engraved the drawings of James Forbes for the latter's *Oriental Memoirs*,[1] and also worked for Salisbury's *Paradisus Londinensis* (1805-08) and other publications ; but he is best remembered by the virulent shade of green which still bears his name.

From the highly scientific and all too little known work of the two Bauers, we must turn now to what is the most popular and most eagerly sought after of all flower books—Thornton's *Temple of Flora.*

[1]The original drawings for this work are at Oscott College, Birmingham.

THORNTON AND THE TEMPLE OF FLORA

THE GREAT folio volume usually known as Thornton's *Temple of Flora* is probably the most famous of all florilegia. Its size, its splendour and its renown entitle it to a separate chapter, although, judged by modern standards, it has little botanical value.

Robert John Thornton (1768?-1837)—son of a successful miscellaneous writer, Bonnell Thornton—was destined for the church, but abandoned theology in favour of medicine. In 1797, after three years at Guy's Hospital and a period of study abroad, he put up his plate in London. Thomas Martyn's lectures and the writings of Linnæus had opened his eyes to the wonders of botany, and almost at the onset of his career he embarked upon the gigantic publishing venture which was to bring him immortality and financial ruin—his *New Illustration of the Sexual System of Linnæus*.[1]

The work was advertised in 1797, and issued in parts, first at a guinea and then at twenty-five shillings each, between 1799 and 1807. No pains and no expense were spared to make it the most sumptuous botanical publication that had ever been produced : distinguished artists such as Reinagle, Pether and Henderson—some of them, however, men without any scientific training—were engaged to make paintings for the plates, which were transferred to copper by more than a dozen eminent engravers. The book was dedicated to the Queen, and " in its progress . . . received the smile of the munificent ALEXANDER, Emperor of Russia."

The elucidation of the various editions and issues of this work is a

[1] Entitled " New " to distinguish it from John Miller's *An Illustration of the Sexual System of Linnæus* (1777).

tangle which we may well leave bibliographers to unravel ;[1] our particular concern must be the twenty-eight magnificent colour-engravings of flowers included in the third section of the work. This section, entitled *The Temple of Flora*, was also published separately. The flower plates are preceded by a number of elaborately engraved calligraphic title-pages, portraits, allegorical scenes and the like : *Linnæus, in his Lapland Dress* (by Hoffman) ; *Flora dispensing Her Favours on the Earth* (by Cosway) ; *Cupid inspiring the Plants with Love* (by Reinagle) ; and *Flora, Æsculapius, Ceres, with Cupid*, honouring the *Bust of Linnæus*. In the latter, " the fair forms of FLORA and of CUPID with the bust of LINNÆUS, cannot fail to disclose to the eye of the observer the magic pencil of a RUSSEL ; and the figures of ÆSCULAPIUS and CERES, the nervous and masterly strokes of an OPIE."

In the flower engravings, it has been Thornton's aim that the artists should set their plants, not against the conventional plain background, nor yet in a formal landscape with " long avenues of upright timber, gravel-walks meeting to some circular bason of water, or a cascade playing its forced part," but in the full richness of their natural setting. But we will let Thornton speak for himself ; his " Explanation of the Picturesque plates " will help us to appreciate the peculiar flavour of his book :

Each scenery is appropriated to the subject. Thus in the *night-blowing* CEREUS you have the moon playing on the dimpled water, and the turret-clock points XII, the hour at night when this flower is in its full expanse. In the *large-flowering* MIMOSA [*Calliandra grandiflora*], first discovered on the mountains of Jamaica, you have the humming birds of that country, and one of the aborigines struck with astonishment at the peculiarities of the plant. In the *Canada* LILY there is expressed the shade it delights in, with a sky whose clouds yet contain snow within their bosom. In the *narrow-leaved* KALMIA, which comes forth under the same zone, but at an earlier season, the mountains are still covered with their fleecy mantle. The *nodding* RENEALMIA [*Alpinia speciosa*], on the contrary, has a warm sky, and cocoa-nut trees skirt the distant scenery. The AURICULA is represented as flourishing on Alpine mountains, when the utility of their banner becomes conspicuous. In the DODECATHEON, or *American* COWSLIP [*Dodecatheon meadia*] a sea

[1]See Dunthorne.

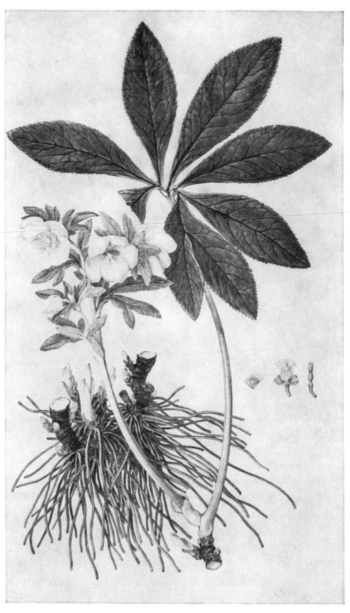

Plate 33 'HELLEBORUS OFFICINALIS' (*Helleborus cyclophyllus*)
Water-colour drawing by Ferdinand Bauer
for J. Sibthorpe, *Flora Graeca*, 1806 – 40
Oxford Botanic Garden

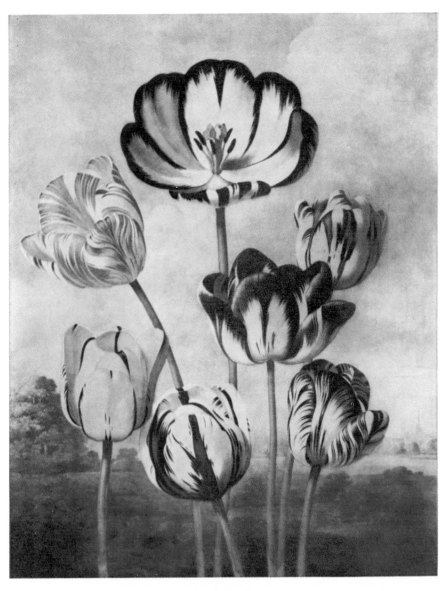

Plate 34 TULIPS
Mezzotint, printed in colour and finished with water-colour, by Earlom
after an oil painting by Philip Reinagle (1749 – 1833)
From R. Thornton, *Temple of Flora*, 1799 – 1807

view is given, and a vessel bearing a flag of that country : the same is shewn by a butterfly in the plates of the *oblique-leaved* BEGONIA ; and the *Pontic* RHODODENDRON. In the *Chinese* LIMODORON [*Phaius tankervilliæ*], and the *Indian* CANNA, are represented the pagodas of the East. The TULIPS and HYACINTHS are placed in Holland, where these flowers are particularly cultivated, embellishing a level country. The ALOE erects, in contrast, its stately form among mountains, and the height and shape of the whole plant may be seen in the background. In the *maggot-bearing* STAPELIA you will find represented a green African snake, and a blow-fly in the act of depositing her eggs in the flower, with the maggots produced from this cause. The clouds are disturbed, and every thing looks wild and sombre about the *dragon* ARUM, a plant equally poisonous as fœtid. In the *white* LILY, where a dark background was obliged to be introduced to relieve the flower, there is a break, presenting to the view a temple, the only kind of architecture that can be admitted in a garden. Hence the several species of PASSION-FLOWERS are seen clambering up pillars, reaching to different heights. As each of these beauties of the vegetable race are carefully dissected, it is hoped, that the rigid botanist will excuse the author, who, striving at universal approbation, has thus endeavoured to unite the " Utile Dulci."

Fourteen of the twenty-eight plates of the *Temple of Flora* are the work of Peter Henderson, who was also known for his genre studies and portraits, among his sitters being Mrs. Siddons ; he exhibited many miniatures at the Royal Academy between 1799 and 1829. Eleven more plates are by Philip Reinagle (1749-1833). At first pupil and drudge of the great portrait-painter Allan Ramsay, Reinagle became disgusted by the slavery involved in producing " 50 pairs of ' Kings and Queens ' at 10 guineas a-piece,"[1] and abandoned portrait for animal, and finally for landscape, painting. He is also remembered for his copies of the work of the Dutch landscape-painters, and for his illustrations to Taplin's *Sportsman's Cabinet.* Two plates are by Abraham Pether (1756-1812), who also supplied the moonlight in Reinagle's *Night-blowing Cereus.* Pether was extremely versatile—a musical prodigy, artist, philosopher, mathematician and inventor of mechanical

[1]George III had an inveterate habit of presenting his friends with full-length portraits of himself and the queen.

gadgets. His passion for painting nocturnal scenes earned him the sobriquet of " Moonlight Pether," and his " astronomical accuracy " was above criticism. He died in great poverty, leaving a widow and nine children destitute. Of the two remaining plates, that of hyacinths is by Sydenham Edwards, and the famous *Roses* by Thornton himself.

Among the team of engravers, Ward, Earlom and Dunkarton were celebrated for their work in mezzotint, and Stadler and Sutherland in aquatint.[1] Some of the plates are executed in the one medium, some in the other, and in certain prints both processes have been used on the same plate. The printing is made in basic colours, at that time an unusual method in England, and the proofs then worked over with water-colour washes.

Plate 34 (p. 205) shows the *Group of Tulips*, painted by Reinagle and engraved by Earlom. " Most prominent in our group, you see a tulip, named after that unfortunate French monarch, LOUIS XVI,[2] then in the meridian of his glory ; it rises above the rest with princely majesty, the *edges* of whose petals are stained with *black*, which is the true emblem of sorrow. . . . The next Tulip in dignity has its six petals of a firmer structure, and is *bordered* with *dark purple*, so that the most rigid critic might excuse the fancy of the florist, who has named this flower after the man ' Justum et tenacem propositi ' [General Washington]. Beneath these is LA MAJESTIEUSE, whose edges are clear, but it possesses an extensive *blue purple stripe* in the *centre* of each petal. The *Carnation* Tulip is called by Botanists LA TRIOMPHE ROYALE, which for beauty of its pencilled stripes certainly triumphs over all the rest. Beneath this is the GLORIA MUNDI, whose *yellow ground* is an emblem of sublunary perfection. Its decisive *dark purple lines* at the *edges*, or in the *centre* of the petals *at their top*, together with its stately position, sufficiently characterise this individual. The two remaining Tulips have been newly raised by Davey and Mason, and were named by me,

[1]The process of aquatint engraving, a variety of etching, was probably invented about the year 1650, though it was not developed or put to serious use until more than a century later. The plate is evenly covered with powdered resin which, under gentle heat, adheres to the metal in small specks. (Another method is to dissolve the resin in alcohol.) When the mordant is applied, the resin resists the action of the acid, which thus etches a fine network of lines upon the plate. In this way a granulation is obtained. When printed, this gives a tone comparable to a water-colour wash. The depth of the tone can be controlled by the use of stopping-out varnish, and various devices are employed to produce gradations. The process is generally used in conjunction with etching.

[2]Sweet relates that in 1827 a hundred guineas was offered, and refused, for a Louis XVI tulip.

after two very distinguished patrons of this work, Her Grace the DUCHESS OF DEVONSHIRE, no less eminent for her fine sense and expressive beauty, than EARL SPENCER, for his memorable conduct of our navy, which has eclipsed, under his administration, even the glory of our ancestors, which was *previously* imagined to exceed almost the bounds of human credibility."

" How much," laments Thornton of his tulips, " does the imitative power of painting fall short in trying to represent these ravishing beauties of the vegetable world ! " Yet how much has been achieved ! His artists have marvellously brought out the characteristic qualities of the flowers they paint : the stateliness of the tulip and the lily, and the velvet texture of the rose ; the drama of the midnight flowering of the cereus, and the terror that surrounds the dragon arum ; the latent obscenity of the maggot-bearing stapelia and the tropical splendour of the sacred Egyptian bean. It matters little, as Mrs. Cardew (1947) points out, that the habitat of the plants is not always correctly shown. To attempt, for instance, to flower the night-blowing cereus in the open in this country—and the church tower in the background is unmistakably British—only entails disappointment ; nor does the American cowslip flourish among seaweed. To cavil at such things in such a book is mere pedantry.

Thornton's prose style plays a valuable part in creating the peculiar atmosphere of the book. His phraseology, if slightly ludicrous at times, is none the less charmingly evocative of his age. What, for instance, could be more useless, yet more delightful, than to be told that the white lily "majestically presents its finely-polished bosom to the all-enlivening sun ? " He appeals to us, also, by the engaging inconsequence of his digressions : we should, for instance, scarcely expect to find in a botanical treatise, information about " the *needless* and *atrocious murder* of the Duke D'ENGHIEN, by torch-light, in the Bois de Boulogne ; "[1] dissertations on Persian, Greek, Hindu and Egyptian mythology ; a diatribe against war ; or full details of the disposition of the opposing fleets at the Battle of Aboukir. Words, indeed, poured effortlessly from Thornton's pen. Besides his purely medical and philosophical works, he was the author of a host of botanical publications, such as : *The History of Medical Plants ; The Elements of Botany ; Practical Botany ; The Philosophy of Botany ; A New Family Herbal* (illustrated with wood-engravings by Thomas Bewick after drawings

[1]Actually he met his death in the moat of the Château of Vincennes.

by John Henderson—see Fig. 53, p. 242); *Outlines of Botany*; *Juvenile Botany*; *The British Flora*; *A Grammar of Botany*; *The Greenhouse Companion*; and *An Introduction to the Science of Botany*.

Yet Thornton was soon in financial straits. He himself attributed all his troubles to the distractions of the continental war: "The once *moderately rich* very justly now complain that they are exhausted through *taxes* laid on them to pay armed men to diffuse *rapine, fire* and *murder*, over *civilised* EUROPE," he wrote in an *Apology* to his subscribers for the curtailment of his scheme for an enlarged *Temple of Flora*. No doubt the war was in part responsible; but, as we have already mentioned, the public was becoming sated with botanical books, and Thornton's heroic but ill-timed venture was foredoomed to failure. In 1811, he obtained an act of parliament authorising him to hold a lottery to save him from disaster.

The *Royal Botanical Lottery*, under the patronage of the Prince Regent, issued twenty thousand tickets at two guineas each and offered ten thousand prizes with a total value of £77,000. The first prize consisted of the original paintings for the plates of the *Temple of Flora*, then on exhibition at the European Museum in King Street, St. James's, values at £5000. Most of these paintings have now vanished; but Major Broughton has kindly allowed me to reproduce that of the "Superb Lily" from his collection (see Pl. 35, p. opp.). The remaining prizes were copies of the *Temple of Flora* and his other botanical books, and unbound sets of the plates.

The lottery seems to have miscarried, for when Thornton died in 1837 his family was left almost penniless. But the fame of his great book lives on: fifty years ago, average plates fetched as much as £20 apiece; and to-day, after a temporary fall from grace, they again command very high prices.

A rival publication to the *Temple of Flora*—Samuel Curtis's *Beauties of Flora* (1806-20)—never achieved the same renown but presumably met with the same fate. The book is exceedingly rare; its plates, which are very few in number, closely resemble Thornton's but are even larger. Several are engraved after paintings by Clara Pope, whose work will be discussed in the following chapter. The Kew Library contains an interesting set of black-and-white trial proofs, two of which are not recorded by Dunthorne.

[1]The nurseryman Samuel Curtis (1779-1860) was a first cousin of William Curtis, whose only daughter he married.

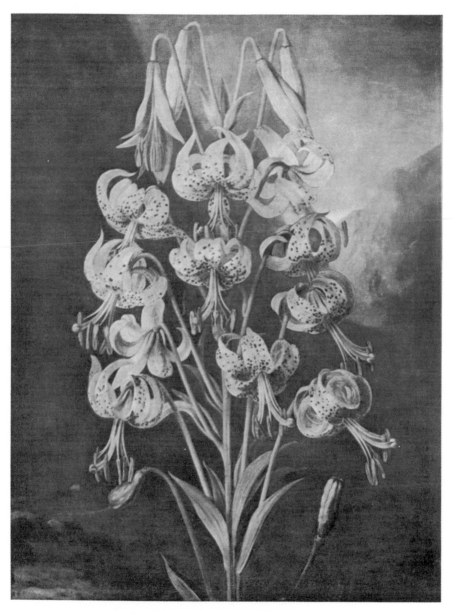

Plate 35 THE SUPERB LILY (*Lilium superbum*)
Oil painting by Philip Reinagle for R. Thornton, *Temple of Flora*, 1799 – 1807
Collection of Major the Hon. H. Broughton

SEE ALSO COLOUR PLATE G

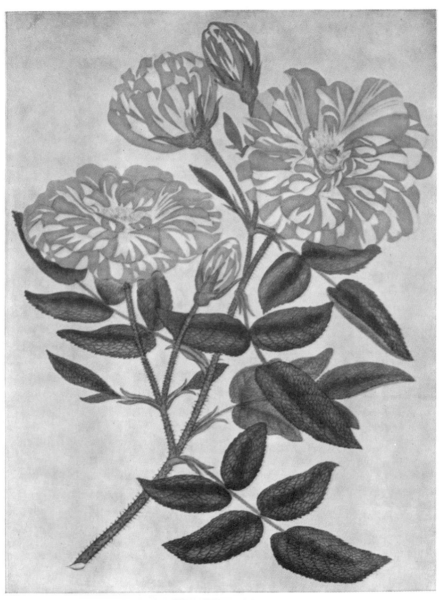

Plate 36 Rosa Mundi
Hand-coloured etching by H. Andrews from his *Roses*, 1805 – 28

ENGLAND IN THE EARLY NINETEENTH CENTURY

I N ENGLAND in the early decades of the nineteenth century, the age which was dominated by the brilliant work of the two Bauers, a host of artists were producing botanical illustrations of real, if lesser, merit. The slump which had contributed to the downfall of Thornton proved to be of brief duration, and soon ambitious ventures were everywhere afoot. Botany, in fact, had become a popular recreation ; flower painting, now accorded a place among the elegant accomplishments of every young lady of fashion, created a demand for manuals of instruction ; and the cult of the language of flowers provided a ready market for sentimental flower books. Floricultural periodicals sprang up on all sides,[1] and though some were deservedly ephemeral, many had a long and useful existence. New flowers from all parts of the world—heaths and pelargoniums from South Africa ;

[1] Many of them will be found in the useful catalogue of the Lindley Library (R.H.S. ; 1927). A few of the more important of those illustrated with coloured plates are : William Curtis, *Botanical Magazine* (1787-) ; Henry C. Andrews, *Botanists' Repository* (1797-1812) ; Sydenham Edwards, John Lindley, etc., *Botanical Register* (1815-47) ; Conrad Loddiges, *Botanical Cabinet* (1817-33) ; Robert Sweet, *British Flower Garden* (1823-38) ; Benjamin Maund, *Botanic Garden* (1825-51) ; Joseph Harrison, *Floricultural Cabinet* (1833-59) ; Joseph Paxton, *Paxton's Magazine of Botany* (1834-49) ; and Benjamin Maund, *Botanist* (1837-46). Besides these periodicals, many other botanical works of the day were published in serial form. On the Continent, the following Belgian works deserve mention, though some of their plates were derived from those in English books : Charles Morren, *Annales de la Société Agricole et Botanique de Gand* (1845-48) and *Belgique Horticole* (1851-85); Louis van Houtte, *Flore des Serres* (1845-83); and Charles Lemaire, *Jardin Fleuriste* (1851-54). In France, Riocreux, Cuisin, Godard and other talented painters produced excellent plates for the *Revue Horticole* (*c.* 1830-).

rhododendrons, chrysanthemums, viburnums, jasmine, *Anemone japonica*, *Kerria japonica* and many others from China; and dahlias from Mexico—stimulated gardeners and artists alike.

Of these English contemporaries of the Bauers it is only possible to mention a few of the better known or more deserving; the names of many others will be found in Britten and Boulger's invaluable *Biographical Index of British and Irish Botanists* (2nd ed., 1931).

In 1794, Henry C. Andrews (*fl.* 1794-1830) began making engravings for his monograph on the heaths, a work illustrated with nearly three hundred hand-coloured etchings and not completed until 1830. In 1797 he started the publication of the *Botanists' Repository*, the first serious rival to the *Botanical Magazine* and its superior in that most of the plants figured in it were new introductions. His *Heathery* (1804-12), in six octavo volumes, brought the ericas to the notice of a wider public and helped to create interest in the new introductions. *Geraniums* (1805), in two quarto volumes containing 124 plates, illustrated many South African species; and *Roses* (1805-28), a work of about the same proportions, figured a number of single and semi-double varieties.

I have only been able to trace one original drawing by Andrews —a rather shoddy study of *Azalea pontica*, made in 1796 and used in the first volume of the *Botanists' Repository*; he must therefore be judged by his published work, which was engraved, coloured, and frequently also described, by himself, His *Coloured Engravings of Heaths* (1802-30), his finest achievement, is noble in conception and impressive in execution; with the exception of Francis Bauer's wonderful figures of heaths in Aiton's *Delineations of Exotic Plants*, there are no better representations of the genus. Most of Andrews's other work has a distinctive flavour which, when once appreciated, makes his plates easily identifiable. Stylization is often carried rather far—in the case of the *Roses* (see Pl. 36, p. 209) almost to the extent of disaster—and the colour tends to be strident. There is, in fact, some justification for the judgment of an anonymous writer in the *Monthly Magazine* (Sept. 1810): "The artist continues apparently to make Chinese paper-hangings his great model. If his pictures were less striking to the vulgar eye, that always delights in gaudy tints, they would be infinitely more prized by those who know how to appreciate the excellencies of the art." That the public of to-day appears to be willing to pay two or three hundred pounds for the *Geraniums*, and probably even

more for the *Roses*, is evidence not so much of their artistic worth but of the completely artificial state of the market for nineteenth-century colour-plate books.

Little is known about Andrews, who appears to have been a man of poor education and an indifferent botanist. He lived for many years in Knightsbridge, and married the daughter of John Kennedy, a nurseryman who aided him for a time with the descriptions in the *Botanists' Repository*.[1]

Andrews was not the first artist to compile a colour-plate book on the rose : Mary Lawrance, who describes herself as a teacher of botanical drawing, published in 1799 a folio monograph which has achieved rather undeserved fame. The ninety hand-coloured etchings which illustrate it, though decorative enough, leave one with the conviction that Miss Lawrance, however efficient she may have been as a teacher, was not really able to practise what she preached. Her leaves are justly described by Dunthorne as a " meaningless network of lines ; " her flowers have the flatness of Chinese work without the oriental beauty of line and rhythm ; and her occasional attempts to suggest form by coarse stipple are wholly unsuccessful. Several other works from her hand are cited by Dunthorne.

The inadequacy of Miss Lawrance's *Roses*, and the high price at which it was issued, encouraged a German named Roessig to publish his *Die Rosen* (Leipzig ; 1802-20). In his preface, Roessig condemns the fumbling attempts of his predecessor : " Her botanical draughts-manship is mostly inaccurate, and she rarely takes notice of the characteristic features of a rose. The lighting of the leaves is extremely bad, and only here and there one comes across one or two roses which are unmistakably identifiable." Yet Roessig's own work, though some advance on Miss Lawrance's, fully deserved the adverse citicism which Redouté aimed at it. John Lindley's own plates to his *Rosarum Monographia* (1820) serve their purpose, which was to record faithfully the characters of his plants, but are not particularly interesting æsthetically. It was neither in Germany nor in England, but in France under Redouté, that the rose at this very moment was finding its true interpreter.

Clara Maria Pope (*d.* 1838), whom we have already mentioned in

[1]The best descriptions in the *Botanists' Repository* are those of the sixth volume, which were contributed by Adrian Hardy Haworth, a botanist most renowned for his work on succulent plants.

connection with Samuel Curtis's *Beauties of Flora*, also illustrated his *Monograph on the Genus Camellia* (1819). She had a sense of the dramatic, and knew how to paint in the grand manner ; all that I have seen of her work is on a large scale, and is more effective in mass than in detail. A number of her spectacular original water-colour paintings of peonies may be studied in the Natural History Museum (see Pl. 37, p. 212). Mrs. Pope (*née* Leigh) first married Francis Wheatley, creator of the famous *Cries of London*, whom she served as a model " for his prettier fancy figures ; " and *en secondes noces* the actor Alexander Pope. For forty years she was a regular exhibitor at the Royal Academy ; at first, surprisingly enough, of miniatures ; then of rustic subjects bearing such titles as *Little Red Ridinghood* and *Goody Two-shoes* ; and finally of groups of flowers, which won her considerable fame. At one time she also painted portraits ; a more fanciful work in this vein, now in the Sir John Soane Museum, shows a bust of Shakespeare before which are heaped the flowers mentioned in his plays. There is also a charming lithograph from her hand, of moss roses in a blue and white Chinese vase, which was published by Samuel Curtis in 1829.

George Loddiges (1784-1846) and George Cooke (1781-1834) made most of the trim little plates for Conrad Loddiges's *Botanical Cabinet* (1818-33). " The figures are neat and often pretty," Hemsley says, " but the work has not the slightest claim to the title 'botanical.' The letterpress is exceedingly meagre, and largely impregnated with pious ejaculations and admonitions." A more considerable artist of small-scale work was Edwin Dalton Smith (*fl.* 1823-46 ?) of Chelsea, who worked for Sweet's *Flower Garden, Geraniaceæ* (1820-30), *Flora Australasica* (1827-28) and other publications, and for Maund's *Botanic Garden*. The original paintings for the *Botanic Garden* were presented to the Natural History Museum by Miss S. Maund. These little miniatures, rich and jewelled in colour, are executed with great finesse ; the plates in the printed work, pleasant though they are, give no idea of the quality of the originals. Frederick Smith, probably Edwin's brother, drew for *Paxton's Magazine of Botany* and for the *Florists' Magazine*. Another artist who made many drawings for Paxton, especially of orchids, was Samuel Holden. His work, which is well represented at the Victoria and Albert Museum, has a cold brilliance that is impressive rather than attractive. Thomas Duncanson (*fl.* 1822-26) was a young gardener who came to Kew where he made skilful drawings under Aiton's direction. Duncanson was succeeded

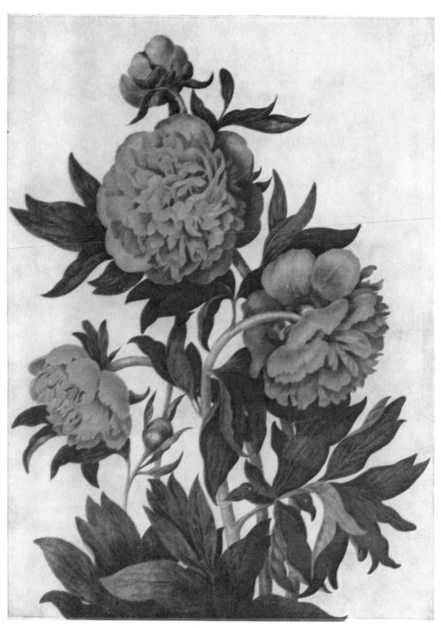

Plate 37 DOUBLE RED PEONY (*Paeonia festiva*)
Water-colour drawing by Clara Pope, 1821
Natural History Museum, London

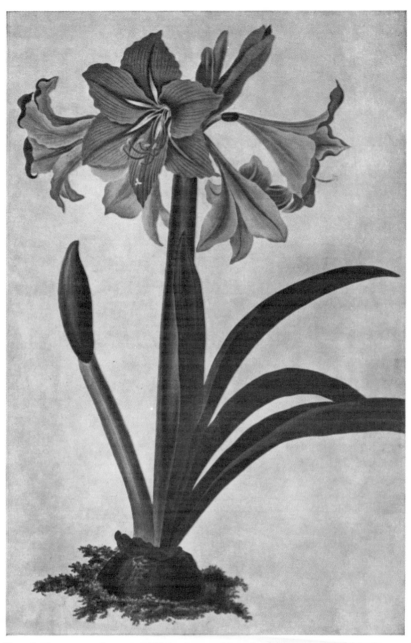

Plate 38 'AMARYLLIS JOHNSONI' (*Hippeastrum × johnsoni*). Aquatint, printed in colour and
hand-coloured by R. Havell, after a painting by Mrs. Edward Bury
From Mrs. Bury, *Hexandrian Plants*, 1831 – 34

by the industrious George Bond (*fl.* 1826-80), seventeen hundred of whose drawings are at Kew ; both artists made important studies of succulent plants.

William Baxter (1787-1871), author of *British Phænogamous Botany*[1] (1834-43), was a capable and energetic Scotsman who at the age of twenty-five was appointed curator of the Oxford Botanic Garden. In this " damp and mildewed environment " he turned appropriately to the study of mosses and fungous diseases. For his work on the British flora, an attractive and, in the main, well-illustrated book, he employed the services of two local artists—Isaac Russell (an Oxford glass painter) and C. Matthews. Though these men were not trained scientists, they acquired by degrees a good working knowledge of botany ; many of the plates—which were coloured by Baxter's daughters and daughter-in-law—are superior to those in Sowerby. " One can hardly find," wrote a contemporary critic in the *Gardeners' Chronicle*, " a more suitable present for a young person." The originals are in the Lindley Library.

Mrs. Edward Bury (*fl.* 1831-37) of Liverpool worked for Maund's *Botanist*, and was the artist of the impressive *Selection of Hexandrian Plants* (1831-34), certainly one of the most effective colour-plate folios of its period. Mrs. Bury modestly admits that she had " no pretensions whatever " to scientific knowledge, or to having made extensive research, and was no doubt a talented amateur. " An endeavour to preserve some memorial of the brilliant and fugitive beauties, of a particularly splendid and elegant tribe of plants," the preface tells us, " first gave rise to this work. . . . Flattered by the opinion of her friends, and encouraged by competent judges of the *fidelity* of the Portraits, Mrs. Edward Bury has yielded to their wishes, and ventured to lay them before the Public." One cannot help feeling that a considerable share of their success must have been due to the skill of the engraver, R. Havell, best known as the interpreter of Audubon ; and ten of Mrs. Bury's original paintings in Major Broughton's collection confirm this suspicion. The " Hexandrian " flowers—lilies, crinums, pancratiums and hippeastrums—are executed in fine-grained aquatint, partly printed in colour, and retouched by hand (see Pl. 38, p. 213). The aquatint gradations are less subtle than those obtained by stipple, and the etched outline is at times too insistent ; but in general, the book deserves the renown it has won. It must always be borne in mind, however, that these great folios are apt to impress one unduly by their

[1]See an article by A. H. Church, in *J. Bot. London,* 57 : 58-63 (1919).

sheer bulk ; I doubt if there is a single plate in the book which can really bear comparison with the attractive hand-coloured aquatint engraving of a hippeastrum made by Barbara Cotton in 1824 for the *Transactions of the Horticultural Society*. Though not completely accurate in detail, it is original and spontaneous in composition. She is an artist about whom one would be glad to learn more, but she seems to have vanished with barely a trace. There is a good study of the potato plant by her in the Victoria and Albert Museum.

The *Transactions of the Horticultural Society*, which appeared in ten volumes between 1805 and 1848, introduce us to several other draughtsmen of note besides those whom we have already mentioned. In particular, both Mrs. Withers and Miss Drake deserve a high place among the artists who contributed to these handsome publications. Together also they illustrated what is probably the finest, and certainly the largest, botanical book ever produced with lithographic plates— James Bateman's *Orchidaceæ of Mexico and Guatemala* (1837-41 ; see Pl. 39, p. 220). An amusing vignette by George Cruickshank shows the difficulty of handling this " librarian's nightmare " (see Fig. 51).

The process of lithography, which attained wide popularity during the nineteenth century, must now be briefly described. Lithography, or drawing upon stone, was discovered in 1797, almost accidentally, by a German named Aloys Senefelder (1771-1834). The drawing is made with greasy ink or chalk upon a particular kind of limestone which is highly porous to both grease and water. The drawing having been " fixed," the stone is then damped with water and a roller loaded with greasy ink passed over it. This charges the stone wherever the drawing has been made upon it, but, owing to the antipathy of grease and water, leaves no mark upon the rest of the surface. Paper is now laid upon the stone, and the whole is passed through a scraper press. Among the advantages of lithography over other reproductive methods are the subtle gradations of tone which can be obtained, and the speed and economy of the printing. Zinc is often used in place of stone for commercial work.

Bateman's book was by no means the first botanical work to be illustrated by lithography : Ackermann's *A Series of Thirty Studies from Nature* appeared as early as 1812, and ten years later Valentine Bartholomew published two attractive sets of flower drawings ; William Roscoe's *Monandrian Plants* appeared between 1824 and 1828 ; Alfred Chandler, a well-known Vauxhall nurseryman, issued his handsome

and rare *Illustrations of Camelliae*, described by Pritzel as "*pulcherrimae*," in 1830-37;[1] and Wallich's *Plantae Asiaticae Rariores*, with its impressive lithographs by M. Gauci after drawings of Vishnupersaud and other native Indian artists, was produced between 1830 and 1832. But in size and in splendour, Bateman's giant folio eclipses the works of all who went before or came after him. Gauci, who executed the forty

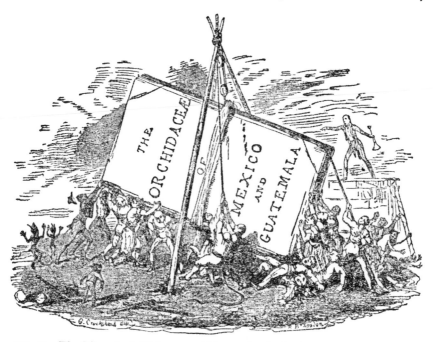

FIG. 51—The Librarian's Nightmare. Vignette by G. Cruikshank from J. Bateman, *The Orchidaceae of Mexico and Guatemala*, 1837-41

lithographs (thirty-seven of which were made from drawings, now at Kew, by Mrs. Withers or Miss Drake), was a true master of the process: his tone ranges from the palest of silvery greys to the richest velvet black; his outline is never mechanical or obtrusive; and the hand-colouring—whoever may have been responsible for it—is executed with consummate skill. In this book, the great orchids of Central America live for us in all their glory.

[1]Some of the originals are in Major Broughton's collection; they scarcely differ from the elaborately painted plates in the published work.

Of Miss Drake " of Turnham Green " (*fl.* 1818-47) almost nothing seems to be known beyond her work, which also includes illustrations for the *Botanical Register* and some fine plates for Lindley's noble *Sertum Orchidaceum* (1837-42). An unfinished drawing for the latter work, showing how the modelling of the flowers and leaves was prepared in monochrome, is reproduced on Plate XXX (p. 227). Mrs. Withers (*fl.* 1827-64), " Flower Painter in Ordinary to Queen Adelaide,"[1] is a figure only a shade less nebulous. She contributed to many works of the period, including studies of fruit for the *Pomological Magazine*, more than a hundred plates for Maund's *Botanist*, and a number of vigorous drawings for the *Illustrated Bouquet* (1857-63). Three of her original paintings are in the Natural History Museum. A " selection of Heartseases " which she exhibited in 1834 at the rooms of the Horti-cultural Society provoked " an eminent artist " to declare that he had " never seen any work of the kind so beautifully executed." Loudon, too, in an article in the *Gardeners' Magazine* for 1831, praised her " high talents and great industry " :

To be able to draw Flowers botanically, and Fruit horticulturally, that is, with the characteristics by which varieties and subvarieties are distinguished, is one of the most useful accomplishments of your ladies of leisure, living in the country. It is due to Mrs. Withers of Grove Terrace, Lisson Grove, to state that her talents for teaching these objects are of the highest order, as many of the plates in the *Transactions of the Horticultural Society* and the *Pomological Magazine* abundantly show. We have observed, with no small pride and pleasure, that several of our principal nurserymen, not only about London, but in the country, have brought, or are bringing, forward their daughters, so as to be competent to make scientific portraits, not only of fruits and flowers, but of trees and shrubs, in their different stages of growth. When once a system of education is formed which shall embrace all modern improvements, and when that system shall be universally applied, the drawing and making portraits of all, or of any objects whatever, will be as general an accomplishment as penmanship is now. To all the mechanical trades, drawing is perhaps of more use than either writing or

[1]Valentine Bartholomew (1799-1879), Flower Painter in Ordinary to the Duchess of Kent and her daughter Queen Victoria, was probably the last artist to hold such office.

arithmetic. It is of immense use to a gardener ; and we hope no young reader will neglect its acquirement. He may do it by copying the cuts in this Magazine . . ."

—a gloomy task, as they consisted mainly of representations of greenhouse stoves, garden rollers, watering cans and the like.

Mrs. Withers, then, was one of the growing band of teachers of botanical drawing, though she published no manual—as did so many of her confrères—for the guidance of her pupils. More than two centuries earlier, as we have already seen, de Passe had given instructions to his readers about the colouring of the plates in his *Hortus Floridus*. Mme Horry (*née* Perrot), in her *Les Leçons Royales* (1686), had revealed the secret (so eagerly sought in all ages) of " how to paint without being able to draw "—her method being simply to buy the engravings of the late Nicolas Robert, to trace them upon vellum, and to tint them according to the recipes given ; and it is clear that during the seventeenth and eighteenth centuries many amateurs had amused themselves by painting—often in the crudest colours—their own copies of floricultural publications.

Robert Sayer's *The Florist* (1760) contained sixty rather indifferently etched plates, with advice on how to colour them ; and several other works of the period were conceived with the same intention. James Sowerby's *A Botanical Drawing Book* (1788), " originally designed for the use of his pupils " and intended to " blend Amusement with Improvement " went a stage further, giving colour plates of botanical details, and advice of a more practical kind. J. D. Preissler's *Gründliche Zeichenkunst* (Nuremberg, 1795) is an early German example of the same type. Miss Lawrance published her *Sketches of Flowers from Nature* (1801) to help the tyro to acquire " that Ultimatum of the Art . . . a natural Appearance." A plate of snowdrops and crocuses is shown in three different stages, and in the remainder the pupil is provided with an outline drawing to be coloured in imitation of the model given. The book is not unattractive, but, as in all Miss Lawrance's work, the drawing is coarse in quality. There is record that her private pupils were charged at the rate of half a guinea a lesson with one guinea " entrance fee."

The Seasons, or Flower Garden . . . with a Treatise or General Instruction for Drawing and Painting Flowers (1806), by Peter Henderson, who also worked for Thornton's *Temple of Flora*, is scarcely better than Miss

Lawrence's book, though I have heard of £75 being asked for a copy. Miss Henrietta Maria Moriarty's *Viridarium; or Green House Plants* (1806) was designed "to foster the very obvious use of correct drawing in boarding schools. The senses," the authoress continues, "cannot be too soon habituated to the nicer descrimination of objects; and those who have the instruction, or, I might say, the formation and even the fashioning of young minds most at heart, often find it difficult to obtain representations in this most pleasing branch of natural history; on the one hand sufficiently accurate, and, on the other, entirely free from those ingenious speculations and allusions, which, however suited to the physiologist, are dangerous to the young and ignorant. . . ."

Soon the market was being flooded with botanical copybooks, though many of them, to judge by their rarity to-day, were either published in small editions or thrown away when they had been duly "tinted in." We may mention a few. Patrick Syme's *Practical Directions for Learning Flower-Drawing*, with its delicate hand-coloured stipple plates, and Edward Pretty's *Essay on Flower Painting*, were both published in 1810. Testolini's *Rudiments of Drawing and Colouring* (1818) is said by Dunthorne to be very fine, but I have not been able to see a copy. George Brookshaw, the artist of several magnificent fruit books, published in 1818 *A New Treatise on Flower Painting; or Every Lady her own drawing master*. "In nature, nothing is stiff," is his watchword, and his flowers writhe about the page in their effort to avoid even a moment of rigidity. He advocates a simple palette, warns his readers repeatedly against painters who brazenly flaunt their "gaudy coloured flowers" before the public, and leaves the general impression that little safe guidance is to be found outside the pages of his own book. His method, it would appear, was almost foolproof: "Many ladies I have had the honour of teaching," he tells us, "sketched flowers so correctly after my manner, that I mistook them for my own drawings." He had no higher praise to give.

Studies of Flowers from Nature (c. 1820), with "instructions for producing a facsimile of the finished drawing by Miss Smith [of Adwick Hall; near Doncaster]," is illustrated with excellent fine-grained aquatints. A. W. Gilbert's *Hints on the Art of Oriental Painting* (1832) proves, in spite of its title, to be a treatise on botanical illustration. The "Gilbertian system" consisted in the use of "theorems," or stencils. "The tedious old method of poring over a leaf for days, to

the great injury of the health of the Pupil, is by this system quite done away with," the author tells us. "The work will be of infinite advantage to the Principals of Seminaries, Governesses and Families who reside in the Country, where Masters are not to be had." A page from James Andrews's *Lessons in Flower Painting* (1835) is shown on Plate 40 (p. 221).

Dunthorne describes *L'Album des Dames* (1830) as "the only French book of note" of this kind; but he does not seem to know of Antoine Pascal's *L'Aquarelle ou les Fleurs peintes d'après la Méthode de M. Redouté* (1836). Nor have I seen this, for what was perhaps the only copy in this country, that at the British Museum, was destroyed by bombs during the second World War; but it might be a work of some importance. *Le Cours de Fleurs du Jardin des Plantes* (*n.d.*), by Redouté and others, contains rather disappointing lithographs.

Mary Rosenberg's *Art of Flower Painting* (1856), Fitch's articles in the *Gardeners' Chronicle* (1869) and F. W. Burbidge's *Art of Botanical Drawing* (1873), herald the later Victorian type of botanical drawing-book, more practical in character and less attractive in appearance, which may still be found upon the dustier shelves of Artists' Colour-men. Miss Rosenberg (1820-1914; *m.* William Duffield) was also the author and artist of *Corona Amaryllidacea* (1839)—a work, issued in a very limited edition and illustrated with eight original paintings, dealing with that "sportive" race the hippeastrum.

Sentimental flower books are a conspicuous feature of the nineteenth century, and, though their texts have no scientific pretensions, competent botanical artists were often enrolled to illustrate them; we cannot therefore leave such works without a mention.

The sentimental flower book originated in France, where the able artists Bessa and Poiteau made quick money by work which, though charming in its way, was unworthy of their great ability. Charles Malo's *Guirlande de Flore* (1815) and *Parterre de Flore* (1820), and Charlotte de Latour's *Le Langage des Fleurs* (1833), all illustrated by Bessa, are typical examples. The translation of the last-named book into English gave birth to a host of imitations, adaptations, and agreeable trifles of a similar nature; and good botanical artists such as James Andrews and William Clark were engaged to provide the plates when the author (or more often authoress) modestly mistrusted his or her own talent. Mrs. Hey's *Moral of Flowers* (1833) and *Spirit of the Woods*

(1837); Mrs. Meredith's *Romance of Nature* (*c.* 1833); James Andrews's *Flora's Gems* (*c.* 1839) and *The Parterre* (1841); and the various works of Robert Tyas and J. E. Giraud; are among the best known English books of this type. In France, Granville's *Les Fleurs Animées* (1846), and in England the flower books of Walter Crane, have justly become classics, though they can scarcely be classed as botanical works.

It will be sufficient to look more closely at one of these books. Mrs. Meredith (*née* Twamley) was both authoress and illustrator of her popular *Romance of Nature*, which was dedicated to William Wordsworth (see Pl. 42a, p. 225). "I love flowers," she wrote in her preface, "as forming one of the sweetest lines in the GOD-WRITTEN Poetry of Nature; as one of the universal blessings accessible to all nations, climes and classes; *blessings* in their own loveliness alone, and in the pleasure ever derivable from the contemplation of loveliness; but trebly blessing us in the familiar and beautiful power they possess of awakening in our hearts feelings of wonder, admiration, gratitude, and devotion; teaching us to look from Earth to HIM who called it into existence, and to feel how worthy of our unceasing thankful adoration must be that Being, the meanest of whose creations is so wonderfully, so beautifully adapted to its appointed position in the vast whole." Her drawings "were invariably made from NATURE. I have never been guilty of curving a stem on my paper, which I found growing straight in the field, or of magnifying a flower for the sake of gay effect. My models always appear to me too perfect in their beauty for me to dream of doing aught but attempt to copy, faithfully as I can, their various forms and colours: invention here must be positive error, and I anxiously strive to avoid *that* fault, however I may sin against the laws of picturesque effect or elegant arrangement."

These little books, with their engaging naïveté of presentation, their charming—if inaccurate—pictures, and their delightfully awful verse (Mrs. Smith's poem on the Snowdrop, beginning "Like pendant flakes of vegetating snow," is typical, and quite irresistible) are pleasant to browse in by the winter fireside. They recall the distant, leisured, carefree childhoods of our great-grandparents in happier England— an England when there was no atom bomb, and income tax was a penny in the pound. But we must keep our sense of values: it is nonsense to consider such trifles, however elegant, as great works of art, and folly to purchase them at the exaggerated prices demanded by booksellers to-day.

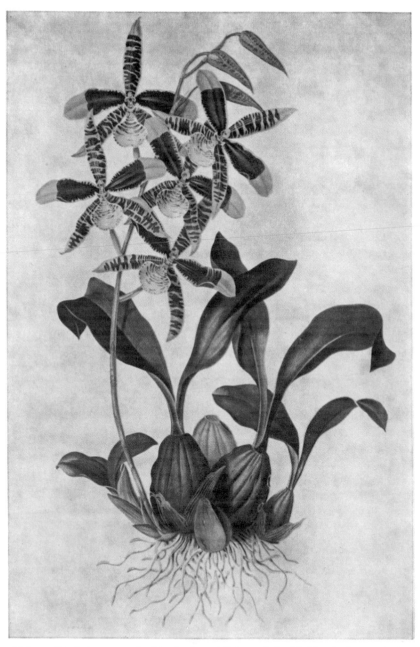

Plate 39 *Odontoglossum grande*. Hand-coloured lithograph by M. Gauci after a painting by Mrs. Withers; from J. Bateman, *Orchidaceae of Mexico and Guatemala*, 1837–41

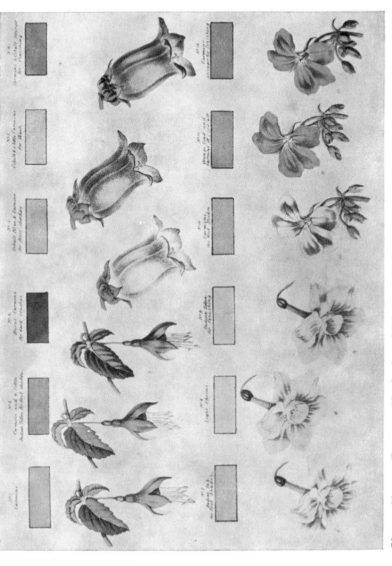

Plate 40 VARIOUS FLOWERS. Hand-coloured lithograph by J. Andrews from his *Lessons in Flower Painting*, 1835

This chapter on the English botanical illustrations of the first part of the nineteenth century must conclude with a brief survey of continental work, other than French, of the period.

In considering botanical illustration, it is easy to be so carried away by the bulk and grandeur of the costly folio works, that more humble volumes of great merit and utility receive less than their due appreciation. Such a work is *Deutschlands Flora in Abbildungen nach der Natur* (Nuremberg, 1796-1862) by Jacob Sturm (1771-1848) and his son Johann Wilhelm Sturm (1808-65).

The book contains more than two thousand neat and attractive little engravings, no more than 5 in. by 3½ in. in size. Engravings of the German flora existed already; but, as Sturm wrote in 1796, " some of them are badly drawn and coloured ; some have been broken up and dispersed ; some are only to be found in large and splendid publications which often even the lover of botany does not get a chance of seeing once in a lifetime." He thus deliberately chose this minute format in order to make a knowledge of the German flora available by pictures to as many as possible and as cheaply as possible. Despite their smallness, they carry a surprising amount of detail.

Jacob Sturm learnt his art from his father, Johann Georg Sturm, who was also a Nuremberg engraver ; his first plates were of insects. Engravings by him appear in a number of works, including A. W. Roth's *Catalecta Botanica* (1797-1806), C. Sternberg's *Revisio Saxifragarum . . . Supplementum* (1822) and D. H. Hoppe's *Caricologia Germanica* (1826). The University of Breslau honoured itself by conferring upon him the degree of Dr. Phil. honoris causa.

Jonas David Labram (1785-1852), a Swiss fabric printer who turned flower painter, made lithographs for various Swiss botanical books, including the *Sammlung von Schweizer Pflanzen* (1827-46) of the Zürich physician and botanist Johann Hegetschweiler (1789-1839). Labram remained so poor that he was never able to afford a table, all his prints being coloured on a large board placed upon the family double bed. " On this bed the prints were set out in a row ; he then took a certain colour on his brush and proceeded from one sheet to the next, always putting in the one colour where it was necessary. In this work he was assisted by his daughter Louise." Labram's house in Basle—Riehenstrasse 39—still stands ; it is the smallest house in the city, having a floor area of only sixteen square metres. Some of Labram's work is reproduced—rather inadequately—in *Flowers all the Year round* (Basle,

1947), and a complete list of his fifteen hundred drawings and illustrations may be found in the first number of that curiously named periodical *Stultifera Navis* (1946).[1]

[1]Among other foreign illustrated botanical books of this period the following deserve mention, though they can rarely stand comparison with the best English and French publications of the day :

Kops, J. ; *Flora Batava* (Amsterdam, 1800-1932).
Van Geel, P. ; *Sertum Botanicum* (Brussels, 1828-32).
Trattinnick, L. ; *Thesaurus Botanicus* (Vienna, 1819).
Host, N. ; *Icones et Descriptiones Graminum Austriacorum* (Vienna 1801-09).
Tausch, I. ; *Hortus Canalius seu Plantarum Rariorum* (Prague, 1824-25).
Ledebour, C. ; *Icones Plantarum Novarum* (Riga, 1829-34).
Reichenbach, H. ; Various works (Leipzig, 1820-35).
Dietrich, A. ; *Flora Regni Borussici* (Berlin, 1833-44).
Gallesio, G. ; *Pomona Italiana* (fruit), (Pisa, 1817).
Savi, G. ; *Flora Italiana* (Pisa, 1818-24).
Targioni-Tozzetti, A. ; *Raccolta di Fiori, Frutti ed Agrumi* (Florence, 1825).
Tenore, M. ; *Flora Napolitana. Atlante* (Naples, 1811-38).

Details of the illustrations in most of these books, and in many others of the same period, are given by Dunthorne.

WALTER FITCH: THE AGE OF THE LITHOGRAPH

Walter Hood Fitch (1817-92), the most prolific of all botanical artists, was a typical product of the Victorian era ; like Sir William and Sir Joseph Hooker, whom he served successively for more than half a century, we can hardly conceive of him as belonging to any other age.

Of the Hookers, it is only possible here to speak very briefly ; a fuller account of their great services to botany may be found in any work dealing with the progress of the science in this country during the nineteenth century.[1] To the general public, their greatest contribution may well seem the creation of Kew Gardens in its present form. This we owe in the main to Sir William ; but to scientists, the work of his son Joseph—friend of Darwin and champion of Darwinism, intrepid explorer, the virtual founder of the study of plant distribution —must appear yet more significant.

Sir William Hooker (1785-1865), though he would have been the first to admit his own limitations, was no mean artist (see Pl. XXIXb, p. 226) and his great botanical knowledge more than compensated for any lack of training or technical skill. After Sydenham Edwards had broken with the *Botanical Magazine* in 1815, several other able artists— principally John Curtis the entomologist (see Pl. 29a, p. 192) and William Herbert—had kept the journal afloat ; but in 1826, William Hooker took upon himself the whole burden of its illustration, remaining

[1]See Sir Joseph Hooker's account of his father's life in *Annals of Botany* (1902) ; Leonard Huxley's *Life and Letters of Sir Joseph Dalton Hooker* (1918) ; J. R. Green's *History of Botany in the United Kingdom* (1914), etc.

for nearly ten years its only draughtsman. Further, most of the drawings made for the additional volumes in the new edition of Curtis's *Flora Londinensis* (1817-28) were his work. He also made the admirable drawings for his *Flora Boreali-Americana* (1829-38). That such distinguished botanists as Hooker, Herbert and Lindley were prepared to " turn artist " is also evidence of the advantage that they realised was to be gained from the keenness of observation acquired by such work, especially where it involved the drawing of dissected flowers enlarged.[1]

Hooker had already enjoyed the help of Dr. Greville, the able cryptogamic botanist, who had provided the plates for their joint *Icones Filicum* (1829-31) and other works. But Greville, too, was a busy man. It was soon obvious that the gigantic and varied tasks which Hooker had set himself, made it imperative for him to find a full-time artist who would shoulder the whole responsibility of botanical draughtsmanship. The opportune discovery of Fitch was a stroke of good fortune which solved all his difficulties.

Fitch was a young apprentice to a firm of Glasgow calico designers when Hooker, who then occupied the Chair of Botany in that city, first made his acquaintance. After working hours, Fitch would assist him in mounting specimens for his herbarium ; but the youth's ability as a draughtsman was soon apparent, and Hooker, by repaying his

[1]Among other botanists who have painstakingly enriched their scientific works with their own illustrations, some of whom are not mentioned elsewhere in this book, are Agnes Arber *née* Robertson (*b.* 1879) of Cambridge, author of *Water Plants* (1920), *Monocotyledons* (1925), *The Gramineae* (1934), all having admirable explanatory morphological and anatomical diagrams ; Nicholas Edward Brown (1849-1934) of Kew, author of many papers on Mesembryanthemum in *The Gardeners' Chronicle*, etc.; Frederick William Burbidge (1847-1905), author of *The Narcissus* (1875); Vincenzo Cesati (1806-83) of Naples, author of *Stirpes Italicae* (1840-43); Arthur Harry Church (1865-1937) of Oxford, author of *Types of Floral Mechanism* (1908); William Griffith (1810-45), author of *Icones Plantarum Asiaticarum* (1847-54); John Hutchinson (*b.* 1884) of Kew, author of *A Botanist in Southern Africa* (1946), etc., (cf. p. 284); Anton Kerner von Marilaun (1831-98) of Innsbruck and Vienna, author of *Monographia Pulmonariarum* (1878); Herbert William Pugsley (1868-1947), author of *Prodromus of the British Hieracia* (1948) ; Victor Felix Schiffner (*b.* 1882) of Prague, author of *Monographia Hellebororum* (1890) and Heinrich Moritz Willkomm (1821-95), author of *Recherches sur . . . Globulariées* (1850), *Icones et Descriptiones Plantarum Novarum* (2 vols., 1852-62), *Illustrationes Florae Hispaniae* (2 vols., 1881-92). Willkomm, a native of Saxony, was Professor of Botany at Tharandt 1855-68, Dorpat 1868-73, Prague (German University) 1873-92. His excellent coloured drawings mostly depict new and little-known plants of Spain, Portugal and the Balearic Islands, the flora of south-west Europe being his life-long interest ; for their dates of publication, see *J. Bot. (London) 53*: 370 (1915).

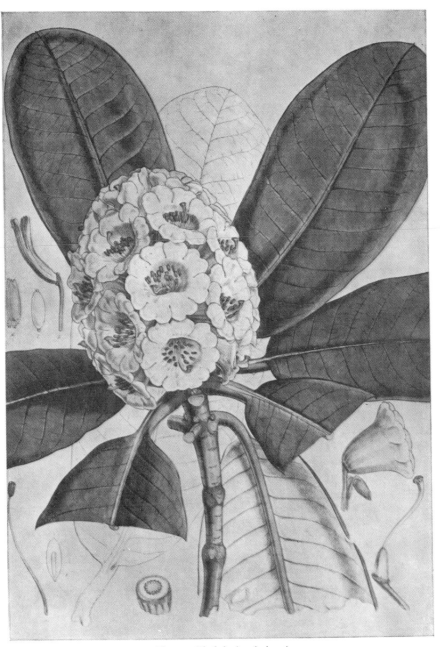

Plate 41 Rhododendron hodgsoni
Hand-coloured lithograph by W. H. Fitch after a field sketch by Sir Joseph Hooker
From J. D. Hooker, *The Rhododendrons of Sikkim-Himalaya*, 1849 – 51

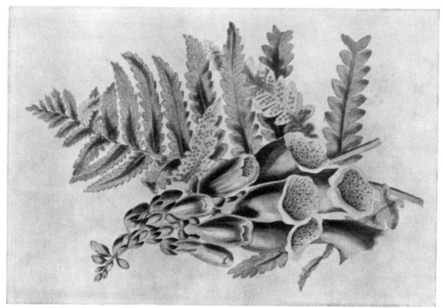

b

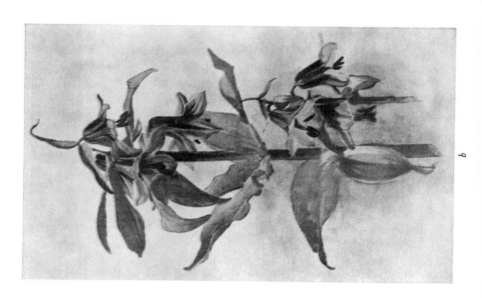

Plate 42a

apprenticeship fee, was able to secure his full services. In 1841, when Hooker was appointed Director of Kew Gardens, he took his young protégé south with him.

Fitch's first published plate in the *Botanical Magazine*, of *Mimulus roseus*, appeared in 1834 (Pl. 3353), and shortly afterwards he became its sole artist, a position which he held until 1877 when a dispute brought his forty-year-long connection with the magazine to an unhappy termination. Some idea of his gigantic industry can be gauged from the fact that 9960 published drawings by him are recorded by W. B. Hemsley (*Kew Bulletin*, 1915 : 277). From this vast corpus of work it is only possible to mention a few of the more outstanding books for which he provided illustrations.

FIG. 52—Coltsfoot (*Tussilago farfara*). Wood-engraving after a drawing by W. Fitch from G. Bentham, *Handbook of the British Flora*, 1865

A Century of Orchidaceous Plants (by W. J. Hooker ; 1851), its sequel *A Second Century of Orchidaceous Plants* (by J. Bateman ; 1867), *A Monograph of Odontoglossum* (by J. Bateman ; 1864-74), and the three volumes of Robert Warner's *Select Orchidaceous Plants* (1862-91), show Fitch's incredible ability in dealing with complex botanical structures. In Sir Joseph's *The Rhododendrons of Sikkim-Himalaya* (1849-51), Fitch has redrawn upon stone the author's admirable field sketches (see Pl. 41, p. 224) ; and he has performed a similar task in adapting drawings by Indian artists to serve for the same author's *Illustrations of Himalayan Plants* (1855). Both these fine works were the fruits of the extensive explorations made by Sir Joseph in the Eastern Himalaya. The most important achievement of Fitch's later years was his set of lithographs to illustrate H. J. Elwes's impressive *Monograph of the Genus Lilium* (1877-80) ; but

he is best known to modern botanists by his neat little illustrations to Bentham (and Hooker's) *Handbook of the British Flora* (1865, etc. ; see Fig. 52).

Sir Joseph Hooker paid many tributes to the "incomparable botanical artist" with his "unrivalled skill in seizing the natural character of a plant." "I don't think that Fitch *could* make a mistake in his perspective and outline," he once said, "not even if he tried." But Fitch's very facility had its dangers : as one surveys the faultless acres of his drawings, one cannot help wishing that somewhere he would betray a moment of hesitation or perplexity. His virtuosity is almost unbearable. Moreover, though his draughtsmanship is impeccable, most of his work lacks sensibility—an imperfection which is far less engaging. His contours, drawn as they often are with a pen and lithographic ink, are too rigid to blend with the texture of the chalk shading ; and when towards the end of his life, in making his lily drawings for Elwes, he worked with chalk only, his line became altogether too swift and too loose. But, all things considered, Fitch remains the most outstanding botanical artist of his day in Europe. He was the first draughtsman to produce really satisfactory drawings from dried herbarium specimens, and for this alone botanists in England would remain for ever in his debt. He was always his own lithographer, and became a skilled exponent of the art ; but he never entirely mastered Gauci's knack of achieving precision without losing sensitiveness of outline.

Otto Stapf's excellent summary of Fitch's method is worth quoting: "Fitch had a marvellous power of visualising plants as they lived and of retaining their image in his memory. This emboldened him rather to treat his originals as sketches than to work them into finished pictures, with the result that when finally drawn on stone they underwent a certain generalisation in which the type of the species came to life and took the place of a photographically true portrait. His colouring was equally bold, which must have been a veritable boon to the colourists, who could mostly get the desired effect with simple washes."

PLATE XXIXa
MARSH HELLEBORINE (*Epipactis palustris*). Water-colour drawing by Francis Bauer, October, 1799. Natural History Museum, London

PLATE XXIXb
MARIGOLD (*Calendula officinalis*). Hand-coloured engraving by W. J. Hooker from the *Botanical Magazine*, vol. 59, 1832

b

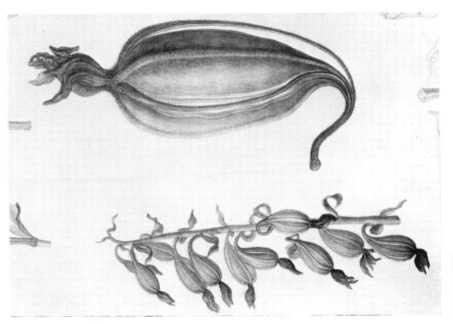

Plate XXIX a

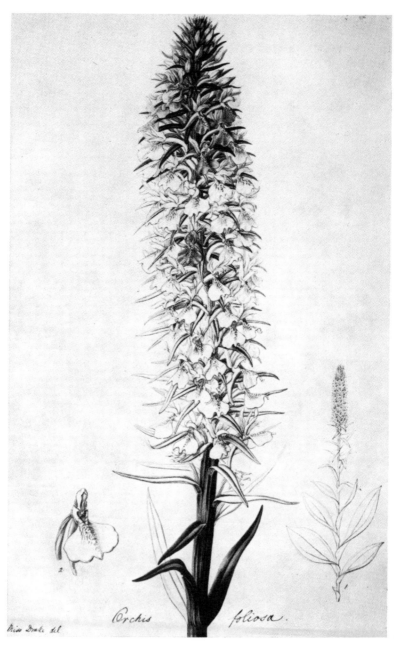

Orchis *foliosa*

Miss Drake del

Plate XXX 'ORCHIS FOLIOSA' (*Orchis maderensis*). Unfinished water-colour drawing by Miss Drake for J. Lindley, *Sertum Orchidaceum*, 1837—42. Kew Herbarium

W. B. Hemsley in the *Kew Bulletin* (1915), gives us a vivid little sketch of Fitch at work upon the drawings for Elwes's *Monograph of the genus Lilium*. Though well over sixty, the artist drew direct upon the stone "without hesitation, and with a rapidity and dexterity that was simply marvellous." That he also made preliminary sketches for these lithographs is known, for a large collection of them, presented by Miss Snelling, is in the Kew Herbarium. Fitch has left us, in a series of articles published in the *Gardeners' Chronicle* (1869), some valuable notes on the technique of botanical drawing which throw some light on his own method of work. Much of what he says is offered in the form of "tips" to the beginner: if the leaves to be drawn are erect in relation to the stem, sketch the lower ones first; if they are reflexed, begin with the upper ones; if they are serrated, put in the serrations before the veining; if they are curved, imagine them as skeletons and make the midrib continuous. The most common error, he says, is that of not placing a flower correctly on its stalk or peduncle, thus "imparting to the sufferer an air of conscious comicality." A good deal of attention is given to the drawing of the foliage, which, he asserts, is usually more difficult than that of the inflorescence.

The article, however, occasionally strike a more personal note:[1]

> Botanical artists require to possess a certain amount of philosophical equanimity to enable them to endure criticism, for as no two flowers are exactly alike, it is hardly to be expected that a drawing should keep pace with their variations in size and colour, and I may add that I never yet ventured to exaggerate a little in that way but I have found that adverse criticism has been nullified by nature excelling itself, as it were, under the fostering care of the many able cultivators of the present day.

Fitch is said to have believed that his true gift lay in the direction of landscape, but he had little time or opportunity to put this to the test; he did, however, devote some of his leisure to "the production of coloured sketches of a mildly humorous kind."

In 1879, Sir Joseph Hooker approached Disraeli on the subject of a pension for Fitch. The Prime Minister hesitated; but Hooker "played upon his imperialist feelings" by showing him the big lithographs which the artist had made of the *Victoria amazonica* water-lily

[1]Since they are still very helpful to botanical draughtsmen, I have reprinted them in an appendix (pp. 268-82).

at Kew, and the following year Fitch was granted a Civil List pension of £100 per annum.

Fitch's work was ably continued after his death by his nephew, John Nugent Fitch (1840-1927), an artist and lithographer second only to himself in industry. He lithographed nearly 2500 drawings for the *Botanical Magazine*, in a manner scarcely distinguishable from that of his uncle, thus carrying their combined connection with the periodical over a period of eighty-two years, during seventy-one of which they were its sole lithographers. John Fitch's lithographs for Cheesman's *Illustrations of the New Zealand Flora* (1914), after drawings by Matilda Smith (1854-1926), show his skill as interpreter of the work of others ; his original drawings for *The Orchid Album* (1882-97), now in the Natural History Museum, and his illustrations to A. R. Horwood's *A New British Flora* (1919), reveal his own talent as a draughtsman.

Robert Morgan[1] (1863-1900) admitted gaining much help in his youth from the articles on botanical illustration by Walter Fitch, on whose style he modelled his own. For many years he was closely associated with the *Journal of Botany* and the publications of the Linnean Society ; but his best drawings (now in the Natural History Museum) are those of pond-weeds, which were used by Alfred Fryer and Arthur Bennett for their *The Potamogetons of the British Isles* (1915). Morgan also lithographed all the plates for Trimen's *Flora of Ceylon* (5 vols., 1893-1900).

After the death in 1840 of both Redouté and Turpin, the high traditions of the French school were still for a long time maintained. François Plée's *Types de chaque Famille et des Principaux Genres des Plantes* (1844-64) deserves particular mention on account of the admirable embryological details in the plates. So, too, does F. Jaubert and E. Spach's *Illustrationes Plantarum Orientalium*[2] (1842-57), in which engravings after the works of various contemporary artists stand side by side with others after N. Robert, Aubriet and Redouté. L. Constans and E. A. Prévost, both of whom were working about 1840-50, produced paintings of miraculously fine quality, and some pretty work of a rather less strictly scientific kind by Marie Anne[3] (c. 1840), may

[1]See *J. Bot. London*, 38 : 489-92 (1900).
[2]See an article by W. T. Stearn in *J. Soc. Bibliogr. Nat. Hist.*, 1 : 255-59 (1939).
[3]Marie Anne's only other recorded work—a flower and fruit piece—was exhibited at the Royal Academy in 1851. Bénézit lists her as " English School," but she painted in the French manner. Possibly she was one of Redouté's royal pupils.

be seen at the Victoria and Albert Museum (see Pl. 28b, p. 175).
J. J. Jung made good plates for Berlèse's *Iconographie du Genre Camellia* (3 vols., 1841-43).

In the second half of the nineteenth century, before the photographer had driven the artist from the field, we find sound work still appearing in *La Revue Horticole*, notably that of Godard, L. Decamps-Sabouret, J. R. Guillot and A. Riocreux. The drawings illustrating the following books are also admirable, and from a botanical point of view beyond praise : Pierre, L. ; *Flore Forestière de la Cochinchine* (1879-1907), with lithographs by Delpy. Cosson, E. ; *Illustrationes Florae Atlanticae* (1882-97), with lithographs by Charles Cuisin. Franchet, A. ; *Plantae Davidianae* (1884-88), with lithographs by d'Apreval. Drake del Castillo, Emmanuel ; *Illustrationes Florae Insularum Maris Pacifici* (1886-92), with lithographs by d'Apreval. Patouillard, N. ; *Phanérogames . . . de Tunisie* (1892), with plates by Cuisin and other artists. Jordan, Alexis, and Fourreau, Jules; *Icones ad Floram Europæ . . . Spectantes* (3 vols, 1866-1903), with plates by A. Mignot and C. Delorme, illustrative of 606 microspecies (jordanons) for the most part distinguished only by minute and subtle characters and thus needing scrupulous accuracy for their portrayal.

The most sensitive and skilful French botanical artist of the period was Alfred Riocreux (1820-1912), who may be considered the Paris counterpart of Walter Hood Fitch. Riocreux was born at Sèvres, near Paris, where his father, who had formerly been employed in the state porcelain factory, was curator of the Musée de Céramique. Trained by his father, the boy progressed so rapidly with drawing and painting that the sketches which he made at the age of thirteen were considered worth preserving at Sèvres. The botanist Adolphe Théodore Brongniart (1801-76), whose father had also been employed at Sèvres, directed the attention of young Riocreux to botany and was probably also responsible for bringing him to the Muséum d'Histoire Naturelle. Here the young artist met Joseph Decaisne (1807-82), for whose superb *Le Jardin Fruitier du Muséum* (9 vols., 1862-75) he made the drawings. He also made numerous illustrations for the periodicals *La Revue Horticole* and *Annales des Sciences Naturelles, Botanique*, both of which were at one time under the editorship of Decaisne, and for many other botanical works. His greatest achievement is considered to be the set of drawings made to illustrate Gustave Thuret's *Études Phycologiques*, said by T. G. Hill (1915) to be " the finest plates ever published in a

botanical work." Riocreux's drawings, which are mostly in black and white, carried on the traditions of iconography associated with the Muséum ; executed under the eyes of skilled botanists, they show a clear grasp of significant detail and are therefore of great value to the systematist. Thirty of his original monochrome drawings for Edouard Raoul's *Choix de Plantes de la Nouvelle Zélande* (1846-) are in the Herbarium at Kew, and there are also a number of *vélins* by him in the Muséum.

JOHN RUSKIN: A DIGRESSION

RUSKIN'S *Proserpina* (1874-86), in spite of its untidy diffuseness, its irritatingly didactic tone and its ill-digested science, remains the most stimulating book ever written about flowers. " It may be described, in one aspect of it," writes his biographer, Cook, " as a series of drawing lessons in flowers."

" For their own sake," Ruskin had said in *Modern Painters*, " few people *really* care about flowers. Many, indeed, are fond of finding a new shape of blossom, caring for it as a child cares about a kaleidoscope. Many also like a fair service of flowers in the greenhouse, as a fair service of plate on the table. Many are scientifically interested in them, though even these in the nomenclature, rather than in the flowers. And a few enjoy their gardens ; but I have never heard of a piece of land which would let well as a building lease remaining unlet because it was a flowery piece. . . . And the blossoming time of the year being principally spring, I perceived it to be the mind of most people, during that period, to stay in towns."

Ruskin loved flowers full-heartedly ; but his approach to Nature, searching and inquiring though it was, remained that of the poet and the painter. He was, on his own confession, " at war with the botanists," and, though he counted several of the most eminent of them among his friends, poured ridicule upon their terminology. He saw no necessity, for instance, for describing the leaves of *Viola epipsila* (" Heaven knows what : it is Greek, not Latin, and looks as if it meant something between a bishop and a short letter e ") as either pubescent-reticulate-venose-subreniform or lato-cordate-repando-crenate, or its stipules as ovate-acuminate-fimbrio-denticulate. He firmly declined to read about a fruit " dehiscing loculicidally." He satirised the passion for turning every botanical term into Latin or Greek by

suggesting that Greek botanists should return the compliment, calling exogens " οὐτσειδβόρνιδες " (outsidebornides) and Caryophylaceæ " νυτλήφιδες " (nutleaf-ides). There was much sense in his criticism and had he stopped here all would have been well ; but he was rash enough to enter the lists himself with a new system of classification which, though poetic enough, was too laughable to be taken seriously by men of science. The *Journal of Botany* did, indeed, twice refer briefly to *Proserpina* (1880, p. 280 ; 1900, p. 199), and Ruskin's drawings were allowed to be " fragmentary, but charming ; " but botanists were not likely to treat with much consideration an author who, " led hopelessly astray by the popular name of *Tillandsia usneoides* arrives at the conclusion that ' the pine-apple is really a moss ; only it is a moss that flowers but imperfectly.' " He trod, alas, ground as dangerous as did Tolstoy when the latter attempted to lay down the law about art.

Ruskin looked at flowers with the eye of an artist. When he was told that the leaves of a plant were occupied with decomposing carbonic acid or preparing oxygen, they became for him no more interesting than a gasometer. He refused to pry with a microscope into the sex life of a flower (" with these obscene processes and prurient apparitions the gentle and happy scholar of flowers has nothing whatever to do "), though he did not scorn a common magnifying glass to make visible beauty more easily apparent. He drew flowers that he might come to know them better. (Incidentally, it was the sudden realisation of the structural beauty of a purple orchis that first made him use his pencil on a Sunday.) " It is difficult," he wrote, " to give the accuracy of attention necessary to see their beauty without drawing them." His drawing, therefore, was not so much an end in itself as a means of exploring the visible beauty of a flower ; and his sketches, lovely though they often are, must rank below his prose descriptions.

As we should expect, he best loved the common wild flower— neither " degraded and distorted by any human interference " nor " provoked to glare into any gigantic impudence at a flower show." A few passages from his description of the common field poppy (*Papaver rhoeas*) will show the depth of his observation and the magic of his style—a style rich and vivid, yet free from the technicolor trickery employed by certain modern horticultural writers :[1]

[1]Reginald Farrer's verdict on Ruskin is perhaps worth quoting in this connection : " An admirable and very verbose writer of doubtful mental balance through most of his life and quite off it in later years."

I have in my hand a small red poppy which I gathered on Whit Sunday on the palace of the Cæsars. It is an intensely simple, intensely floral, flower. All silk and flame: a scarlet cup, perfect-edged all round, seen among the wild grass far away, like a burning coal fallen from Heaven's altars. You cannot have a more complete, a more stainless, type of flower absolute; inside and outside, *all* flower. No sparing of colour anywhere—no outside coarsenesses—no interior secrecies; open as the sunshine that creates it; fine-finished on both sides, down to the extremist point of insertion on its narrow stalk; and robed in the purple of the Cæsars. . . .

We usually think of the poppy as a coarse flower; but it is the most transparent and delicate of all the blossoms of the field. The rest—nearly all of them—depend on the *texture* of their surfaces for colour. But the poppy is painted *glass*; it never glows so brightly as when the sun shines through it. Wherever it is seen—against the light or with the light—always, it is a flame, and warms the wind like a blown ruby. . . .

Gather a green poppy bud, just when it shows the scarlet line at its side; break it open and unpack the poppy. The whole flower is there complete in size and colour,—the stamens full-grown, but all packed so closely that the fine silk of the petals is crushed into a million of shapeless wrinkles. When the flower opens, it seems a deliverance from torture: the two imprisoning green leaves are shaken to the ground; the aggrieved corolla smoothes itself in the sun, and comforts itself as it can; but remains visibly crushed and hurt to the end of its days.[1]

Ruskin did not admire wild flowers indiscriminately. In his description of *Viola cornuta*, which seeded itself in his garden at Brant-wood, he shows how well he could hate: "This disorderly flower is lifted on a lanky, awkward, springless, and yet stiff flower-stalk; which is not round, as a flower-stalk ought to be, but obstinately square, and fluted, with projecting edges, like a pillar run thin out of an iron foundry for a cheap railway station. . . . I perceive, farther that this lanky flower-stalk, bending a little in a crabbed, broken way, like an obstinate person tired, pushes itself up out of a still more stubborn,

[1] C.f. Nehemiah Grew's description of the poppy petals in bud "cramb'd up . . . by hundreds of little *Wrinkles* or *Puckers*, as if three or four fine *Cambrick Handcherchifs* were thrust into one's *Pocket*" (*The Anatomy of Plants*; 1682).

nondescript, hollow angular, dog's-eared gaspipe of a stalk . . . with a quantity of ill-made and ill-hemmed leaves on it, of no describable leaf-cloth or texture. . . . Nobody in the world could draw them, they are so mixed up together, and crumpled and hacked about, as if some ill-natured child had snipped them with blunt scissors, and an ill-natured cow chewed them a little bit afterwards and left them, proved for too tough or too bitter."

For the artist, such descriptions are " botanical illustrations " that neither Leonardo's crayon nor Dürer's brush could better. But when Ruskin takes his pencil in hand he is less sure of himself : he " breaks down " in trying to draw the separate tubes of a thistle blossom ; he was " beaten " by the young leaf of a marsh thistle, and " had to leave it, discontentedly enough ; " often he has only time to indicate the " gesture " of a plant, for life was " really quite disgustingly too short " for the thousand different projects and schemes upon which he was engaged, and his health ever precarious. But in Ruskin's drawings there is a tenderness and sympathy with nature which survive even the ordeal of translation upon steel plates.[1]

Ruskin showed warm admiration for the figures in the *Botanical Magazine* (though he deplored its text), the *Flora Londinensis*, " Old " Sowerby's *English Botany* and, most particularly, the *Flora Danica*. But his admiration was always tempered with criticism. His drawing of *Erica tetralix* (Fig. 49), was made to demonstrate where Sowerby had failed : " By comparing it with the plate of the same flower in Sowerby's work [Pl. 30a, p. 193], the student will at once see the difference between attentive drawing, which gives the cadence and relation of masses in a group, and the mere copying of each flower in an unconsidered huddle." It is of interest to note that in the whole course of the thirty-nine volumes of the collected edition of his works there is not a single mention of the name of Fitch, his almost exact contemporary and the most famous botanical artist of his day. The explanation is probably simple : mere virtuosity left Ruskin unmoved.

Ruskin had noted with surprise how rarely the great masters painted flowers other than as mere accessories. " Every other kind of object they paint, in its due place and office, with respect ; but, except compulsorily, and imperfectly, never flowers. A curious fact this ! Here are men whose lives are spent in the study of colour, and the

[1] Mr. Alister Wedderburn possesses 48 pages of a botanical notebook written and illustrated by Ruskin about 1863.

one thing they will not paint is a flower ! " We have already seen how true this is of the great Italian painters, and it is no less true of most of the famous artists of other schools right down to the middle of the nineteenth century : there were specialist flower-painters, and there were botanical illustrators ; but among the work of those painters most illustrious in the general history of art it is the rarest exception to find an honest study of a flower painted for its own sake.

With figure-painters this is perhaps more readily understandable ; but with the advent of more than one flourishing school of landscape painting, it might well be expected that the fresh beauty of the individual flower would have proved an inspiration. Crome, it is true, painted a well-known study of burdock, now at Norwich Castle, and other pieces of the same nature ; Thomas Stothard made water-colour studies of flowers, several examples of which may be seen at Kew ; Constable and Paul Sandby made one or two sketches of wild flowers ; and there are in the British Museum a slight but attractive plant study by Gainsborough and several less interesting and even slighter ones by Turner ; but not until the days of Manet and the Impressionists did it become a general custom for figure and landscape painters to include, as a matter of course, flower subjects among their work. Even the Pre-Raphaelites, though they painted flowers tenderly, rarely used them except as adjuncts to figure pieces ; and the work of William Hunt, so lauded by Ruskin, and the example of the Master himself, did little more than bring into being a small and rather dreary school of botanical draughtsman such as Thomas Rooke, W. H. Gill and Charlotte Murray.

The Impressionists, with their passion for colour and light, turned instinctively to flowers, though they seem rarely to have made separate botanical studies. Manet's white peonies and the lovely mixed posies of Fantin-Latour were followed by the velvet roses of Renoir, Monet's water-lilies, and the no less wonderful flower-pieces of the Post-Impressionist painters—Cézanne and Gauguin, and Van Gogh whose " portraits " of sunflowers are among the best known flower-pieces in the world ; and in the present century no exhibition is complete without its quota of flower-paintings. Though a brief mention must be made of the dazzling dahlias, sunflowers and delphiniums of Epstein, a discussion of such work really lies outside our province.

ENGLAND—THE SECOND HALF OF THE NINETEENTH CENTURY

I N ENGLAND during the second half of the nineteenth century the popularity of botanical works continued unabated. Though the strong personality of Fitch was still dominant, other influences and new forces were at work : the invention of photography, with all its unimagined potentialities, and the revival of the woodcut, brought the artistic (as opposed to the purely commercial) lithograph into disrepute and gave the impulse to experiment.

Already by the middle of the century the lithograph had declined from its earlier perfection. Mrs. Loudon's attractive flower books, first published in the forties, were reissued ten or fifteen years later with plates that had become coarsened and joyless. Almost alone, Walter Fitch and his nephew maintained a standard in lithography which could continue to command respect, though in France much excellent work was still being done.

Of the many artists active at this time we can mention but a few. The plates in Anne Pratt's *The Flowering Plants and Ferns of Great Britain* (S.P.C.K., 1855), a book which did much to interest the general public in the British flora, are pleasantly composed, though, owing to the limitations of the newly popular technique of chromolithography, not always very accurate in colour. Anne Pratt (1806-93) was a grocer's daughter of Strood, in Kent. The drawings which illustrate her book are her own work, though in their published form they no doubt owe a good deal to the artists of the firm of W. Dickes and Co., who redrew them on the stones. I have not come across any of her original studies. *The Dictionary of National Biography* lists fifteen other works, mainly botanical, from her pen.

236

Elizabeth Twining (1805-89), a granddaughter of Richard Twining the tea merchant, divided her time between philanthropy and botany. Her true memorial is the " Mothers' Meeting," which she was the first to organise; her own drawings for *Illustrations of Natural Orders* (1849-55), though sound botanically, are not of very great artistic interest.

John Traherne Moggridge (1842-74) " drew with great faithfulness and delicate charm " the flowers of the Riviera, where, on account of ill health, he spent the last winters of his short life. The lithographs made after his drawings to illustrate his *Flora of Mentone* (1864-74) give but a faint idea of the beauty and sureness of his line, and even less of a thistledown lightness of touch which inevitably defies reproduction. The little study of *Gentiana ciliata*, in the Church Collection at Kew, is in its way perfect. The Kew Herbarium contains a large number of sheets of his drawings—snipped, alas, into minute fragments so that each flower can be filed with other drawings of the same species.

It may seem unkind to speak slightingly of the art of Marianne North (1830-90), for she not only presented her life-work to the nation but built at Kew, at her own charge, a museum to house it. Indefatigable alike as painter and traveller,[1] she scoured the globe for spectacular plants which she painstakingly recorded in oils in their natural surroundings. Botanists consider her primarily as an artist ; but artists will hardly agree, for her painting is almost wholly lacking in sensibility. The disagreeable impression made by her pictures is enhanced through her determination to display nearly eight hundred paintings in a gallery barely capable of showing fifty to advantage. Moreover her work, being painted in oils, is almost unaffected by light and remains perennially gaudy, whereas the choice little collection of miscellaneous water-colours, formed by Sir Arthur Church and formerly on exhibition in the same building,[2] almost became a total loss.[3] More amateur,

[1]Indefatigable indeed ! 1865 (with her father) to Syria and Egypt ; 1871-72, to U.S.A., Canada, Jamaica and Brazil ; 1875 to Canary Islands ; 1875-77, to California, Japan, Borneo, Java and Ceylon ; 1878-79, to India ; 1880 (at the suggestion of Charles Darwin) to Borneo, Australia, New Zealand and California ; 1882-83, to South Africa ; 1883-84, to Seychelles Islands ; 1884-85, to Chile (to paint Araucarias). Unfortunately the conditions of the bequest do not permit the reproduction of one of her pictures.

[2]Until the War ; the gallery is at present closed.

[3]But this is hardly worse than their remaining for ever invisible upon museum shelves. I would advocate the holding of small exhibitions, changed every six months, of fine illustrated botanical books and original drawings. It ought not to be difficult to find space in one of the museums in Kew Gardens ; and the Natural History Museum has the materials for something even more impressive on similar lines.

but more sensitive, than Marianne North's work is that of her sister, Mrs. John Addington Symonds, whose studies of alpine flowers are in the possession of her daughter, Dame Katherine Furse. Some of her drawings are reproduced in Reginald Farrer's *Among the Hills* (1911). The family tradition is continued by Dame Katherine's son, Paul Furse, who has made flower-paintings for the Royal Horticultural Society.

James Andrews (1801-76) has already been mentioned as an illustrator of sentimental flower books. Little of his original work seems to have survived, and nothing is known of his career ; but a fine water-colour of *Lilium speciosum* in my own collection shows him to have been very talented. Henry Noel Humphreys (1810-79)— artist, naturalist and numismatist—made the pleasant drawings for Mrs. Loudon's *British Wild Flowers* (1845), but is better known for his books on coins. The wood-engravings for the Rev. Charles Johns's once popular *Flowers of the Field* are largely adapted from Curtis's *Flora Londinensis*. J. L. Macfarlane (1836—*c.* 1913), lithographer, did many plates for nurserymen, notably William Bull, Thomas Cripps and B. S. Williams, advertising their introductions ; he also contributed to various horticultural journals such as *The Florist and Pomologist*. Frederick Edward Hulme (1841-1909), for some time Art Master at Marlborough College, made neat little water-colours for *Familiar Wild Flowers* (1875-1900) and other popular works.

George Maw (1839-1912) was the industrious illustrator of his great opus on the Crocus (1886). A many-sided and remarkable man, Maw was not a botanist by profession but the head of a pottery firm at Broseley, Staffs. His monograph, the result of ten years of inquiry, was the most complete work of its kind that had been published on any genus. The plates of this work are marvels of comprehensive detail and put to shame those of many more skilled draughtsmen. From the botanical point of view this work is a landmark ; and Ruskin, in an unpublished letter in the possession of Mr. W. T. Stearn, described the drawings for it (which are now at Kew) as " most exquisite . . . and quite beyond criticism."

All gardeners owe an infinite debt of gratitude to William Robinson —founder of *The Garden* (1871-1927) and *Flora and Sylva* (1903-05), and author of *The English Flower Garden* (1883, etc.) and other works—who helped to break the tyranny of formal bedding and, like Ruskin, drew attention to the beauties of the wild garden. Among the artists whom

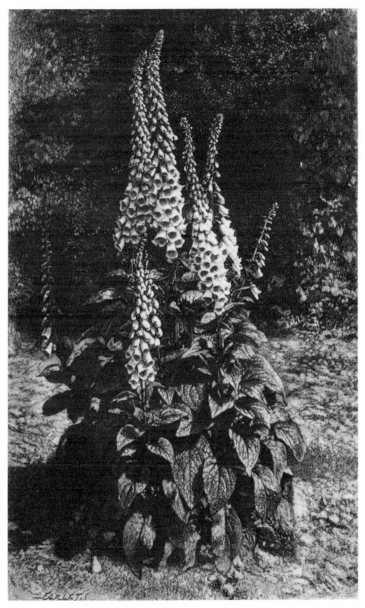

Plate XXXI Foxglove (*Digitalis purpurea*)
Wood-engraving by Farlet from a photograph by H. Hyde;
from W. Robinson, *The English Flower Garden*, 1883

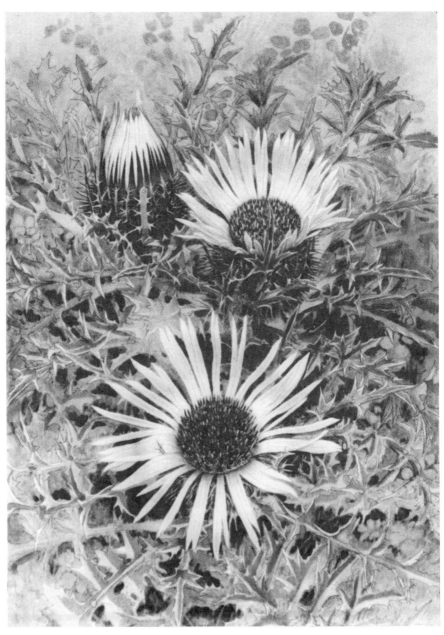

Plate XXXII CARLINE THISTLE (*Carlina acaulis*)
Water-colour drawing by Paul Robert from his *Alpine Flowers*, 1938

he employed was Henry Moon, who struck a new and personal, if not entirely healthy, note in botanical illustration.

Henry Moon (1857-1905) studied at an art school but was obliged to earn a livelihood in a solicitor's office. In 1880 Robinson invited him to join the staff of *The Garden* as artist, and five years later he was commissioned by Frederick Sander, whose daughter he later married, to make the plates for his great orchid folios, *Reichenbachia* (1888-94). During the latter part of his life Moon devoted an increasing proportion of his time to landscape painting—a field which he felt gave greater scope to his particular talent. His last botanical drawings were made for Robinson's *Flora and Sylva*, a periodical which did not survive the artist's death.

Robinson, in *Flora and Sylva*, vol. *3*. p. 346-47 (1905), has written an interesting account of Moon's method of work, and of his own views on botanical illustration. Moon's manner of painting has been practised in this country during the last fifty years by a host of amateurs, and by professional artist such as Francis James (1849-1920) ; this fact justifies a fuller description of his methods than his own work would merit :

> Before the days of the *Garden* plates it was a common practice to exaggerate the drawing of flowers. There was a false florist's ideal set up to which all had to conform : a circle and a large Cauliflower being the accepted models. This way was bad for all, and for none more so than the unfortunate artists who had not to think of what they saw, so much as of the corrupt ideal they were told to strive for. So we began with the determination to draw things as they drew themselves, and never deviated from it—no matter who was displeased. If the flowers of a plant were small, from the weakness of newly-introduced or feeble plants, all the better if they were in time found to be more beautiful and larger than shown in the plate. And the public rarely saw the beauty of the drawings, owing to the drawbacks of even the best colour-printing, in which all the more delicate work of the artist is often injured.
>
> In his work [Moon] took great pains to put the shoot in its natural attitude—studying that at first and then fixing his flowers securely, exactly in the way they were to be drawn. This, which seems the common-sense way, is not at all followed by students, who often begin any way, and then try to arrange as they go.
>
> His grouping was simple and unique. . . . He always painted

one flower in each group as its focus or most important point, and the leaf-colouring was always studied from nature and not merely a conventional green. He never overcrowded his flowers like Fantin-Latour, or over-coloured them like James Andrews and Walter Fitch. His outlines were of the slightest, often done with a brush dipped in local colour, or in the case of white flowers with a few lines and touches of apple-green. The grouping and outlining were indicated rather than completed, and the outlines were then finished with a full brush of the predominant colour. His powers as a pure colourist were remarkable, and depended on his knowledge and experience of wet colours, and the exact effect they would have on the dry paper. To see him working seemed simplicity itself. The outline rightly suggested, the blot-colouring was laid in with a firm hand, and its drying watched and regulated with infinite patience, lightened by the touch of a damp brush here, or deepened with a touch of colour there, until the form and curl of the petals with their gloss and sheen, grew up before one's eyes. When the drawings had dried out, the finishing touches were given, the model flowers still before him, and the result always struck one as far ahead of what could have been expected from such apparently simple means.

We must make some allowance for Robinson's enthusiasm ; he was writing the obituary notice of a personal friend and an artist who had loyally supported him in his work. Moon's technique, indeed, is one which is better suited to landscape painting than to botanical illustration, and he was right in believing that the former was really his *métier*. Some of his flower work is not unattractive in its way (see Pl. 42b, p. 225) ; but the methods of colour reproduction in use at the end of the nineteenth century were not satisfactory, and in particular the chromolithographic plates to the *Reichenbachia* are singularly disagreeable.

The woodcut, which during the triumphant progress of the metal plate throughout the seventeenth and eighteenth centuries had almost disappeared from the illustrated book, had been given a new lease of life by Thomas Bewick (1753-1828).[1] Bewick's only botanical venture —his engravings, after drawings by John Henderson, for Thornton's

[1]For woodcutting and wood-engraving see p. 31.

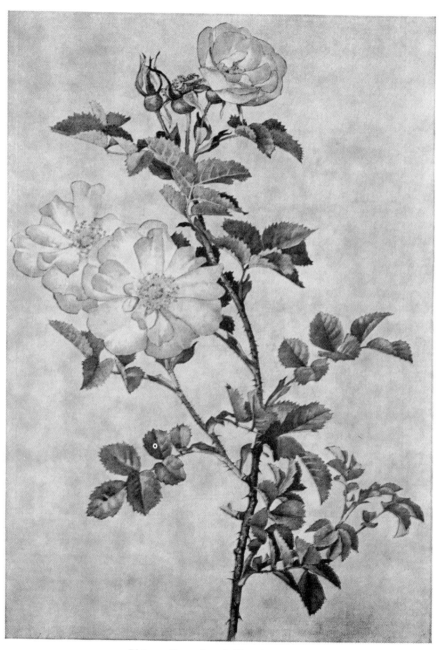

Plate 43 *Rosa eglanteria* 'Janet's Pride'
Water-colour drawing by Alfred Parsons for Ellen Willmott, *The Genus Rosa*, 1910 – 14
Lindley Library, London

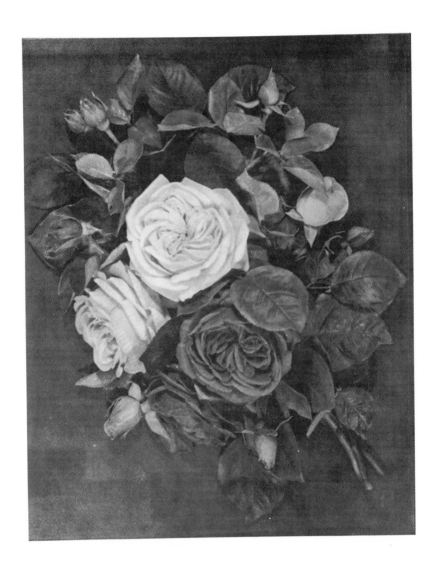

Plate 44 ROSES. Model in wax by Mintorn
Royal Botanic Gardens, Kew

A New Family Herbal (1810)—was among his least interesting work (see Fig. 53) ; but during the nineteenth century, in spite of the great popularity of the lithograph, the use of wood gradually returned to favour. At first, wood-engraving was usually reserved for cheap figures in the text ; but later it was employed, with almost unbelievable virtuosity, for detailed illustrations which were not infrequently made from photographs. The figures in Robinson's *The Garden* and *The English Flower Garden* (see Pl. XXXI, p. 238) show the highest technical brilliance, and, at the same time, the dangers of a technique which, since it sought to imitate photography, was doomed to obsolescence when "half-tone" and other mechanical processes of tone reproduction were developed.[1] In France, Duchartre's *Éléments de Botanique* (1867 ; with wood-engravings after drawings by A. Riocreux), and Baillon's *Histoire des Plantes* (1870 ; illustrated by A. Faguet, see Fig. 54), and in Germany the wood-engraved illustrations after various artists for Anton Kerner's *Pflanzenleben* (1887-91 ; see Fig. 55)[2] prove that continental engravers were little if at all inferior in skill to British craftsmen. Only recently, by the employment of a style of cutting which does not attempt to compete with the camera, has wood-engraving been restored to the status of an art.

Alfred Parsons (1847-1920), well known as a landscape painter, was also employed by Robinson, but his best botanical illustrations are those which he made to illustrate Ellen Willmott's *The Genus Rosa* (1910). The Lindley Library possesses the original paintings ;[3] and a comparison of these with the chromolithographs shows how terribly the former have suffered in reproduction. A buff tint pervades the plates ; the freshness of the pinks and the coolness of the greens are wholly lost. The original paintings are delicate and charming, and well repay study. Plate 43 (p. 240) shows that of ' Janet's Pride ', a rose found growing wild in Cheshire at a considerable distance from any signs of habitation.

Matilda Smith (1854-1926) began making drawings for the

[1] A technical account of the mechanical methods of reproduction made possible by photography cannot be given here, but a compact description of some of them will be found at the end of Philip James's *English Book Illustration* (King Penguin ; 1947). Robinson had a rooted objection to half-tone.

[2] Chromolithographs after paintings by E. Heyn and a number of other German artists also illustrate this valuable work, which was translated into English by F. W. Oliver (1894-95).

[3] See Cardew (1948).

Botanical Magazine in 1878 and soon became its sole artist, a position that she held until 1923. Sir Joseph Hooker trained her to make and draw floral dissections, and she was noted for her skill in "re-animating dried, flattened specimens, often of an imperfect character." Miss Smith, like Mlle Basseporte, remained to the end a rather fumbling draughtsman, more remembered for her "great pains" and "untiring

FIG. 53—Meadow Saxifrage (*Saxifraga granulata*)
Wood-engraving after a drawing by J. Henderson; from R. J. Thornton,
A New Family Herbal, 1810 (enlarged)

efforts" than for her skill, but best of all esteemed for the charm of her personality. She was on occasion her own lithographer; but she owed much to John Fitch, who made some attractive lithographs from her rather hesitant sketches.

In the work of Worthington Smith (1835-1917) we reach the

zenith—or the nadir—of distasteful efficiency. Worthington Smith trained first as an architect—a dangerous schooling for a botanical artist. After a short career as a book illustrator, during which he acquired great skill in wood-engraving, he turned to botany and was appointed to the staff of *The Gardeners' Chronicle*, a post which he held for nearly forty years. Many hundreds of his monochrome drawings

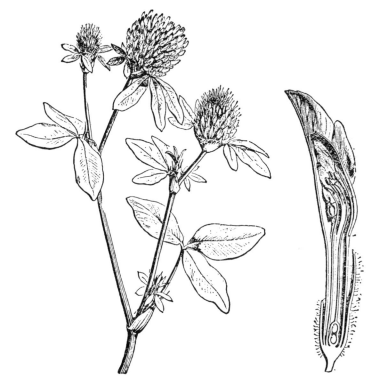

FIG. 54—Red Clover (*Trifolium pratense*). Wood-engraving after a drawing by A. Faguet, from H. E. Baillon, *Histoire des Plantes*, 1870

are in the Natural History Museum, and wood-engravings from them may be found in almost any issue of *The Gardeners' Chronicle* between 1875 and 1910 (see Fig. 56). The drawings are probably all that a botanist could desire, but to the artist they reveal little trace of sensibility : the outlines are crude and monotonous, the shading mechanical, and the general effect repellent. An exception must be

made of a few, presumably early, drawings of British orchids, and some of his colour plates in *The Floral Magazine* are effective ; but that it could come to be written of his art in general that " he had no rival after the death of Fitch " only serves to prove to what depths botanical illustration was sinking. Yet the botanist must be grateful that even inferior artists such as Worthington Smith and Matilda Smith put graphically on record so many plants of which there would otherwise be no illustration available.

Smith also performed a useful service in saving from total disintegration the famous collection of models of fungi made by James Sowerby. Time had dealt harshly with them, for, though some of the materials used by Sowerby—such as wire, cane, sheet iron, zinc, lead, and "coades artificial stone "—were fairly permanent, others—like pipe-clay, wash-leather, wax, and gold-beater's skin—had perished. Smith reconstituted the defective parts, and, with true Victorian realism, substituted genuine horse-dung for the granite support upon which the model of *Coprinus niveus* had been mounted.

Various methods of making scientific three-dimensional models of plants have been devised during the last hundred years. Among the most interesting work in this field is the famous Ware collection of glass flowers made by Leopold and Rudolph Blaschka (see Kredel, 1940). Leopold Blaschka (1822-95), a Bohemian glass-worker, was a keen student of natural history. In 1865, he prepared a set of glass models of jelly-fish for the Natural History Museum at Dresden, and the following year a set of sixty orchids for Reichenbach ; the latter, which were placed in the Liége Museum, were destroyed by fire two years later. Between 1887 and 1936, Leopold and his son Rudolph (1857-1939) made a series of several thousand botanical models, illustrating 164 families of flowering plants and a number of cryptogams. This great collection was commissioned by Mrs. Elizabeth Ware and her daughter and presented by them to the Botanical Museum of Harvard University, where it attracts as many as two hundred thousand visitors a year.

Wax has also been extensively used for botanical models, and most natural history museums contain examples made in this medium. The American Museum of Natural History, New York, has published an illustrated brochure giving details of the process (Guide Leaflet No. 34 ; 1911). A simple leaf is made by placing a living specimen face upwards upon a bed of clay. Plaster is poured over the leaf, producing a mould

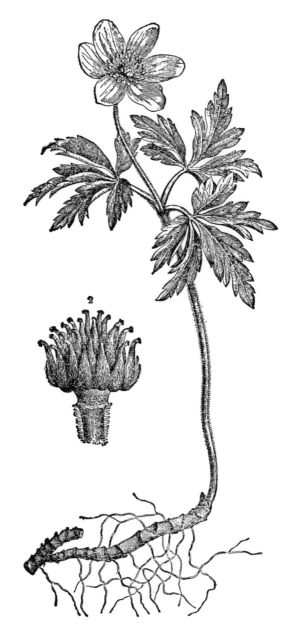

FIG. 55—Wood Anemone (*Anemone nemorosa*). Wood-engraving from Kerner
von Marilaun, *The Natural History of Plants* (tr. and ed. by F. W. Oliver, 1894-95)

into which sheet wax is now pressed. Upon this wax, wire is laid to correspond with the main venation, and the surface is given the necessary support by means of a layer of waxed gauze. The leaf is trimmed to shape with heated scissors. Squeeze and piece moulds are used for more elaborate types of leaves, and for flowers where die-stamping and hand cutting are unsuitable. Stems are made of silk-wound wires wrapped with wax gauze, these being sometimes attached to the original wood after it has been treated with glycerine and formaldehyde. Pistils, stamens and the like are contrived from thread drawn through boiling wax. Anthers are made of coloured wax applied with a hot tool. There is plenty of scope for ingenuity, and much successfully *trompe-l'œil* work has been done by variations of simple methods of this kind.

The chief exponents of this art in England in the nineteenth century were the two Mintorns who, at the ages of eleven and seven, gained gold medals for their flower modelling. Queen Victoria, having raised one of their artificial flowers to the royal nose at a City Banquet, testified her appreciation of the successful deception by appointing them Queen's Modellers. Specimens of their work (see Pl. 44, p. 241) may be seen in the Museums at Kew, together with the no less skilful models of Miss Emmett (Mrs. Blackman). Mr. S. L. Stammwitz, of the Natural History Museum, who is now in charge of the model-making section there, has improvised new methods and produced interesting results. In France, experiments are being made with rubber; and from America comes the rumour that attempts are on foot to dehydrate living plants and, by impregnating them with synthetic resin, to preserve the actual specimens indefinitely.[1]

As might be expected, the most useful—though not necessarily the most artistic—contributions to the task of recording pictorially the plants of the world have been made by artists who worked in collaboration with eminent botanists, and who were therefore well acquainted with the scientific needs of the time. Thus Redouté drew under the eyes of L'Héritier, Desfontaines, de Candolle, Ventenat and Bonpland —a notable array of talent. Turpin, too, was closely associated with

[1]The following books also give information about the making of plant models : Redouté ; *Fleuriste Artificiel et Feuillagiste.* Sourdon, Mlle; *Fleuriste Artificiel Simplifié,* Mintorn, J. H. ; *Lessons in Flower and Fruit Modelling in Wax.* Pepper, C. and Elise, Mme ; *The Art of Modelling and Making Wax Fruit and Flowers.* Browne, Montagu ; *Artistic and Scientific Taxidermy and Modelling* (1896).

botanists of the same calibre, such as La Billardière, Poiteau, de Candolle, Ventenat, Bonpland and Kunth. Heyland owed his career to de Candolle ; Fitch was a product of the two Hookers ; and Faxon's plates (see p. 248) are linked with Sargent's text. These examples are well known ; an association likely to be overlooked is that of Adolf Engler (1844-1930), greatest of German taxonomists, with Joseph Pohl (1864-1939), much of whose work is unsigned.

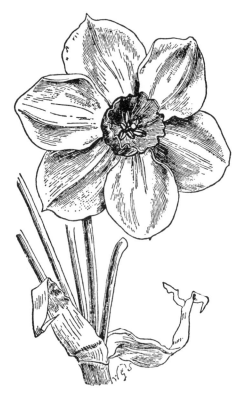

FIG. 56—' Trew's Tazetta Narcissus ' (*Narcissus trewianus*). Wood-engraving by Worthington Smith (1835-1917) from *The Gardeners' Chronicle*, 1890

Joseph Pohl (who should not be confused with Johann B. E. Pohl, author of *Plantarum Brasiliae Icones* illustrated by the Viennese artist Wilhelm Sandler) was born at Breslau in 1864 and served his apprentice-ship as a wood-engraver. Engler, then professor of botany at Breslau,

was at that moment in search of an artist to help him in his grandiose schemes of phytology, and his eye alighted upon Pohl. The youth's talent exactly met his needs ; when the botanist moved to Berlin in 1889, he took Pohl with him. The long association which ensued was marked in 1929 by Engler's dedication to him of a genus of Podo-stemaceæ, Pohliella.

Pohl belongs to the same class as Matilda Smith and Worthington Smith : his work is conscientious, accurate, useful, and in great quantity—but not on a high artistic level. His importance lies in his close connection with the many valuable publications of Engler which he illustrated for over forty years. Through him, the characters of an immense number of new and unfamiliar plants were made known pictorially. His drawings, uninspired though they often are—a consequence partly of the didactic temperament and aims of Engler, partly of their being made from dried specimens—excellently supple-ment the long Latin descriptions of Engler and his co-workers. They have acquired an especial value through the destruction during the war of the Berlin Herbarium. Such works as *Die Pflanzenfamilien* (1887-1909), *Das Pflanzenreich* (1900 *et seq.*), *Die Pflanzenwelt Afrikas* (1908-10), *Monographien Afrikanischer Pflanzenfamilien* (1898-1904) and the periodical *Botanische Jahrbücher* (1881 *et seq.*), for which Pohl provided most of the illustrations, are of lasting importance to systematic botany. Pohl also made the illustrations of orchids in Martius's *Flora Brasiliensis* 3 H. 4-6 (1893-1906).

Pohl links the nineteenth century with the twentieth century ; before passing on to a consideration of the work of the present day, one or two other illustrated botanical books produced on the continent and in America during the second half of the nineteenth century should be mentioned. In Holland : Miquel, F. ; *Choix des Plantes Rares ou Nouvelles* (1864), with plates by various artists. In Austria : Schott, H. ; *Icones Aroidearum* (1857), with lithographs by J. Oberer ; Peyritsch, J. ; *Aroideae Maximilianae* (1879), with chromolithographs. In Spain : Blanco, Manuel ; *La Flora de Filipinas* (1877-80). In Belgium, the artist J. Cambresier was employed by Edouard Morren of Liége to make drawings of his wonderful collection of Bromeliaceae ; he also made many plates for *La Belgique Horticole*.

In the U.S.A., the most important botanical artist of the period is Charles Edward Faxon (1846-1918), at one time instructor in botany at the Bussey Institute of Harvard College. His work includes 1925

published drawings, illustrating such important books as C. S. Sargent's *Silva of North America* (1891-1902), *Trees and Shrubs* (1902-13), *Manual of Trees of North America* (1905), and the journal *Garden and Forest* (1888-98) ; and many of the plates in C. D. Eaton's *The Ferns of North America* (1879-80). To quote Sargent, Faxon " united accuracy with graceful composition and softness of outline. He worked with a sure hand and great rapidity."[1] I. Sprague's illustrations to Asa Gray's *Genera Florae Americae Boreali-Orientalis Illustrata* (1848-49) also deserve mention.

[1]See *Rhodora,* 20 : 117-22 (Boston, 1918).

CHAPTER 23

THE TWENTIETH CENTURY

THE FLOWER paintings of Redouté or Francis Bauer reflect a
leisured, unhurried age—an age when a lifetime could be offered
in single-minded devotion to the service of botanical illustration.
Few artists to-day have the same opportunity ; but much good work
is yet being done in moments snatched from already crowded days.
It is too soon to attempt to give a balanced account of recent work,
and the difficulty of foreign travel makes the task doubly hard ; it
would, however, be a pity to omit on this account all reference to
contemporary achievement. Some description, too, of the technical
methods of flower-painting as practised in England to-day may be of
interest to the amateur who seeks a brief escape from the hard realities
of the present.

Mr. Frank Harold Round (1879—), while Assistant Drawing Master
at Charterhouse, made the fine paintings which, in rather unsuccessful
reproduction, form the illustrations to W. R. Dykes's *The Genus Iris*
(1913), and a large collection of studies of the same flower for the
Hon. N. C. Rothschild. The former are now in the Lindley Library,
the latter in the Natural History Museum (see Pl. 45a, p. 256). Mr.
Round modestly asserts that he is not proud of his flower studies, that
he knew nothing about irises and only carried out his instructions to
make " clear, descriptive drawings as though for a catalogue ; " the
work, however, shows agreeable sureness of hand and eye. Sometimes
during the iris season Dykes would appear at 5 a.m. in his dressing-
gown with a rare species that had to be painted immediately. Yet
Mr. Round can write : " The drawings for Dykes were easy and
comfortable to do ; he was a nearby colleague, so he handed me the

plants at our mutual convenience. But Rothschild's came by post, often three or four at a time. As I was teaching most of the day, it was a hectic rush. Often I had to start with the closed buds of several plants, and then make use of them again, when they opened, to replace the blooms at the top which had meanwhile died." Little in the finished paintings gives a hint of the difficulties with which the artist had to contend, except, perhaps, the structure of the leaves, which is not so carefully considered as that of the flowers. Another draughtsman who worked for Mr. Rothschild was Mr. E. J. Bedford, whose conscientious studies of British orchids are also in the Natural History Museum.

Miss Lilian Snelling (1879—) has been principal artist of the *Botanical Magazine* for nearly thirty years, and has made the memorable illustrations to Grove and Cotton's *Supplement to Elwes' A Monograph of the Genus Lilium* (1934-40) and to F. C. Stern's *A Study of the Genus Paeonia* (1946). She studied lithography under Morley Fletcher, and has lithographed many of the paintings which, during the last twenty years, Miss Ross-Craig has made for the *Botanical Magazine*. She shows great skill in placing her plants upon the page, and her work is as remarkable for its grace as for its botanical accuracy. One of Miss Snelling's studies is shown on Plate 45b (p. 256).

In the making of scientific black-and-white line illustrations, Miss Stella Ross-Craig (1906—) stands to-day unrivalled, for she combines sound botanical knowledge with sure draughtsmanship. She has done excellent work for Hooker's *Icones Plantarum*; and her *Drawings of British Plants* (see Fig. 58), now being issued in parts, will eventually provide the standard illustrations of the British Flora. Miss Ross-Craig has kindly written for me the following account of her methods :

When making a water-colour painting of a living specimen, I first study the plant from all angles—as a sculptor might study a head when making a portrait—to grasp its *character*. To understand the structure of the flower it is sometimes necessary to use a magnifying glass. The most pleasing aspect having been decided upon, I sketch in the composition—lightly, but accurately as regards the measurements. Leaves are adjusted, within scientific reason, to make an agreeable arrangement, and flowers that have been damaged in the post or are, for any other reason, defective, are replaced in the drawing by perfect specimens. When a flowering

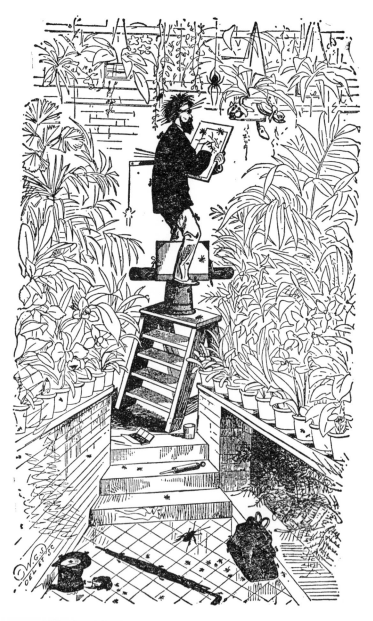

FIG. 57—'The late Mr. Worthington G. Smith sketching under difficulties'
Drawn and engraved on wood by Worthington Smith (1835-1917);
from *The Gardeners' Chronicle*, 1917

stem is to be drawn, and room has to be left for the addition later of leaves and fruit, it may be necessary to consult herbarium specimens in order to judge the space required. At this stage consideration has to be given to the spacing of enlarged dissections of parts of the plant, if these are to be included in the plate. It is, incidentally, a great pity that so little attention is paid nowadays to the underground parts of plants ; sixteenth-century artists were well aware of their importance.

The sketch completed, I work up the " portrait " in detail, beginning with fugitive parts such as quickly opening buds. Plants that change or wither rapidly present a very difficult problem to which there is only one answer—speed ; and speed depends upon the immediate perception of the essential characteristics of the plant, a thorough knowledge of colours and colour mixing, and perfect co-ordination of hand and eye. Crocuses are especially awkward to manage when working indoors, for a bud one moment is an open flower the next, and it is necessary to move them at frequent intervals into a darker, or a cooler, place to restore them to their original condition. It must also be borne in mind that a painting made for scientific purposes must be completed before the plant withers, since the actual specimen figured must be dried and preserved for the Herbarium.

I find that Hot-pressed Whatman paper is the most suitable for water-colour paintings of plants, as there is no " surface texture " to contend with and the finest detail can be shown. An H.B. pencil is usually hard enough, but it is sometimes necessary to use an H. for very delicate work. When a painting is to be worked up in full colour, I avoid pencil shading, which tends to produce muddy tones. Life-like solidity is obtained by the use of the minimum amount of water, together with the correct choice of colours for mixing to give the required degree of opacity.

Drawing from dried specimens has both advantages and dis-advantages. The artist gains, of course, in not having to work at high pressure for a short period ; but on the other hand there is the difficulty of creating the illusion of three dimensions. This can only be overcome by a thorough knowledge of botany and of perspective. When the specimen to be drawn (and it should be typical of the species) has been decided upon, the angles of the various branches and flowers must be calculated as the drawing proceeds, all measure-

ments being accurately checked. The position of the main stems, branches, etc., having been determined, flowers, and any other parts that are difficult to see with the naked eye, are boiled—or, with very fragile material, gently soaked—to facilitate microscopic dissection. The true character of such parts is thus revealed, accurate measurements are established, and perspective drawings can be constructed.

It is, of course, undesirable, for reasons of accuracy, to use colour when working from a dried specimen, and in my opinion, line-drawing is the most satisfactory method of illustration ; the use of a screen in the block-making is thereby avoided, and consequently no detail is lost. I work on Bristol Board, which allows a certain amount of correction to be made, and use for preference a Gillot 290 lithographic pen, which is extremely flexible and gives a wide range in breadth of line.

Miss Snelling's method of work in water-colour is very similar to that of Miss Ross-Craig, but she makes more use of body-colour and confesses that on occasions she has had to resort to coloured ink, especially magenta, to get the brilliance unobtainable by other means.

Among prominent botanical artists who have worked overseas are two English women—Miss Page (in South Africa) and Miss Eaton (in the United States). Miss Maud Mabel Page was born in London in 1867, and went out in 1911 to South Africa, where she at first painted flowers purely for her own amusement. Here, in 1915, she met Harriet Bolus (née Kensit), a leading botanical authority on the South African flora, who taught her " to paint from the botanical point of view " and to appreciate the minute differences between closely allied species which must be accurately portrayed. From 1915 until her death in February 1925 Miss Page was employed as botanical artist in Bolus Herbarium, University of Cape Town. The greater part of her work, which includes two hundred coloured drawings of Mesembryanthemum, is unpublished ; but a number of illustrations by her have appeared in *Annals of the Bolus Herbarium* (1916-28), *Journal of the Botanical Society of South Africa* (1917-25) and *Flowering Plants of South Africa*. The genus Pagella (Crassulaceæ) and *Erica pageana* commemorate her.

Miss Mary Emily Eaton, who was born at Coleford, Forest of Dean,

FIG. 58—Yellow Water-lily (*Nuphar luteum*)
Pen-and-ink drawing by Stella Ross-Craig from her *Drawings of British Plants*, 1948

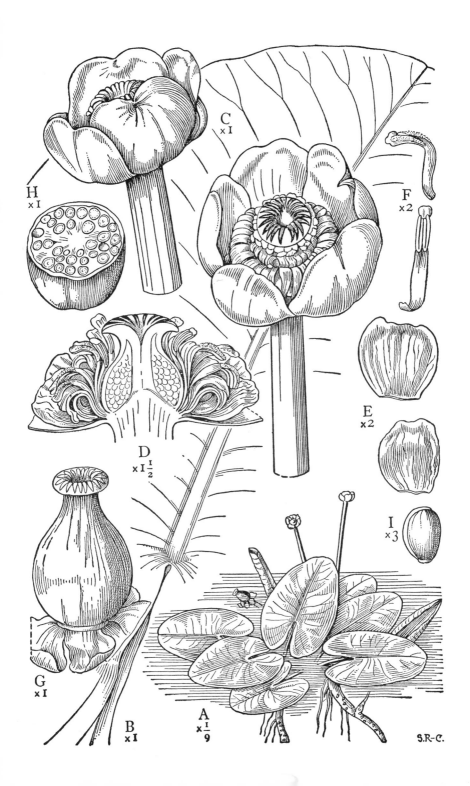

C
×1

H
×1

F
×2

E
×2

D
×1½

I
×3

G
×1

B
×1

A
×1/9

S.R-C.

in 1873, had no specialised botanical training but was always interested in flowers. In 1909 she went to stay with a brother and sister in Jamaica, where she began to paint butterflies and moths. The attention to detail which she showed in these paintings obtained for her the position of artist to the New York Botanical Garden, a post which she held from June 1911 to January 1932. She never changed her nationality, and returned to England in May 1947. Originals of her work are mostly at the New York Botanical Garden, but the National Geographic Society of Washington, D.C., possesses about five hundred drawings which are still unpublished. Most of her published work is in *Addisonia* and in Britton and Rose's *Cactaceae* (1919-23).

In Canada since 1939 another Englishwoman, Miss Emily Sartain, has been portraying in colour the flora of British Columbia; she developed her talent as a flower-painter in England when figuring meritorious garden plants between 1932 and 1939 for the records of the Royal Horticultural Society. Others employed by the Society for this purpose have included Miss M. Walters Anson (*d. c.* 1935), Elsie Katherine Dykes *née* Kohnlein (*d.* 1933), second wife of W. R. Dykes whose *Notes on Tulip Species* (1930) she illustrated, Miss Nelly Roberts (*b.* 1872) who has long specialised in painting garden orchids, Miss Winifred Walker, and Alfred John Wise (*b.* 1908).

In America, effective work in black and white has been done by Florence McKeel (Mrs. Harry J. Lambeth), first full-time botanical artist to the Bailey Hortorium of Cornell University. Many of her drawings have been published in *Gentes Herbarum*. Other American botanical artists include Schuyler Matthews, Gordon Dillon of Harvard, Henry Evans, Anne Todd and Marion Ruff.

The flower paintings of Miss Helen Garside (1893—), all too few of which have been published, show a very subtle appreciation of texture and great delicacy of handling (see Pl. 46, p. 257). She is of the lineage of Dürer, finding beauty in the meanest weed. Like Miss Snelling, she worked at one time in a broader manner, and has modified her technique, in part to suit the exigencies of scientific illustration, in part

PLATE 45a
Iris aphylla var. *hungarica*. Water-colour drawing by F. H. Round (1879—). Natural History Museum, London

PLATE 45b
Iris histrioides. Water colour drawing by Lilian Snelling, 1931, for the *Botanical Magazine*. Kew Herbarium.

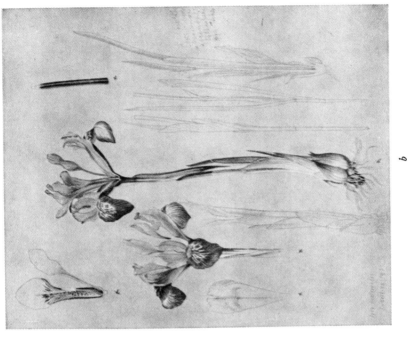

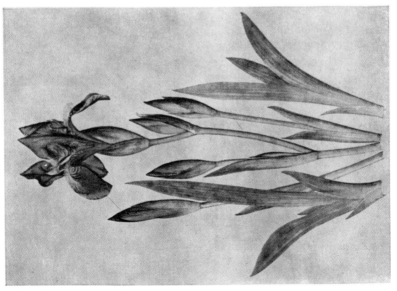

b

Plate 45a

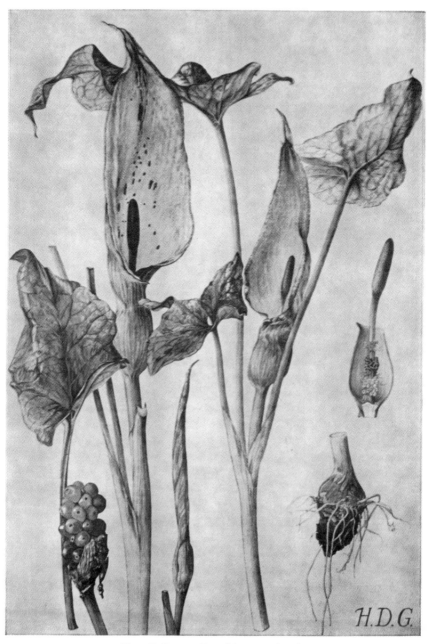

Plate 46 CUCKOO-PINT (*Arum maculatum*)
Water-colour drawing by Helen Garside, 1948. Author's collection

to realise to the fullest possible extent the quality of the flowers that she paints. Miss Dorothy Martin (1882-1949), for thirty years Art Mistress at Roedean School, painted several hundred fine sheets of British wild flowers. In this same field, good work has also been done by Mr. and Mrs. Alfred Powell, and by Mrs. Powell's sister, Thérèse Lessore (Mrs. Walter Sickert). Miss Rose Ellenby has made attractive and decorative water-colour drawings for John Ramsbottom's *Edible Fungi* and *Poisonous Fungi* (King Penguin, 1943, 1945) ; and that veteran of horticulture, E. A. Bowles (1865—), has illustrated several of his own books and articles. Anthony William Darnell's *Winter Blossoms from the Outdoor Garden* (1926), *Orchids for the Outdoor Garden* (1930) and *Hardy and Half-hardy Plants* (2 vols., 1929-31) are also illustrated with the author's drawings. Among other twentieth century books, the following may be mentioned : H. I. Adams, *Wild Flowers of the British Isles* (1907) ; A. H. Church, *Types of Floral Mechanism* (1908) ; Vere Temple, *Flowers and Butterflies* (1946) ; and from the United States, the five volumes of Mary Walcott's *North American Wild Flowers* (Washington, 1925).

Black-and-white illustration has been successfully pursued in England and elsewhere during the present century, and wood-engraving has broken free from the rather mechanical style of cutting employed by Victorian craftsmen. John Nash has illustrated several works on plants and gardening, notably William Dallimore's *Poisonous Plants* (1927), Jason Hill's *The Curious Gardener* (1932) and *The Contemplative Gardener* (1940), Patrick M. Synge's *Plants with Personality* (1939), and Robert Gathorne-Hardy's *Wild Flowers in Britain* (1938 ; see Fig, 59) ; it is interesting to compare his line drawings with those made by E. W. Hunneybun for C. E. Moss's *Cambridge British Flora* (1914-20), the latter well demonstrating how lifeless a figure can become when sensibility is lacking. Miss Clare Leighton (see Fig. 61), Miss Agnes Miller Parker, Mrs. Gertrude Hermes and other wood engravers have made plates, including many of flowers, for a variety of books dealing with the British countryside. Neat pen-and-ink drawings (see Fig. 60) by the author are reproduced side by side with early woodcuts in R. G. Hatton's *The Craftsman's Plant-Book* (1909). Etching has been employed by Mrs. Blanche Ames to illustrate Prof. Oakes Ames's *Orchidaceae* (Boston, 1905-22). The art lithograph has also been revived to some effect : in conjunction with colour it has been employed by John Farleigh to illustrate Sacheverell Sitwell's *Old Fashioned Flowers* (1939), and by John Nash for his own *English Garden Flowers* (1948).

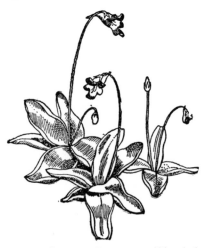

FIG. 59—Common Butterwort (*Pinguicula vulgaris*). Pen-and-ink drawing by John Nash ; from R. Gathorne-Hardy, *Wild Flowers in Britain,* 1938

In Germany, Hegi's monumental *Illustrierte Flora von Mittel-Europa* (1906-31) is copiously and competently illustrated by E. Pfenninger and others. The Neue Sachlichkeit movement, with its emphasis on Pre-Raphaelite detail and finish, has produced some meticulous flower painting, particularly of succulents.

George Flemwell's familiar paintings of Swiss flowers, reproduced in several books published shortly before the first World War, were praised by H. Correvon, the author of *La Flore Alpine.* The latter book was illustrated by a Swiss artist of some individuality — Philippe Robert (1881-1930)—whose compositions seem to have been influenced by the Japanese. M. Eugène Burnand, who contributes the preface to this book, compares the artist's work, rather surprisingly, to that of Fra Angelico, finding in it " the same feeling of intimacy, the same scrupulous fidelity of rendering, the same absence of strained effect, the same meditative and sympathetic vision." Robert's flowers are set against backgrounds of strongly contrasting colours, and the result has a certain primitive gaiety ; but there, so far as I can see, all resemblance ceases. S. Rivier also worked for Correvon, in a manner scarcely distinguishable from that of Robert. Another Swiss artist, Paul Robert (*b.* 1901), the youngest of Philippe Robert's brothers, has made delightful paintings of plants in their natural surroundings ; some of them (see Pl. XXXII, p. 239) have been published in a book entitled *Alpine Flowers* (1938). It is interesting to compare this book with an earlier attempt of the same nature—Elijah Walton's *Flowers from the Upper Alps, with Glimpses of their Homes* (1869). Some effective flower posters, in support of a campaign to preserve Switzerland's great national heritage of Alpine plants, have been produced in recent years.

The work of the Genevese botanist Gustave Beauverd (1867-1940)

deserves mention here. Of humble parentage, he was apprenticed at the age of seventeen to a lithographic establishment in Geneva and followed the trade of engraver, draughtsman and retoucher at Ardan (Valais) and Geneva until 1900, when he was appointed curator of the important Herbier Barbey-Boissier, his enthusiastic study of local plants having brought him to the notice of William Barbey. From then onwards he devoted himself whole-heartedly to botany and published some 400 or so papers, most of them illustrated with his own neat and informative

FIG. 60 — Great Bindweed (*Calystegia sepium*). Pen-and-ink drawings by R. G. Hatton from his *The Craftsman's Plant-Book*, 1909

drawings of little-known plants. He developed a keen eye for subtle distinctions and it is fortunate his pencil was ever ready to record them graphically. Beauverd's work appeared for the most part in the *Bulletin de la Société botanique de Genève* and other Swiss scientific periodicals. In 1925 he received the degree of D.Sc. honoris causa from the University of Geneva.

The student of Scandinavian plants has available in *Bilder ur Nordens Flora* (3 vols., Stockholm, 1901-05 ; 3rd ed. 1921) by the well-known Swedish botanist Carl Axel Magnus Lindman (1856-1928) an excellent series of coloured plates. Bjorn Ursing's *Svenska Växter i Text och Bild* (Stockholm, 1947) is a handy assemblage of neat little coloured illustrations of Swedish plants, too small for detail but well portraying general habit. Norway possesses good line drawings of its plants in Johannes Lid's *Norsk Flora* (Oslo, 1944) illustrated by Dagny Tande Lid, and in Rolf Nordhagen's *Norsk Flora, Illustrasjonsbind* (Oslo, 1944-48) illustrated by Miranda Bødtker. Some of Lid's boldly outlined drawings have also appeared in the new flora of Iceland, Askell Löve's *Islenzkar Jurtir* (Copenhagen, 1945).

The plants of France, Switzerland, Corsica and Belgium have been completely illustrated in black and white by Hippolyte Jacques Coste (1858-1924) in his *Flore descriptive et illustrée de la France* (3 vols. ; Paris

FIG. 61—Stinking Hellebore (*Helleborus foetidus*)
Wood-engraving by Clare Leighton from her *Four Hedges*, 1935

1901-06) and in colour by Mlle. Julie Poinsot in Gaston Bonnier's *Flore complète illustrée de France, Suisse et Belgique* (12 vols.; Paris, 1912-35).

In France, Holland and Italy I have found little sign of contemporary work of outstanding interest; but present conditions make

it difficult to explore the continental field with thoroughness. It is probably safe, however, to assert that the best botanical illustration being made to-day is to be found in England.

Books illustrated with fine photographs of flowers have come from Central Europe during the years between the two wars. Volckmar Vareschi and Ernst Krause's *Mountains in Flower* (Lindsay Drummond, 1939) and Karl Foerster and Albert Steiner's *Blumen auf Europas Zinnen* (Zürich, 1937) show what effective results can be obtained by a close-up in sharp relief set against a more or less diffused background. Karl Blossfeldt, in his *Art Forms in Nature* (Zwemmer, 1935), explores the potentialities of micro-photography. In England, Victoria Sackville-West's *Some Flowers* (1937) and Blanche Henrey's *Flower Portraits* (1937) and *Trees and Shrubs throughout the Year* (1944) also reach a high standard. Now colour photography is playing an increasingly important part, as may be seen in other volumes of the NEW NATURALIST series, and in books such as H. H. Hume's *Camellias in America*. The Swedish *Vilda Växter i Norden* (Stockholm) by Torsten Lagerberg, and its Norwegian version *Våre ville Planter* (Oslo) by T. Lagerberg and Jens Holmboe, contain a remarkably fine series of colour photographs, supplemented by line drawings, of Scandinavian plants. But it seems unlikely that, even for scientific purposes, the photograph will ever prove a full substitute for the drawing. It can hardly be doubted, however, that the great days of botanical art lie behind us, and that, in the future, flower drawing will become little more than a by-product of science or a relaxation in art.[1]

[1] " A great flower-painter," said Goethe, " is not now to be expected : we have attained too high a degree of scientific truth ; and the botanist counts the stamens after the painter and has no eye for picturesque grouping and lighting." *Conversations of Goethe with Eckermann* (Mar. 27, 1831).

EPILOGUE: FIVE HUNDRED YEARS OF BOTANICAL ILLUSTRATION

F LOWER PAINTINGS, we have now seen, have been made at
different times by diverse types of artists and for diverse purposes :
by bold explorers in the cause of science, and by timid spinsters
to the glory of God ; to record the homely wild flowers of the European
homeland, and to make known the gaudy exotics of distant countries ;
to train the eye of the botanist ; to bring knowledge within the reach
of the student, or a moment of fleeting pleasure to princes. In a brief
concluding essay I hope to unravel some of the various threads which
constitute this tangled chapter in the history of art and science—the
story of botanical illustration since the close of the Dark Ages.

In the sixteenth century, science slowly began to emerge from the
confused superstitions of earlier times. Out of the superstition of
astrology the science of astronomy was born ; and out of the credulous
plant-lore of the Rhizotomi and their medieval successors—a super-
stition for which we have no convenient name—appeared the first
adumbrations of modern scientific botany. The accurate and intelligent
representation of plants was a necessary adjunct of this new-born
science.

The pictures of plants in the early manuscript and incunabula
herbals, based for the most part upon the dim recollection of classical
prototypes, had gradually degenerated from tolerably naturalistic
drawings into stylized figures which served little purpose beyond that
of enlivening the appearance of the page. Modern scientific botanical
drawing, though foreshadowed in the work of artists such as Andrea

Amadio, Dürer and Leonardo da Vinci, may really be said to date from the publication in 1530 of Brunfels's *Herbarum Vivae Eicones* ; and during the remaining years of the sixteenth century, though the botanical woodcut made little if any further advance technically or æsthetically, a wealth of finely illustrated books put on record the known plants of the day. Under Fuchs (1542) and his successors, dissections of flower and fruit were sometimes added to the plates. The influx of new plants, especially from the Near East, provided an ever-increasing corpus of material for the artist. Thus by 1601 about 1500 species, mostly European but including a number from America and the Near East, had been portrayed in realistic woodcuts.

Botanical artists have always been limited in their work by the technical means at their disposal. The woodcuts in Brunfels's herbal, vigorous and lovely though they are, inevitably lack the subtle detail of Weiditz's original water-colours. But with the advent, at the close of the sixteenth century, of the copper plate, it became possible to record the minute differences between certain species that a more scientific age demanded. Botanists paid the piper and called the tune ; it was the business of the scientific botanical draughtsman to give to the best of his ability the details of structure that were demanded, and the steady development of technical methods has kept illustration abreast of scientific requirements.

The seventeenth century was memorable for the work of the great systematists, culminating in England in that of John Ray and Robert Morison, who began to bring order out of the chaos of rapidly accumulating data. But it is to France, rather than to England or elsewhere on the continent, that we must turn at this period for the most important illustrations of a scientific nature—the famous *vélins*, and the plates, also made under royal patronage, of Nicolas Robert and his collaborators for the *Recueil des Plantes*. In this age, stimulus was also given to botanical illustration by the development of travel made partly or wholly for the purpose of collecting and recording plants. Aubriet in the Levant, Wagner and other artists in Brazil, Rumphius's assistants at Amboyna, Hartog at the Cape, Kaempfer in Persia and Japan, Plumier and Merian in America, and van Rheede at Malabar, stirred the imagination of Europe by their illustrations of the strange flora of distant lands.

The unsettled state of Europe during the opening years of the eighteenth century was not propitious for the patronage of art or

science; but before the middle of the century we encounter the great names of Linnæus (*b.* 1707) in botany and Ehret (*b.* 1708) in illustration. Many new plants from America were introduced and recorded at this time. The close of the century inaugurated—with the work of van Spaëndonck, Redouté and Turpin in France and of the two Bauers in England—a truly remarkable age: an age when scientific illustration reached heights never surpassed before or since. For this the Binomial System of Linnæus, which necessitated a complete revision of plant names, was in no small measure responsible. After 1840, Fitch in England and Riocreux in France followed to the best of their powers the lead given by their great predecessors. The *Botanical Magazine*, to which many of the finest British botanical draughtsmen have throughout its long history contributed drawings, still perpetuates to-day, in the work of Lilian Snelling and Stella Ross-Craig, all that is best in the English tradition of scientific illustration.

Scientific botanical books may be further grouped by their subjects. During the eighteenth and nineteenth centuries, important illustrated floras, chiefly of European countries, were produced by Oeder (Denmark and Norway); Jacquin (Austria); Pallas (Russia); Curtis and Sowerby (Britain); Waldstein and Kitaibel (Hungary); Sibthorp (Greece); Vaillant (France); Sturm (Germany); Reichenbach (Germany, Austria, Switzerland); Labram (Switzerland); Martius (Brazil). These and countless other floras amplified the tentative efforts of earlier botanists. Where wealthy patronage was available, these books were splendidly and expensively produced; Labram's little volumes are characteristic of the products of a country where such patronage was lacking.

As more distant lands were scientifically investigated, their floras were made the subject of carefully compiled studies. Roxburgh's *Plants of the Coast of Coromandel* may serve as an example of the many hundreds of books of this kind which have already been published. As new territory is opened up and developed, fresh volumes are yearly being added to swell the records of the world's plants; H. R. Descole's *Genera et Species Planatarum Argentinarum* (Buenos Aires; vol. 1, 1914; still in course of publication) bears witness that such works can be produced in the grand manner even to-day.

Further, there are the monographs which deal with a particular genus or group of plants. From such humble beginnings as Belon's *De Arboribus Coniferis* . . . (1553) we pass on, by way of the *Roses* and

Liliacées of Redouté and a host of other richly illustrated nineteenth century folios and quartos—of which Maw's *Crocus* (1886) deserves special mention for its meticulous detail—to contemporary works such as Erich Nelson's *Die Orchideen Deutschlands* (1931), Mary Vaux Walcott's *Illustrations of North American Pitcherplants* (1935), A. Grove and A. D. Cotton's *Supplement to Elwes' Monograph of the Genus Lilium* (1934-40), V. B. Baird's *Wild Violets of North America* (1942) and F. C. Stern's *Study of the Genus Paeonia* (1946).

Books dealing with plant structure, a theme first made possible by the invention of the microscope, date from the works of Grew and Malpighi in the second half of the seventeenth century. Francis Bauer's enlarged dissections of plants are a miracle of patient study. But in this field, above all others, the photographer may with justice be permitted to supersede the artist. Among scientific text-books, Anton Kerner von Marilaun's *Pflanzenleben*, which deals with the ecological and geographical aspects of botany, is an obvious example of a book in which illustration plays a prominent part.

Thus we may group and subdivide, almost indefinitely, the vast corpus of illustrated books dealing with plants from a scientific point of view. The theme is admirably treated by Jessen in his *Botanik der Gegenwart und Vorzeit* (1864 ; new ed. 1946), a book which, as the best concise general history of botany yet written, surely deserves an English translation.

The works so far discussed in this chapter have been primarily scientific. The florilegium, or picture-book of garden flowers, may be considered as a book compiled for the horticulturist rather than for the botanist, though it is not always easy to draw a precise line of demarcation between scientific and non-scientific intention. This type of book was developed towards the close of the sixteenth century, when flowers first began to be extensively cultivated for their beauty rather than for their utility, and reached its highest popularity in the seventeenth century. Crispin de Passe's *Hortus Floridus*, Besler's great *Hortus Eystettensis*, and countless hand-painted florilegia such as those by Marshal, Walther and Simula, are characteristic examples of books made to charm the wealthy amateur. In a later age, some of the paintings by Ehret, and many of those by Redouté, are horticultural in character. Redouté's *Choix des Plus Belles Fleurs*, for instance, is a florilegium, while his illustrations to *Les Liliacées*, though some of them

figure in the former work, were primarily made for a scientific purpose. Many of the nineteenth century periodicals, though claiming scientific intent, were designed to entertain and instruct the gardener. The flimsiest of pretexts would suffice for the launching of yet another of these almost endless publications : Maund's *Botanist*, for instance, was started because " it seemed to the editor that there was no work which precisely combined accurate scientific instruction with an occasional appeal to the imagination, and to the moral and religious feelings." Recently there has been a spate of books, many of them illustrated with coloured photographs of flowers, which make no claim to a scientific approach.

The widespread popular interest in flowers in both England and France at the beginning of the nineteenth century was of a more sentimental character than that which had swept Holland two hundred years earlier ; yet it owed its origin, in part at any rate, to the Linnean system of classification which converted botany into a parlour game for any young lady who could count up to twelve. Books of instruction for the young flower-painter, and romantic little volumes full of pretty posies and execrable verse, sold by their thousands, especially in England. Lovers studied the " language of flowers " and carried on clandestine flirtations by means of carefully selected nosegays. But many popular flower books of the Victorian age—such, for instance, as Anne Pratt's *The Flowering Plants . . . of Great Britain* contrived to combine easily digested science with miscellaneous romantic flower-lore.

Thus, throughout the ages, the flower-painter has been tossed like a shuttlecock between the scientist on the one hand and the lover of the beautiful on the other. His art, like the art of opera, is not a pure one : he has to reconcile two conflicting ideals and contrive to effect a compromise. The true artist—the *mere* artist, if I may so call him : a painter like Renoir or Fantin-Latour—will succeed in giving you the exact *impression* of the hundred petals of a rose, and the artist is satisfied. But the botanist is not ; he cannot count the petals, comprehend the structure. Had this book been a history of flower-painting, not a history of botanical illustration, the work of the great still-life painters of Holland and France would have called for detailed treatment ; this, however, must wait for the sequel to this volume—the history of the use of flowers in painting and design.

But within the limits imposed upon the botanical illustrator, how much has been accomplished! Some measure of its quality can be gauged from the pages of the *Index Londinensis to Illustrations of Flowering Plants and Ferns* (6 vols., 1929-31; Suppl., 2 vols., 1941), that noble example of collaboration between the Royal Horticultural Society, the Royal Botanic Gardens, Kew, and the Oxford University Press, in which over 480,000 figures of flowers published under botanical names between 1753 and 1930 are listed. Of its quality I hope I have already shown examples enough to prove my case. A careful study of the best botanical drawings will open our eyes to the endless variety of nature and train them to enjoy, not merely the obvious charm of bluebell woods in spring, but the subtler beauties of colour, rhythm and texture, the structural miracle of cell and tissue, which are to be found in each individual flower, however humble.

BOTANICAL DRAWING

Eight articles by Walter Hood Fitch

Reprinted from The *Gardeners' Chronicle*, 1869

IT HAS been suggested to me by some who, I trust, are better able to appreciate my qualifications than my native modesty will allow me to do, that a few hints on botanical drawing, from my pen, might be useful to some of the readers of the *Gardeners' Chronicle*. Yielding to their superior judgment—though I am more accustomed to the pencil than the pen—I shall venture to make a few remarks, which, however simple and trifling they may appear to me, and perhaps to others, may be of some service to those who are ambitious of doing correctly what any one is supposed to be capable of doing, viz., sketching a flower, or a plant.

I have frequently heard the remark, that Mr. So-and-so is a good colourist but a bad draughtsman—a very left-handed compliment, equivalent to that of being pronounced able to write but not to spell, to paint a portrait but not to represent the individual. It is as well that correct drawing and colouring should be found in the same work, for the absence of the former cannot be compensated by any excellence in the latter. Most beginners in flower drawing are desirous of rushing into colour before they can sketch —unaware that the most gorgeous daub, however laboured, if incorrectly drawn is only a crude effort at " paper staining," as it is technically termed. The eye of a qualified critic is not to be foiled by colour. Facility in colouring is easily acquired, but a correct eye for drawing is only to be rendered by constant observation.

I may have occasion hereafter to say something about colouring— botanical and fanciful, for there is a difference between the two—similar to that between a portrait, and a mere picture. A strictly botanical drawing generally represents but one or two individual plants, and they must be equally correctly drawn and coloured. A fancy drawing or group in proportion to the number of plants introduced may have the details

judiciously slurred over, for the eye of the observer cannot comprehend the minute points of all at a glance, so there is no labour lost. I may state that this dependence upon the carelessness of the observer is very frequently carried too far—and if at all times far from flattering, is often offensive ; and that the works of many professors of flower drawing are not calculated to improve the public taste for the domain of Flora.

To argue the propriety of correctness in anything may seem like discussing a truism, but correctness is very often a question of degree, or a matter of taste. We judge according to the light that is in us.

I have particularly in view the edification of young gardeners ; for in the numerous works intended for their instruction, I am not aware that there are any hints in relation to botanical or flower drawing. Judging from the omission, one might almost suppose it was thought that if the pupils but mastered half the matter that was written for their improvement, they might well dispense with so trifling an accomplishment. I need not dilate on the usefulness to gardeners of a knowledge of sketching, not flowers only, but anything in the way of their profession, for many have expressed to me their regret at their inability, being deterred from testing it by imaginary difficulties. I may state that a slight sketch is often more explanatory than any description ; and to collectors and cultivators, figures of the plants they collect or deal in are particularly desirable. I purpose making a few remarks, which I hope will be of assistance to beginners in overcoming the difficulties they may encounter in their first attempts. The simple means I have employed in the course of some years' experience will be found applicable equally to drawing dried as well as living plants.

I may premise that a knowledge of botany, however slight, is of great use in enabling the artist to avoid the errors which are occasionally perpetrated in respectable drawings and publications, such as introducing an abnormal number of stamens in a flower ; giving it an inferior ovary when it should have a superior one, and *vice versa*. I have frequently seen such negatively instructive illustrations of ignorance—quite inexcusable, for a little knowledge would enable them to be avoided. It is more creditable that one's works should furnish an example than a warning.

Materials.—For flower drawing smooth paper is best suited, as it allows of finer touches and lines, and smoother washes of colour.

The best pencil to use is an H. for delicate subjects, such as white flowers, and an F. for leaves, and any part which is to receive dark colours, so that the lines may not be entirely obliterated.

In botanical subjects it is sometimes desirable to represent the roots, bulbs, etc., but they are so easily drawn that I think no special directions are necessary.

Stems.—In the straight stem there is always some degree of curve,

therefore, the ruler should never be used ; it is the last resort of those unable to make " straight strokes," and only worthy of schoolboys. It is more difficult to draw parallel lines, and the best practice is to sketch grasses or long-leaved plants. Leafy stems or branches should be first faintly outlined their whole length, of their proper thickness, so that the drawing may occupy a well-balanced position on the paper. Then mark whence the leaves spring. It is also desirable to note the shape of the stem, whether square, round, winged, etc. The slight sketch below will show the advantage of proceeding thus cautiously, and will enable every leaf petiole to have its proper point of attachment, whether visible or not.

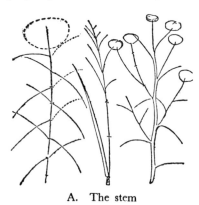

A. The stem

Leaves.—If the leaves are more or• less erect in relation to the stem, sketch the lower ones first, as a guide for those above, as in the left-hand cut in the following sketch (Fig. B).

If reflexed, commence with the upper leaves, for the same reason. If done thus systematically, there will be a great saving of time and india-rubber.

Opposite leaves are best shown slightly askew, but if the stem is branched, the leaves on some of the branches should be more or less fore-shortened, for the sake of variety.

Outline large leaves faintly before sketching them decidedly, and that should be done with one stroke of the pencil, and not with repeated touches, unless the leaves are woolly, when an indefinite outline is advisable. It is better to put in the midrib first, and it should always have some degree of curve, however stiff the leaves may be—leaves are very seldom so rigid as to have none ; then mark whence the veins spring.

In serrated leaves it is safer to put in the serrated outline before doing the veins ; and, in cases where the latter terminate in the points of the serratures, commence the veins at the points, and they are sure to terminate properly.

In lobed leaves, after faintly indicating the lobes, put in the ribs and veins first, and the outline of the lobes, particularly if they be toothed, will be found much easier. In digitate leaves indicate the petiole and midribs first, the relative position of the leaflets can be kept with greater certainty. In pinnate leaves, when large, after faintly sketching the rachis and the points whence the leaflets spring, put in the midribs first, and define the leaflets last ; if the pinnate leaf is small, this is unnecessary.

Leaves in Perspective.—Leaves have been subjected to more bad treatment

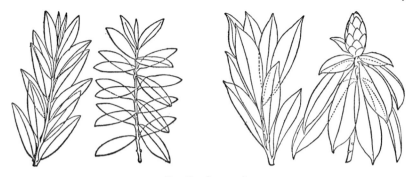

B. Leaf growth

by the draughtsman than perhaps any other portion of the vegetable
kingdom ; they have been represented, or rather misrepresented, in all
kinds of impossible positions. Numerous are the tortures to which they
have been subjected : dislocated or broken ribs, curious twists, painful to
behold—even their wretched veins have not escaped ; and all these errors
in perspective arise from inattention to the simple fact, that in a curved
leaf, showing the under side, the midrib should be continuous, and the
veins should spring from the midrib. The simple way to avoid perpetrating
such vagaries, is to treat a leaf as if it were skeletonised, and I would
recommend skeletonised leaves as admirable subjects to illustrate their
own perspective. A little study of them in this state would be beneficial
to those who are wont to take unwarrantable liberties with them when

C. Serrated, pinnate and lobed leaves

rejoicing in their summer garment of green, which veils their curious anatomy.

In representing leaves in perspective, then, the first faint outline will be found of the greatest service, and in making it, the leaves should be treated as if they were skeletonised, i.e. continue the outline through the curved portion of the leaf. Here I may impress upon the reader the importance of noting the angle formed by the veins with the midrib, their respective distances apart, their faintness or prominence. It is also useful in drawing for scientific purposes, to represent a leaf cut across, to show the thickness ;

D. Leaves in perspective

but that is chiefly desirable when it is leathery or succulent. The cuts in Figure D will illustrate these remarks.

Flowers.—Flowers are often considered the most difficult parts of a plant to sketch ; but such, I think, is not really the case, their perspective being more evident and less varied than that of leaves whose positions are almost infinite.

The most common error perpetrated is that of not placing the flower correctly on its stalk or peduncle, but with its neck dislocated as it were, thus imparting to the sufferer an air of conscious comicality. To avoid this infliction, in making the first sketch prolong the stalk or axis through the

flower to the centre, whence the petals or divisions may be made to radiate correctly beyond a doubt. Another common fault is to represent them all pointing in one direction ; sometimes this may occur in Nature, but it is not artistic to copy it in every case.

For scientific purposes it is desirable that positions should be as varied as possible, so that at least a front side and back of a flower be exhibited. A third error I may also allude to, and it is one very common in drawings made from dried specimens for scientific purposes—I have often seen otherwise correct and beautiful plates marred by it—viz., the representing all or most of the flowers in a panicle or mass, with one particular division of the corolla directed towards the spectator ; such uniformity is too mechanical to be natural. As good a flower as any to commence with is a Primrose, and for a mass of flowers the Polyanthus or Oxlip, as in these cases they are presented to the eye in various positions.

E. Tubular flowers

For the front view a faint circle should be pencilled, the centre and the divisions of the corolla indicated, and then sketched in as firmly as is desirable. If the drawing is to be coloured, the outline and veins, if any, should be strong enough not to be quite obliterated by dark colour.

In a side view the tube should be properly adjusted to correspond with the throat or eye ; the simplest way to do so is to carry the outline of the tube faintly through to the centre of the flower, as in the foregoing cut. In a position showing the tube foreshortened, or in a back view, the same method should be adopted as shown in the above illustrations. Tubular

flowers are often sadly treated by draughtsmen ; take, for instance, the common Daffodil, in which, if lines were drawn round each centre, they ought to be in the same plane. The next sketch will better explain my meaning.

It is one of the most difficult flowers to sketch correctly in its natural position, and the best way to test correctness is to turn the paper, so that the flower be erect, when the bad drawing, if any, will be obvious.

Composite flowers, such as the Daisy, after being faintly defined, should

F. The Daffodil

be subdivided by lines radiating from the centre, as a guide for the direction of the outer florets. Inattention to this precaution is apt to result in the said florets being all endowed with a twist or curve to one side or the other, an arrangement unknown, I believe, to botanists, in this natural order.

In drawings for scientific purposes, it is proper to mark the number of outer florets, also the number of teeth at the tips, as in some plants they are more or less numerous. The direction the florets assume, whether spreading or reflexed, should be noted.

The florets of the disc, or centre, will be found rather troublesome to render, being geometrically arranged, and often very numerous. An attempt to put in every floret particularly would be certain to result in confusion, therefore it is a saving of labour, and more effective, merely to put in the more prominent parts which strike the eye of the observer, such as the anthers and stigmas.

Four-petaled flowers, such as the Wallflower, should be treated somewhat similarly when they are large enough to be worthy of that trouble ; a square or circle should be first drawn round the petals, then divide it into four parts—great assistance will be derived from it in insuring the relative size of the petals.

Pendulous flowers, such as the Fuchsia, may be treated likewise, but in such flowers there is one thing that should be particularly attended to—the curve formed by the peduncle or flower-stalk, owing to its slenderness or the weight of the flower. To make sure of the proper curve, it is useful to indicate the flower-stalk by a faint line carried through the flower as its axis in sketching, which will be found of great service, and the errors frequently visible in drawings of such things would be of less common

occurrence, not to speak of the protruding filaments pointing in various singular though impossible directions. I shall not attempt to furnish more than hints as to sketching oblique or irregular flowers.

The following cut (Fig. G ii) will show how to fit the corolla on its tube with some degree of certainty, but the amount of obliquity must be given by observation. To flowers such as those of the Aconitum or Monkshood, the Larkspur, and labiate flowers generally, often very varied in form, many of the previous remarks will hardly apply ; and the best way to proceed is to measure one part by another ; thus the tube may be rather longer than the calyx, the upper lip may be shorter or longer than the lower one, etc.

Be careful to represent the teeth of the calyx in their proper place in relation to the divisions of the corolla, viz., alternate with them, or inter-

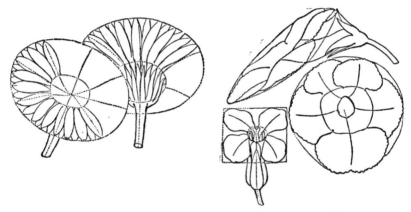

G. (i) Composite flowers ; (ii) The corolla and tube

mediate. And as a general fact, however irregular the flower may be, the teeth of the calyx point betwixt the petals or divisions. The want of observation of this fact is an error very common in slovenly drawings, but in the estimation of a botanist its exhibition would be quite enough to shake his faith in the trustworthiness of any artist, however beautiful his works might otherwise be, as it betrays carelessness, which is worse than ignorance.

Botanical artists require to possess a certain amount of philosophical equanimity to enable them to endure criticism, for as no two flowers are exactly alike, it is hardly to be expected that a drawing should keep pace with their variations in size or colour, and I may add that I never yet ventured to exaggerate a little in that way but I have found

that adverse criticism has been nullified by Nature excelling itself, as it were, under the fostering care of the many able cultivators of the present day.

Orchids.—Perhaps there are no flowers more varied in size, form, and colour, than those of Orchids, and I think I may add more difficult to sketch, if the artist has not some general knowledge of their normal structure. Dr. Lindley remarked, upon seeing the representatives of three different genera flourishing on the same spike, that after that they were capable of any eccentricity. Indeed they almost seem to have been created to puzzle botanists, or to test an artist's abilities, and consequently they are all the more worthy of a skilful pencil in endeavouring to do justice to them.

Owing to the great variation in form presented by some species, if the artist render correctly any specimen put in his hands, he is liable to have his veracity called into question, and, if any abnormal growth come in his way, he had better not be rash enough to represent what may be regarded as impossible by some authority who has made Orchids his speciality. It might tend to upset some favourite theory, or possibly to destroy a pet genus—an act of wanton impertinence which no artist endowed with a proper respect for the dicta of men of science would ever wilfully be guilty of !

It is impossible to lay down any rules for sketching these protean plants, but if the structure is not correctly rendered in a drawing it is worse than useless, as no colouring will redeem it. At the risk of saying what I presume is well known, I may state that the parts of the flower consist of a germen, or ovary, surmounted by three sepals, two petals, a lip, and a column, as in the following cut.

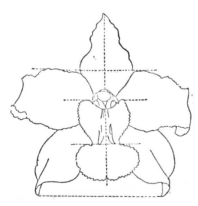

As Orchid flowers are so very irregular in the relative size of their parts, and especially so as regards the lip, the best way is to measure one part by another, and, if a front view of a large flower be given, a perpendicular line should be made, or imagined, through the centre, and also transverse ones, as guides for the pose of the petals, etc.

In the following sketch I suggest a means of testing the relative size of a front and side view. The artist should be guided by the front flowers in his drawing, for there is a liability to make the side views too

H. The Orchid, front view

large. Another matter to be noted, and which is often neglected, is the junction of the flower-stalk and column ; the way to prevent any hitch in this respect is to carry the outline of the germen and flower-stalk through to the back of the column, as in the right-hand cut of Figure I.

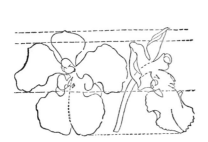

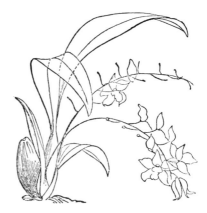

I. Orchid, perspective views J. Orchid ; a study in composition

Drawings of the smaller species of Orchids are of little scientific value without a flower and magnified representations of its parts, as the smaller they are the more curious is often their structure.

In magnified portions of simple flowered species, it is generally enough to give a side and front view of the lip and column, but in some cases it is necessary to pull the flower asunder, in order to represent parts otherwise hidden. If the flower or its parts be just large enough to be comprehended by the naked eye without a lens, it would be as well for the artist to regard it with one eye only, or he will find if he sketches it as seen with both eyes, that he sees round the corners, and is apt to commit an error similar to that of representing both ends of a drum as visible from the same point of view.

In the next cut (Fig. J) I offer a sketch of an Orchid, to show how to fill a sheet of paper as tastefully as the plant will allow, so as to leave no unnecessary vacant space. Some Orchids are very unmanageable in this respect.

If the pseudobulbs are compressed, it is as well to show the flowering one edgewise, so as to have variety in the position of the leaves, viz., a front and back view of them. The same may be said also of the spikes of flowers. After deciding whence the spike should spring, and the curve, if any, to be given to it, I would recommend that the attachment of the flower-stalks

should be ticked off, and that a line continuous with the stalks be carried through the flower faintly to the column, which should be put in first as the axis, then the lip and other petals can be correctly placed with reference to it. By following this simple plan, the flowers, though they may hide the flower-stalk, will be certain to be correctly placed.

Analyses.—In drawing analyses of flowers, their size should be regulated by that of the drawing in which they are to be introduced, as small dissections added to a large plate appear trifling, and if they are to be of use in explaining the structure they should always be sufficiently magnified to exhibit unmistakably and correctly the smallest peculiarity that may be of interest.

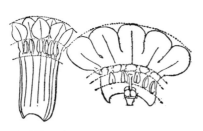

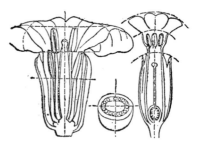

K. Dissections of (i) Angular Solomon's Seal ; (ii) Forget-me-not

L. Dissections of (i) Wallflower; (ii) Cowslip

In some earlier works on botany, the dissections are often represented of even less than the natural size, and are placed, perhaps judiciously, so as almost to escape observation : an instance of bad taste or timidity, which is not so common in later productions of the pencil or the press. If analyses are intended to be useful, they should be large enough to be sufficiently explanatory even in respect to their hairs, glands, etc. There is a general tendency in first attempts at dissection to represent the portions too small, on the same principle, possibly, that schoolboys are rather partial to small handwriting, under the impression that errors are not so easily detected. It requires some judgment to hit the happy medium.

For general purposes a flower shown cut open through the middle is sufficient, but for scientific enlightenment much more is requisite : and the beginner, if he wishes to perfect himself in these matters, should consult some botanical work, for it is not my object in these notes to give a lecture on structural botany.

If a Forget-me-not be the subject of study, the beginner should first faintly define the contour, then mark off the relative position and size of

the stamens, and notice whether they are betwixt or opposite the lobes of the corolla, as in Figure K(ii).

When the ovary is represented cut open, to show the arrangement of the ovules, it is advisable to cut the corolla also in half vertically, and treat it as in the former case. Cruciferous plants, such as the Wallflower, will be found easier to render if treated as in Figure L(i) ; the lines there marked across as a test of the distance and size of the parts, may be put in or imagined. In making sections of the ovary, it will save much trouble and use of india-rubber if they be treated as in the section given below ; if there are many compartments this circle should be divided systematically, by lines radiating from the centre, and it is possible thus to make them all of the same dimensions. The right-hand figure in this diagram shows how the structure of the Cowslip may be shown.

Irregular flowers, such as those of the Mint or Dead Nettle, may be represented neatly divided vertically with but half the parts remaining, as in the following cut, or spread open like any regular flower. It must be remembered that, however unequal the lobes of the corolla may be, the stamens or filaments almost always spring from between them, and it is a certain test to draw a faint line from the base of each filament to the cleft of the flower. The filaments in

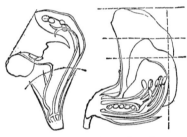

M. Dissections of irregular flowers : (i) Labiate ; (ii) Pea

such flowers are often attached low down in the tube, and if this precaution be not taken, a botanist might have some reason to doubt the correctness or botanical knowledge of the draughtsman. Figure M(i) will, perhaps, be of service in illustration of my observations.

Papilionaceous, or Pea-flowers are often represented, for scientific purposes, with all the parts separated, but it is a good and concise method to show a flower cut vertically in half through the ovary, so as to explain the relative position of the parts, the number of ovules in the seed-vessel, etc. (Fig. M(ii)).

The foregoing remarks may be serviceable to those who are ambitious of testing their patience, and correctness of eye, by dissecting flowers. Indeed, one of the finest exercises of the former virtue with which I am acquainted, is the analysis of a dried flower, from an herbarium specimen, perhaps very small, worm-eaten and gluey, and having no apparent analogy to any known plant.

After treating of the inside of flowers, it may be well to allude to the various coverings of the outside, and of plants generally, viz., the hairs,

down, and spines with which they are sometimes clothed. Let not the botanical artist who would earn a character for careful observation and correct representation, regard these as trifling matters, for they have caused more schism in the botanical world, perhaps, than their apparent importance would justify—ay, even to the bandying between opposing parties of opprobrious epithets, such as " hair-splitters " and "lumpers". It is best to steer a middle course between the contending factions, for an artist, if judicious, should have no bias either way—he is generally regarded as a neutral person.

Hairs, however, if very obvious on a plant, should certainly be rendered, and not in a slovenly manner. The angle they form with the part covered should be noted, as well as their general form, whether glandular or stellate, etc. : if they are represented at all, they should be done correctly. The artist will see that it is safest to be correct to a hair, and if he wishes to educate and refine his eye in this respect, I could not recommend more suitable subjects for the purpose than the British Roses and Brambles, two groups of plants greatly indebted to acute British botanists for their numerous subdivisions, and which, without the aid of particularly correct drawings, it would be very difficult to define.

The few hints that I have given, if applied practically, will, I hope, induce the beginner to proceed systematically in flower drawing, as he should do in any other pursuit. Then, by dint of zealous application, he may become qualified even to draw a dried specimen from the herbarium —an effort which will test his judgment, and call forth all his knowledge of perspective and adjustment.

It is not absolutely desirable (as some by their works would seem to imagine) that a drawing should exhibit any amount of evidence that it has been made from a dried specimen, but it is a curious fact that in drawings made from such materials some latent manifestation is seldom wanting, though the acute botanical critic would not hesitate to whom he should award credit for bad taste or ignorance—the plant or the artist. Sketching living plants is merely a species of copying, but dried specimens test the artist's ability to the uttermost ; and by drawings made from them would I be judged as a correct draughtsman.

Shading.—Having delivered myself of these truisms, and my humble opinion thereon, I shall venture to say something about the shading of plants, premising that I do not allude to the artistic treatment of which they are susceptible, but rather to theoretical shading.

In drawings with a background all the shades require to be proportionally deeper than in those on white paper, and various effects of light and shade may be rendered which should be charily indulged in when the background is white, for in the latter case the tone may be as light or dark as suits the taste of the artist. In strictly botanical drawings a background is seldom

given, and in most cases all the shading necessary is just enough to give unmistakable form to the parts, which should be all treated as if opaque. The transparency of the flowers may be slightly rendered, but the translucency of the leaves should never be attempted.

As a general rule in shading with pencil or with brown or black, if the drawing is not to be coloured, the shading should be faintly put in, and any attempt to supply the place of actual colour by tinting all the surface of a flower or leaf should be avoided as a useless waste of labour, and consequently in bad taste. I make an exception in the case of dark-coloured fruits or stems ; they may be tinted and shaded deeper with good effect.

In using the lead pencil it is of course necessary to produce the effect of shade by a series of touches, and unless the leaves be small, the lines should never be made in the direction of the midrib, but should follow the direction of the veins as shown in the left hand figure of the following cut.

N. The shading of (i) leaves ; (ii) petals and stem

If the artist should have occasion to lithograph or draw for wood-engraving, he will find the advantage of proceeding in this manner, as the lines answer a double purpose, and impart both shade and texture. In the shadow of one leaf on another (an effect which should always be rendered in a coloured or highly-shaded drawing) the lines may be hatched, as it is technically termed, i.e., crossed diagonally. In flowers the touches should blend with the visible or suppositious venation, for the shading, however finely done, if the lines be not systematically arranged, will never give the proper effect of shading. To make the lines of the shading harmonise with the venation may appear a very simple thing, but if the reader will test his

skill in that respect, I venture to predict that he will discover it to be one of the most difficult exercises of the pencil.

Stems, or any cylindrical portions of plants, should be treated as in the instance of the right hand figure in the foregoing cut—a reflected light should be left on the shaded side ; this will suggest that a section would be circular,but were the shading deepest near the outline of the stem, it would appear compressed, and a section would be oval. I have heard it remarked that reflected lights are an artistic refinement in botanical drawings for scientific purposes, but as it is certainly effective and natural an artist may safely give the paper on which he draws some credit for reflection.

SOME ILLUSTRATED WORKS ON BRITISH PLANTS

ADAMS, H. I. and BAGNALL, J. E. (1907-10). Wild Flowers of the British Isles. Illust. by H. Isabel Adams. Col. pls. 2 vols. 8vo. London

ANDREWS, J. Illust. See Tyas, R.

BAXTER, W. (1832-43). British Phanerogamous Botany. Illust. by W. A. Delamotte, G. Havell, C. Matthews and Isaac Russell. Col. pls. 6 vols. 8vo. Oxford. [For a history of this work, see A. H. Church in *J. Bot.* (London). 57 : 58-63 (1919)]

BENTHAM, G. (1865). Handbook of the British Flora. Illust. by Walter Hood Fitch. 2 vols. 8vo. London. 2nd ed. [The illustrations were later issued separately ; see Fitch and Smith]

BOULGER, G. S. (1914). British Flowering Plants. Illust. by I. S. Perrin (Mrs. Henry Perrin). Col. pls. 4 vols. 4to. London

BROWN, N. E. See Smith, J. E. (1891-92)

BUTCHER, R. W. (1930). Further Illustrations of British Plants. Illust. by Florence E. Strudwick. 8vo. Ashford, Kent. [A companion to Fitch and Smith, Illustrations]

BUTE, LORD. See Stuart, J.

CATLOW, A. (1848). Popular Field Botany. Col. pls. 8vo. London. (3rd ed., 1852)

CURTIS, W. (1775-87). Flora Londinensis, or Plates and Descriptions of such Plants as grow wild in the Environs of London. Illust. by Sydenham Teast Edwards, William Kilburn and J. Sowerby. Col. pls. 6 fasciculi in 3 (or 2) vols. Folio. London. [For information about dates of publication, see B. D. Jackson in *J. Bot.* (London) 19 : 309-10 (1881), W. A. Clarke, op. cit. 57 : 100 (1919), W. T. Stearn in Fedde, *Repert. Sp. Nov.* 45 : 216-17 (1938). B. D. Jackson published an index in *J. Bot.* (London) 54 : 153-64 (1916)]

——(1817-28). Flora Londinensis containing a History of the Plants

indigenous to Great Britain. Enlarged by G. Graves and W. J. Hooker. Col. pls. 5 vols. folio. London 2nd ed. [Reissued by Bohn in 1835]

DEAKEN, R. (1841-48). Florigraphia Britannica. Col. pls. 4 vols. London

DELAMOTTE, W. A. *Illust. See* Baxter, W.

EDWARDS, S. T. *Illust. See* Curtis, W.

FITCH, J. N. *Illust. See* Horwood, A. R.

FITCH, W. H. *Illust. See* Bentham, G., Moore, T., Plues, M.

FITCH, W. H. and SMITH, W. G. (1924). Illustrations of the British Flora. 8vo. London. 5th ed. [Fitch's illustrations were first published in Bentham's *Handbook*, then issued separately with additional figures by Smith in 1886]

FRYER, A. and BENNETT, A. (1915). The Potamogetons (Pond Weeds) of the British Isles. Illust. by E. C. Knight, Robert Morgan and Matilda Smith. Col. pls. 4to. London

GATHORNE-HARDY, R. (1938). Wild Flowers in Britain. Illust. by John Nash. Col. pls. 8vo. London. (3rd ed., 1948)

GODFERY, H. M. *Illust. See* Godfery, M. J.

GODFERY, M. J. (1933). Monograph and Iconograph of Native British Orchidaceae. Illust. by Hilda Margaret Godfery. Col. pls. 8vo. Cambridge

GOWER, C. *Illust. See* Hogg, R. and Johnson, G. W.

GRAVES, G. *See* Curtis, W. (1817-28)

GREEN, C. T. (1902). The Flora of the Liverpool District. Illust. by Emily Margaret Wood. 8vo. Liverpool

HANBURY, F. J. (1889-98). An illustrated Monograph of the British Hieracia. Illust. by Gulielma Lister and Mrs. F. J. Hanbury. Col. pls. 8 parts (all published). Folio. London

HAVELL, G. *Illust. See* Baxter, W.

HOGG, R. and JOHNSON, G. W. (1863-80). The Wild Flowers of Great Britain. Illust. by Charlotte Gower and Worthington George Smith. Col. pls. 11 vols. 8vo. London

HOOKER, W. J. *See* Curtis, W. (1817-28)

HORWOOD, A. R. (1919). British Wild Flowers in their Natural Haunts. Illust. by John Nugent Fitch. Col. pls. 6 vols. 8vo. London

HULME, F. E. (1875-1900). Familiar Wild Flowers. Col. pls. 9 series. 8vo. London. [Reissued in 1910]

HUMPHREYS, A. N. *Illust. See* Loudon, J. W.

HUNNYBUN, E. W. *Illust. See* Moss, C. E.

HUTCHINSON, J. (1945). Common Wild Flowers. 8vo. London

——(1948). More Common Wild Flowers. 8vo. London

——(1948). British Flowering Plants. Col. pls. 8vo. London

JACKSON, M. E. (1840). The Pictorial Flora ; or British Botany Delineated. Col. pls. 8vo. London

JOHNSON, C. *See* Smith, J. E. (1832-46)

JOHNSON, C. P. (1861-62). The Useful Plants of Great Britain. Illust. by John Edward Sowerby. Col. pls. 8vo. London

KILBURN, W. *Illust. See* Curtis, W.

KNIGHT, E. C. *Illust. See* Fryer, A. and Bennett, A.

LANKESTER, P. (1864). Wild Flowers Worth Notice. Illust. by John Edward Sowerby. Col. pls. 8vo. London

LISTER, G. *Illust. See* Hanbury, F. J.

LOUDON, J. W. (Mrs. J. C. Loudon). (1846). British Wild Flowers. Illust. by Henry Noel Humphreys. Col. pl. 4to. London. (3rd. ed., 1859)

LOWE, E. J. (1858). A Natural History of British Grasses. Col. pls. 8vo. London

MATTHEWS, C. *Illust. See* Baxter, W.

MILLER, —. *Illust. See* Thornton, R. J.

MILLER, J. S. *Illust. See* Stuart, J.

MOORE, T. (1862). The Field Botanist's Companion. Illust. by Walter Hood Fitch. Col. pls. 8vo. London

MORGAN, R. *Illust. See* Fryer, A., and Bennett, A.

MOSS, C. E. (1914-20). The Cambridge British Flora. Illust. by Edward Walter Hunnybun. Vols. 2 and 3 (all published). 4to. Cambridge

NASH, J. *Illust. See* Gathorne-Hardy, R.

PARNELL, R. (1845). The Grasses of Britain. 8vo. Edinburgh

PERRIN, I. S. (Mrs. Henry Perrin). *Illust. See* Boulger, G. S.

PLUES, M. (1867). British Grasses. Illust. by Walter Hood Fitch. Col. pls. 8vo. London

PRATT, A. (1855). The flowering Plants, Grasses, Sedges and Ferns of Great Britain. Col. pls. 5 vols. London. (3rd ed., 6 vols., 1873)

ROBINS, T. *Illust. See* Sole, W.

ROSS-CRAIG, S. (Mrs. J. R. Sealy). (1948-49). Drawings of British Plants Parts 1-3 (to be continued). 8vo. London

RUSSELL, I. *Illust. See* Baxter, W.

SALTER, J. W. *Illust. See* Smith, J. E. (1829-66)

SANSOM, F. *Illust. See* Curtis, W.

SKENE, M. (1935). A Flower Book for the Pocket. Illust. by Charlotte Georgiana Trower and Ruth Weston. Col. pls. 8vo. Oxford

SMITH, J. E. (1790-1814). English Botany. Illust. by James Sowerby. Col. pls. 36 vols. 8vo. London. [Not arranged according to any system of classification. The best edition as regards the engraved plates.]

——(1829-66). Supplement to English Botany, by W. J. Hooker and others. Illust. by James de Carle Sowerby and John William Salter. Col. pls. 5 vols. 8vo. London

——(1832-46). English Botany. Edited by C. Johnson. Col. pls. 7 vols.

8vo. London. (2nd. ed. arranged according to the Linnaean method.) [A cheap and humble edition ; the plates only partly coloured]

SMITH, J. E. (1863-86). English Botany. Edited by J. T. Boswell Syme. Col. pls. 12 vols. 8vo. London. (3rd. ed., re-arranged according to the natural orders.) [The best edition as regards the text, but with lithographed plates inferior to the engraved plates of the first edition]

——(1891-92). English Botany. Vol. 13 (supplement vol.) by Nicholas Edward Brown. Col. pls. 8vo. London (3rd ed.)

SMITH, M. *Illust. See* Fryer, A and Bennett, A.

SMITH, W. G. *Illust. See* Fitch, W. H. and Smith, W. G., Hogg, R. and Johnson, G. W.

SOLE, W. (1798). Menthae Britannicae. Illust. by T. Robins and others. Folio. Bath

SOWERBY, J. *Illust. See* Smith, J. E. (1790-1814) ; Curtis, W.

SOWERBY, J. de C. *Illust. See* Smith, J. E. (1829-66)

SOWERBY, J. E. *Illust. See* Johnson, C. P. ; Lankester, P.

STRUDWICK, F. E. *Illust. See* Butcher, R. W.

STUART, J. 3rd Earl of Bute. (1785). Botanical Tables, containing the different Familys of British Plants. Illust. by John Sebastian Miller. Col. pls. 9 vols. 4to. No place of publication stated. [For notes on this work, of which only 12 copies were issued, see W. B. Hemsley in *Kew Bull.* 1892 : 306-08 ; J. Britten in *J. Bot.* (London) 54 : 84-87 (1916)]

SYME, J. T. B. *See* Smith, J. E. (1863-86)

THORNTON, R. J. (1812). The British Flora. Illust. by ——. Miller. 5 vols. 8vo. London

TROWER, C. G. *Illust. See* Skene, M.

TYAS, R. (1840-50). Favourite Field Flowers, or Wild Flowers of England popularly described. Illust. by James Andrews. Col. pls. 2 series. 8vo. London

WESTON, R. *Illust. See* Skene, M.

WOOD, E. M. *Illust. See* Green, C. T.

SOURCES OF FURTHER INFORMATION

DETAILS of further articles dealing with British botanical artists will be found in Britten and Boulger's *A Biographical Index of* . . . *British and Irish Botanists*. Pritzel's *Thesaurus* is the invaluable source of reference for botanical books in general, while Arber (1938) and Dunthorne give much useful information for their particular periods.

ANON. (1916). Sir Arthur Church's collection of botanical drawings. *Kew Bull.* 1916 : 162-68

ALTENA, I. Q. VAN REGTEREN (1930). Vergeten Namen, II. Johan Verwer. *Oud-Holland,* 47. iv : 167-68

ARBER, A. (1921). The draughtsman of the " Herbarum Vivae Eicones." *J. Bot. London,* 59 : 131-32

——(1938). Herbals, their Origin and Evolution. 2nd edition. Cambridge University Press.

——(1940). The colouring of sixteenth-century herbals. *Nature, London,* 145 : 803

——(1946). Goethe's botany. *Chronica Botanica,* 10 : 63-126

AUBRIET, C. *See* Bultingaire, L. (1928)

BASSEPORTE, M. *See* Bultingaire, L. (1928)

BÉNÉZIT, E. (1911-23). Dictionnaire . . . des Peintres. . . . Paris

BERGSTRÖM, I. (1947). Stillebenmålerei under 1600-talet. Göteborg

BERNHARD, O. (1925). Pflanzenbilder auf griechischen und römischen Münzen. *Veröffentl. Schweiz. Ges. Med. Naturwiss.* 3

BESLER, B. *See* Schwertschlager, J.

BIESE, C. J. A. A. (1892). Die Entwicklung des Naturgefühls. Leipzig

BINYON, L. (1911). The Flight of the Dragon. London

BLUNT, W. (1950). Tulipomania. Harmondsworth, Penguin Books

BOURDICHON, J. *See* Camus, J. ; Delisle, L. ; Gibbon, D. ; Mâle, E.

BRIQUET, J. (1940). Biographies des Botanistes à Genève. *Ber. Schweiz. Bot. Ges.* 50a

BRITTEN, J. (1920). The Duchess of Beaufort's Flower Drawings. *The Garden*, 84 : 428-429

BRITTEN, J. and BOULGER, G. S. (1931). Biographical Index of British and Irish Botanists. 2nd edition. London

BROCKHAUS, M. (1937). Der Blumenmaler Pierre Joseph Redouté und seine Rosenbildnisse. *Gartenflora*, 86 : 156-58

BRUNFELS, O. *See* Sprague, T. A.

BULTINGAIRE, L. (1926). Les origines de la collection des vélins du Muséum et ses premiers peintres. Paris, *Archives du Muséum*, Ser. 6, 1 : 129-49

——(1927). Les Vélins du Muséum d'Histoire naturelle de Paris : Fleurs exotiques. Paris

——(1928). Les peintres du Jardin du Roy au XVIIIe siècle. Paris, *Archives du Muséum*, Ser. 6, 3 : 19-36

——(1930). Les peintres du Muséum à l'époque de Lamarck. Paris, *Archives du Muséum*, Ser. 6, 6 : 49-58

——(1935). L'art au Jardin des Plantes. Paris, *Archives du Muséum*, Ser. 6, 12 : 667-78

CAMUS, J. (1894). Les noms des plantes du Livre d'heures d'Anne de Bretagne. *J. Bot. Paris*, 8 : 325-35, 345-52, 366-75, 396-401

CARDEW, F. M. G. (1947). Dr. Thornton and the "New Illustration," 1799-1807. *J. Roy. Hort. Soc.* 72 : 281-85 (See also 72 : 450-53)

——(1948). A note on the illustration of roses. *J. Roy. Hort. Soc.*, 73 : 180-82

CHURCH, A. H. *See* Anon.

COCKAYNE, T. O. (1864). Leechdoms, Wortcunning and Starcraft of Early England. Vol. 1. London

COGGIOLA, G. (1903-08). La Breviaire Grimani. Leiden

CRANMER-BYNG, L. (1932). The Vision of Asia. London

CROZET, RENÉ. (1949). Communication. *Bulletin de la Société des Antiquaires de l'Ouest*, Ser. 3, 15 : 40-44

CURTIS, W. H. (1941). William Curtis 1746-1799 . . . with some notes on his Son-in-law Samuel Curtis. Winchester

DELANY, M. (1861-62). The Autobiography and Correspondence of Mary Granville, Mrs. Delany. London

——*See* Johnson, R. B.

DELISLE, L. V. (1913). Les Grandes Heures de la Reine Anne de Bretagne. Paris

DE TONI, G. (1922). Le Piante e gli Animali in Leonardo da Vinci. Bologna

DIOSCORIDES, PEDIANOS. *See* Gunther, R. W. T. (1934) ; Karabacek, J. V. ; Stearn, W. T. (1949)

DUNTHORNE, G. (1938). Flower and Fruit Prints of the Eighteenth and early Nineteenth Centuries. London

DURAN-REYNALS, M. L. (1947). The Fever Bark Tree. London

DÜRER, A. See Gerstenberg, K. ; Killerman, S. (1910) ; Lippmann, F. ; Winkler, F.

DURFORT, —. (1937). The Château of Ancy le Franc, Burgundy. *Country Life*, 82 : 246-51

EHRET, G. D. (1896). A memoir of Georg Dionysius Ehret . . . written by himself. *Proc. Linn. Soc. London*, 1894-95 : 41-58

EMMART, E. W. (1940). The Badianus Manuscript (Codex Barberini, Latin, 24) Vatican Library ; an Aztec Herbal of 1552. Baltimore

EVANS, J. (1933). Nature in Design. Oxford

FAXON, C. See Sargent, C.

FITCH, W. H. (1869). Botanical Drawing. *Gardeners' Chronicle*, 1869 : 7, 51, 110, 165, 221, 305, 389, 499

——*See* Hemsley, W. B. (1915)

FUCHS, L. See Sprague, T. A. and Nelmes, E.

GABRIELI, G. (1929). Due codici iconografici di piante miniate nella Biblioteca Reale di Windsor. Rome, *Rendiconti Accad. Naz. Lincei Sci.* VI. 10 fasc. 10 : 531-38

GANZENMÜLLER, W. (1914). Das Naturgefühl im Mittelalter. Leipzig

GARIDEL, P. J. (1715). Histoire des Plantes qui naissent en Provence. Aix en Provence

GARRY, F. N. A. (1903-04). Notes on the drawings for " English Botany." *J. Bot. London*, 41-42 : Suppl.

GARSIDE, S. (1942). Baron Jacquin and the Schönbrunn Gardens. *J. South African Bot.* 8 : 201-24

GEISBERG, M. (1923). Die Anfänge des Kupferstiches. Leipzig

GELDER, J. G. VAN. (1936). Van Blompot en Blomglas. Amsterdam, *Elsevier's Geïllustreerd Maandschrift*, 91 : 73-166

GERSTENBERG, K. (1936). Albrecht Dürer : Blumen und Tiere. Berlin

GHIBERTI, L. See Schlosser, J.

GIBBON, D. M. (1933). Jean Bourdichon. Glasgow

GIGLIOLI, O. H. (1924). Giacomo Ligozzi. *Dedalo, Milan*, 4 : 554-70

GNECCHI, F. (1919). The Fauna and Flora on the Coin-types of Ancient Rome. (Reprinted from the *Numismatic Circular*, 1916-18.) London

GOETHE, J. W. VON. See Arber, A. (1946) ; Scheuermann, W. ; Schuster, J.

GREEN, J. R. (1914). A History of Botany in the United Kingdom. London

GRIMANI BREVIARY. See Coggiola, G.

GROLIER, CLUB, N. Y. (1941). Plant Illustration before 1850, a catalogue of an exhibition. New York

GUINEY, R. (1949). On the whereabouts of the " Oxford copy" of Rudbeck's " Campi Elysii." *Proc. Linn. Soc. London*, 161 : 50-56

GUNTHER, R. W. T. (1925). The Herbal of Apuleius Barbarus . . . (MS. Bodley 130). Oxford

——(1934). The Greek Herbal of Dioscorides illustrated by a Byzantine A.D. 512. Oxford

HAGEN, V. W. VON. (1948). " The immortal botanist " (Jose Celestino Mutis). *J. New York Bot. Gdn.* 49 : 177-84, 210-18

HAMY, E. T. (1901). Jean le Roy de la Boissière et Daniel Rabel. Paris, *Nouvelles Archives du Muséum*, Ser. 4, 3 : 1-120

HATTON, R. G. (1909). The Craftsman's Plant-book. London

HAWKS, E. (1928). Pioneers of Plant Study. London

HEMSLEY, W. B. (1887). The " Botanical Magazine." *Gardeners' Chronicle,* Ser. 3, 1 : 345, 381, 450, 479, 514, 642, 671, 767 ; Ser. 3, 2 : 11, 45, 127, 246, 368, 433, 471, 620

——(1915). Walter Hood Fitch, botanical artist, 1817-1892. *Kew Bull.* 1915 : 277-84, 392

——(1890). John Miller, and his work. *Gardeners' Chronicle.* Ser. 3, 7 : 255-56

HILL, T. G. (1915). The Essentials of Illustration. London

HOEFNAGEL, G. *See* Killermann, S. (1911)

HORTUS FLORIDUS. *See* Savage, S. (1923-29)

HORTUS SANITATIS. *See* Schreiber, W. L.

HUNGER, F. W. T. (1927). Charles de l'Escluse (Carolus Clusius), Nederlandsch Kruidkundige, 1526-1609. The Hague

——(1915). The Herbal of Pseudo-Apuleius. Leiden

ISTVÁNFFI, G. (1900). A Clusius-codex. Budapest

JACKSON, B. D. (1905). The history of botanic illustration. *Trans. Herts. Nat. Hist. Soc.* Ser. 12, 4 : 145-56

——(1924). Botanical illustration from the invention of printing to the present day. *J. Roy. Hort. Soc.* 49 : 167-77

JACQUIN, N. J. *See* Garside, S.

JESSEN, K. F. W. (1864). Botanik der Gegenwart und Vorzeit. Leipzig. (New impression, 1948; Waltham Mass., U.S.A.)

JOHNSTON, R. BRIMLEY. (1925). Mrs. Delany. London

JOUBERT, J. *See* Bultingaire, L. (1926)

KARABACEK, J. VON. (1906). Dioscurides Codex Aniciae Iulianae Picturis illustratus, nunc Vindobonensis. *Med. Graec. I,* 2 vols. Leiden

KENNEDY, R. W. (1948). The Renaissance Painter's Garden. New York

KICKIUS, E. *See* Britten, J.

KILLERMAN, S. (1910). A. Dürer's Pflanzen- und Tierzeichnungen. *Studien zur Deutschen Kunstgeschichte,* 119. Strasbourg

——(1911). Die Miniaturen im Gebetbuche Albrechts V. von Bayern. *Studien zur Deutschen Kunstgeschichte,* 140. Strasbourg

——(1937).Pflanzen und Tieren in illuminierten Büchern. *Sankt Wiborada,* 4

KREDEL, F. (1940). Glass flowers in the Ware Collection. New York

KRELAGE, E. H. (1942). Bloemenspeculatie in Nederland. Amsterdam

——(1946). Drie Eeuwen Bloembollenexport. The Hague

LANE, A. (1946). Flower painting on pottery and porcelain. *Geogr. Mag.* 18 : 522-30

LÉGER, C. (1945). Redouté et son Temps. Paris

LEONARDO DA VINCI. *See* De Toni, G.; Popham, A.E.

LIGOZZI, G. *See* Giglioli, O.

LIPPMANN, F. (1883-1929). Zeichnungen von Albrecht Dürer. Berlin

LOCY, W. A. (1921). The earliest printed illustrations of natural history. *Sci. Monthly, New York,* 13 : 238-58

LÜTJEHARNS, W. J. and VAN OOSTSTROOM, S. J. (1936) Über eine botanische Handschrift aus dem 15 Jahrhundert. *Blumea,* 2 : 75-85

LUTZE, E. (1936). Die Bilderhandschriften der Universitätsbibliothek Erlangen. Erlangen

MÂLE, E. (1946). Les Heures d'Anne de Bretagne. Paris

MERIAN, M. S. *See* Pfeiffer, M.; Schnack, F.; Nienhuis, J. S.

MEYER, E. H. F. (1854-57). Geschichte der Botanik. Königsberg

MICHIEL, P. A. (1940). I cinque Libri di Piante. Transcrisione e commento di Ettore de Toni. Venice

MILLER, J. *See* Hemsley, W. B.

MÖBIUS, M. (1933a). Pflanzenbilder der Minoischen Kunst in botanischer Betrachtung. *Jahrb. Deutschen Archäolog. Inst.* 48 : 1-39

——(1933b). Pflanzen der altkretischen Kunst. Engler, *Bot. Jahrb.,* 66 : 103-12

MUTIS, J. C. *See* Duran-Reynals, M.L. ; Hagen, V. W. von

NIENHUIS, J. S. (1945). Verborgen Paradijzen. Arnhem

NISSEN, C. (1933). Botanische Prachtwerke. Die Blütezeit der Pflanzenillustration von 1740 bis 1840. Vienna. (Reprinted from *Philobiblon. Zeitschrift für Bücherliebhaber,* 6 nos. 7-9)

OOSTSTROOM, S. J. VAN. (1946). On an eighteenth-century oil-painting of botanical interest. *Blumea Suppl.* 3 : 120-21

PÄCHT, O. (1948). The Master of Mary of Burgundy. London

PARSONS, A. *See* Cardew, F. M. G. (1948)

PASSE, CRISPIN DE. *See* Savage, S. (1923a ; Rohde, E. S. (1928-29))

PAYNE, J. F. (1903). On the " Herbarius " and " Hortus Sanitatis." *Trans. Bibliogr. Soc.* 6 : 63-126

——(1912). English Herbals. *Trans. Bibliogr. Soc.* 11 : 299-310

PEVSNER, N. (1945). The Leaves of Southwell. Harmondsworth, Penguin Books

PFEIFFER, M. (1931). Die Werke der Maria Sibylle Merian. Meissen

PLANCHON, J. E. (1873). Sur les espèces de fritillaires de France, à propos des " Icones " et d'un manuscrit inédit de Pierre Richer de Belleval. *Bull. Soc. Bot. France*, 20 : 96-124

POPHAM, A. E. (1946). The Drawings of Leonardo da Vinci. London

POST, F. *See* Sousa-Leao, J. de

PRITZEL, G. A. (1872). Thesaurus Literaturae Botanicae. 2nd edition. Leipzig (Reprint, Milan, 1950)

RABEL, D. *See* Bultingaire, L. (1926) ; Hamy, E. T. ; Savage, S. (1923-6)

REDOUTÉ, P. J. *See* Brockhaus, M.; Bultingaire, L. (1928); Léger, C.; Wegener, H. (1937)

ROHDE, E. S. (1922). The Old English Herbals. London

——(1928, 29). Crispian Passeus. Hortus Floridus. London

ROBERT, N. *See* Bultingaire, L. (1926); Uzanne, O.

ROSEN, F. (1903). Die Natur in der Kunst. Leipzig

RUDBECK, O., father and son. Campi Elysii. *See* Guiney, R.

RYTZ, W. (1933). Das Herbarium Felix Platters. *Verhandl. Natur. Ges. Basel*, 44 : 1-222

——(1936). Pflanzenaquarelle des Hans Weiditz aus dem Jahre 1529. Berne

SACHS, J. VON. (1890). History of Botany, 1530-1860. Transl. by H. E. F. Garnsey. Oxford

SALTER, E. (1912). Nature in Italian Art. London

SARGENT, C. S. (1918). Charles Edward Faxon. *Rhodora*, 20 : 117-22

SAVAGE, S. (1921). A little-known Bohemian herbal. *Trans. Bibliogr. Soc.*, Ser. 2, 2 : 117-31

——(1922). The discovery of some of Jacques Le Moyne's botanical drawings. *Gardeners' Chronicle*, Ser. 3, 71 : 44

——(1923a). The " Hortus Floridus " of Crispijn vande Pas the Younger. *Trans. Bibliogr. Soc.*, Ser. 2, 4 : 181-206

——(1923b). Early botanic painters. *Gardeners' Chronicle*, Ser. 3, 73 : 8, 92-93, 148-49, 200-01, 260-61, 336-37

SCHEFFER, J. (1938). De Tentoonstelling van boeken, teekeningen . . . Leiden, *Bijdragen tot de dierkunde*, 27 : 115-63

SCHEUERMANN, W. (1937). Ein zeitgemässe Sammlung. *Gartenflora*, 86 : 65-69

SCHLOSSER, J. VON. (1908). Die Kunst- und Wunderkammern der Spätrenaissance. Leipzig

——(1941). Leben und Meinungen des Florentinischen Bildners Lorenzo Ghiberti. Basle

SCHNACK, F. (n.d.). Das kleine Buch der Tropenwunder. Leipzig

SCHREIBER, W. L. (1924. Die Kräuterbücher des XV und XVI Jahrhunderts. Munich. (Published as supplement to Facsimile-ausgabe des Hortus Sanitatis, Deutsch)

SCHUSTER, J. (1924). Goethe, Die Metamorphose der Pflanzen. Berlin

SCHWERTSCHLAGER, J. (1890). Der botanische Garten der Fürstbischöfe von Eichstätt. Eichstätt

SERRA, L. (1940). L'Arte nel Theatrum Sanitatis. Rome

SINGER, C. (1921). Studies in the History and Method of Science. Vol. 2 London

——(1923). Herbals. *Edinburgh Review*, 237 : 95-112

——(1927). The herbal in antiquity and its transmission to later ages. *J. Hellenic Studies*, 47 : 1-52

——(1928). From Magic to Science. London

SMITH, E. (1911). The Life of Sir Joseph Banks. London

SOUSA-LEAO, J. DE. (1942). Frans Post in Brazil. *Burlington Mag.* 80 : 59-61

SOWERBY, J. *See* Garry, F. N. A.

SPAËNDONCK, G. VAN. *See* Bultingaire, L. (1928)

SPRAGUE, T. A. (1928). The herbal of Otto Brunfels. *J. Linn. Soc. Bot. London*, 48 : 79-124

——and NELMES, E. (1931). The herbal of Leonhart Fuchs. *J. Linn. Soc. Bot. London*, 48 : 545-642

STAPF, O. (1926). The "Botanical Magazine": its history and mission. *J. Roy. Hort. Soc.* 51 : 29-43

STEARN, W. T. (1938-39). An annotated index to Salm-Dyck's "Monographia Generum Aloes et Mesembryanthemi." *Cactus J.* 7 : 34-44, 66-85

——(1939). Ventenat's "Description des Plantes . . . de J. M. Cels", "Jardin de la Malmaison" and "Choix des Plantes." *J. Soc. Bibliogr. Nat. Hist.* 7 : 199-201

——(1940). Schneevoogt and Schwegman's "Icones plantarum rariorum." *J. Bot. London* 78 : 66-74

——(1949a). Kaempfer and the lilies of Japan. *Roy. Hort. Soc. Lily Year Book* 12 (for 1948) : 65-70

——(1949b). A survey of literature on delphiniums from the first to the seventeenth century A.D. *British Delphinium Soc. Year Book*, 1949 : 1-15

SYNGE, P. M. (1948). The "Botanical Magazine." *J. Roy. Hort. Soc.* 73 : 5-11

THEATRUM SANITATIS, *See* Serra, L.

THIEME, U., and BECKER, F. (1907). Allgemeines Lexicon der bildenden Künstler. Leipzig

THORNTON, R. J. *See* Cardew, F. M. G. (1947)

TOWNROW, K. R. (1947). A note from Dürer's "Virgin with the Iris" lately acquired by the National Gallery. *Burlington Mag.* 89 : 102

TREVIRANUS, C. L. (1855). Die Anwendung des Holzschnittes zur bildlichen Darstellung von Pflanzen. Leipzig. (New impression ; Utrecht, 1949)

UZANNE, O. (1875). La Guirlande de Julie. Paris

VOET, C. B. *See* Scheffer, J.

WAAGEN, G. F. (1866). Die vornehmsten Kunstdenkmäler in Wien. Vienna

WADE, A. E. (1942). Plant Illustration from Woodcut to Process Block. Cardiff (Nat. Mus. of Wales)

WALKER, E. H. (1935). An aid to botanical drawing *Phytologia* I : 165-66

WARNER, R. (1928). Dutch and Flemish Fruit and Flower Painters of the XVIIth and XVIIIth Centuries. London

WEGENER, H. (1936). Das grosse Bildwerk des Carolus Clusius in der Preussischen Staatsbibliothek. *Forschungen und Fortschritte, Berlin,* 12 : 374-76

——(1936). Ein unbekanntes Werk des Carolus Clusius ? *Medizinische Mitteilungen,* 8 : 191-95

——(1936) Die Lehrjahre der deutschen Blumenzucht *Gartenflora* 85 : 47-50 (see also other articles in this volume)

——(1937). Die Rosenabbildungen bis Redouté. *Gartenflora,* 86 : 154-56

——(1938). Die wichtigsten naturwissenschaftlichen Bilderschriften nach 1500 in der Preussischen Bibliothek. Berlin, *Zentralbl. für Bibliothekswesen,* 55

WEIDITZ, H. *See* Arber, A. (1921); Rytz, W.

WEISS, F. E. (1941). Notes on the botanical chamber in the festal temple of Thutmosis III at Karnak. *J. Roy. Hort. Soc.,* 66 : 51-54

WHITE, J. *See* Savage, S.

WHITE, V. V. (1947). Flowers of ten Centuries, an Exhibition. New York

WIDDER, F. (1949). Actaea nutans Tausch und der Hortus Canalius. *Phyton,* 1 : 258-68

WIJNGAERT, F. VAN DEN. (1947). De botanische Teekeningen in het Muséum Plantin-Moretus. *De Gulden Passer Antwerp,* 25 : 34-51

WINKLER, F. (1936-37). Die Zeichnungen Albrecht Dürers. Berlin

WRIGHT, R. (1937). Twenty-five Flower Prints. New York

ALEXANDER, E. J., and WOODWARD, C. H. (1941). The flora of the Unicorn Tapestries. *J. New York Bot. Garden.* New York

FISCHER, H. (1929). Mittelalterliche Pflanzenkunde. Munich.

LEITGEB, J., etc. (1950). *Blumen-Aquarelle von M. M. Daffinger* (Albertina-Facsimile). Vienna

NISSEN, C. (1949). Die naturwissenschaftliche Abbildung. *Gutenberg-Jahrbuch* 1944-49: 249-66

——(1950-). *Die botanische Buchillustration.* Stuttgart

SARTON, G. (1927-). Introduction to the History of Science. Baltimore

TEZA, E. (1897). II *De Simplicibus* di B. Rinio nel Codice Marciano. *Atti R. Ist. Veneto sci. litt. art.* 9: 18-29. Venice

TONI, E. de. (1919-24). De Libro dei Semplici di Benedetto Rinio. *Mem. Accad. Nuovi Lincei,* vols. 5, 7, 8. Rome

INDEX

Items in the two bibliographies (pp. 283–94) are not indexed. Plants are listed under their scientific names. Plate numbers in roman numerals, e.g. (Pl. IV, p. 33) refer to black-and-white plates. Plate numbers in arabic figures, e.g. (Pl. 41, p. 224), refer to black-and-white plates formerly in colour. Main entries are in heavy type.

295